Curator / Creative Director __ Sijuan
Publisher __ Abdul Nasser
Project Editor __ Melissa Lin
Project Designer __ Vvhy Yip

Produced by __

BIG WORKSHOP
~ www.bigbrosworkshop.com ~

Bigbros Workshop
For more enquiries, kindly email to us __
info@bigbrosworkshop.com

Publish by __

B BASHEER
GRAPHIC BOOKS

Last Gasp
777 Florida Street
San Francisco, CA 94110
phone 415.824.6636
fax 415.824.1836
W __ www.lastgasp.com

ISBN: 978-0-86719-742-6

Basheer Graphic Books
Add. Blk 231, #04-19, Bain Street
Bras Basah Complex,
Singapore 180 231
T __ (65) 6336.0810
F __ (65) 6334.1950
E __ abdul@basheergraphic.com
W __ www.basheergraphic.com

PSYCHEDELIC POP

The revolution of love and peace that was the 60's has left an indelible mark in virtually every aspect of youth and alternative culture. It's threads live on today in the domains of spirituality, music, fashion the art world as well as the revolutionary movement.

The Summer of Love brought to the world the ubiquitous yellow smiley face, flower power, beads,lush velvet and bare feet. It heralded the birth of a new era, giving us Janis Joplin, Jimi Hendrix, the beatles,Jim Morrison and the avant garde - Velvet Underground and Andy Warhol, the icons of their generation, who in turn fueled the message of peace not war, free love and sexual expression (nudity being a feature of that spirit, also symbolic of shedding class barriers).

American youth at the time were bored with consumer culture and the authoritative and conservative society who championed the nuclear family and traditional moral values. There was a desire to seek out something radically different, something that would change their lives and the world at large. It happened that there began a growing consciousness, starting with the beat generation in the 50's, a momentum that was built up and eventually evolved into a potent counterculture of the 60's hippies.

The hippies were appalled at the Vietnam war and began campaigning against Nuclear weapons, racism and poverty. The feminist movement began when women started questioning their sexual roles and limited life choices in domesticity. The invention of the pill during this time gave women what they never had before - reproductive freedom. The ecology movement also had its roots in the 60's. In a quest for alternative and peaceful forms of living, many of the flower children opted to live in communes, organize massive protests, cook free food for people, and actively challenged the status quo.

Even in this new century, the impact of the 60's movement has far from faded away. It's psychedelic sound are roots of modern day musicians and bands, from the psychedelic soul of Lenny Kravitz to the shoe gazing psychedelia of Spiritualized. The music and lifestyle of the 60's was inseparable with the visual culture of the time. Buildings, political banners, fashion, walls and vehicles made statements and propelled the viewer into the bliss of floating in multi-hued beauty. The art on Album sleeves and festival posters explored different dimensions and trips that could be had, listening to the sounds and looking at the art, waking the world up to color, vivid, bright and strong patterns curling and exploding, wonderfully mysterious and mind boggling.

One of the earliest poster artists, Wes Wilson, lettered band names in a blobby fashion. The letters were hard to make out, unless you were stoned, characterizing the art and design of psychedelia, that life, music, politics and art were meant to be fully experienced. Like Ken Kesey of the Merry Pranksters said, "You're either on the bus, or off the bus."

Psychedelic pop pays homage to the Art, the gorgeously morphing and surreal landscape, often spiritually and politically insightful iconography that was born in the 60's. Take a trip with us, and discover the continuum of peace, joy and hope that has sprouted and grown, albeit in different context, with renewed energy.

CONTENTS

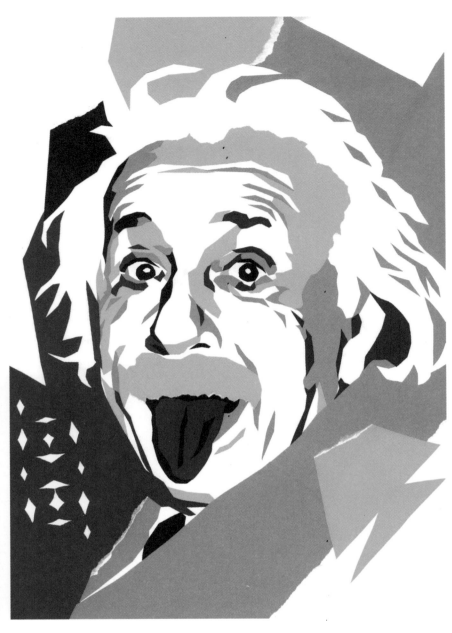

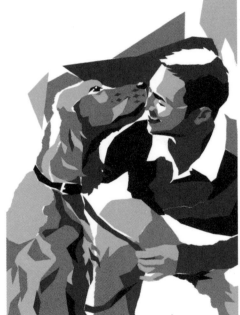

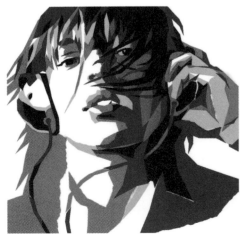

ARTIST__**HIROKI SUZUKI** TYPE OF WORK__**PRINT**

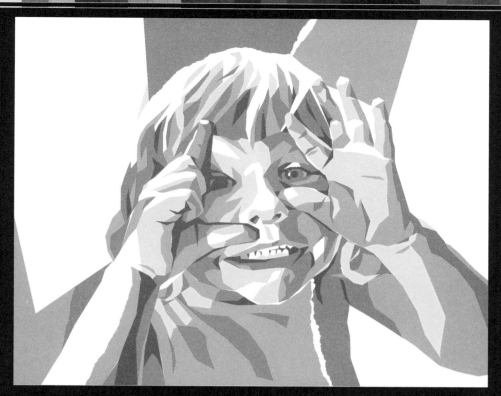

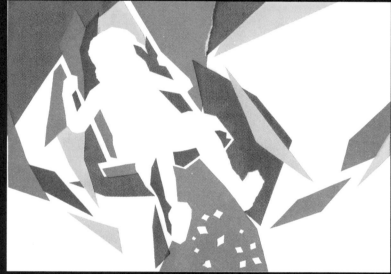

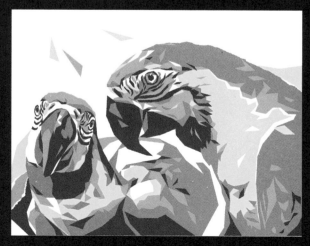

ARTIST__**HIROKI SUZUKI** TYPE OF WORK__**PRINT**

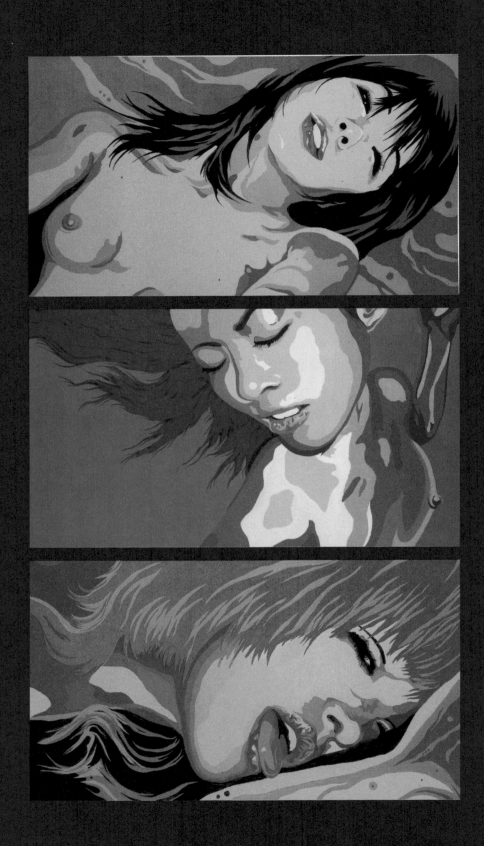

ARTIST__**JAHAN LOH** TYPE OF WORK__**PRINT**

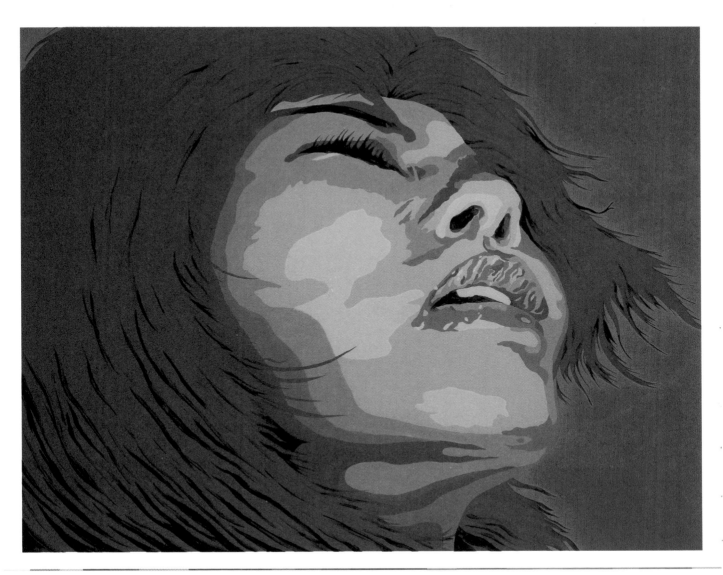

ARTIST__**JAHAN LOH** TYPE OF WORK__**PRINT**

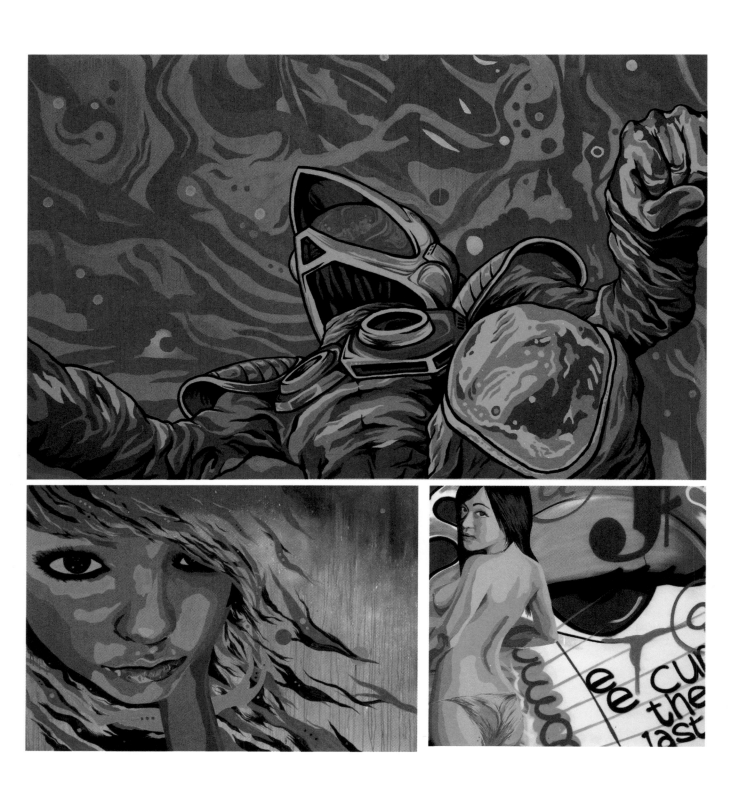

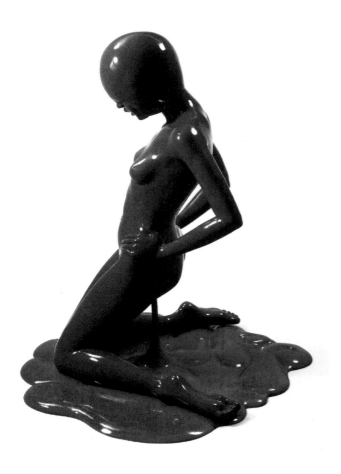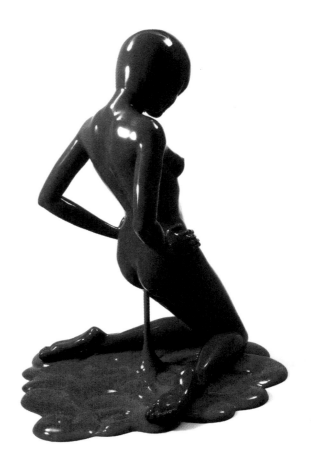

ARTIST__**JAHAN LOH** TYPE OF WORK__**CHARACTER DESIGN**

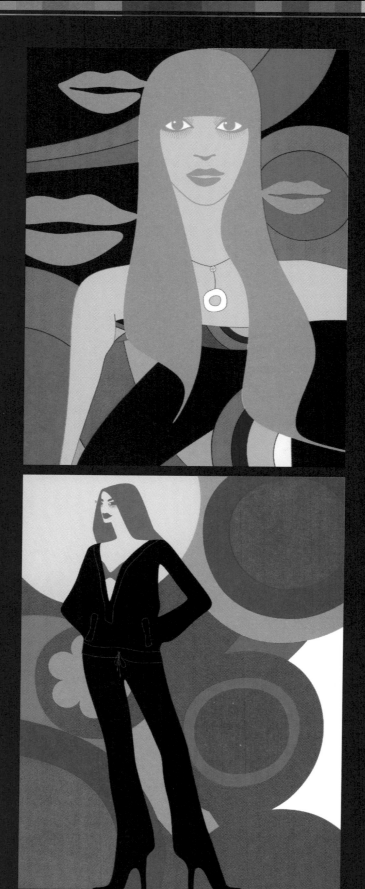

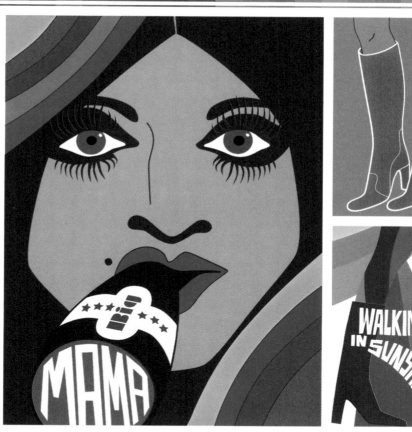
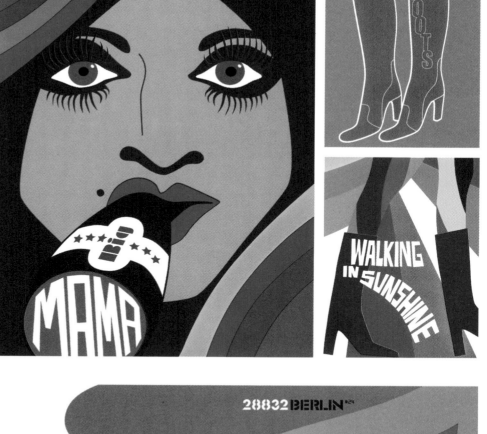

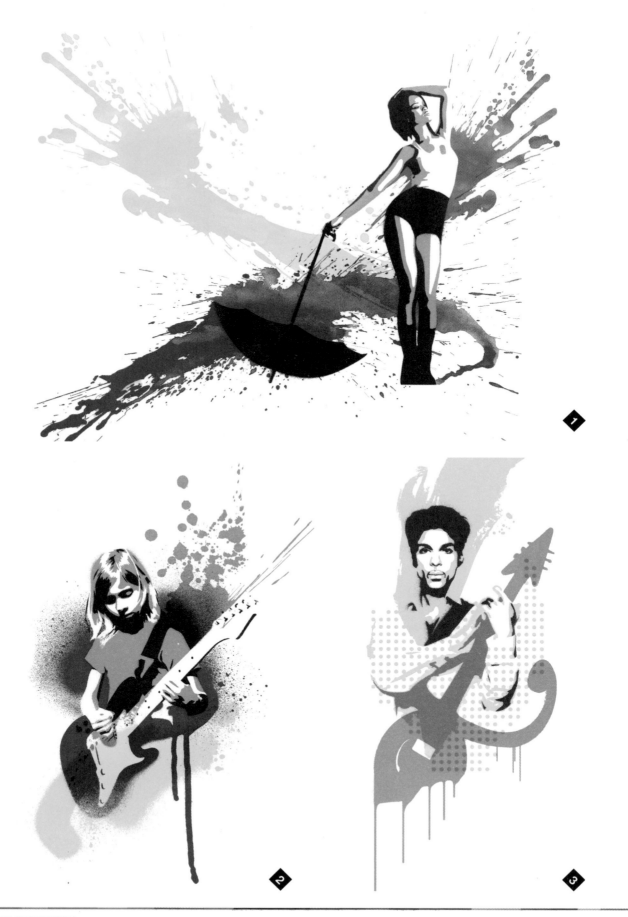

ARTIST__**MILES DONOVAN**
TITLE__**1-"RIHANNA" . 2-"LEARN TO PLAY GUITAR" . 3-"PRINCE"**
TYPE OF WORK__**PRINT**

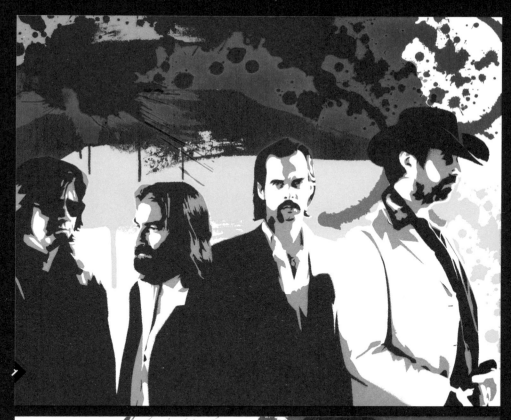

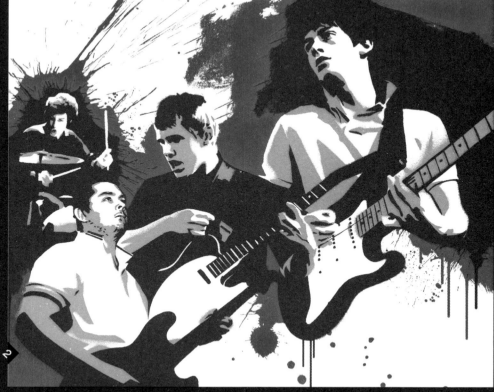

ARTIST__**MILES DONOVAN**
TITLE__**1-"GRINDERMAN" . 2-"THE ARCTIC MONKEYS"**
TYPE OF WORK__**PRINT**

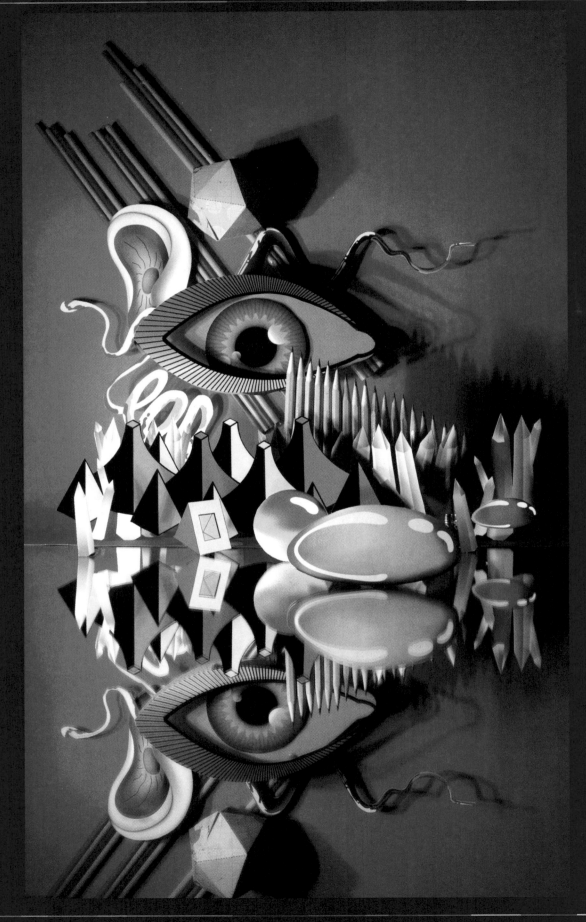

ARTIST__**ELI CARRICO** TITLE__**DREAM** TYPE OF WORK__**ICON & CHARACTER**

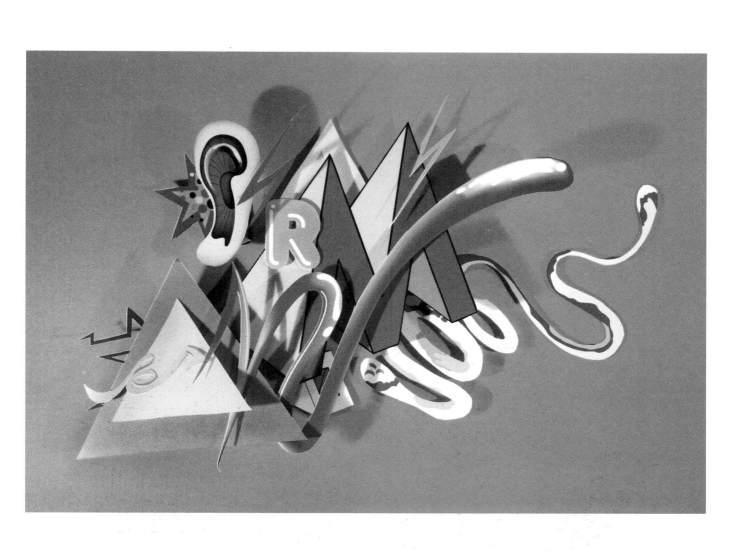

ARTIST__**ELI CARRICO** TITLE__**DREAM** TYPE OF WORK__**ICON & CHARACTER**

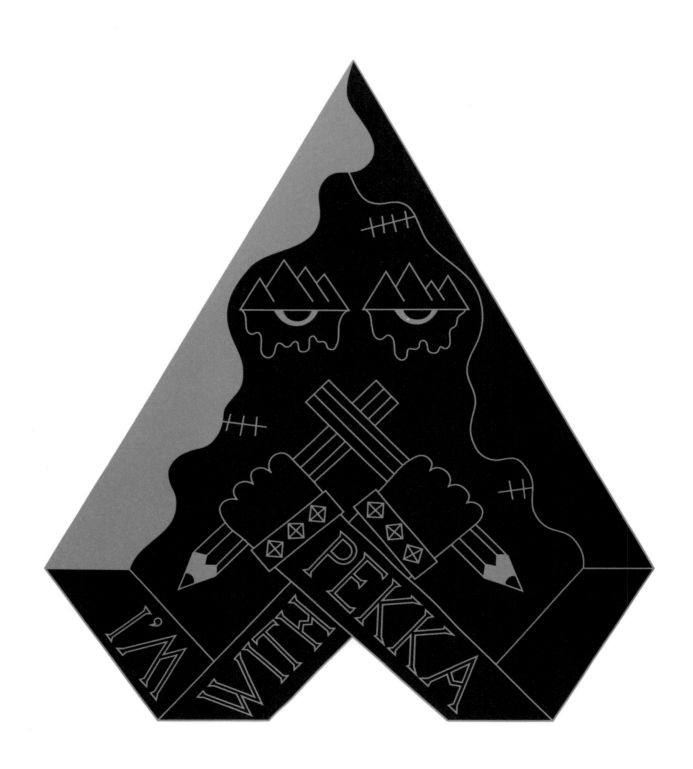

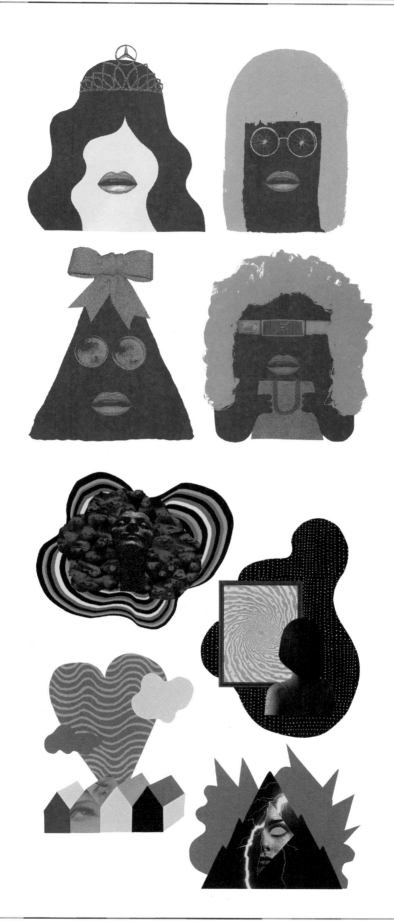

ARTIST__**ANTTI UOTILA** TYPE OF WORK__**ICON & CHARACTER**

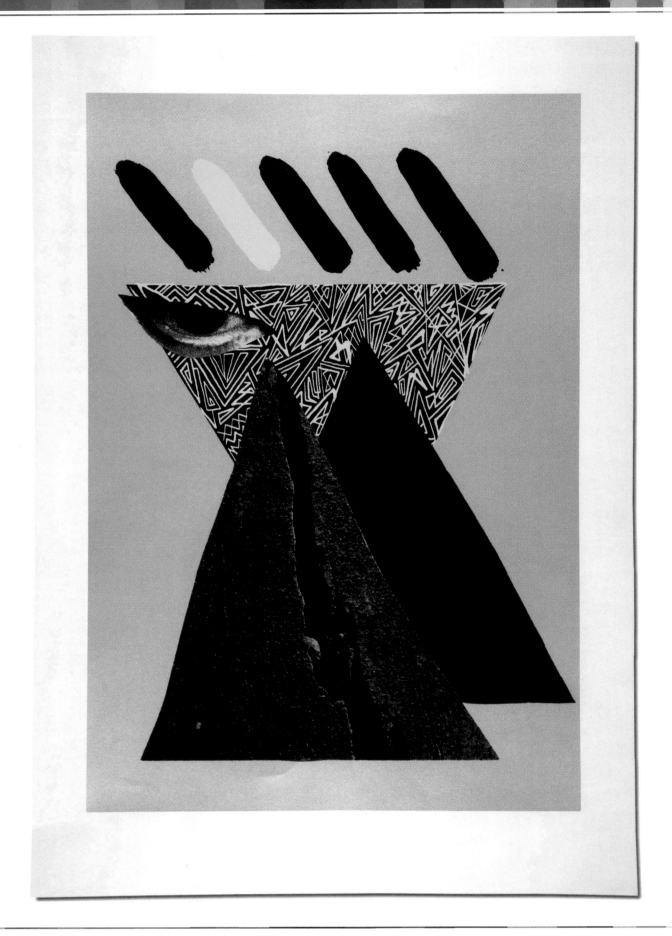

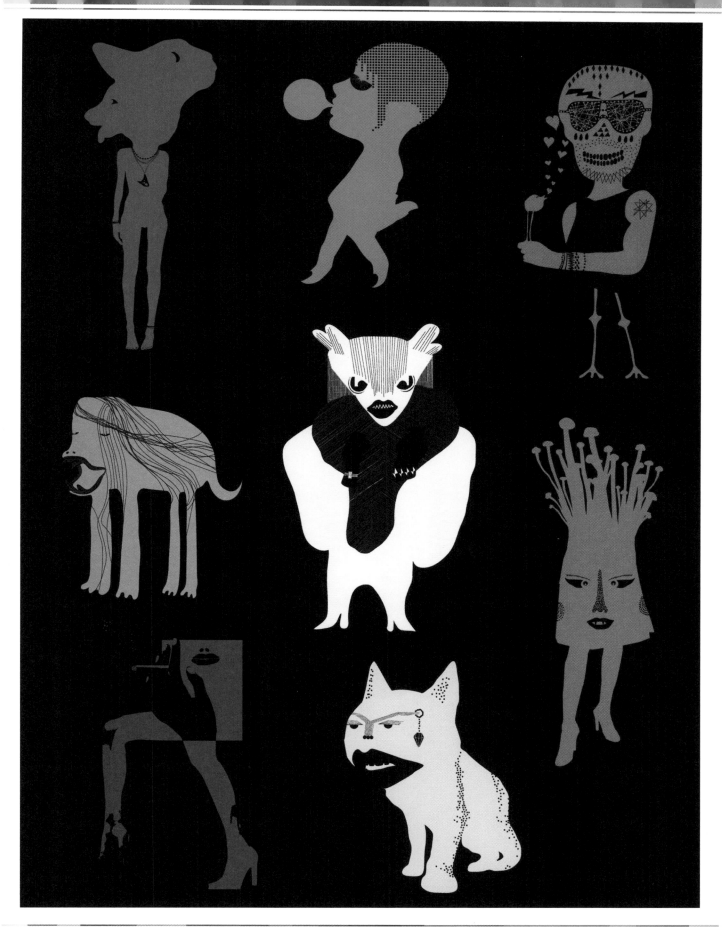

ARTIST__**ANTTI UOTILA** TYPE OF WORK__**ICON & CHARACTER**

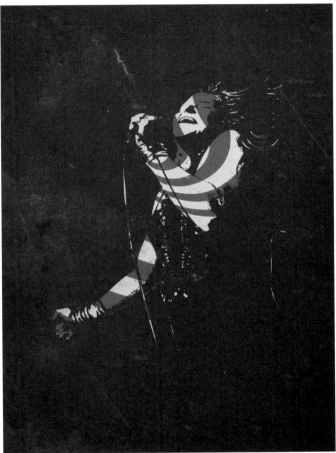

ARTIST__**DESIGNERFAKE** TYPE OF WORK__**PRINT**

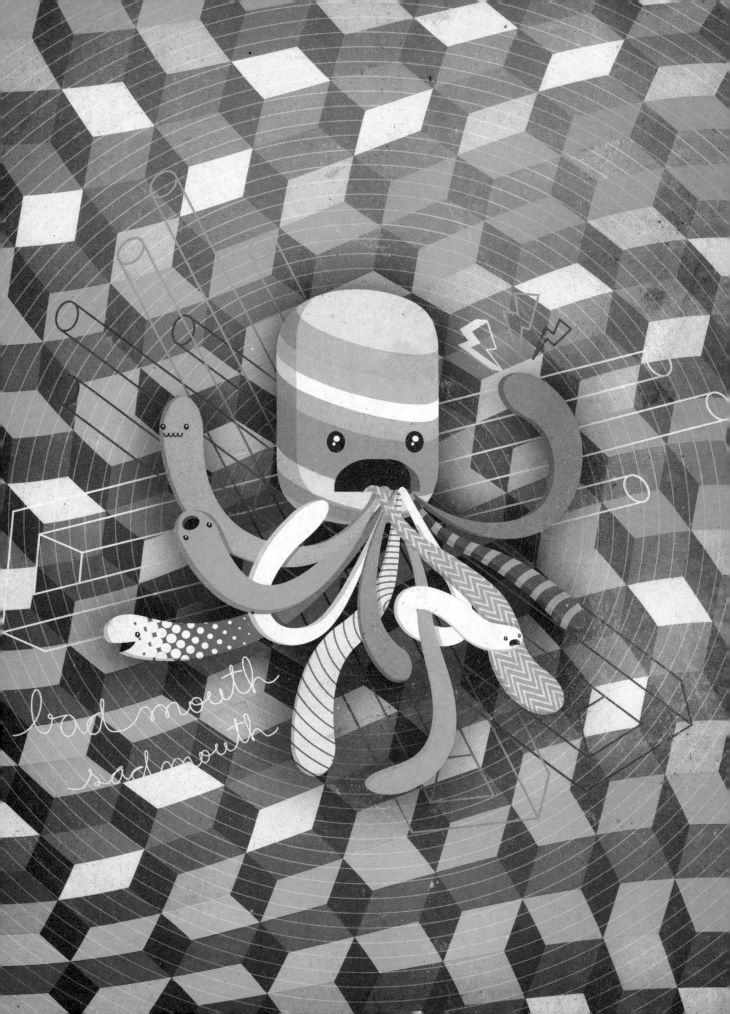

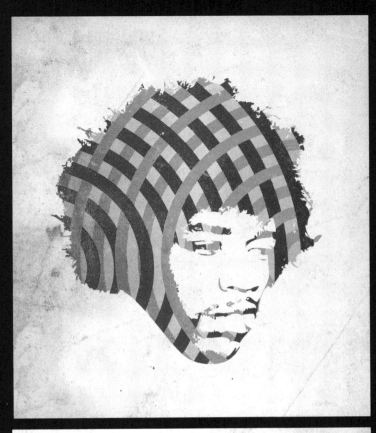
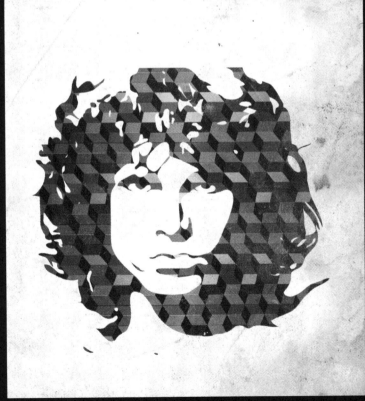

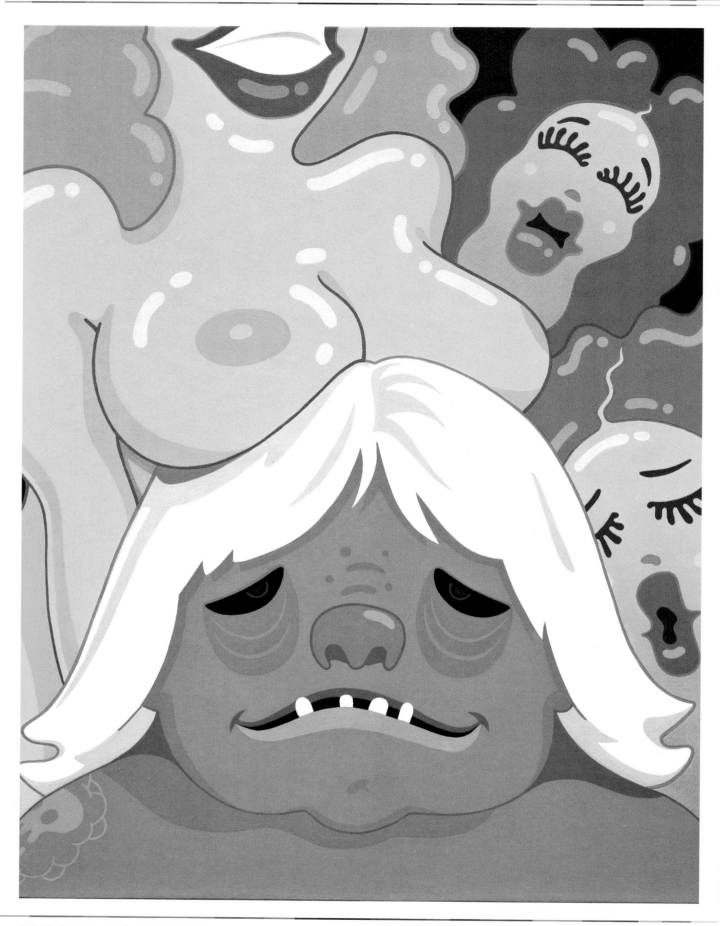

ARTIST__**ARBITO** TITLE__**SAND BAGGING** TYPE OF WORK__**ICON & CHARACTER**

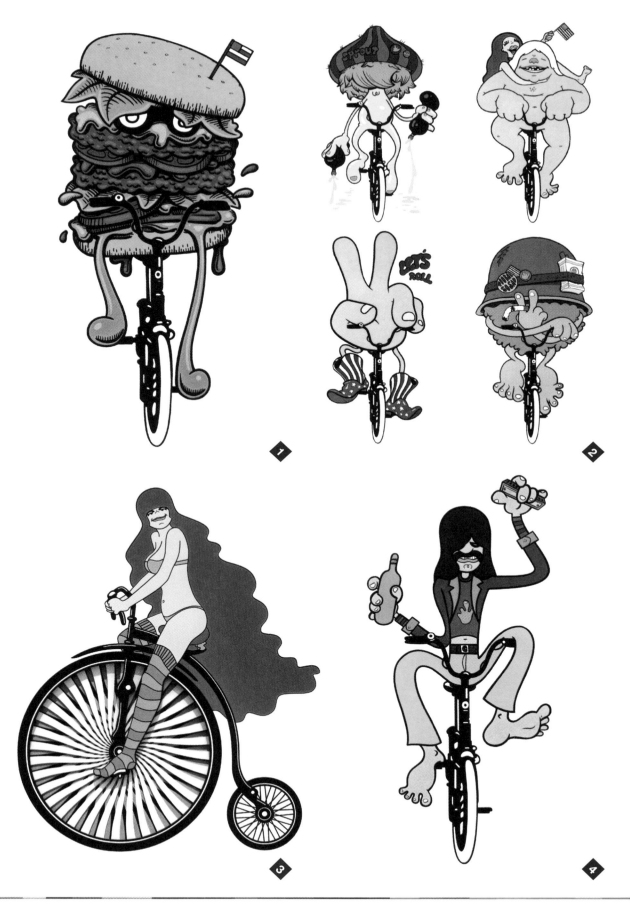

ARTIST__**ARBITO**
TITLE__**1-LET'S ROLL "PATTY POWER" . 2-LET'S ROLL "SPROUT" . LET'S ROLL "MISSY & MORLOCK" . LET'S ROLL "TOOTIN" .**
 LET'S ROLL "FUR BOMB" . 3-CYCLEDELIC SISSI . 4-LET'S ROLL "BOOT"
TYPE OF WORK__**ICON & CHARACTER**

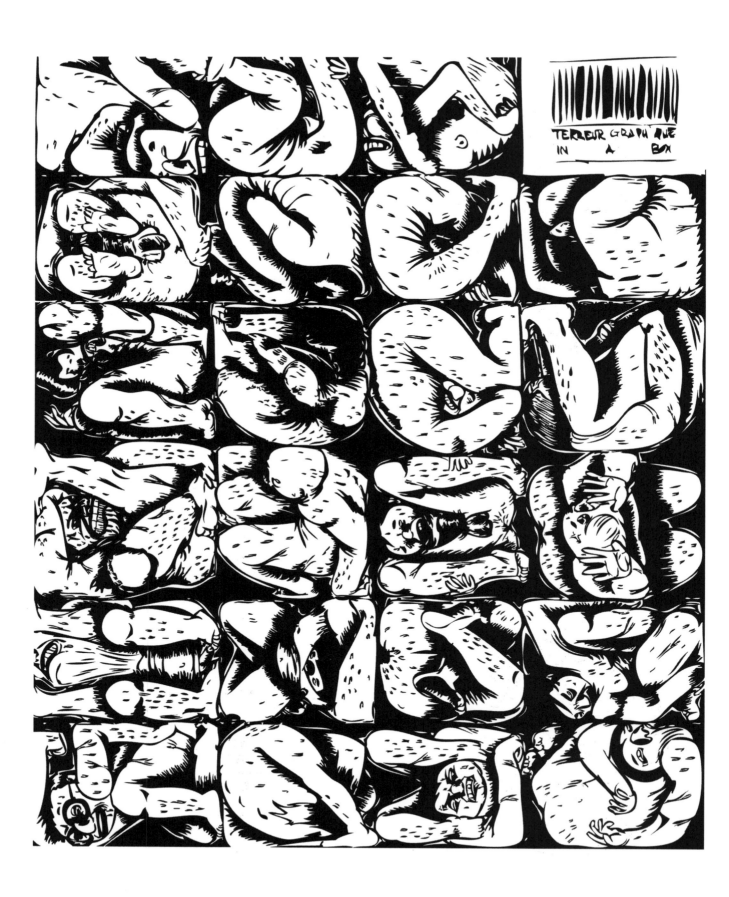

ARTIST__**TERREUR GRAPHIQUE** TITLE__**"TERREUR IN A BOX"** TYPE OF WORK__**ICON & CHARACTER**

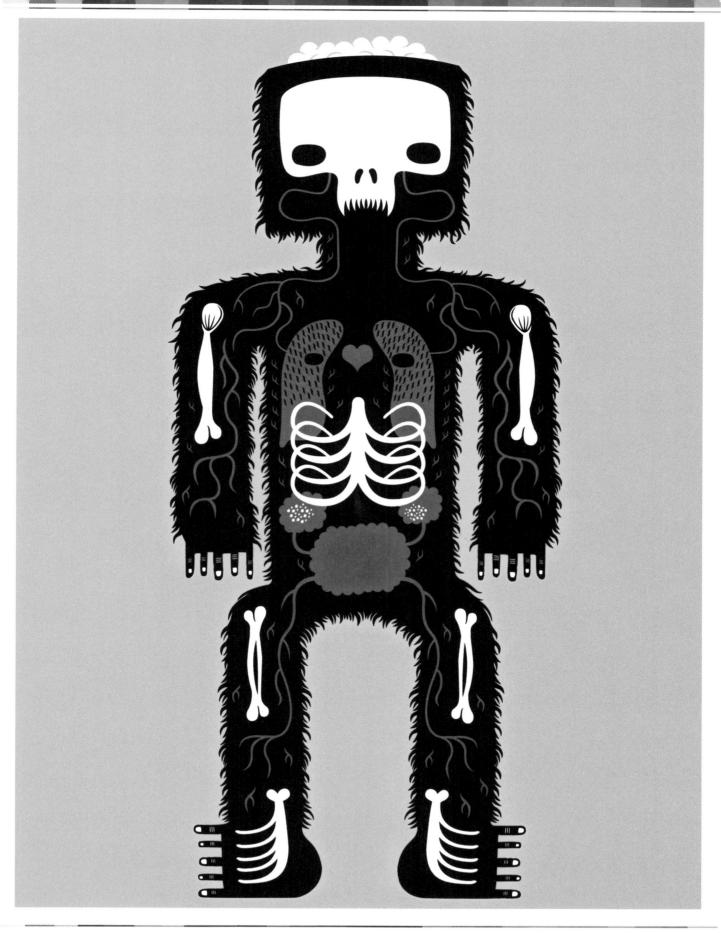

ARTIST__**SERGE SEIDLITZ** TYPE OF WORK__**ICON & CHARACTER**

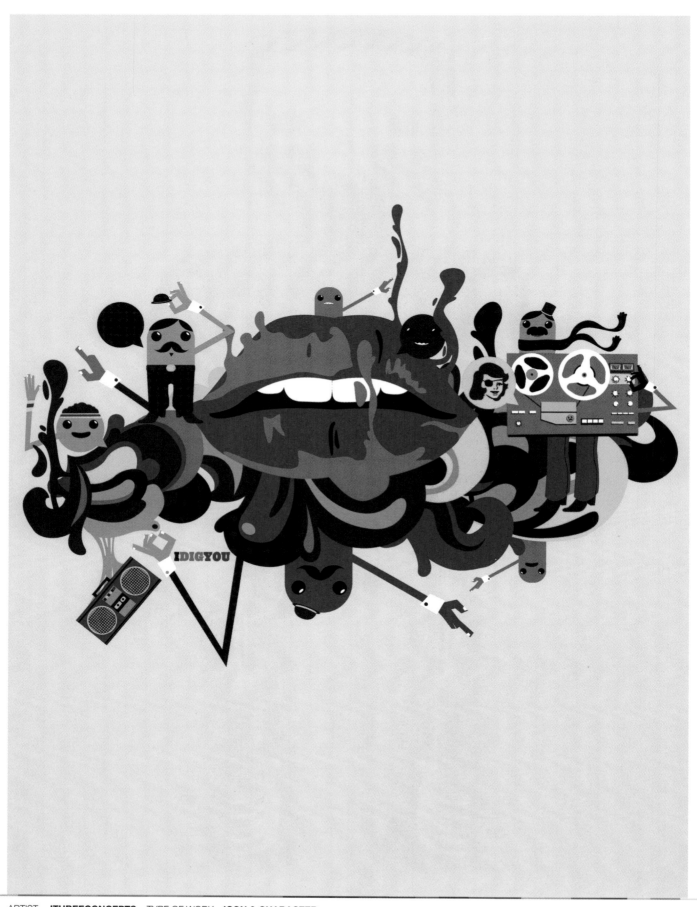

ARTIST__**JTHREECONCEPTS** TYPE OF WORK__**ICON & CHARACTER**

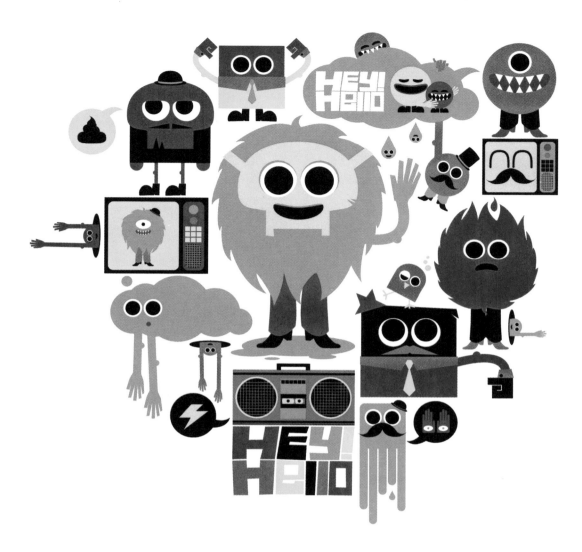

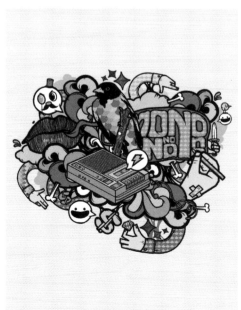

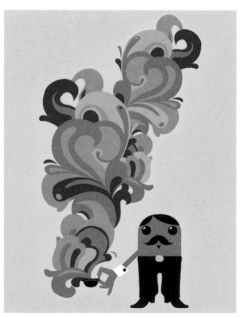

ARTIST__**JTHREECONCEPTS** TYPE OF WORK__**ICON & CHARACTER**

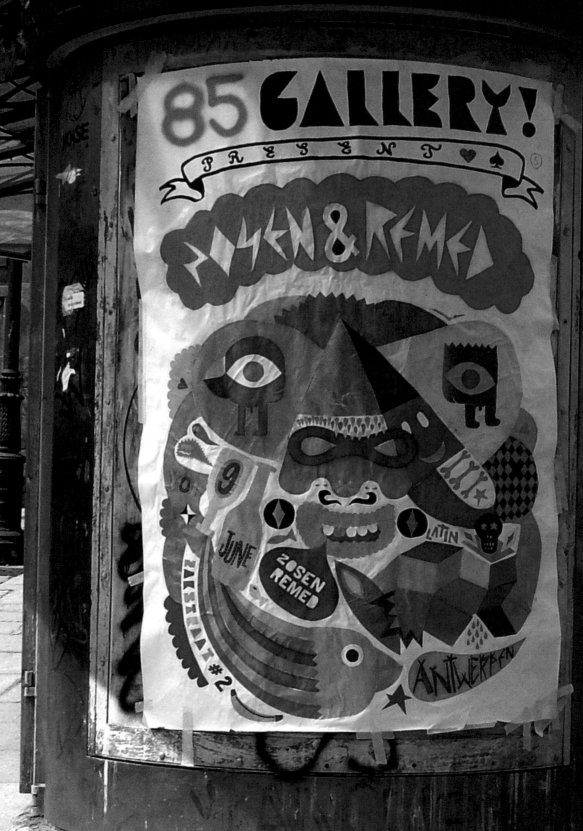

ARTIST__**REMED ART** TITLE__**"ZOSEN&REMED"** TYPE OF WORK__**INSTALLATION**

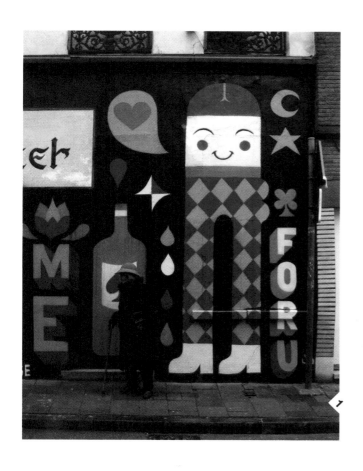
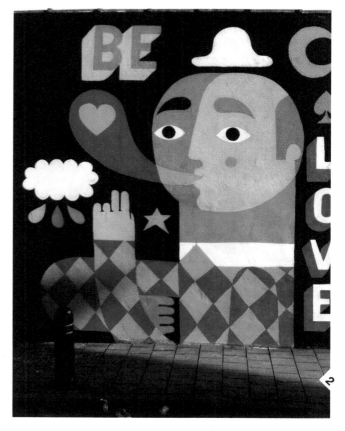

ARTIST__**REMED ART** TITLE__**1-ME4YOU . 2-BE LOVE** TYPE OF WORK__**INSTALLATION**

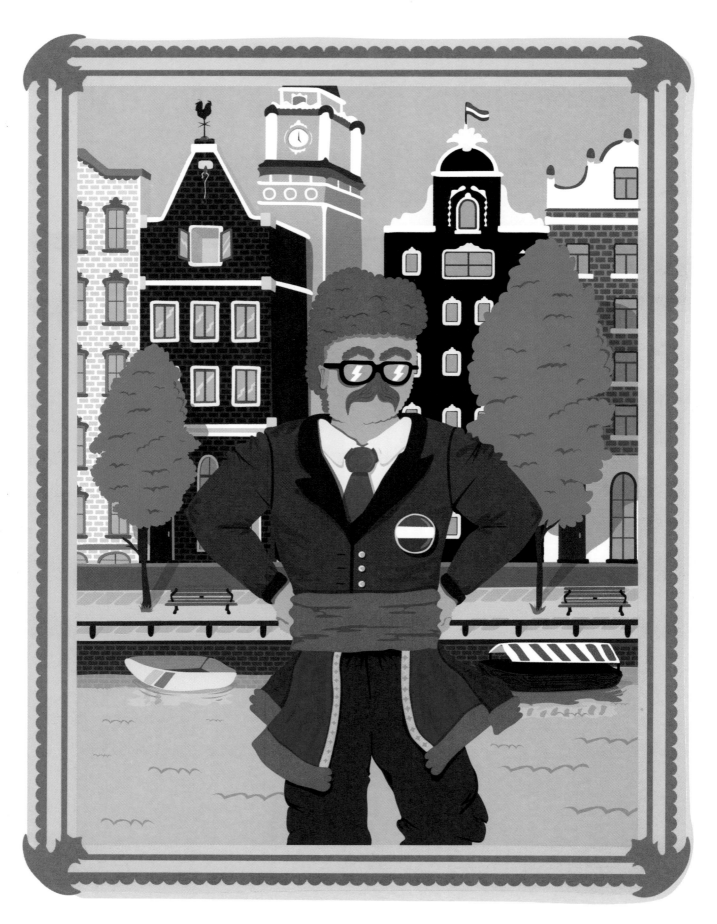

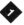

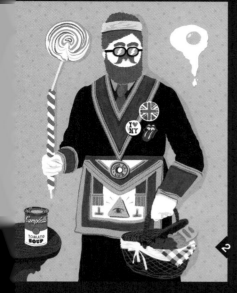

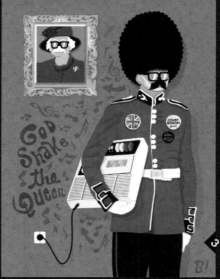

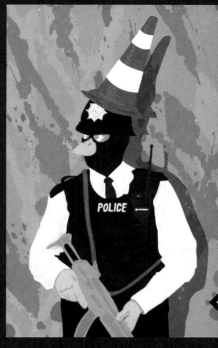

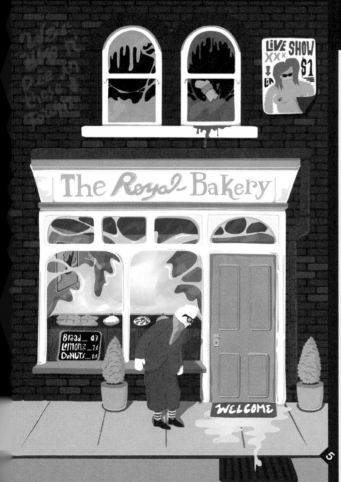

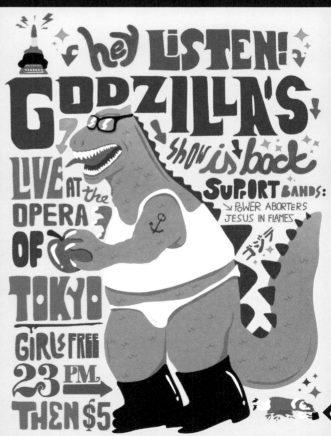

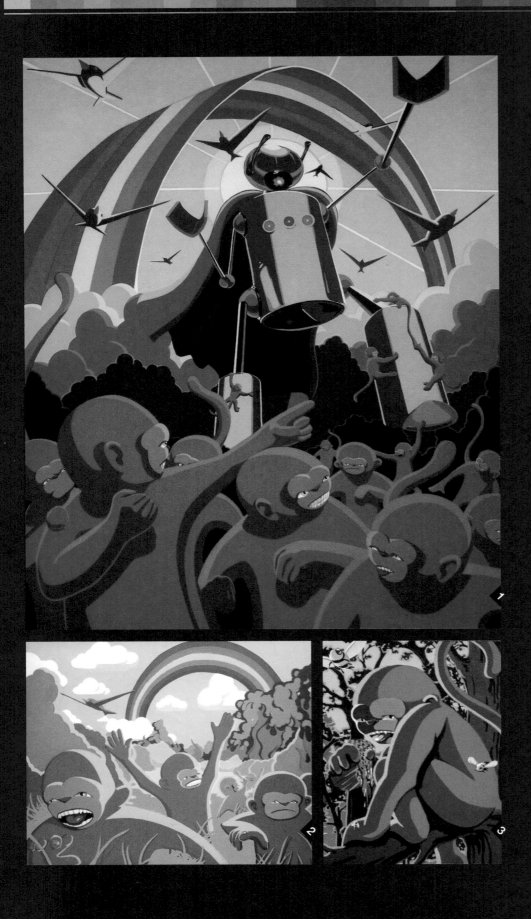

ARTIST__ **JOHN LYTLE WILSON**
TILTE__ **1-OH MAJESTY! . 2-CALAMITY! . 3-STEALING HONEY**
TYPE OF WORK__**ICON & CHARACTER**

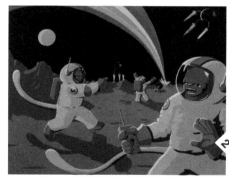

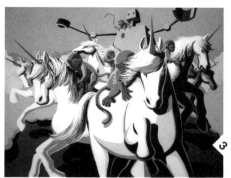

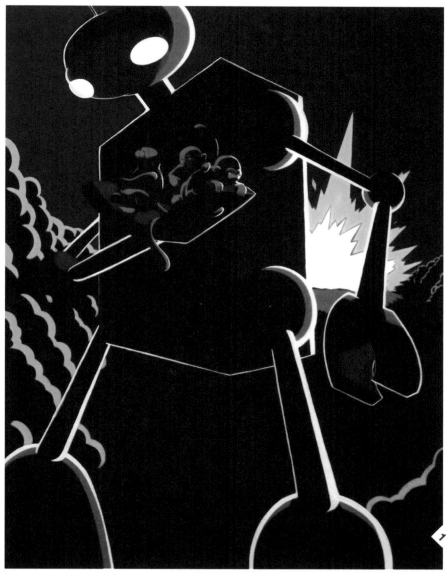

ARTIST__**JOHN LYTLE WILSON**
TILTE__**1-EXODUS . 2-MONKEYFORCE UNDER ATTACK! . 3-VIOLA!**
TYPE OF WORK__**ICON & CHARACTER**

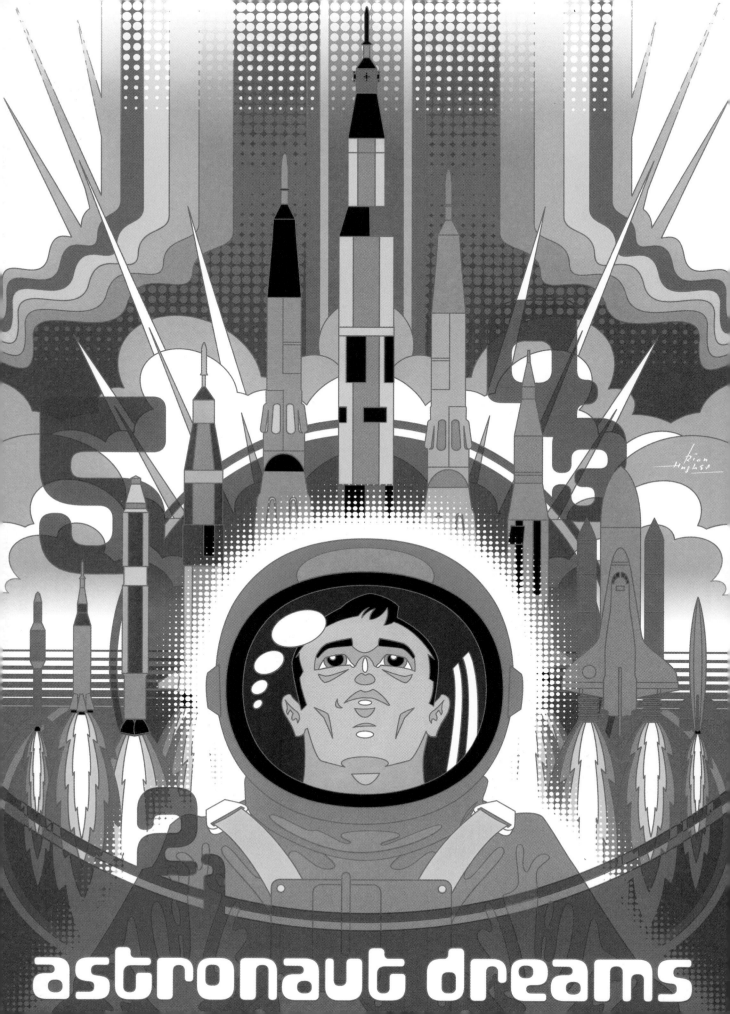

astronaut dreams

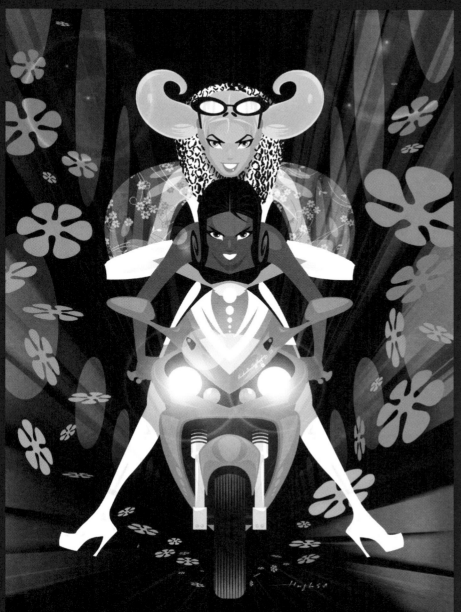
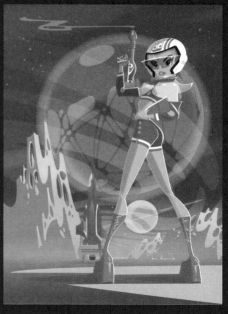
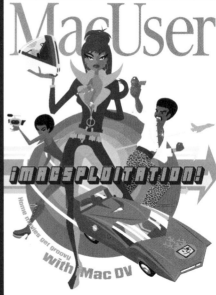

¡MACSPLOITATION!
With Mac DV

ARTIST_ **DEVICE • RIAN HUGHES** TYPE OF WORK_ **ICON & CHARACTER**

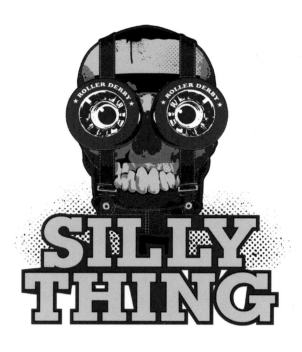

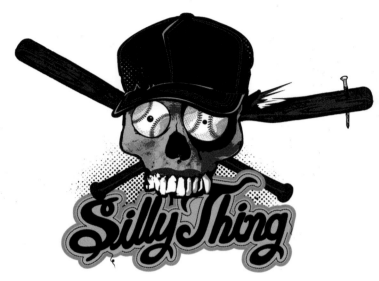

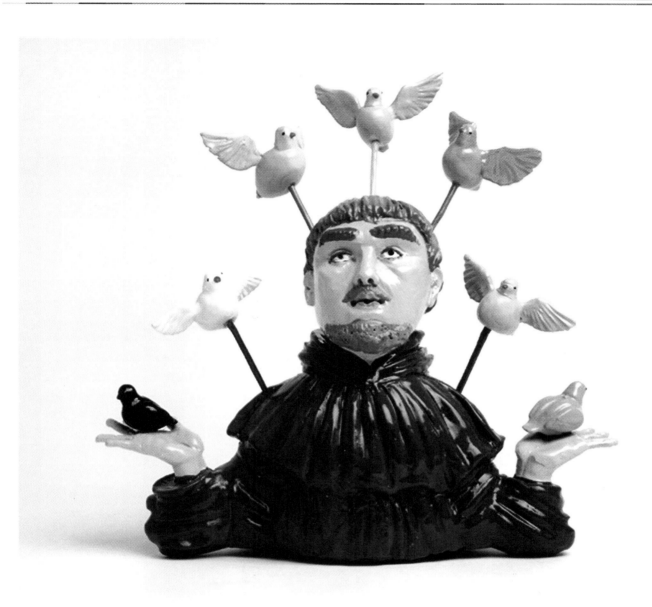

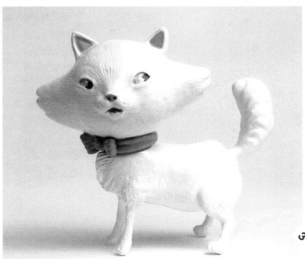

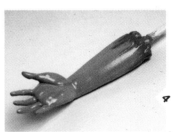

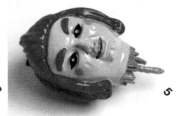

ARTIST__**JOCK MOONEY**
TITLE__**1**-"ST FRANCIS IS A SISSY" . **2**-"VOM SHIT DOG" . **3**-"CAT FROM NEXT DOOR" . **4**-"DAPHNE'S ARM" . **5**-"DAPHNE'S HEAD"
PHOTOGRAPHER__**COLIN DAVISON . PAUL BERRY**
TYPE OF WORK__**PRODUCT**

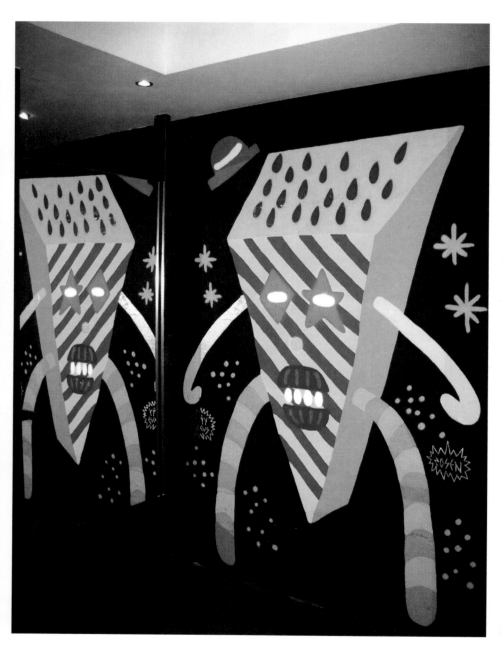

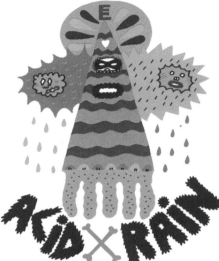

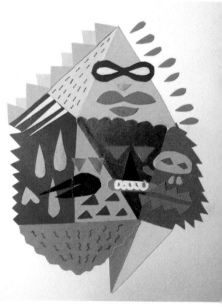

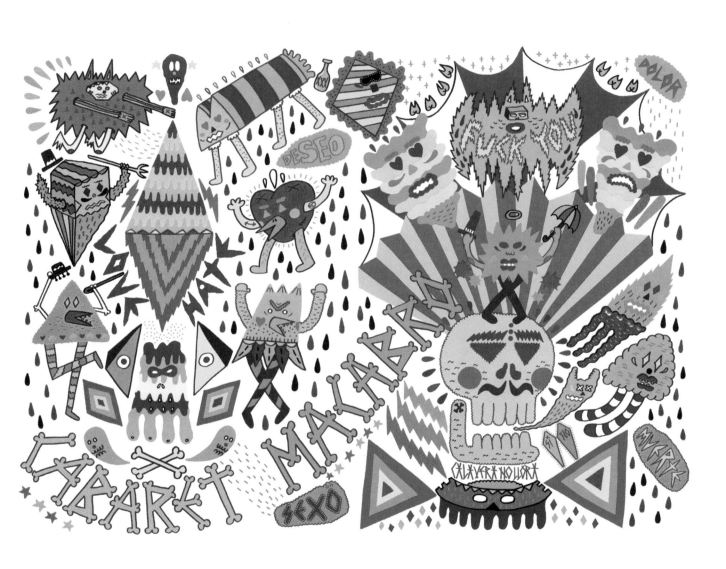

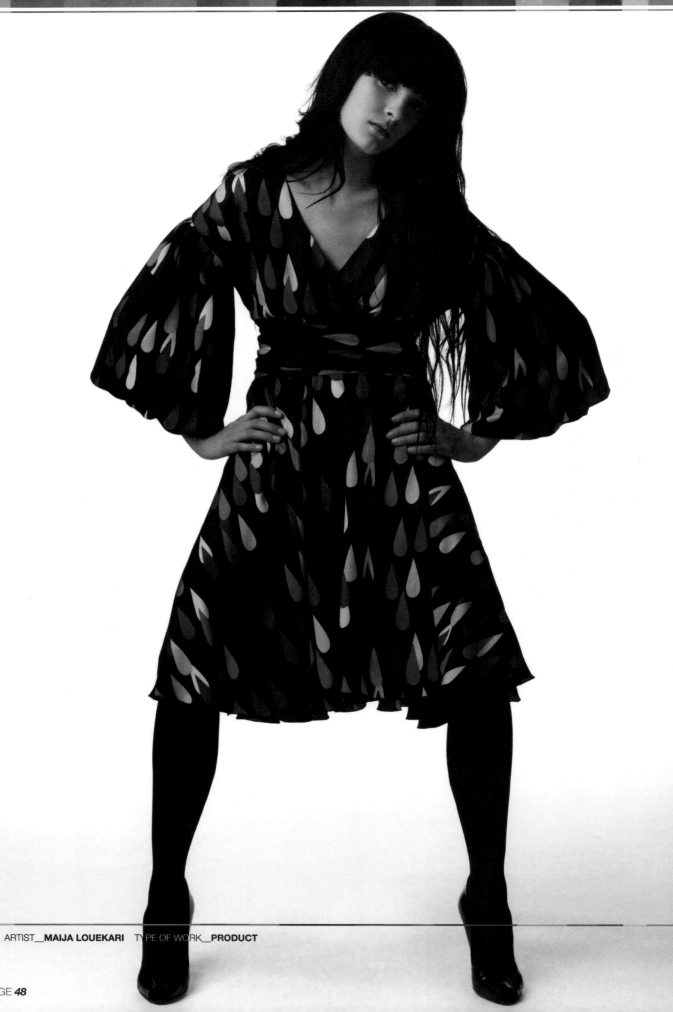

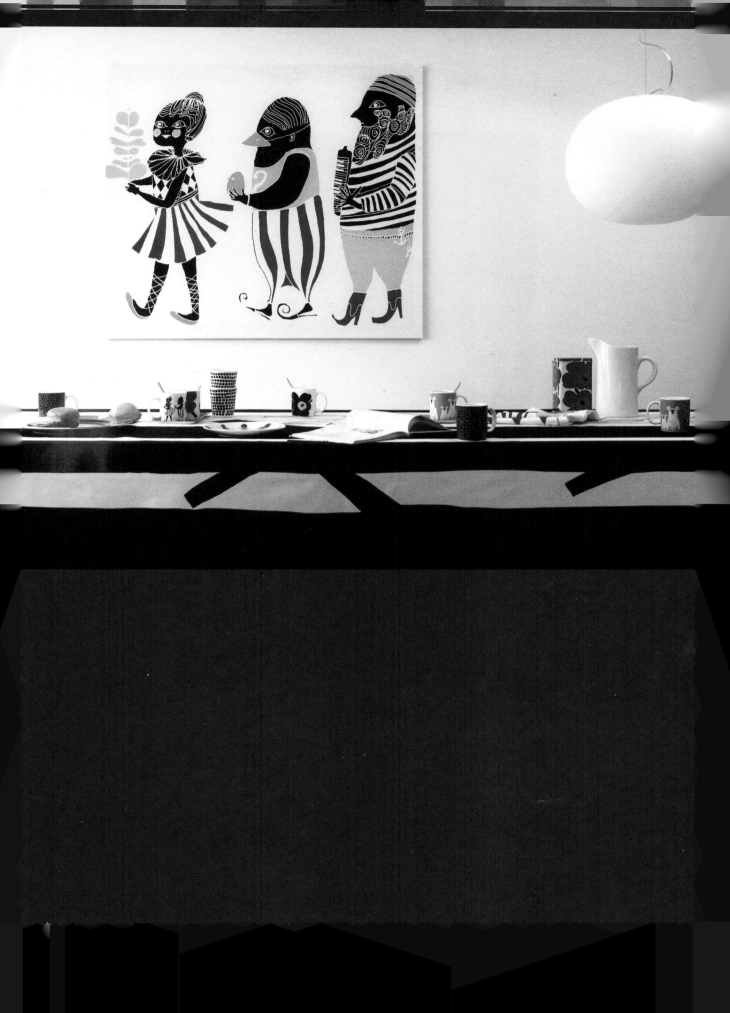

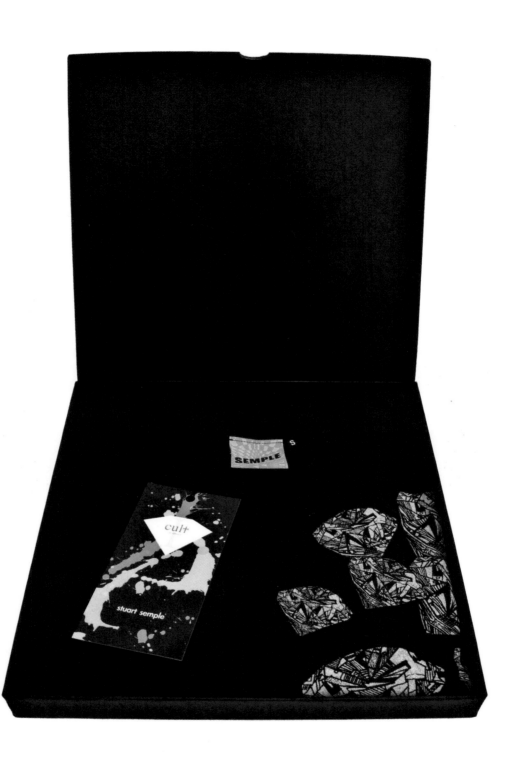

ARTIST__**STUART SEMPLE**
TITLE__**FOREVER**
TYPE OF WORK__**SILK SCREENED T SHIRT,** limited edition of 60 on the occasion of stuart semple's **'Cult Of Denim'** solo exhibition at selfridges, 2008.

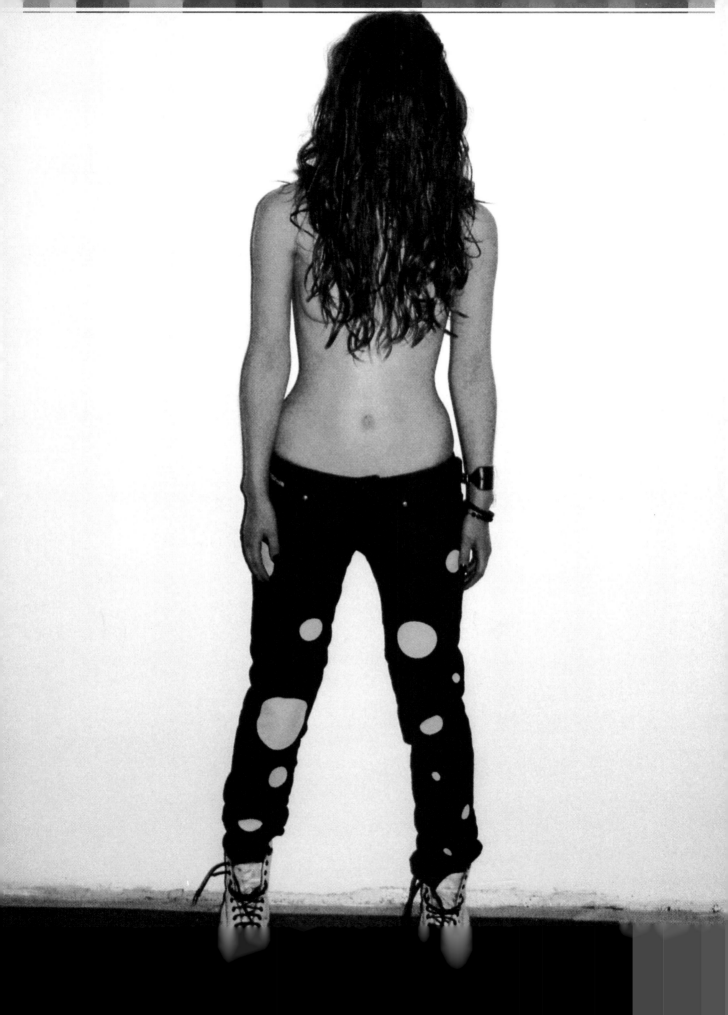

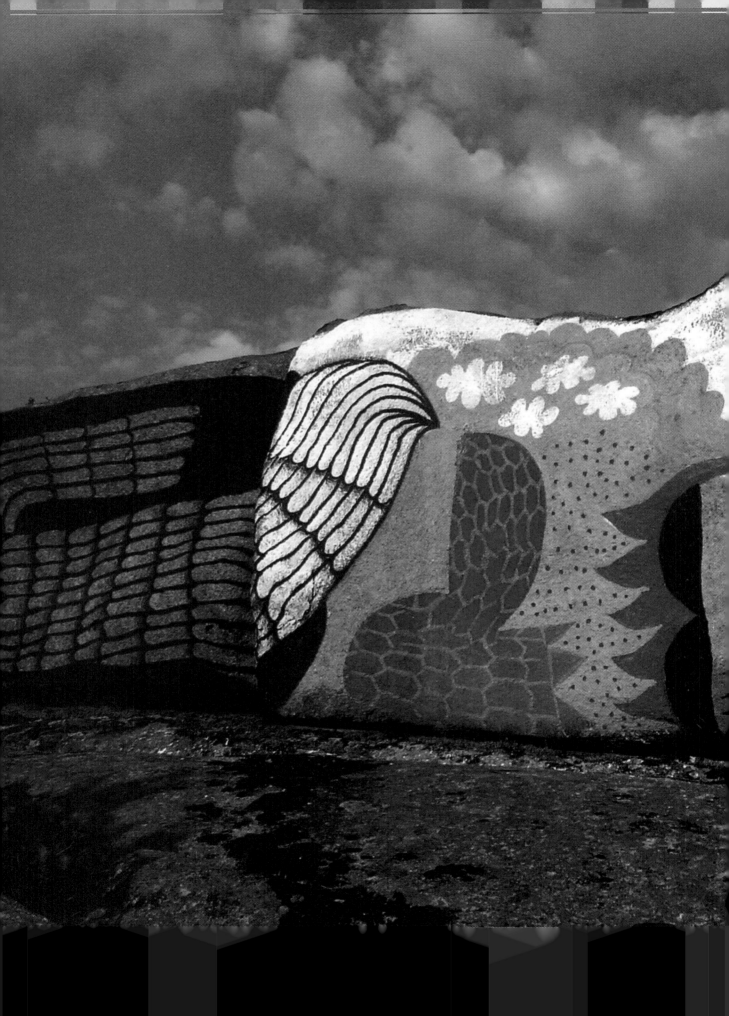

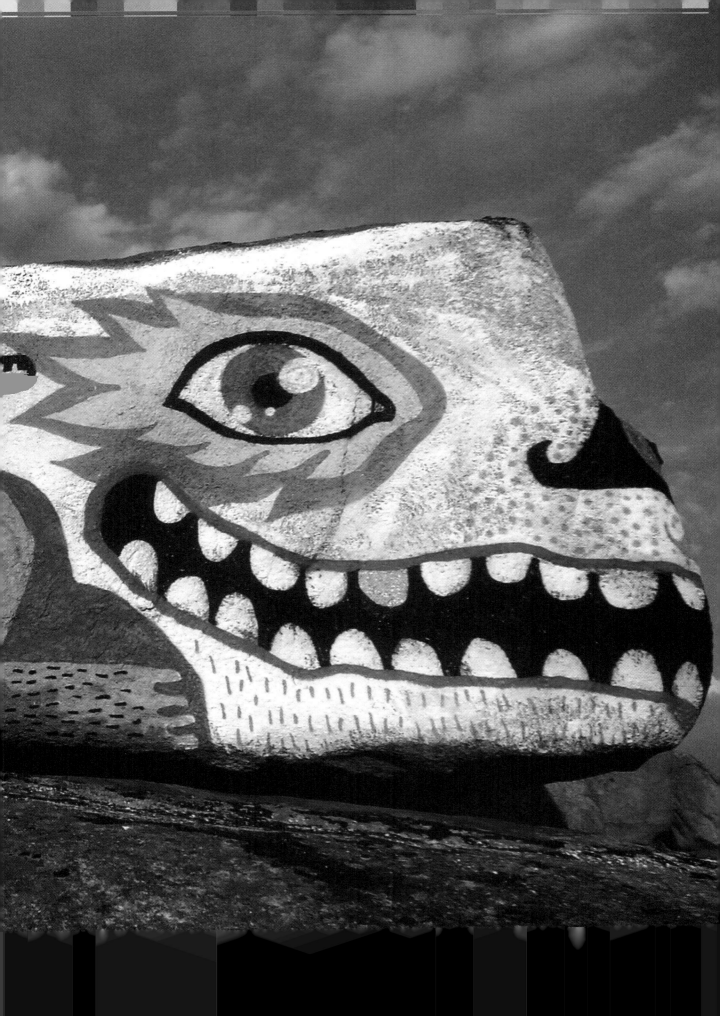

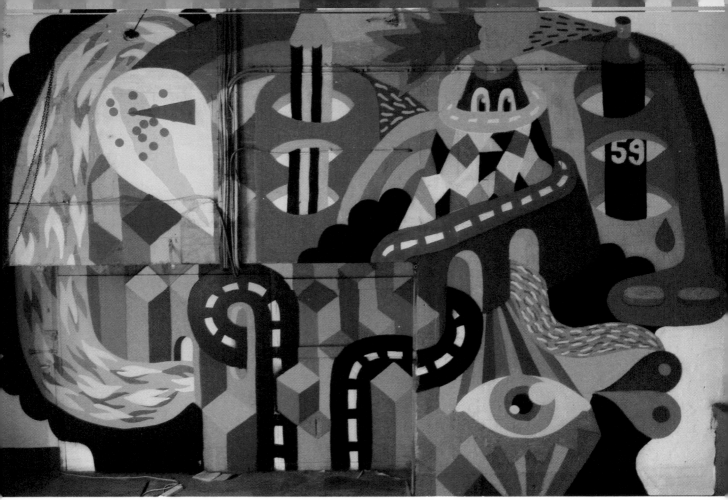

ARTIST__**REMED ART** TYPE OF WORK__**INSTALLATION**

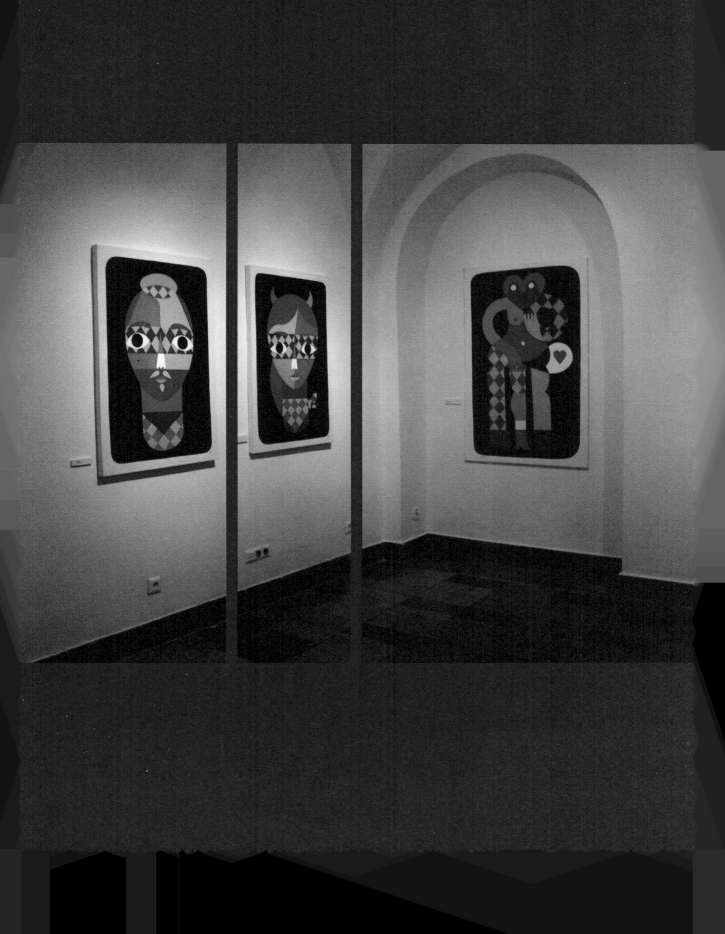

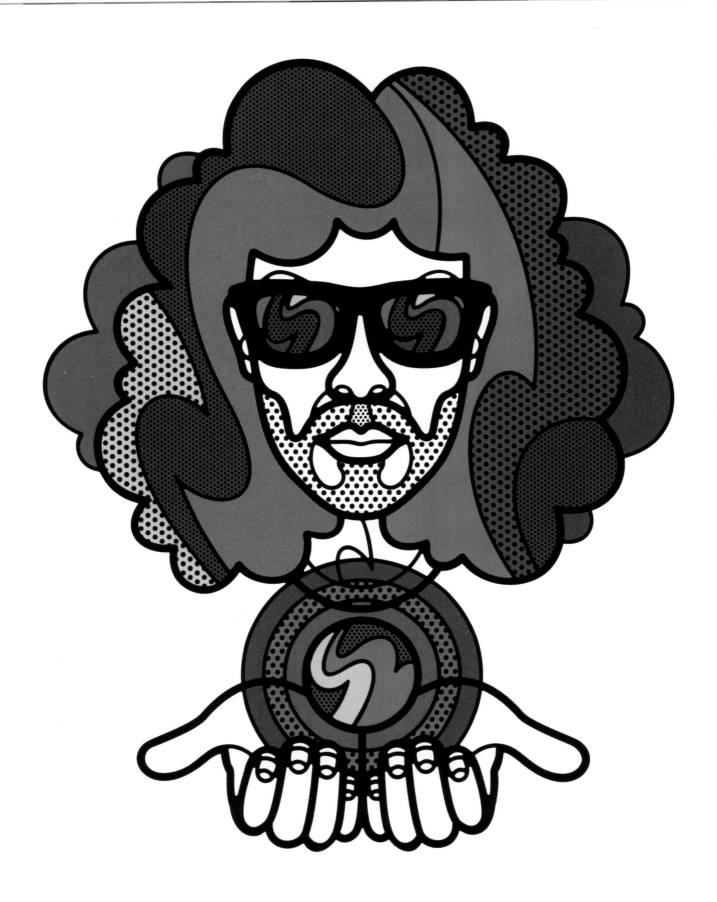

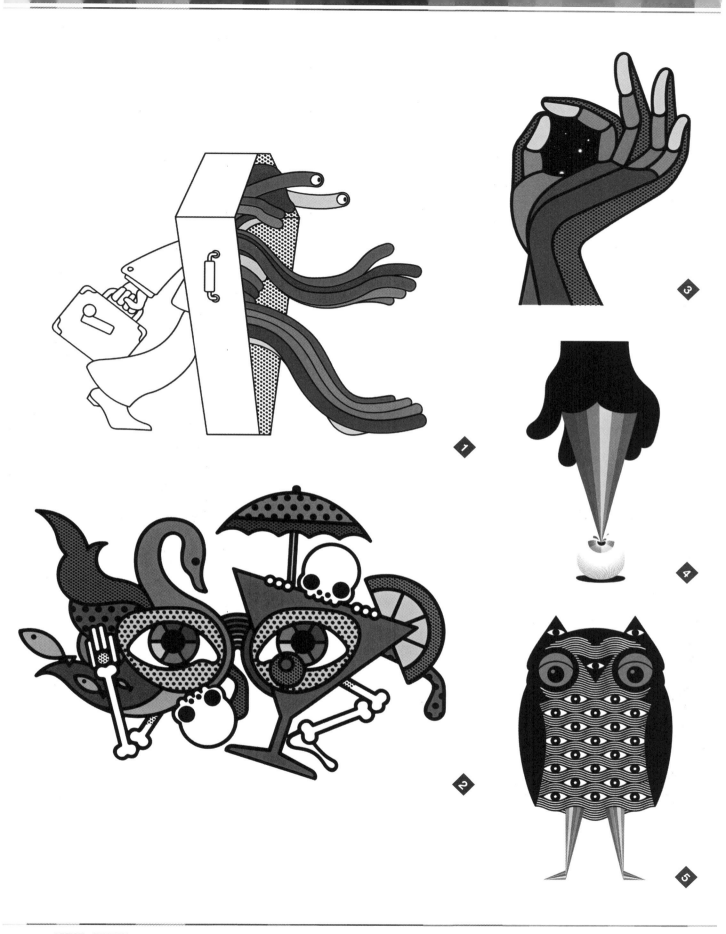

ARTIST__**RINZEN**
TITLE__**1-PERMANENT VACATION . 2-SEE YOUR OWN WAY . 3-CLOSER EVERY DAY . 4-PRESSURE . 5-HOO KNOWS**
TYPE OF WORK__**ICON & CHARACTER**

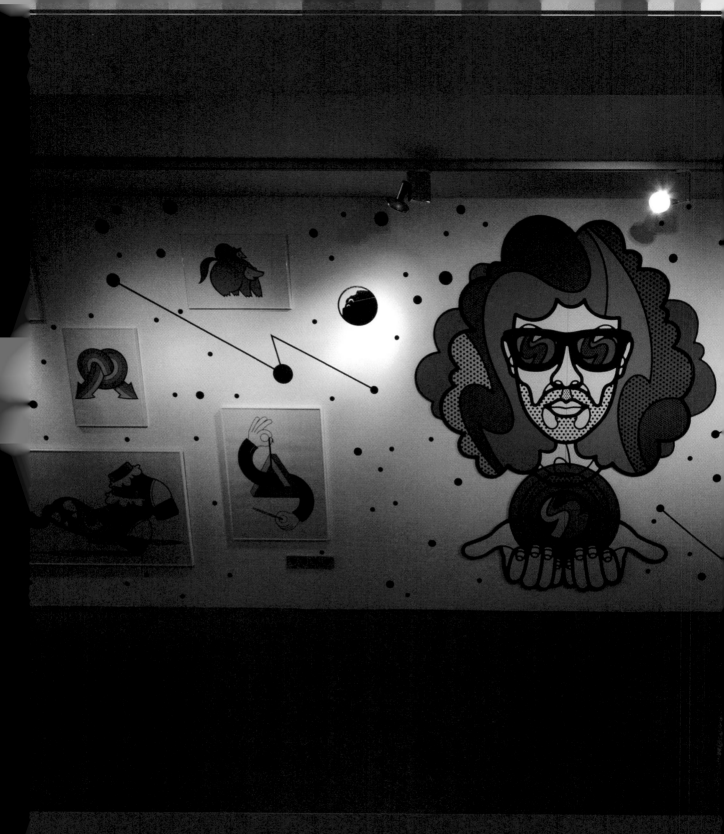

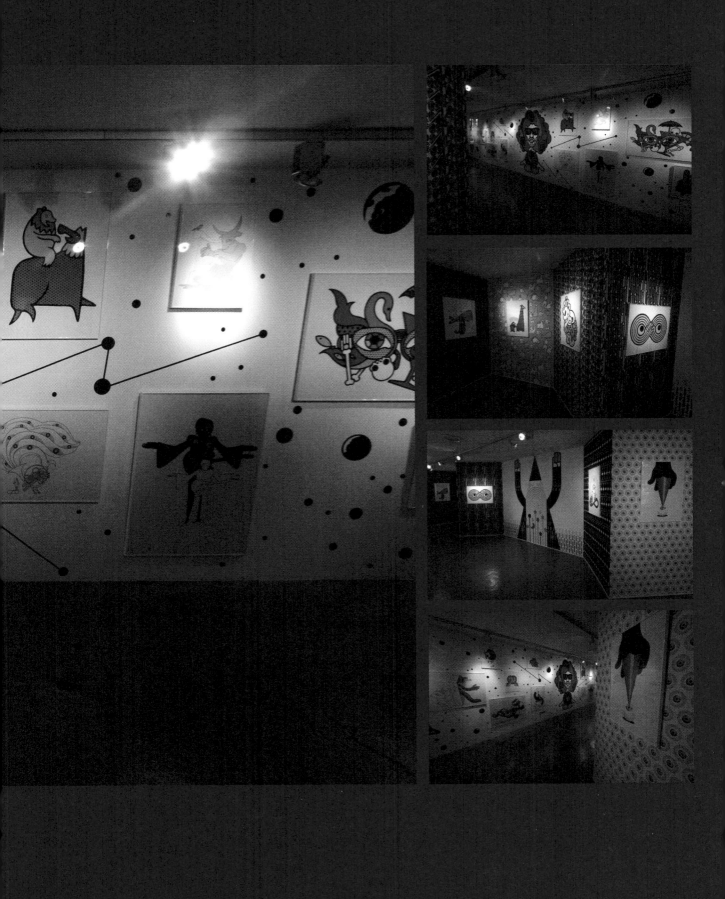

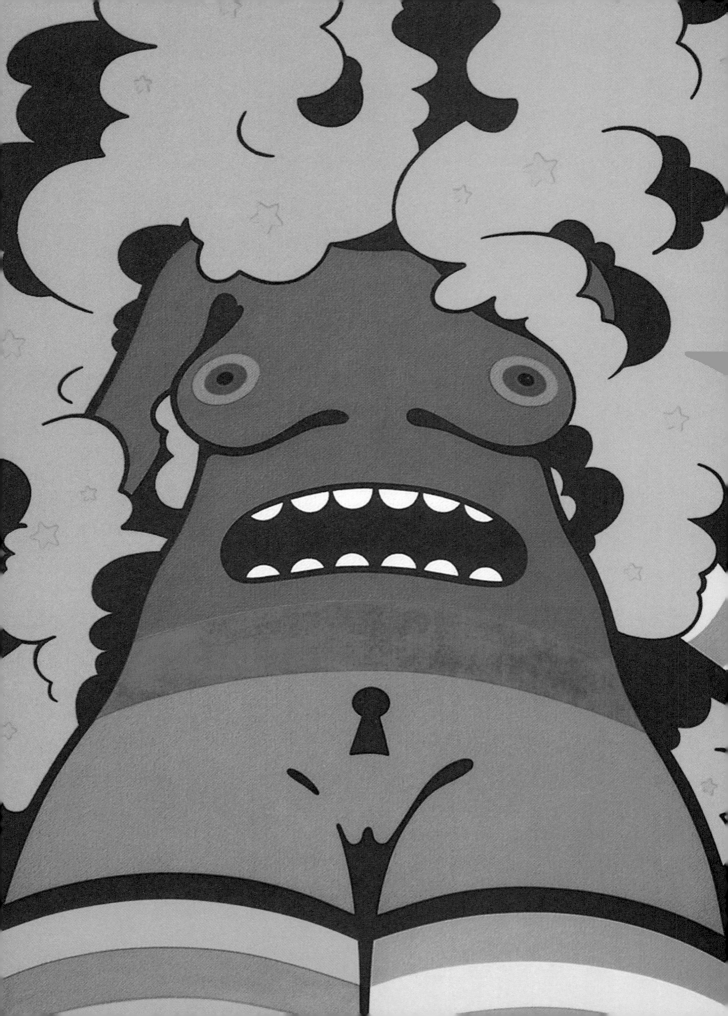

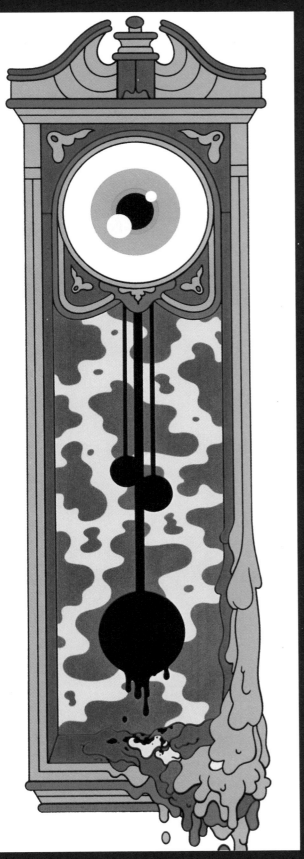
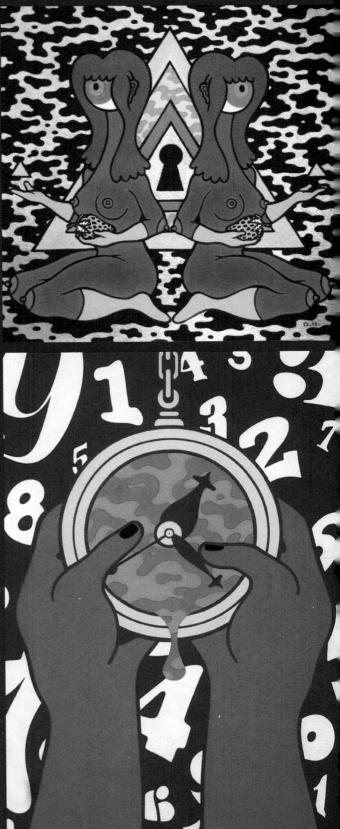

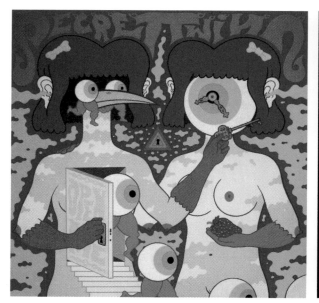

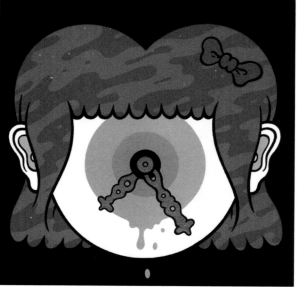

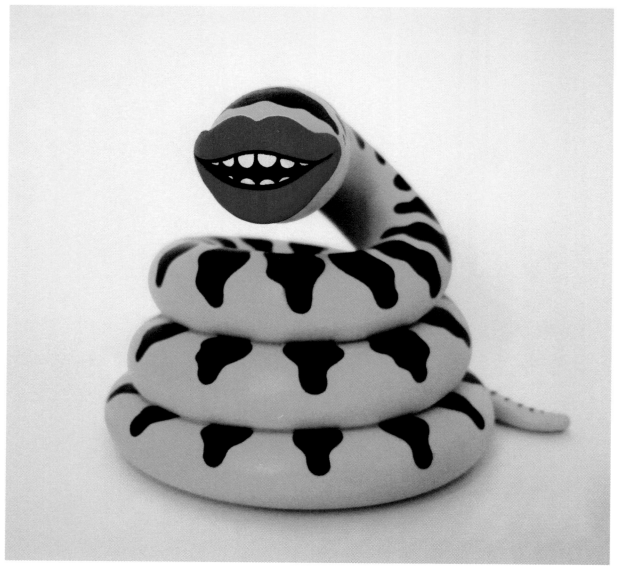

ARTIST__**OLIVER HIBERT**　　TYPE OF WORK__**PRINT & FIGURE**

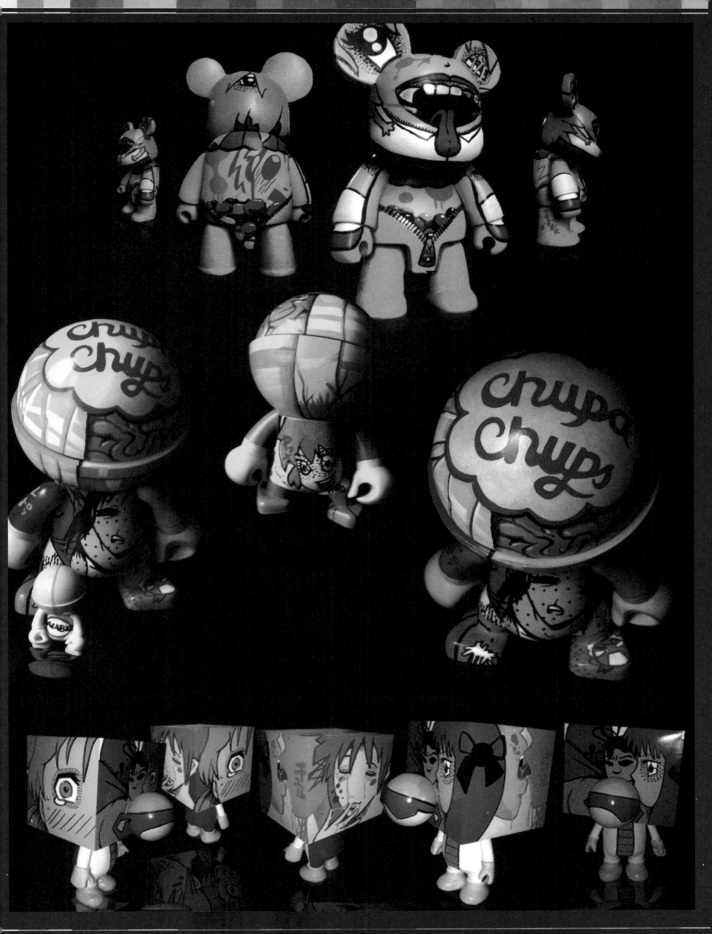

ARTIST__**TALING** TITLE__**CUSTOM . BEARBEAR Q, TRIXIE, GUM-TO-FU** TYPE OF WORK__**FIGURE**

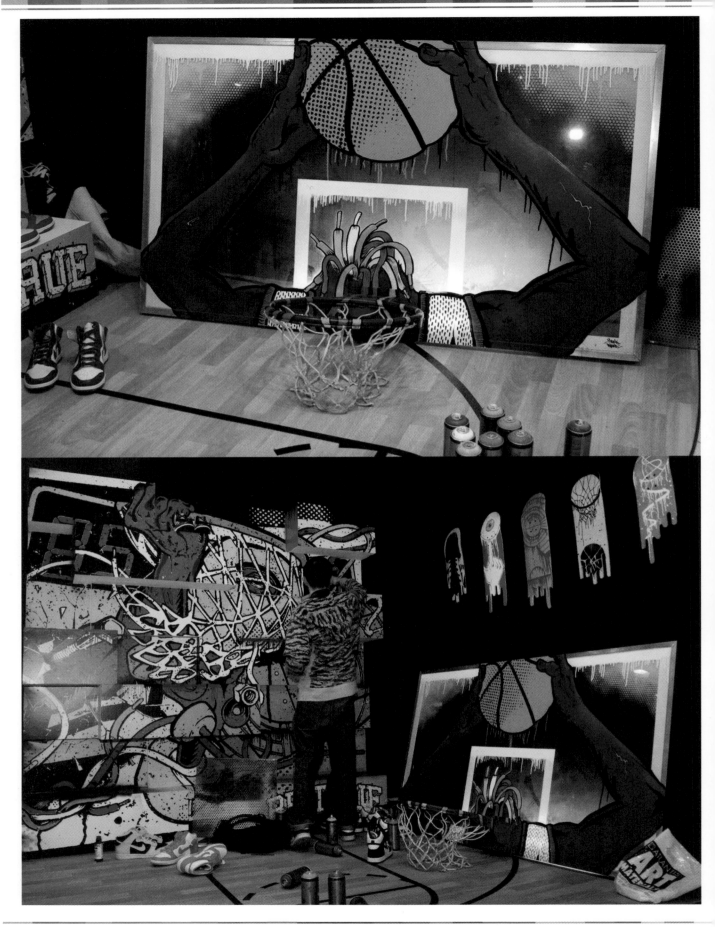

ARTIST__**GRAPHICNONSENSE • MARK WARD** TITLE__**SEAT BEAT** TYPE OF WORK__**INSTALLATION**

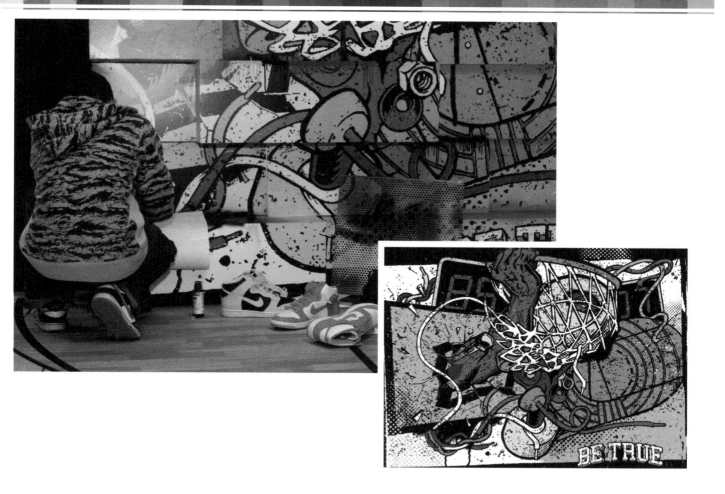

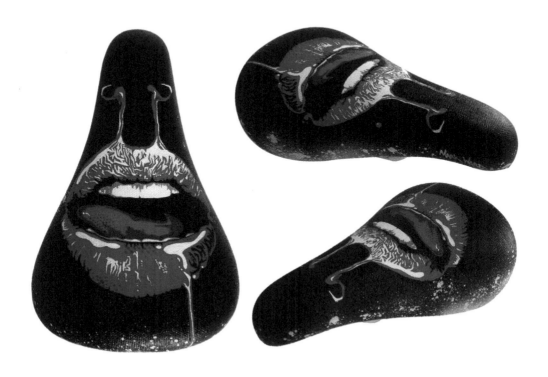

ARTIST__**GRAPHICNONSENSE • MARK WARD** TITLE__**SEAT BEAT** TYPE OF WORK__**PRODUCT & INSTALLATION**

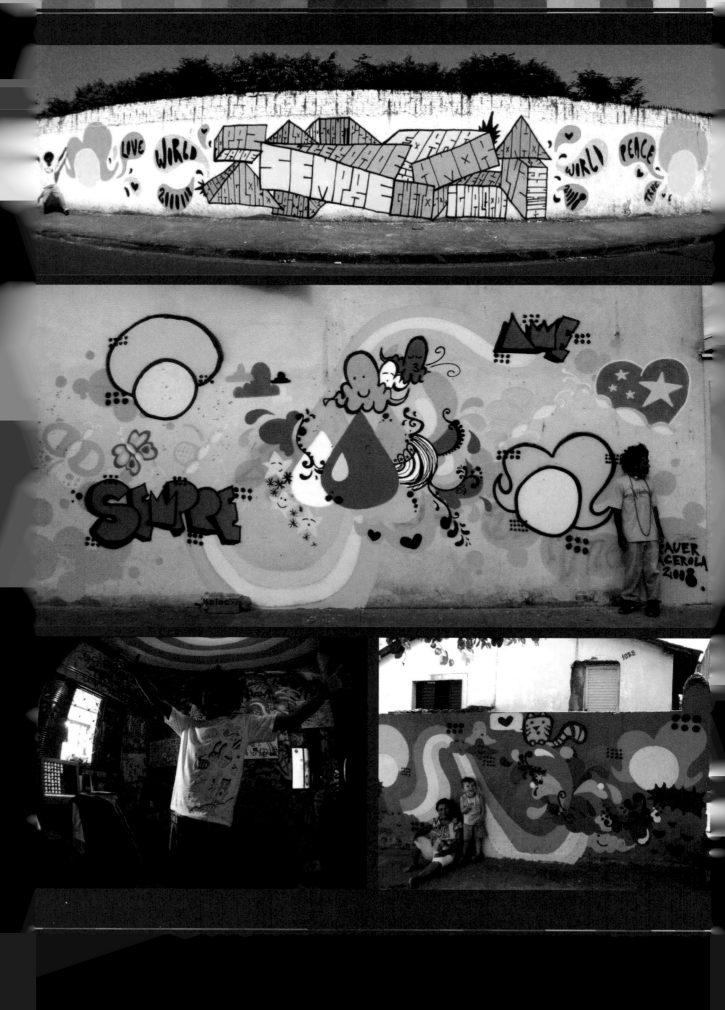

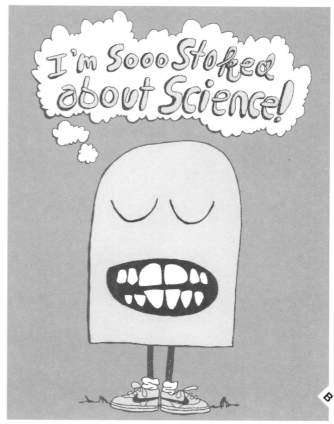

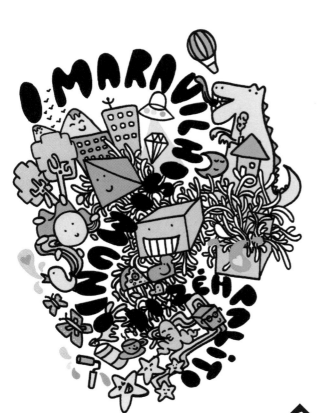

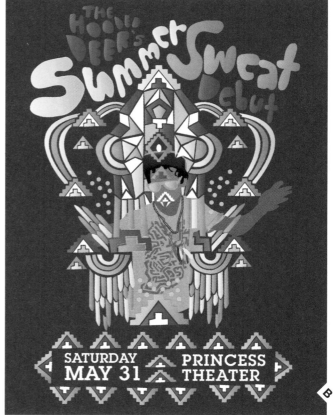

A ... ARTIST__**ZÈH PALITO** TYPE OF WORK__**ICON & CHARACTER**
B ... ARTIST__**WILL-BRYANT** TYPE OF WORK__**ICON & CHARACTER**

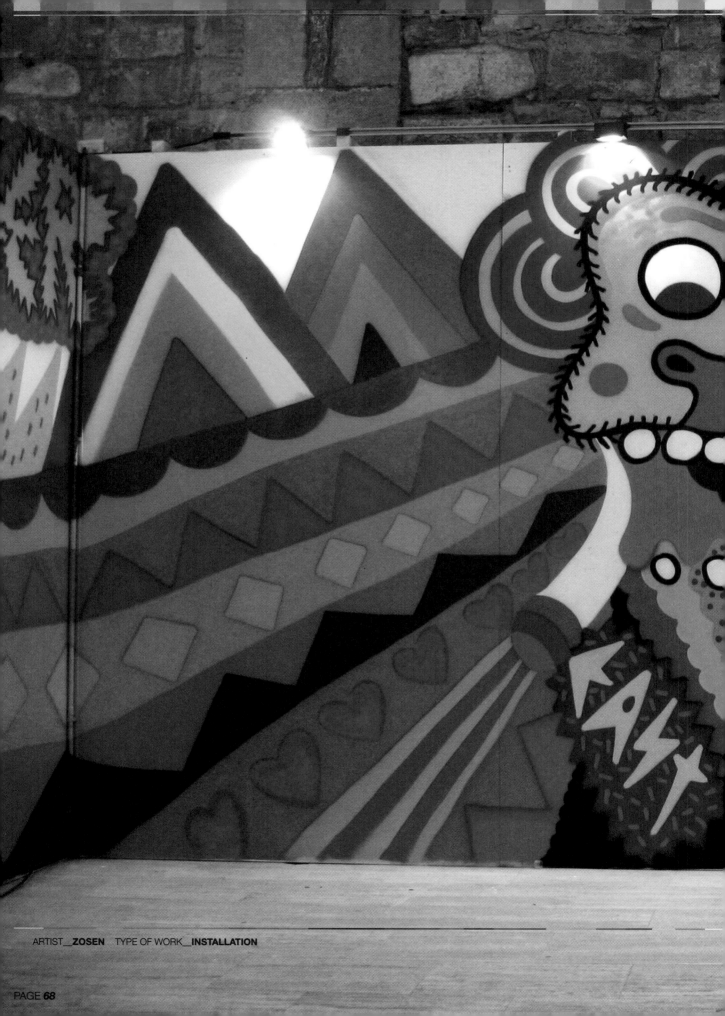

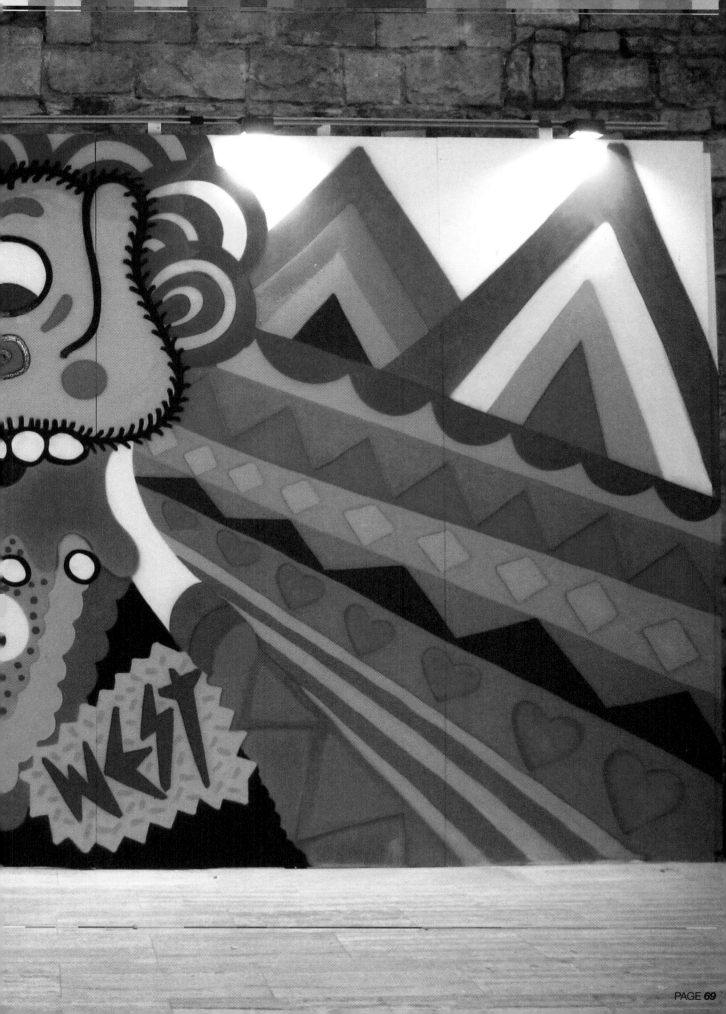

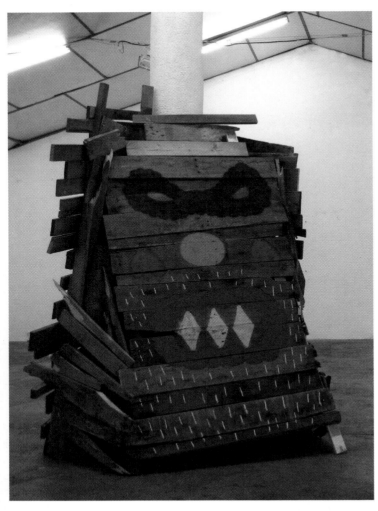

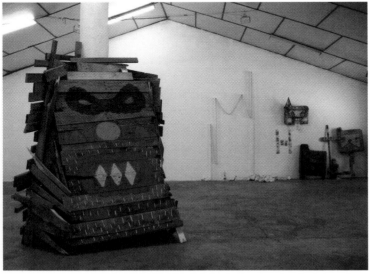

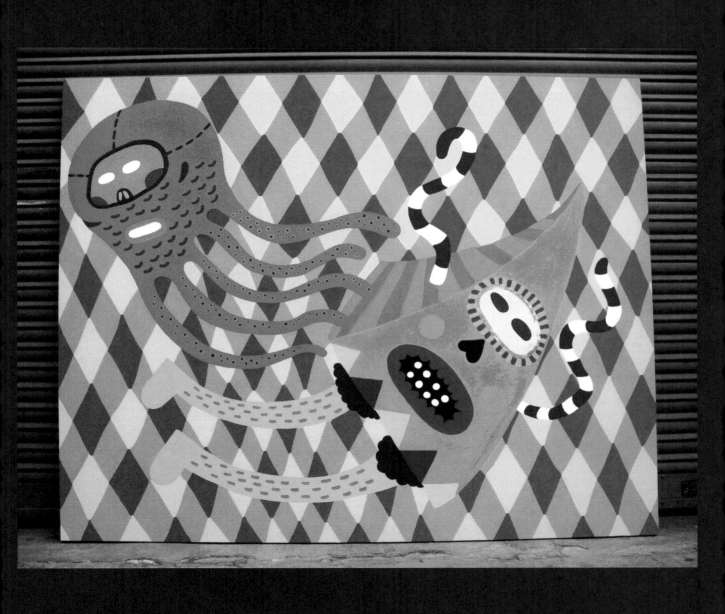

ARTIST__**ZOSEN** TYPE OF WORK__**PAINTING**

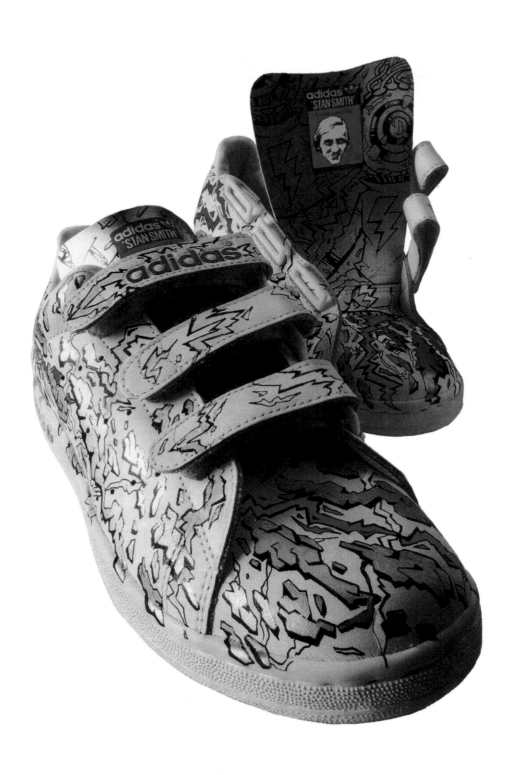

ARTIST__**IMAITOONZ** TITLE__**"SNEAKER CUSTOM PAINT"** TYPE OF WORK__**ILLUSTRATION**

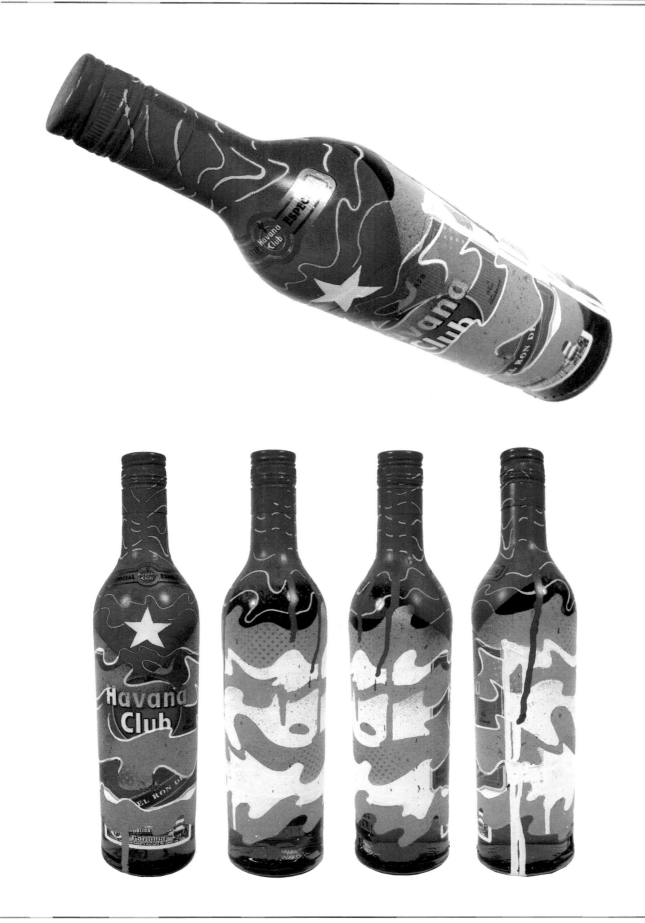

ARTIST__**GRAPHICNONSENSE • MARK WARD** TITLE__**HAVANA CLUB RUM** TYPE OF WORK__**PRODUCT**

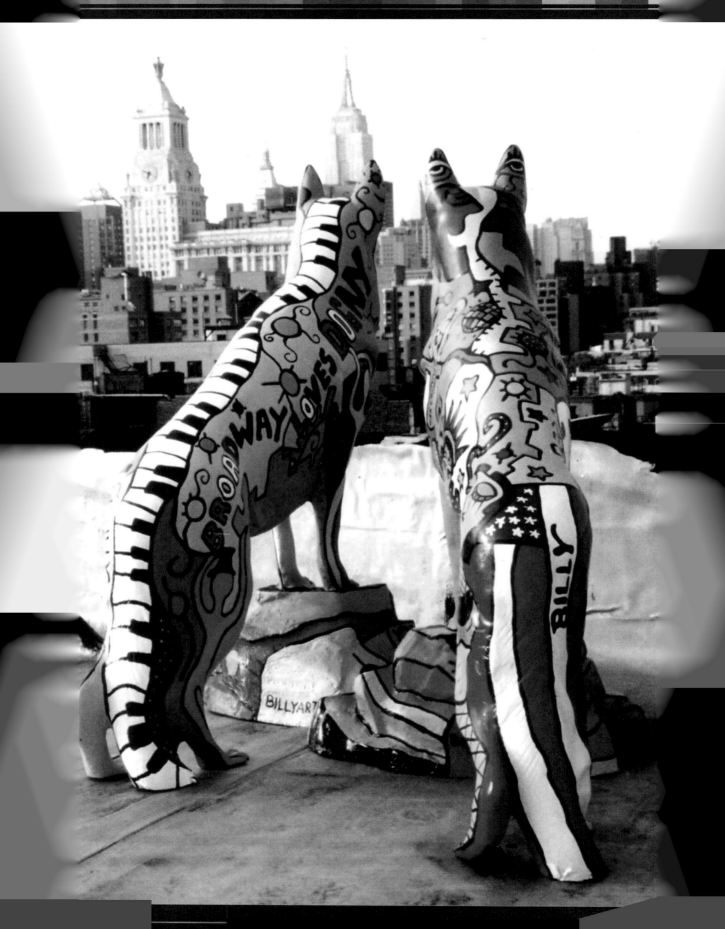

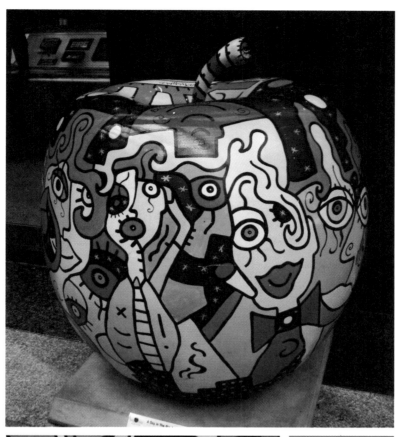

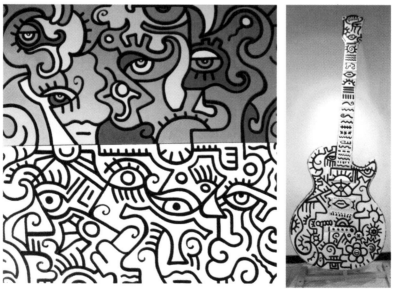

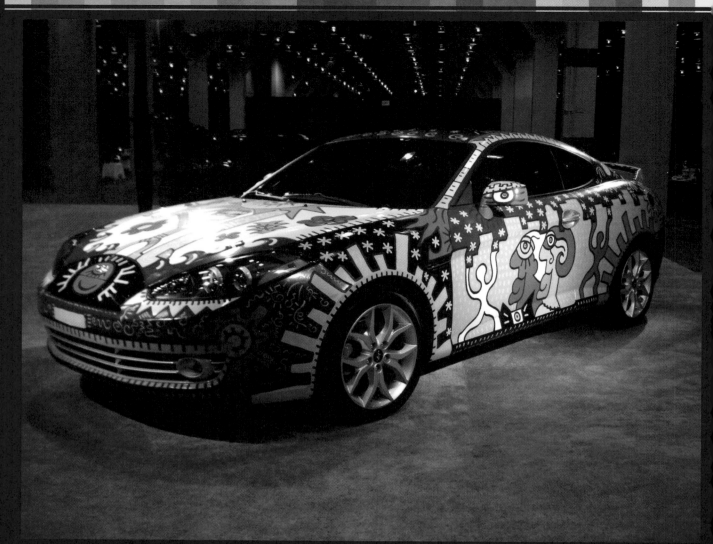

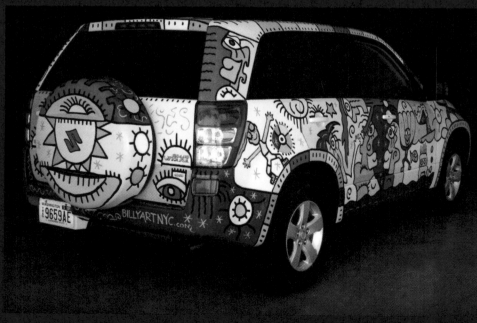

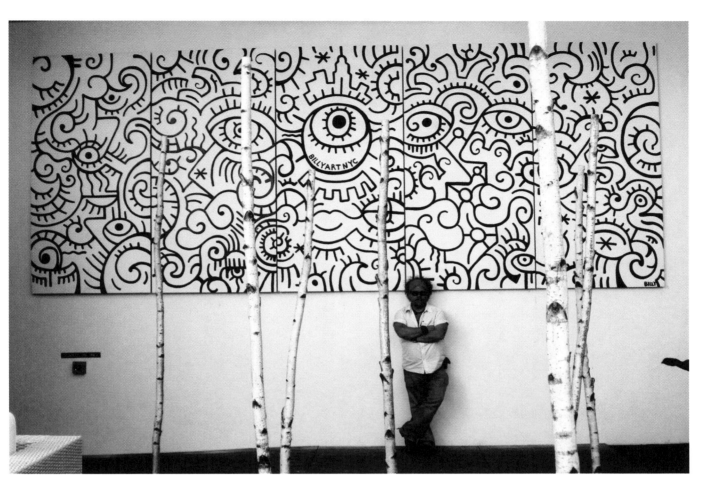

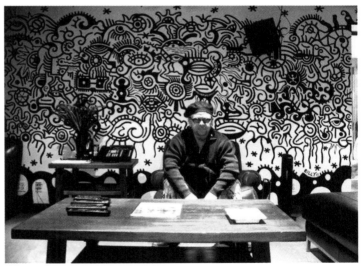

ARTIST__**BILLY** TYPE OF WORK__**PAINTING**

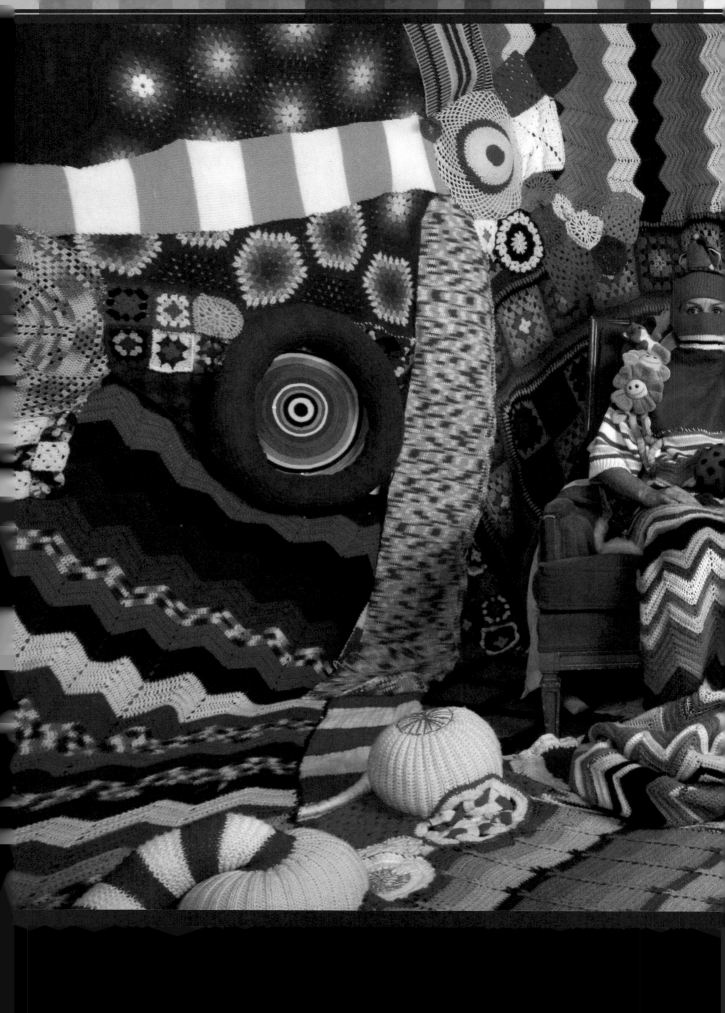

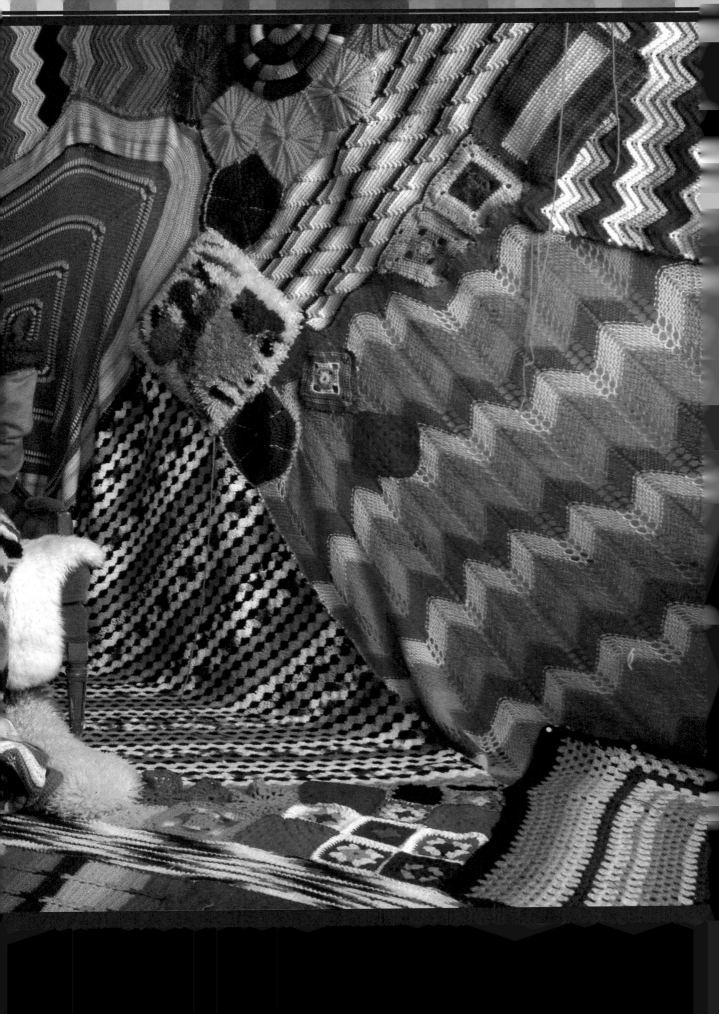

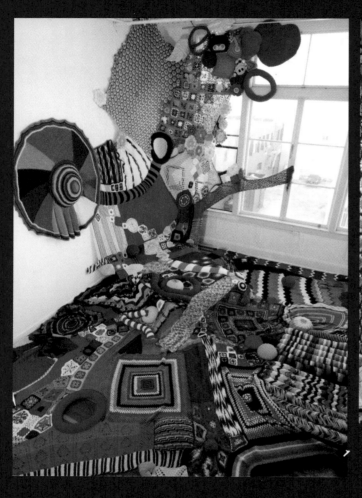
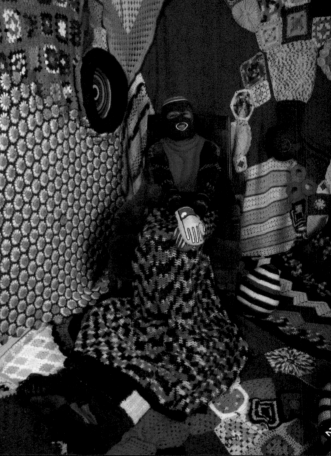

ARTIST__**SARAH APPLEBAUM**
TITLE__**1-PHANTASMAGORIA . 2-STATIC COSTUME IN NATURAL ENVIRONMENT**
TYPE OF WORK__**INSTALLATION**

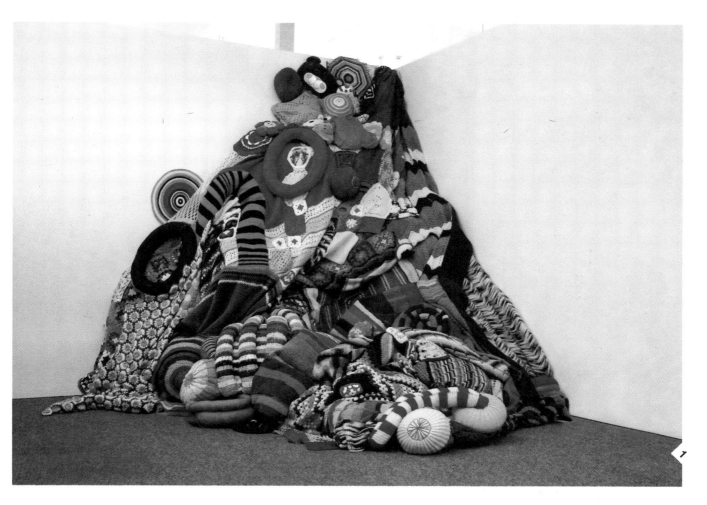

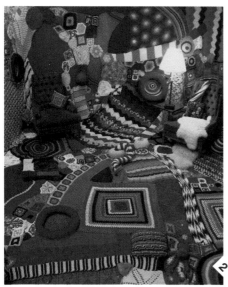

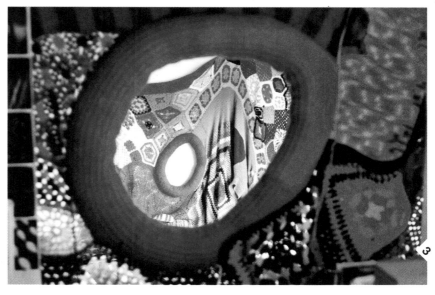

ARTIST__**SARAH APPLEBAUM**
TITLE__**1-THE PILE . 2-PADDED ROOM . 3-**Holes detail from (hang out some)
TYPE OF WORK__**INSTALLATION**

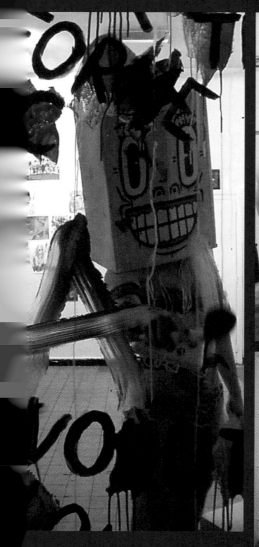
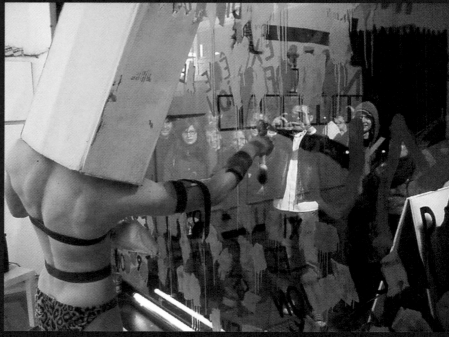
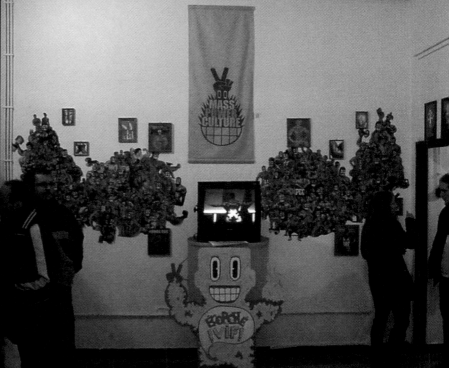

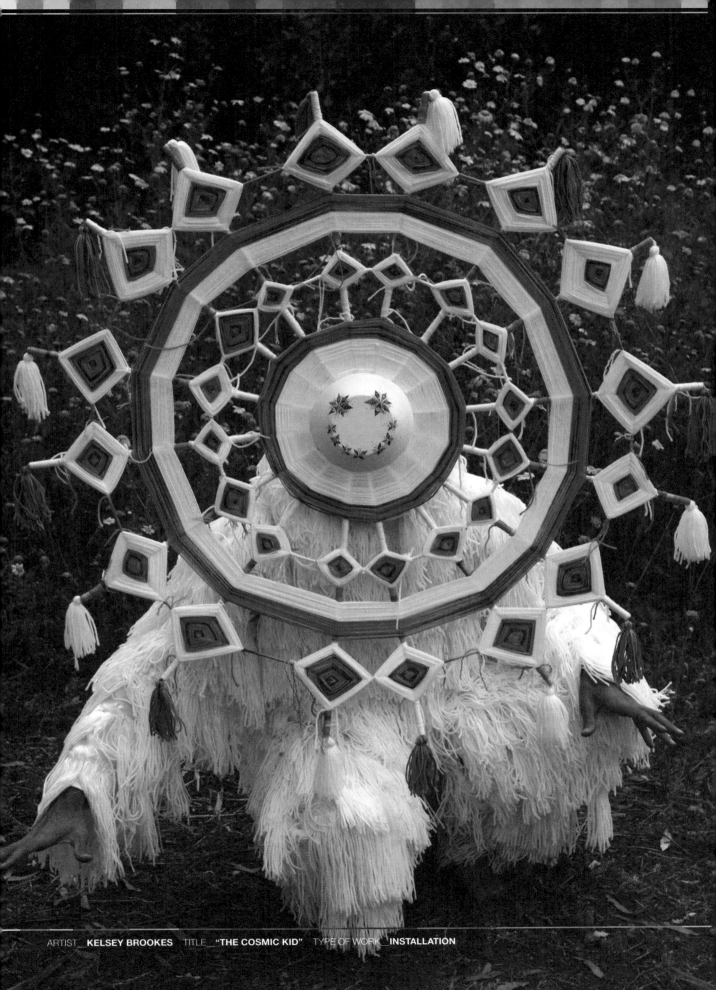

ARTIST__**KELSEY BROOKES** TITLE__"THE COSMIC KID" TYPE OF WORK__INSTALLATION

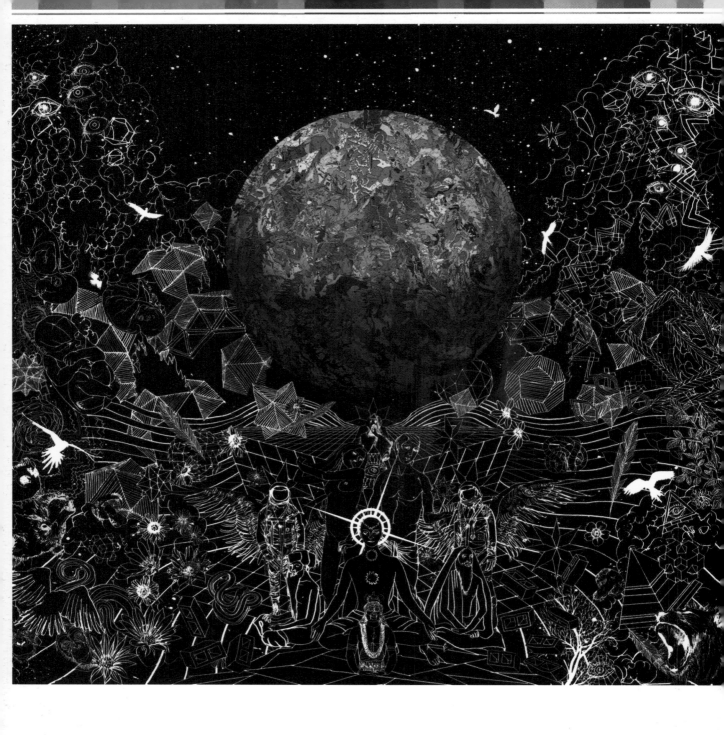

ARTIST__**GUILHERME MARCONI**
TITLE__**APOLLO SUNSHINE 'SHALL NOISE UPON *FRONT COVER FOR FULL LENGTH ALBUM 2008**
TYPE OF WORK__**PRINT**

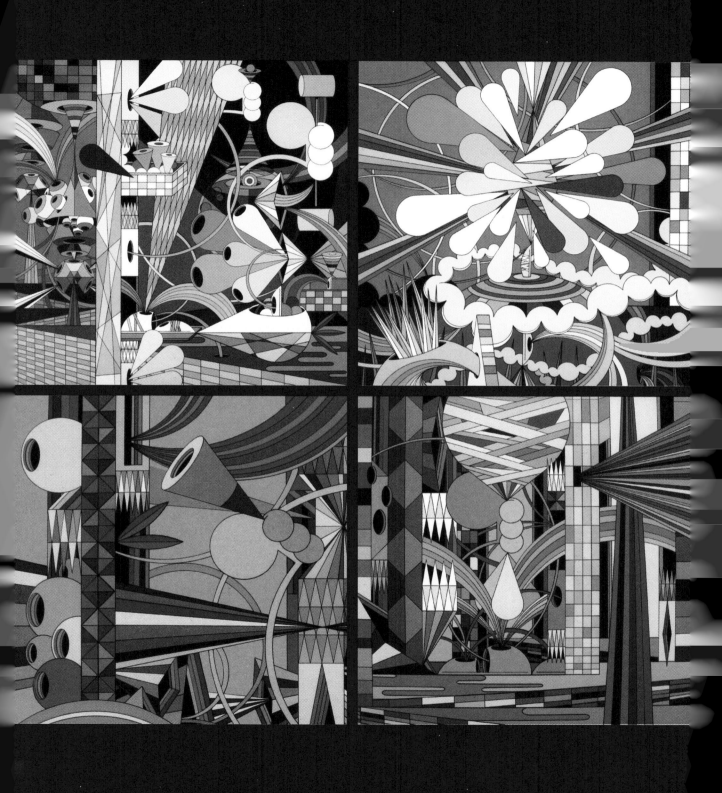

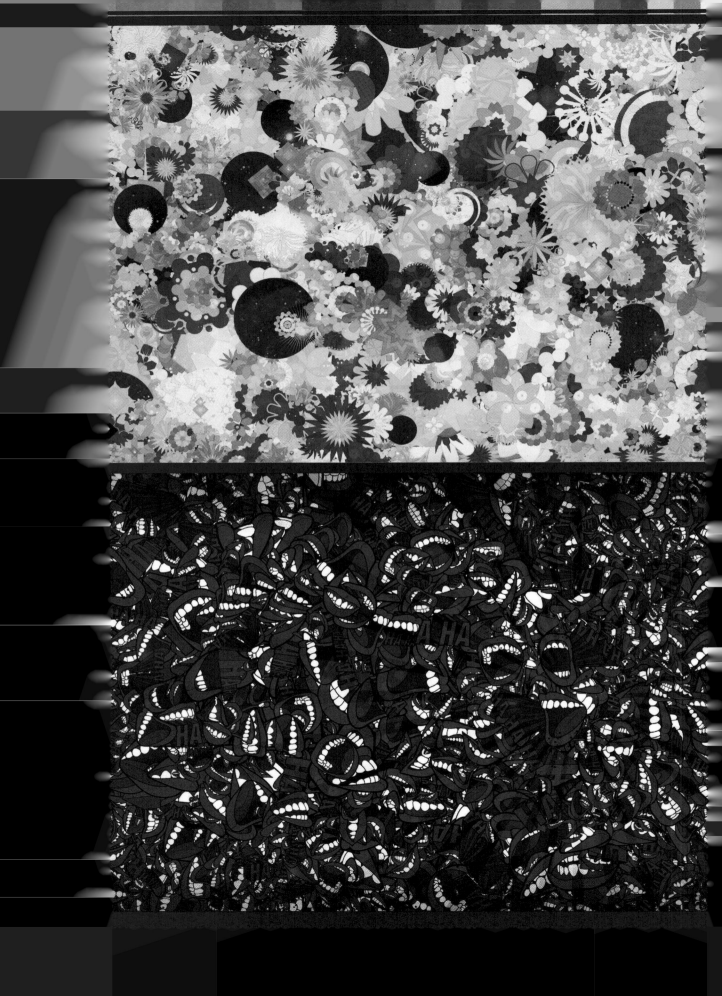

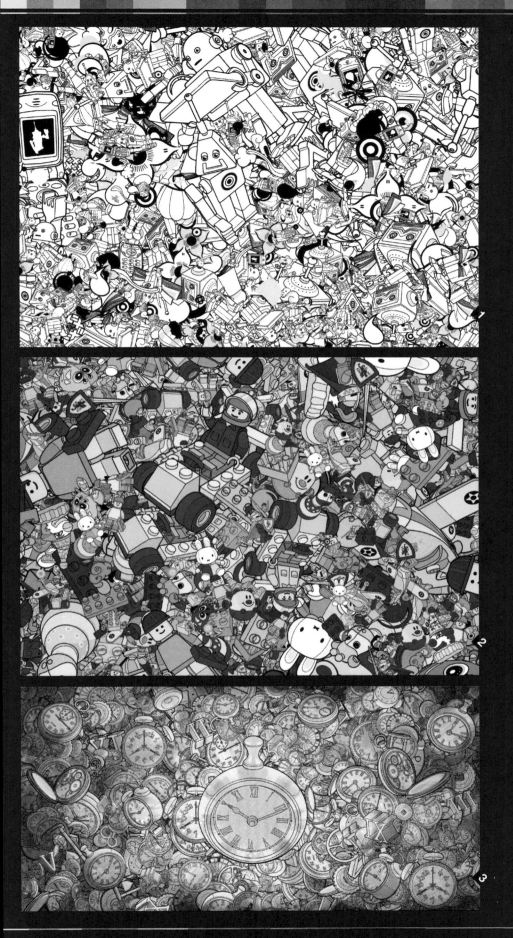

ARTIST__**GUILHERME MARCONI**
TITLE__**1-MY ROBOTS . 2-LET´S PLAY . 3-GOLDEN TIME**
TYPE OF WORK__**PRINT**

A ... ARTIST__**DESIGNERFAKE** TYPE OF WORK__**PRINT**

B ... ARTIST__**MARCOS CHIN** TITLE__**FALLING OFF THE WORKOUT WAGON** TYPE OF WORK__**PRINT**

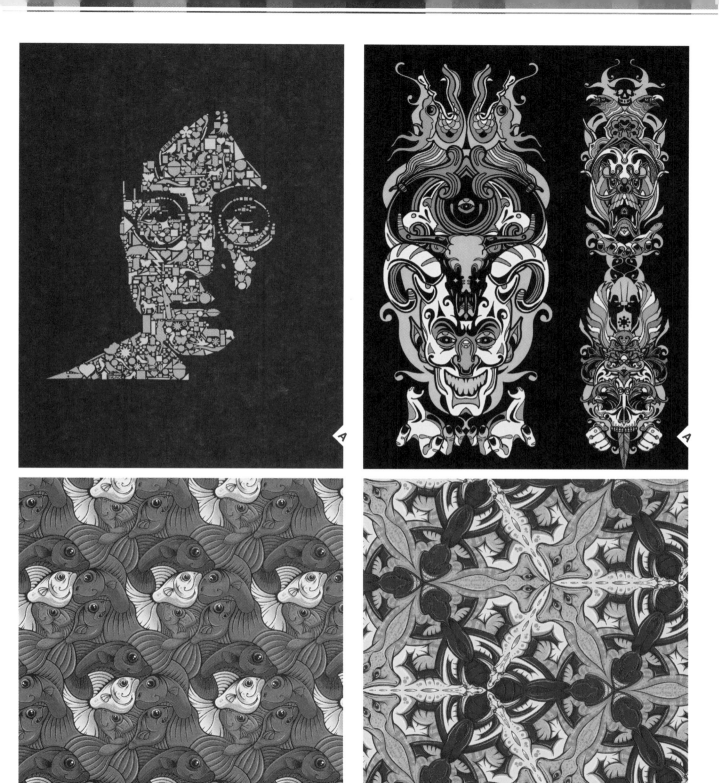

A ... ARTIST__**EELCO VAN DEN BERG** TYPE OF WORK__**PRINT**
B ... ARTIST__**FAT PUNK STUDIO** TYPE OF WORK__**PRINT**

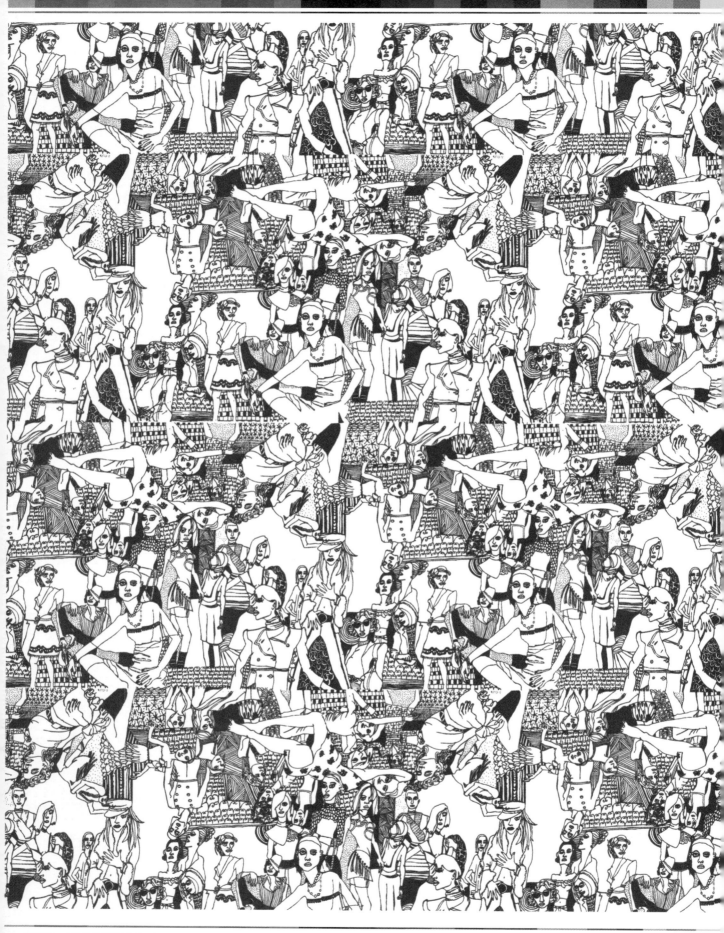

ARTIST__**JULIA ROTHMAN** TITLE__**FASHIONISTAS** TYPE OF WORK__**PRINT**

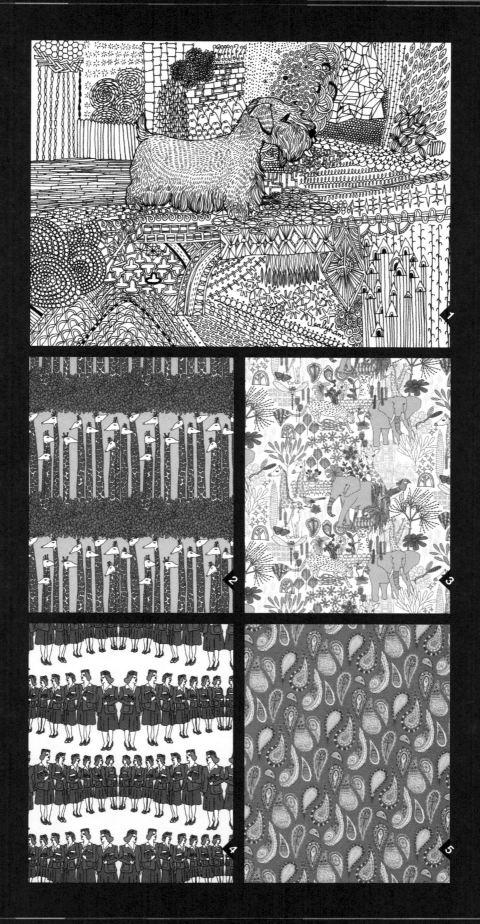

ARTIST__**JULIA ROTHMAN**
TITLE__**1-SEALYHAM TERRIER *WURSTMINSTER DOG SHOW . 2-GIRAFFES . 3-SAFARI FOR URBAN OUTFITTERS QUILT .**
 4-STEWARDESS . 5-PAISLEY
TYPE OF WORK__**PRINT**

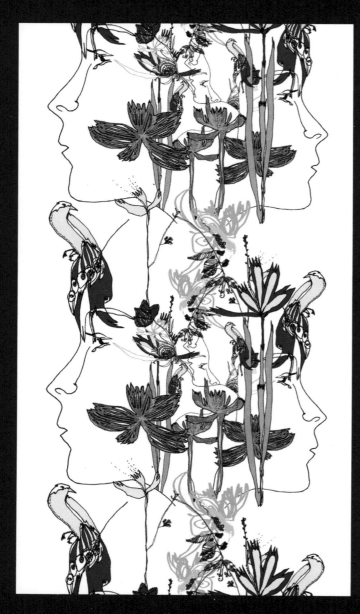
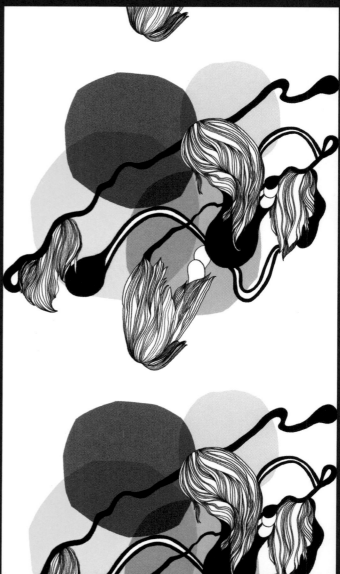

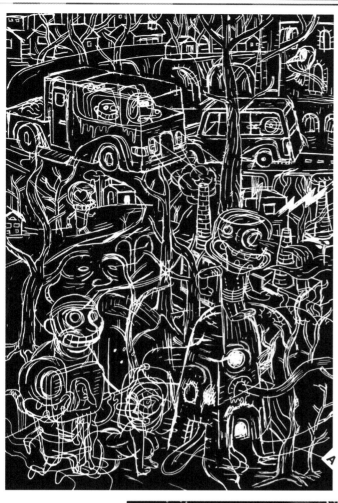

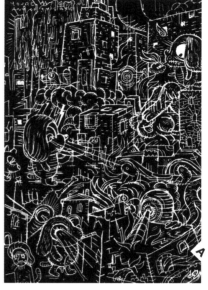

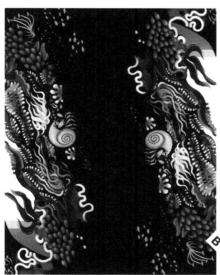

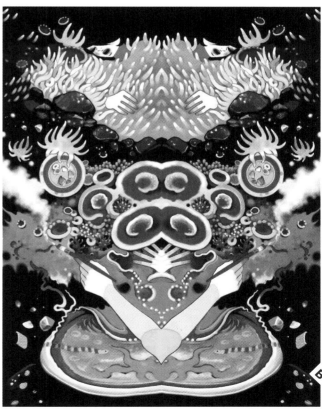

A ... ARTIST__**MARCUS NYBLOM** TYPE OF WORK__**PRINT**
B ... ARTIST__**MINCHI** TITLE__**1-HERMIT CRAB . 2. BEAUTIFUL LINE** TYPE OF WORK__**PRINT**

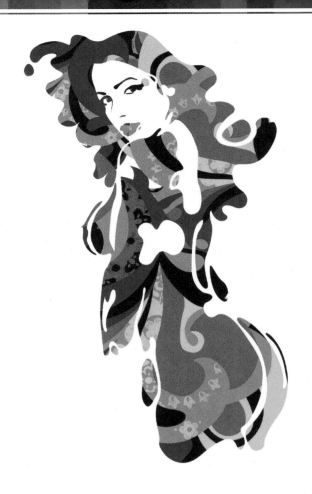

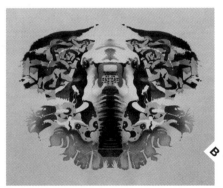

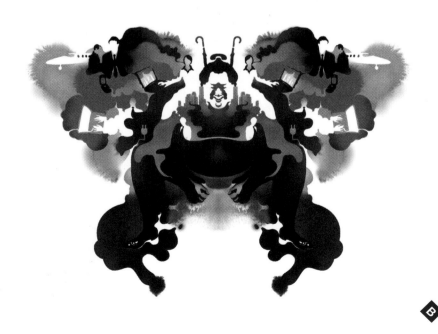

A ... ARTIST__**JTHREECONCEPTS** TYPE OF WORK__**PRINT**
B ... ARTIST__**PILLO3 • PHIL WHEELER** TYPE OF WORK__**PRINT**

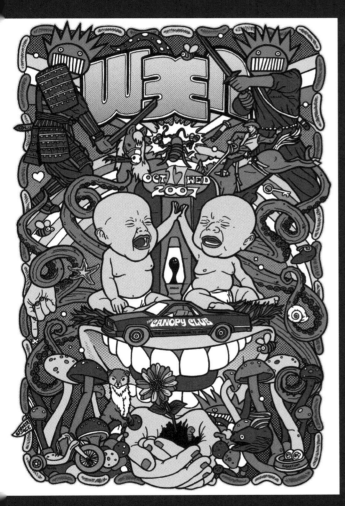

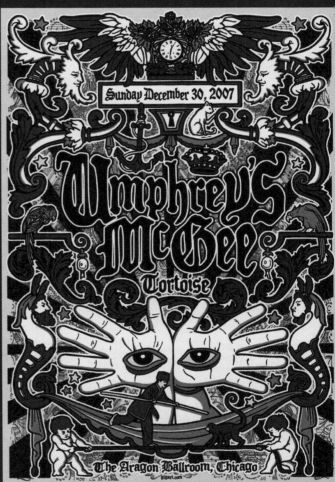

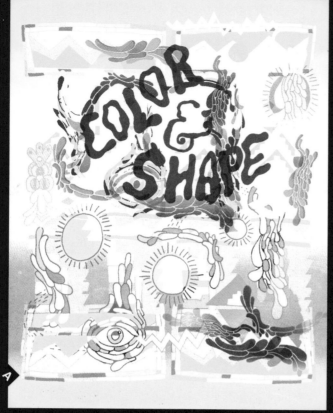

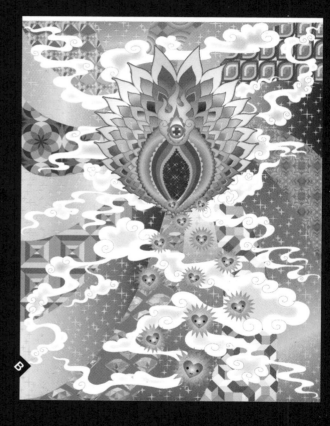

A ... ARTIST__**WILL-BRYANT** TYPE OF WORK__**PRINT**
B ... ARTIST__**MARIA ROZALIA FINNA** TYPE OF WORK__**PRINT**
C ... ARTIST__**RYU ITADANI** TITLE__**RED FLOWERS** TYPE OF WORK__**PRINT**

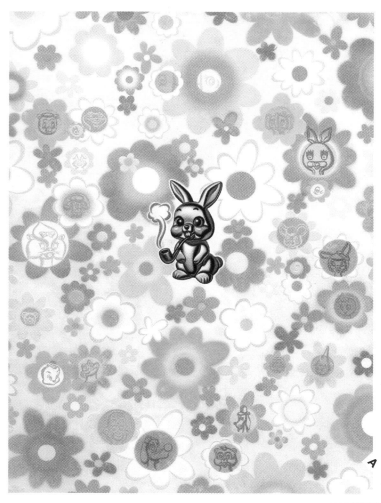

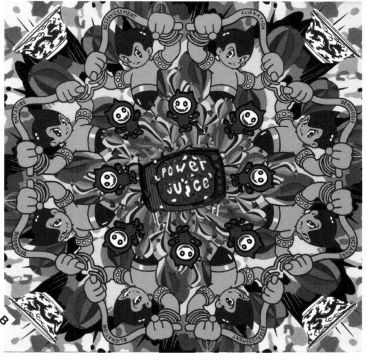

A ... ARTIST__**MITCHOCONNELL** TYPE OF WORK__**PRINT**

B ... ARTIST__**MINCHI** TITLE__**POWER JUICE** TYPE OF WORK__**PRINT**

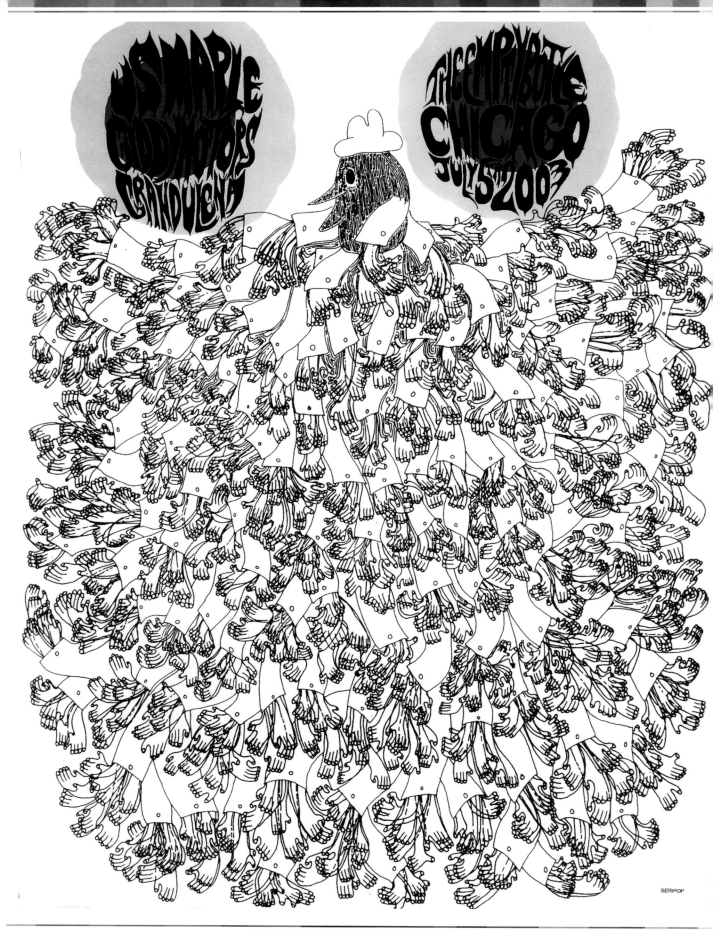

ARTIST__**SERIPOP** TYPE OF WORK__**PRINT**

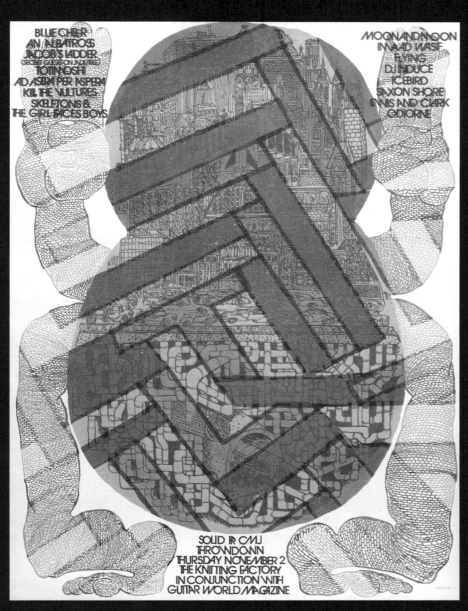

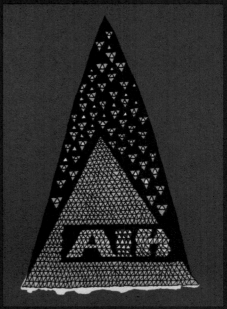

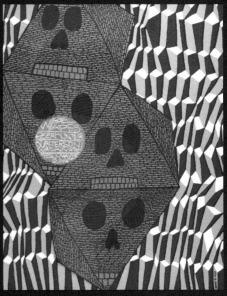

ARTIST__**SERIPOP** TYPE OF WORK__**PRINT**

ARTIST__**SERIPOP** TITLE__**MSTRKRFT** TYPE OF WORK__**CD COVER**

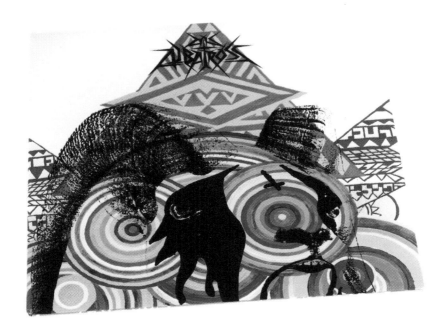

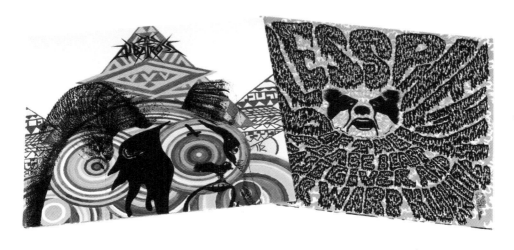

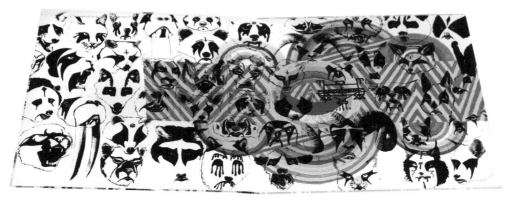

ARTIST__**SERIPOP** TITLE__**BLESSPHEMY** TYPE OF WORK__**PRINT**

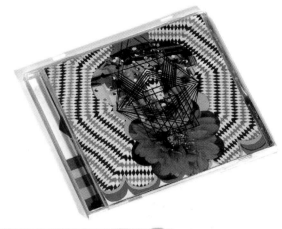

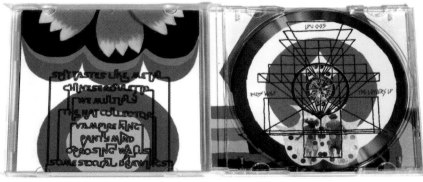

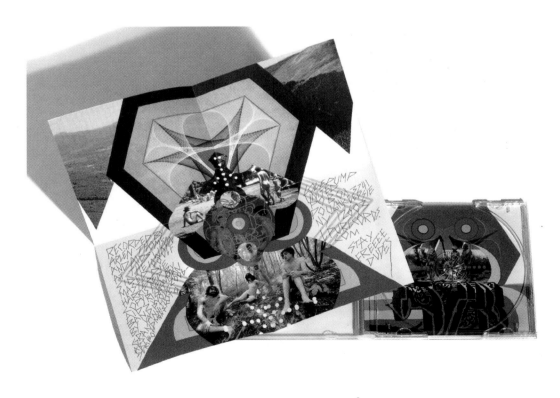

ARTIST__**SERIPOP** TITLE__**THE LOVVERS LP** TYPE OF WORK__**CD COVER**

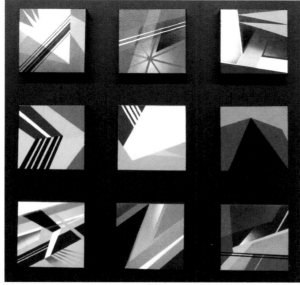

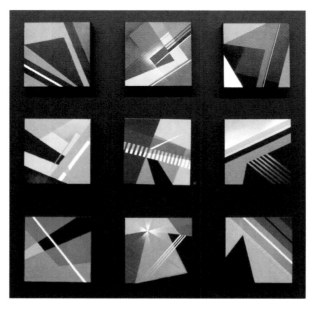

ARTIST__**MWMGRAPHICS** TYPE OF WORK__**PRINT**

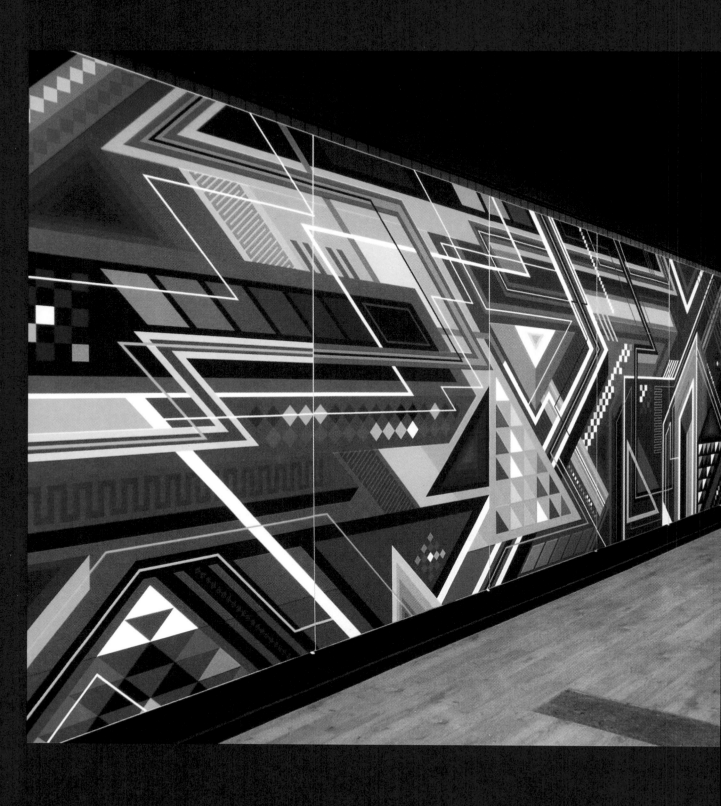

ARTIST__**MWMGRAPHICS** TYPE OF WORK__**INSTALLATION**

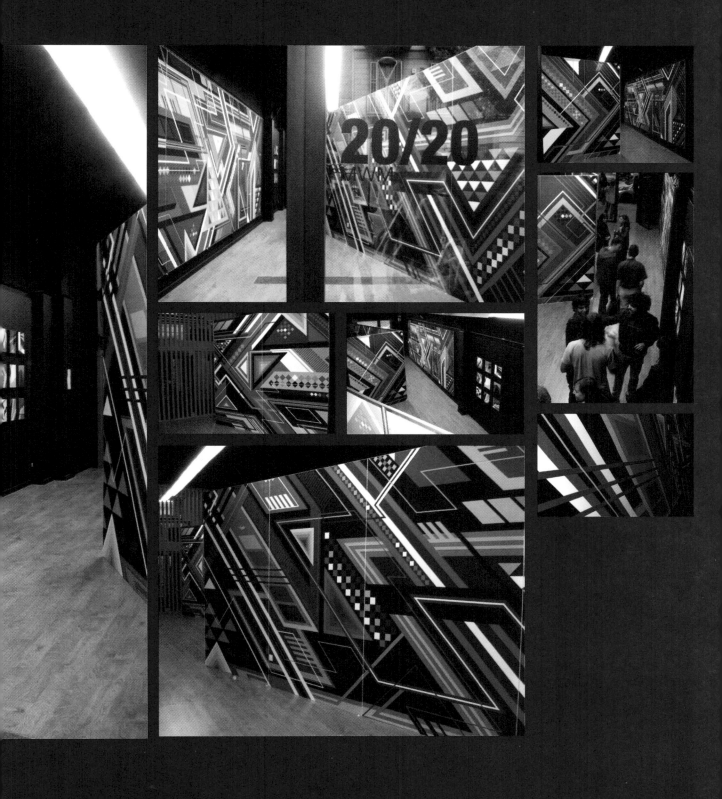

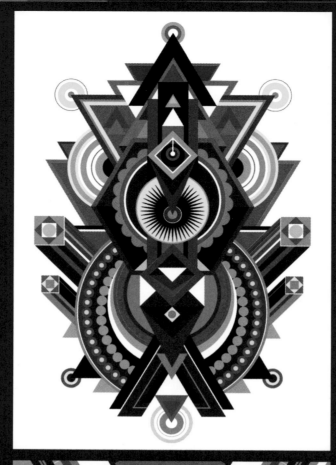

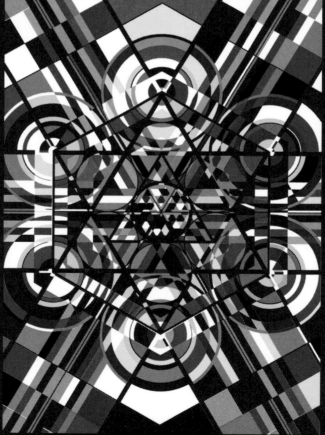

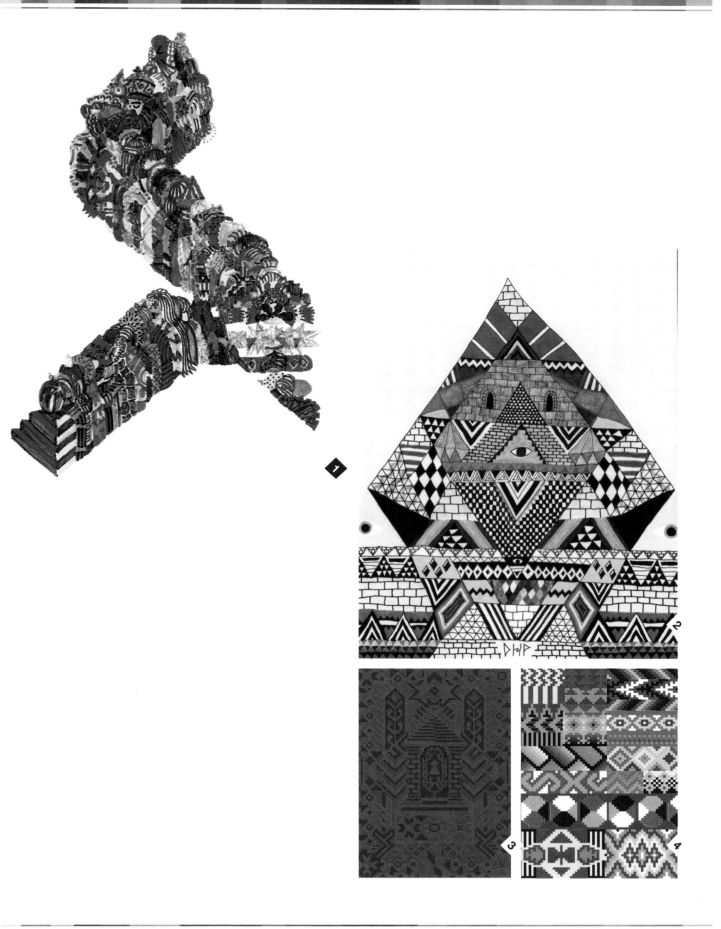

ARTIST__**YO!FEST**
TITLE__**1-149PEOPLE . 2-TRYANGLE . 3-SINDIRGI YO!GCIBEDIR . 4-SWATCHY**
TYPE OF WORK__**PRINT**

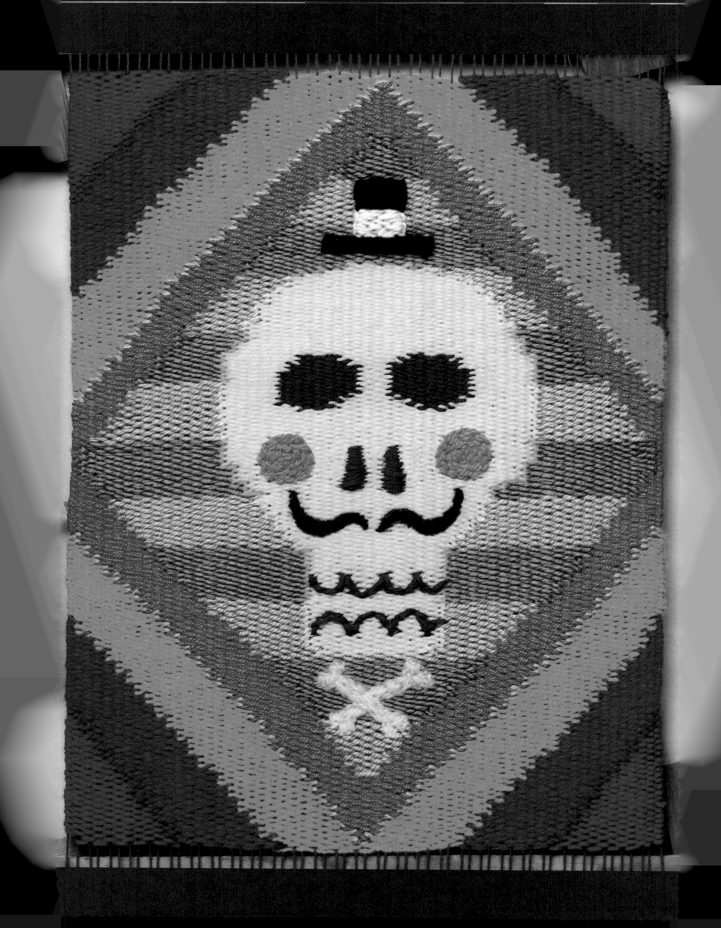

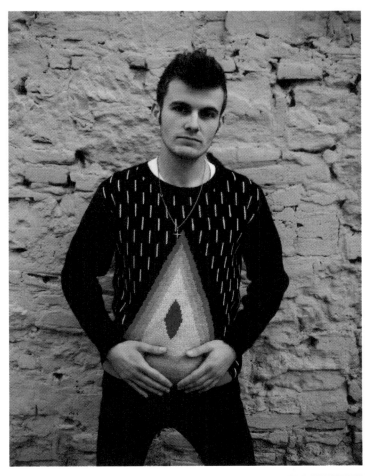

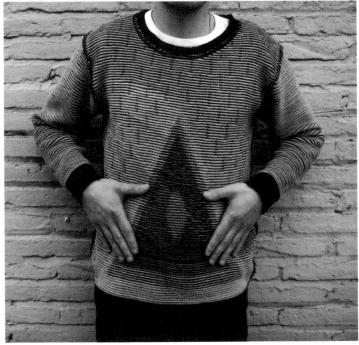

ARTIST__**ANIMALBANDIDO** TYPE OF WORK__**PRODUCT**

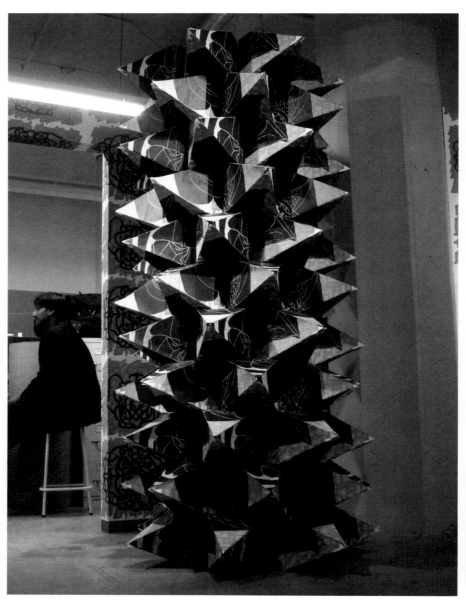
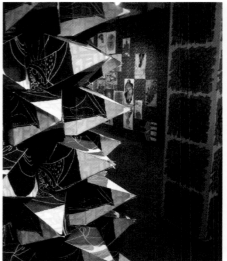

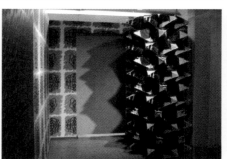

ARTIST__**SERIPOP** TITLE__**BRUCE & SHERYL** TYPE OF WORK__**PAPER SCULPTURE**

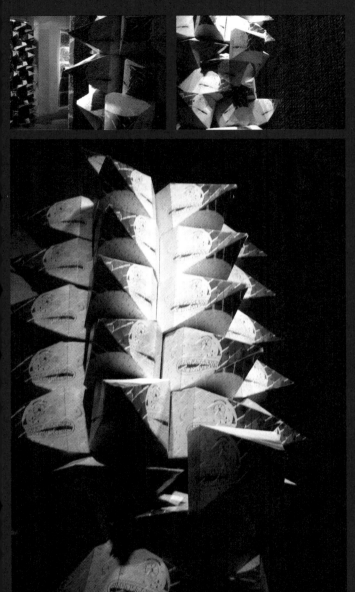

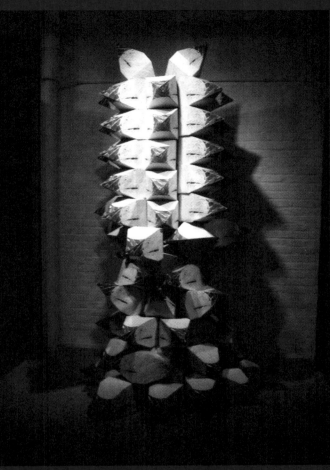

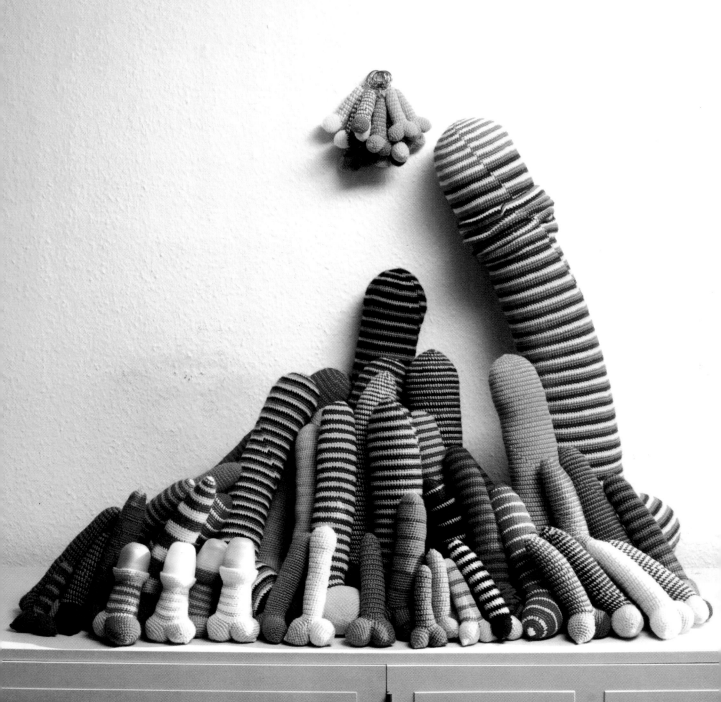

ARTIST__**ANDREA PRITSCHOW** TITLE__**HP-GROUP PHOTO** TYPE OF WORK__**PRODUCT**

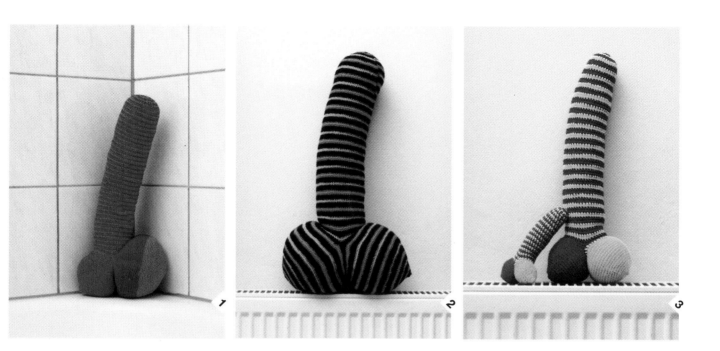

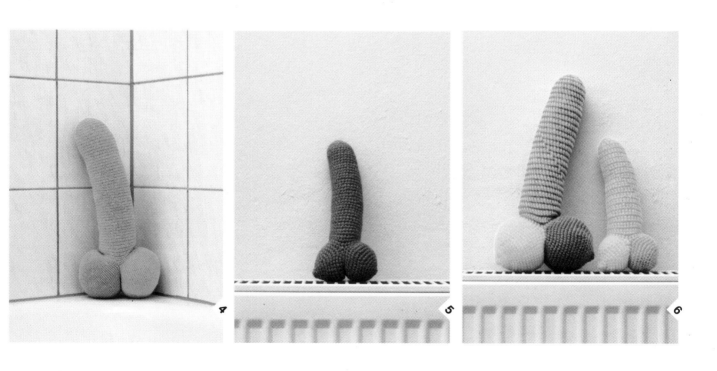

ARTIST__**ANDREA PRITSCHOW**
TITLE__**1-HP-1A . 2-HP-1B . 3-HP-4B . 4-HP-3A . 5-HP-5B . HP-6B**
TYPE OF WORK__**PRODUCT**

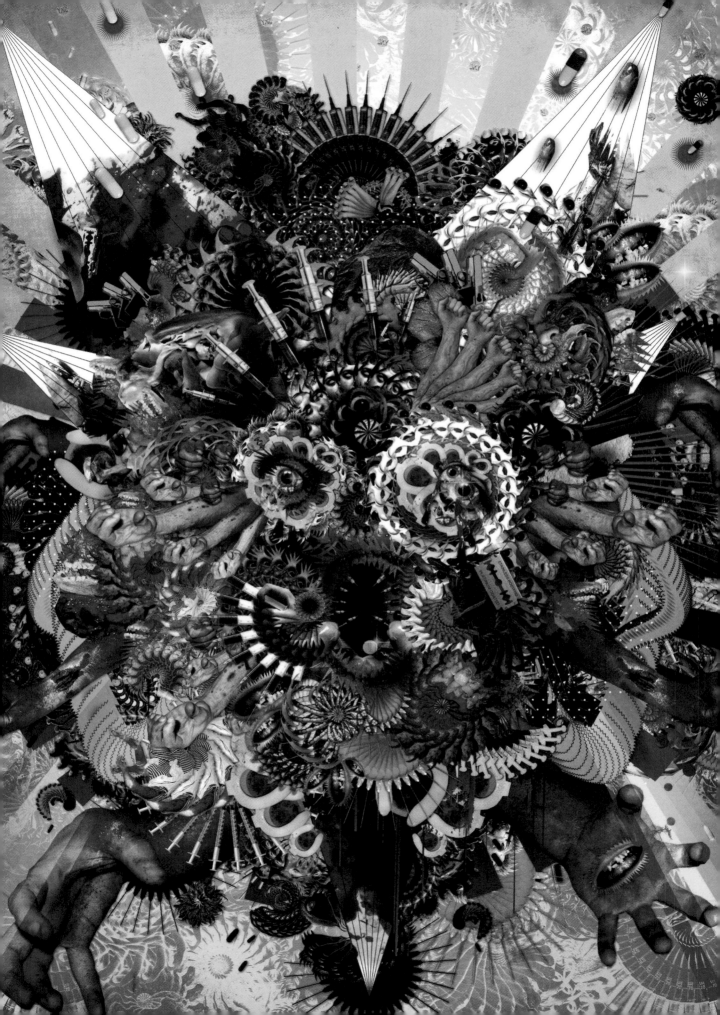

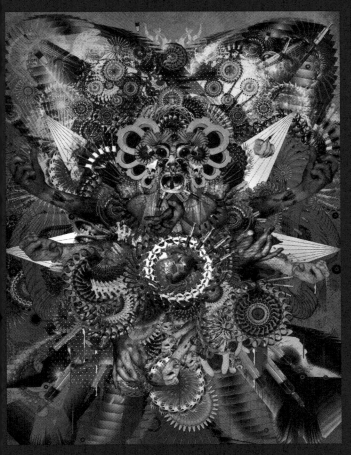

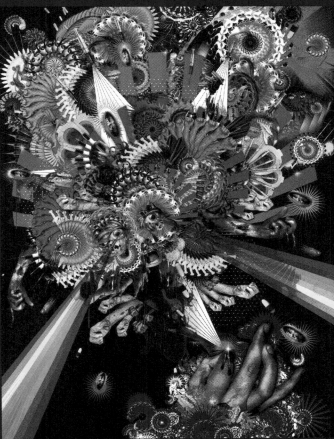

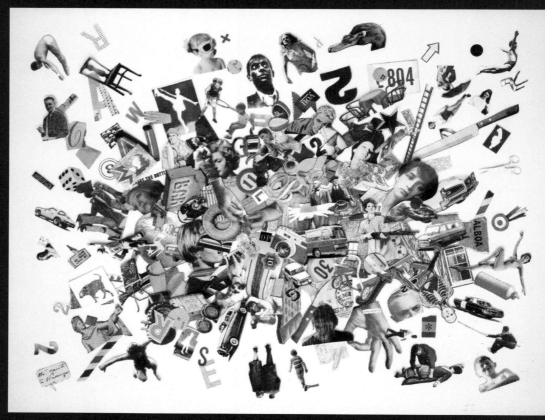

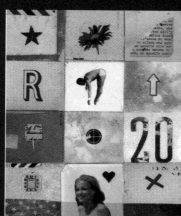

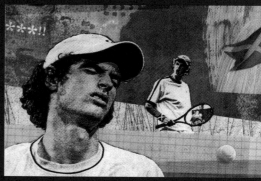

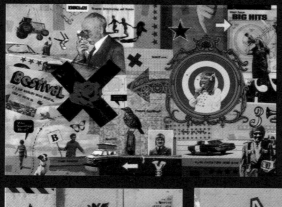

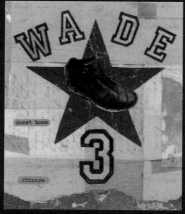

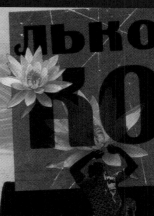

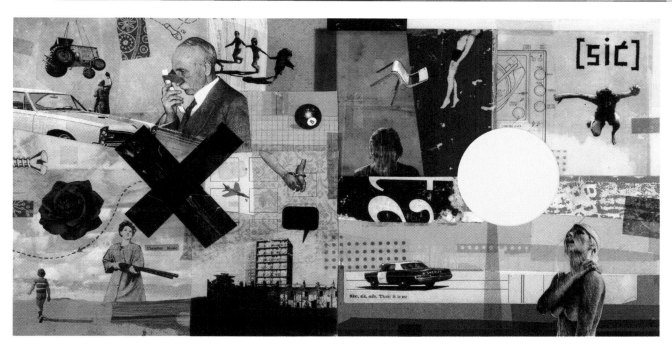

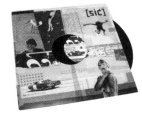

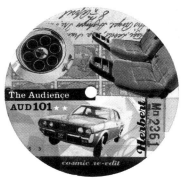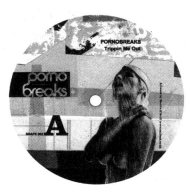

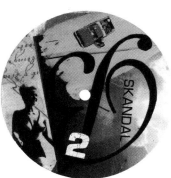

ARTIST__**MARTIN O'NEILL** TYPE OF WORK__**COLLAGE**

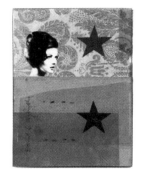

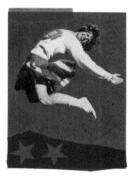
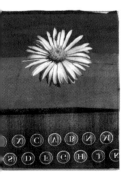

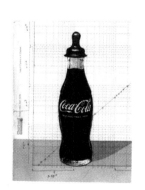
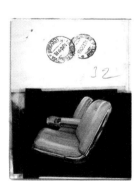

ARTIST__**MARTIN O'NEILL** TYPE OF WORK__**COLLAGE**

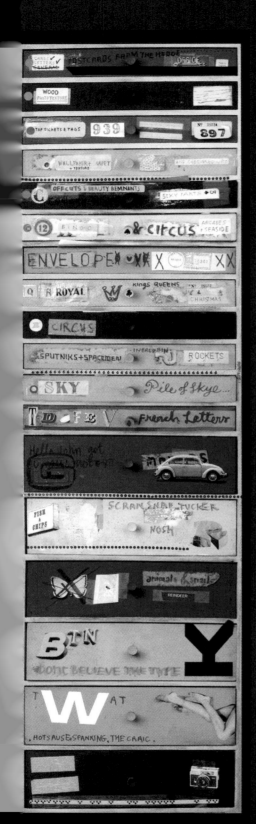

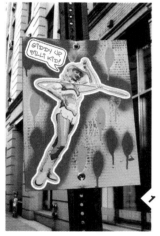

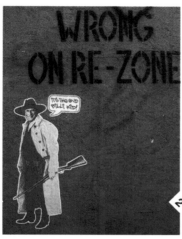

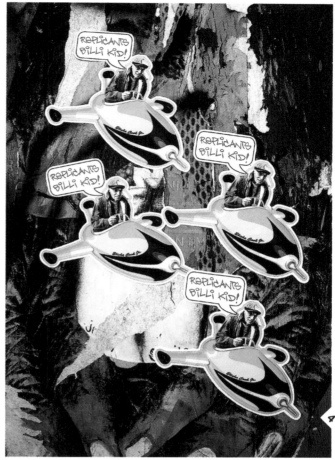

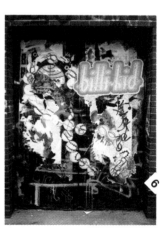

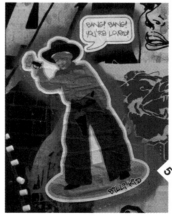

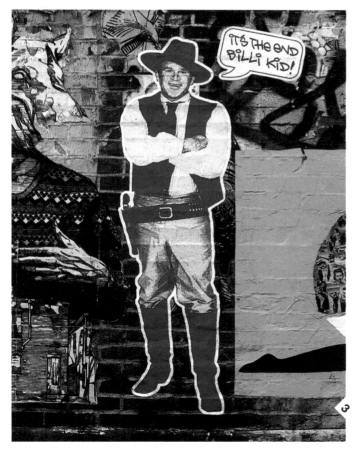

ARTIST__**BILLI**

TITLE__**1-GIDDY UP BILLI KID! . 2-IT'S THE END BILLI KID!2 . 3-IT'S THE END BILLI KID! . 4-REPLICANTS BILLI KID! .**
5-BANG! BANG! YOU'RE LOVED! . 6-BILLI KID

TYPE OF WORK__**COLLAGE**

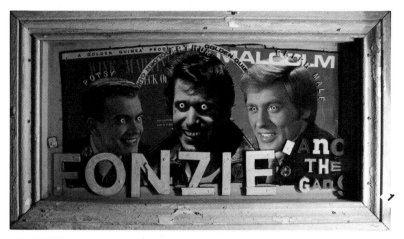

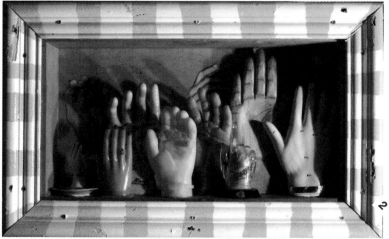

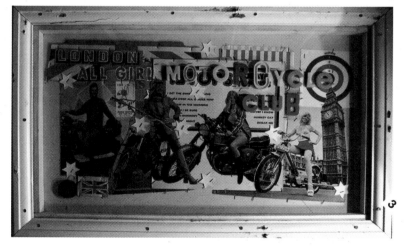

ARTIST__**PETER QUINNELL MA . RCA**
TITLE__**1-'FONZIE' AND THE GANG . 2-HANDS . 3-LONDON ALL GIRL MOTORCYCLE CLUB**
TYPE OF WORK__**COLLAGE**

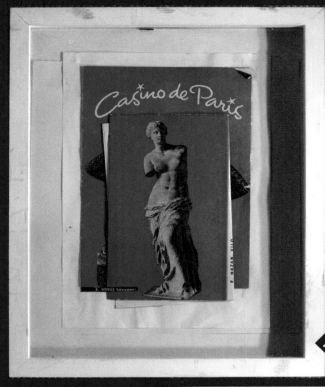

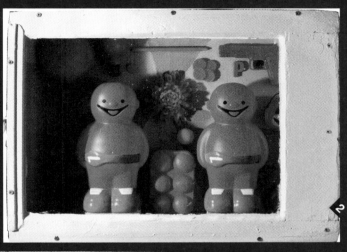

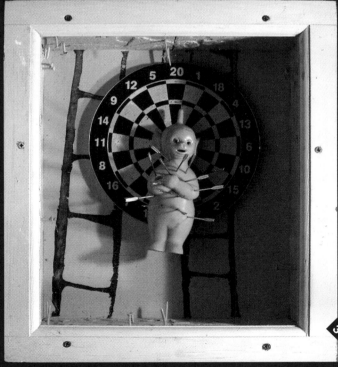

ARTIST__**PETER QUINNELL MA . RCA**
TITLE__**1-VENUS . 2-ORANGE JELLY TWINS . 3-SEBASTIAN ASCENDING**
TYPE OF WORK__**COLLAGE**

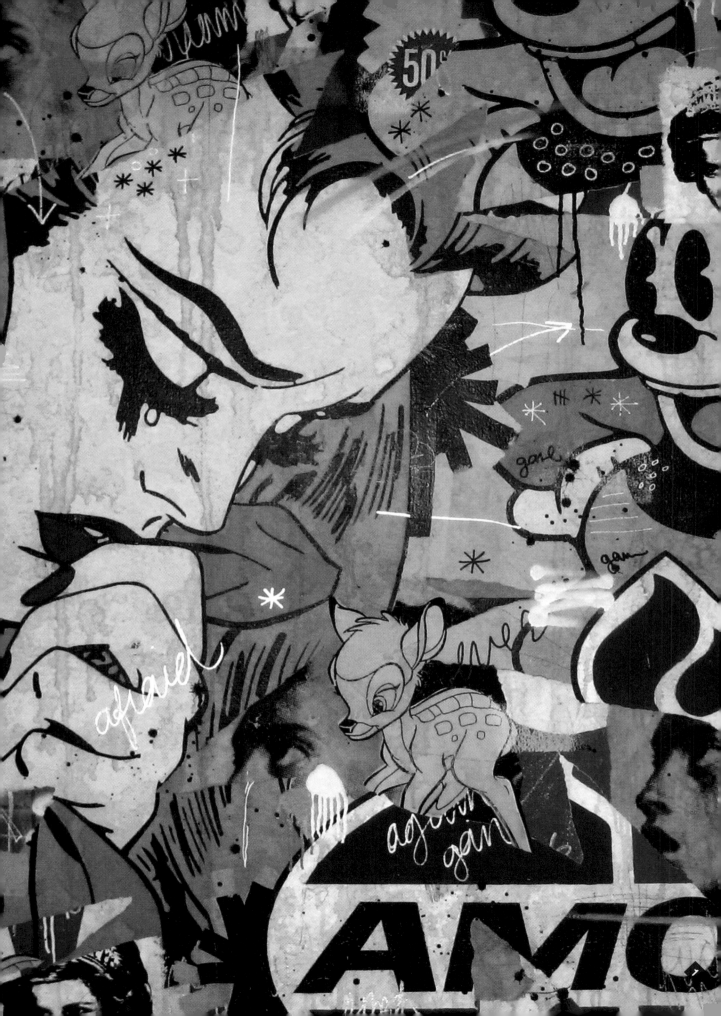

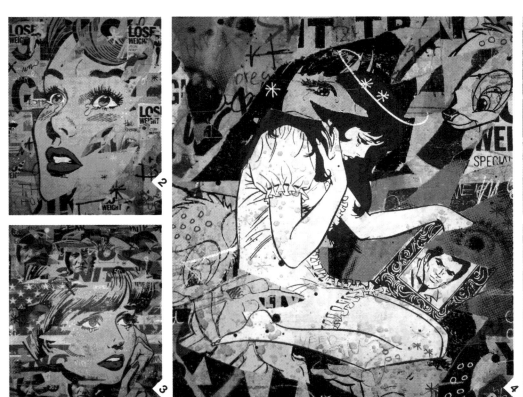

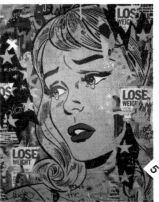

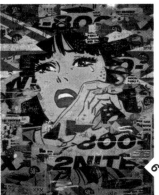

ARTIST__**GREG GOSSEL**

TITLE__**1- "STRUCK" . 2-"BUY ANY MEANS NECESSARY" . 3-"A DOLLAR AND A DREAM" .**

 4-"PLAY SCARED" . 5-"SHINY NIGHTS" . 6-"MAYBE NEXT TIME"

TYPE OF WORK__**COLLAGE**

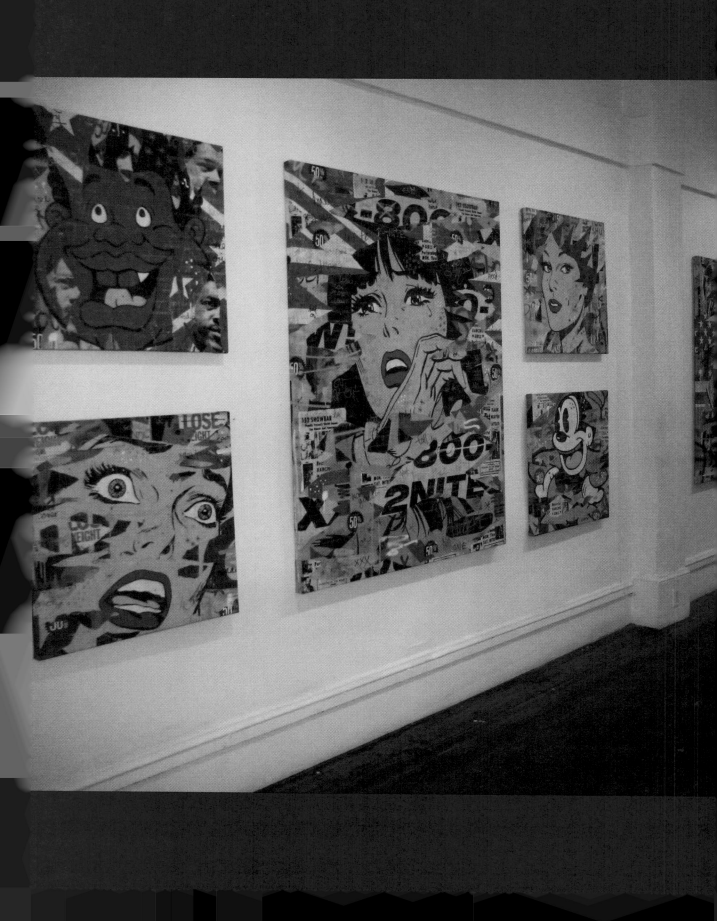

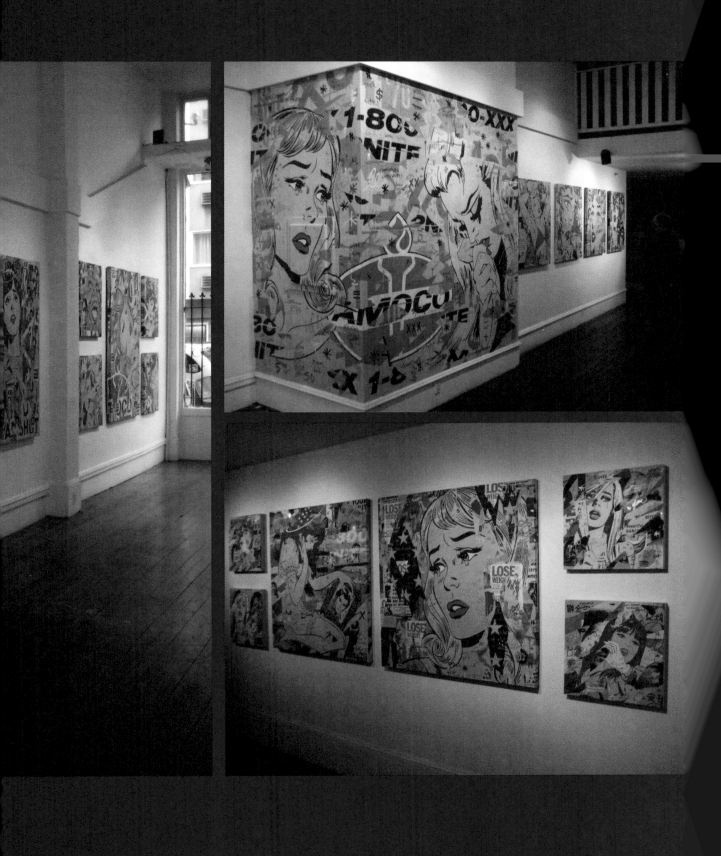

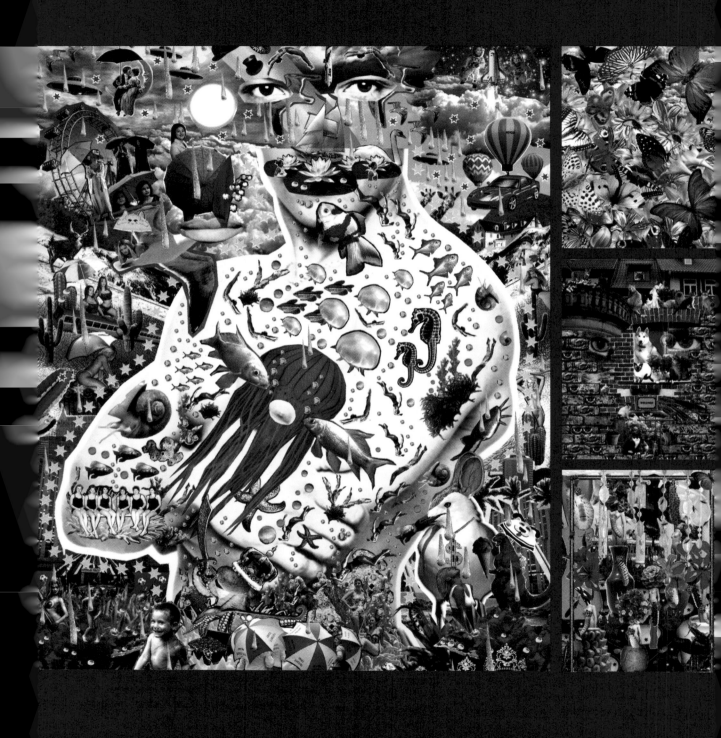

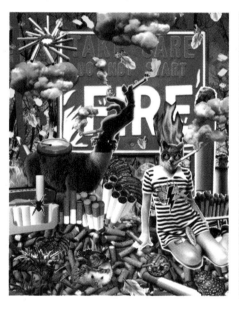 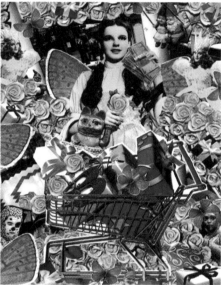 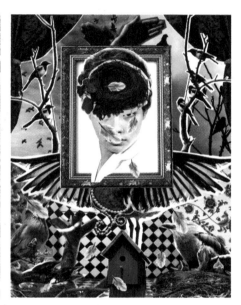

ARTIST__**YASEN** TYPE OF WORK__**COLLAGE**

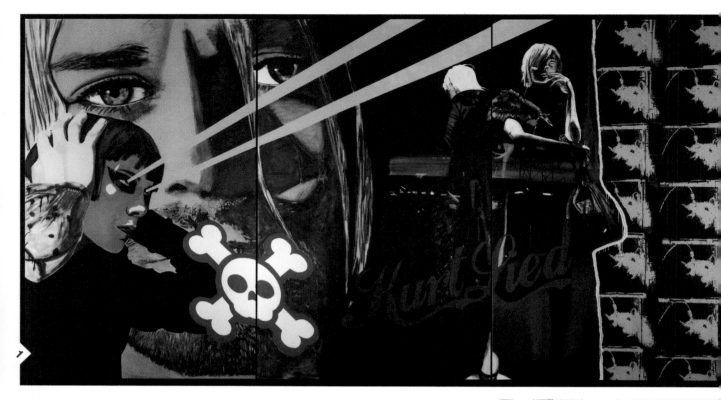

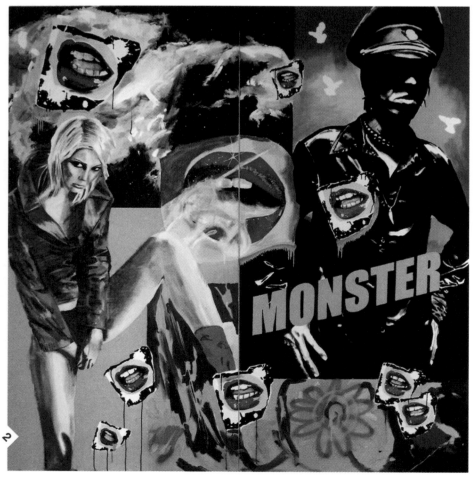

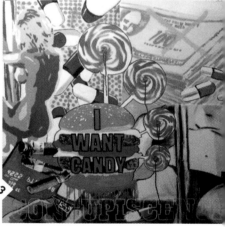

ARTIST__**STUART SEMPLE**
TITLE__**1-KURT LIED . 2-MONSTER . 3-I WANT CANDY**
TYPE OF WORK__**COLLAGE**

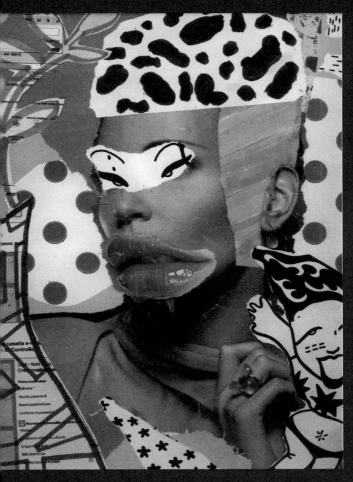
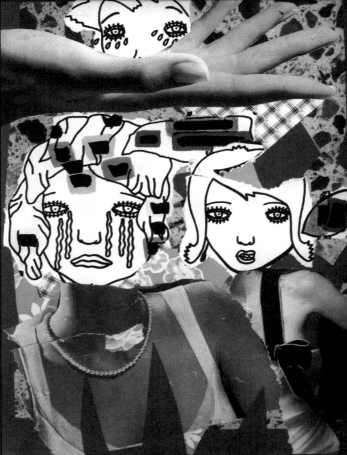

ARTIST__ **CLAUDIO PARENTELA** TYPE OF WORK__**COLLAGE**

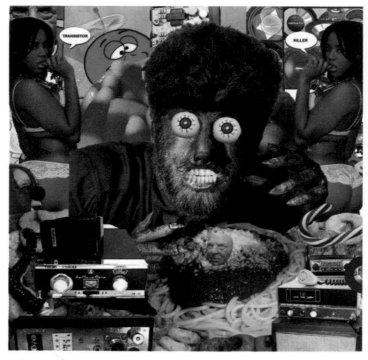

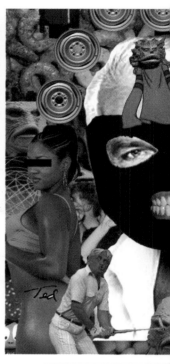

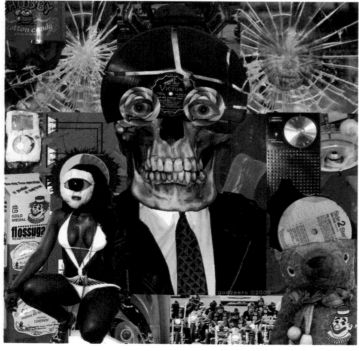

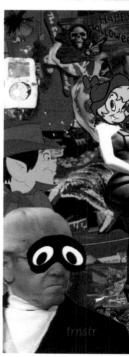

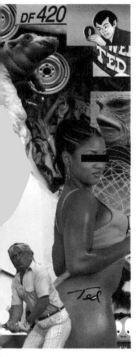
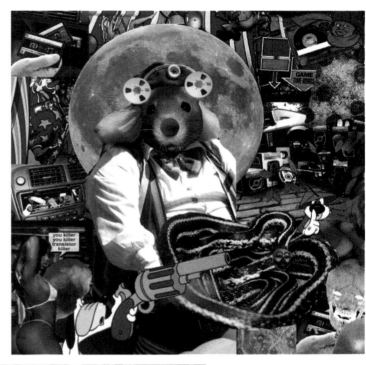
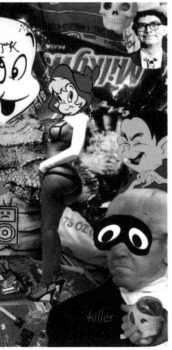
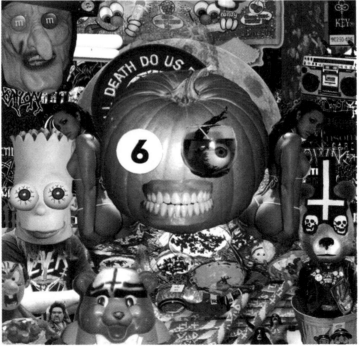

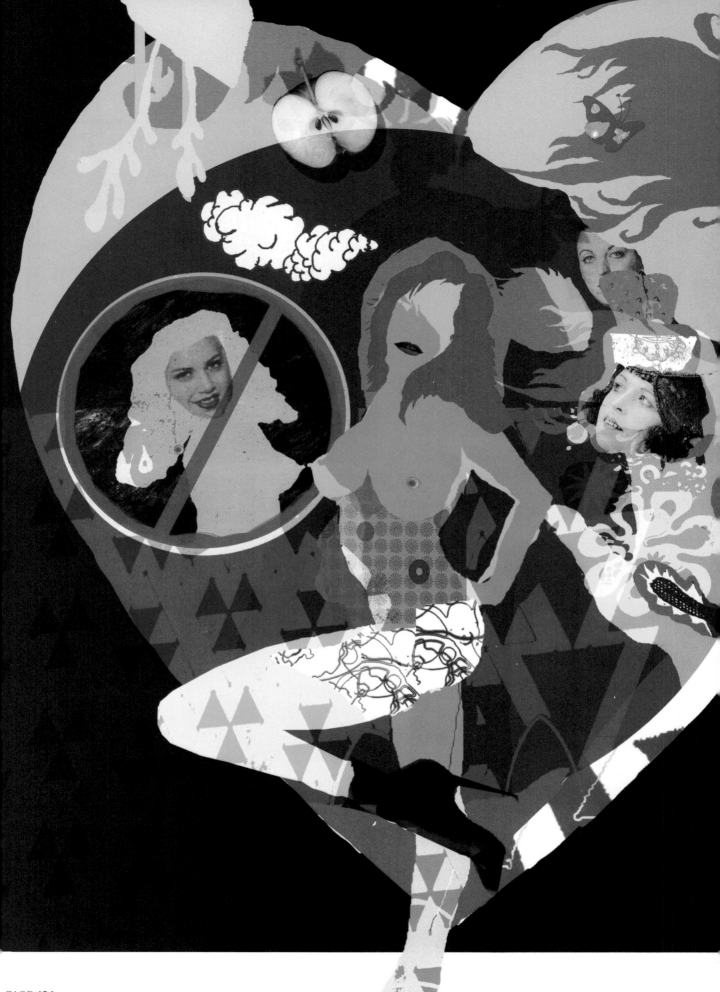

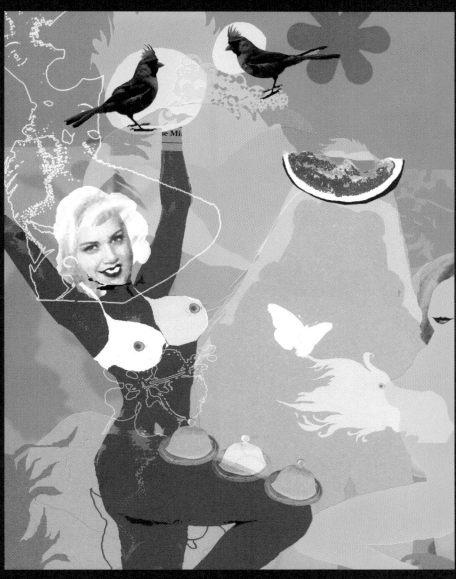

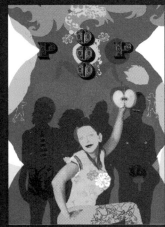

ARTIST__**EVA TATCHEVA** TYPE OF WORK__**COLLAGE**

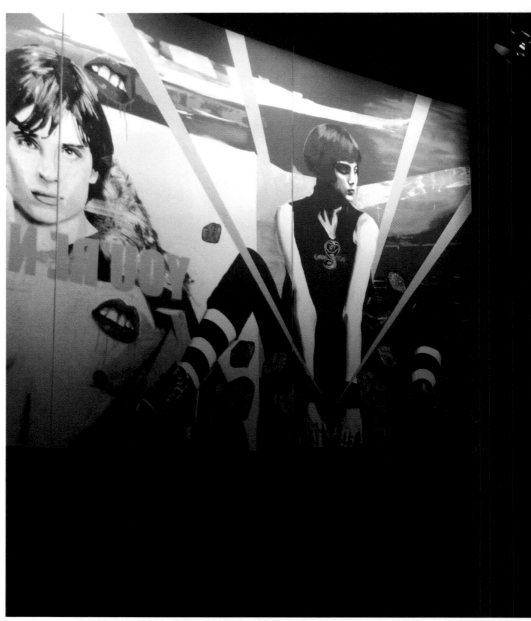

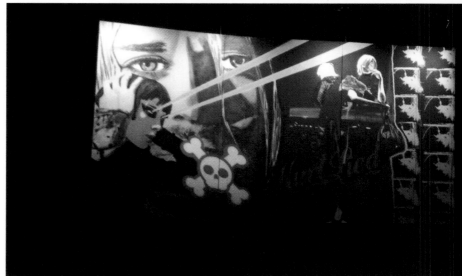

ARTIST__**STUART SEMPLE**
TYPE OF WORK__**INSTALLATION** view of Stuart Semple's **'Fake Plastic Love'** solo exhibition, 2007

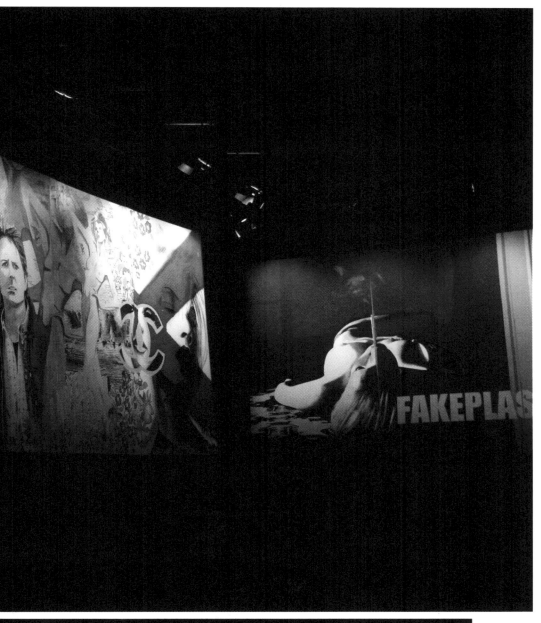

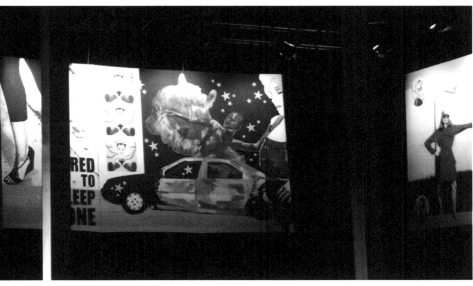

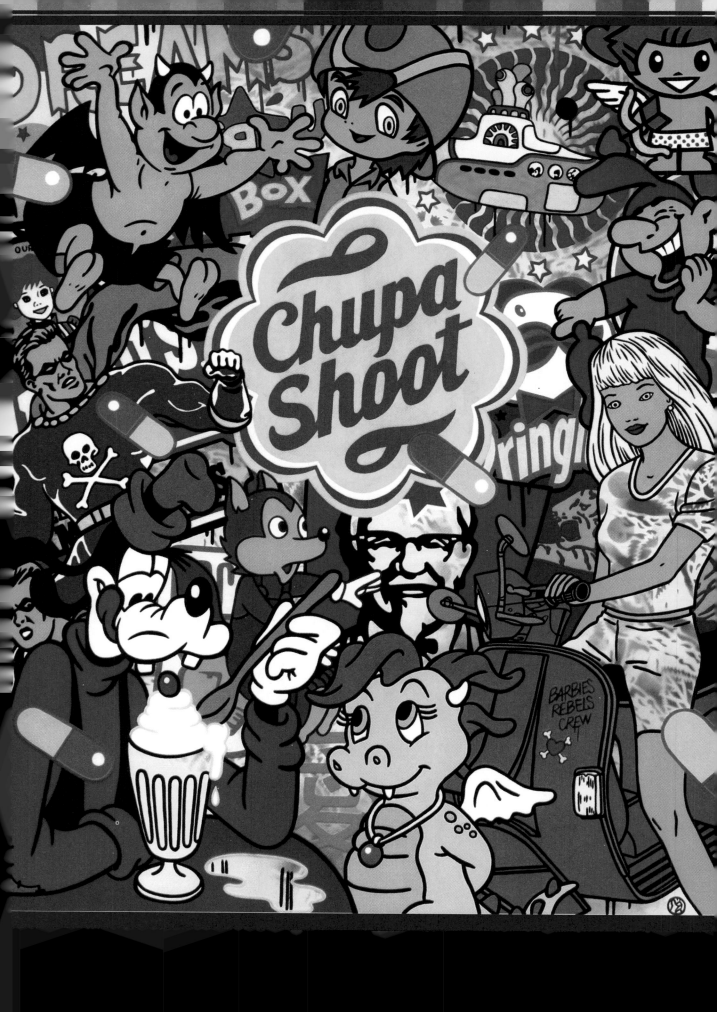

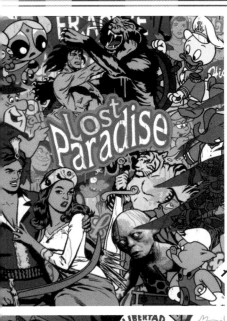

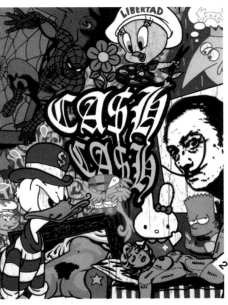

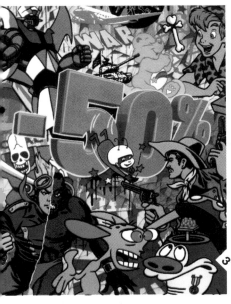

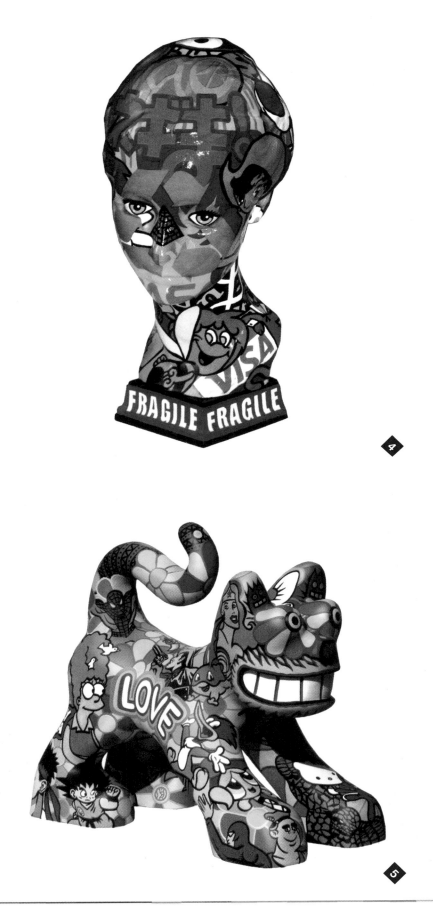

ARTIST__**SPEEDYGRAPHITO**
TITLE__1-**"Lost Paradise"** 2007 . 2-**"Ca$h Ca$h"** 2007 . 3-**"-50%"** 2007 . 4-**"FRAGILE"** 2007 . 5-**"FELIN LOVE"** 2008
TYPE OF WORK__**COLLAGE & FIGURE DESIGN**

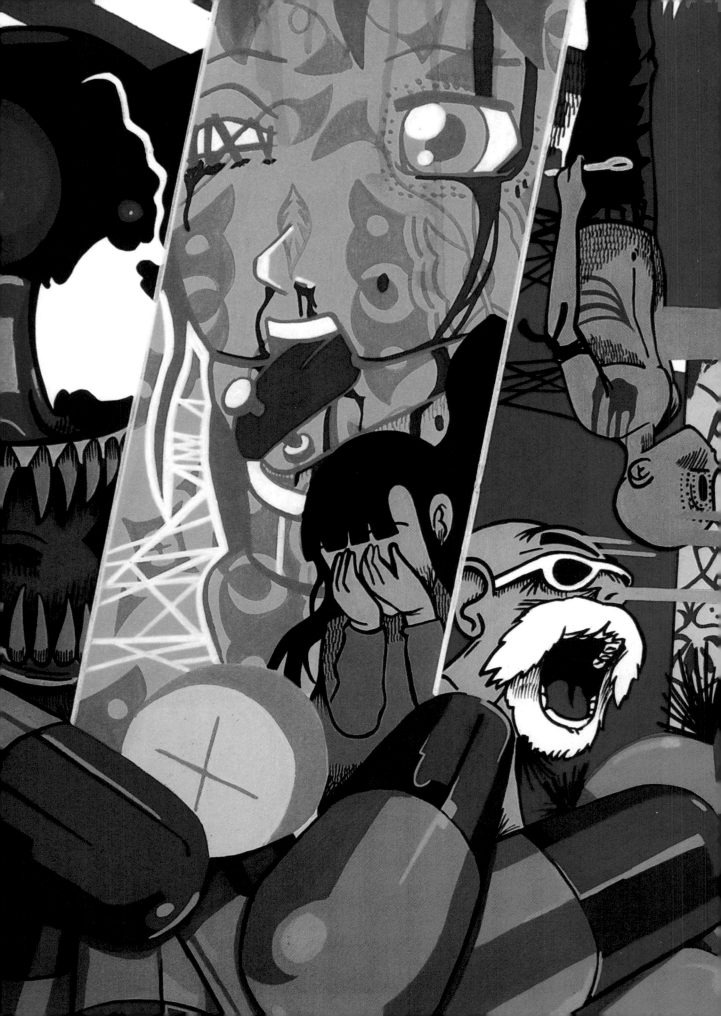

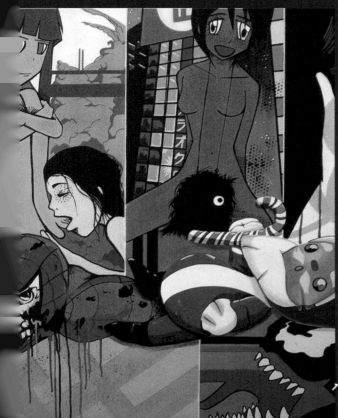

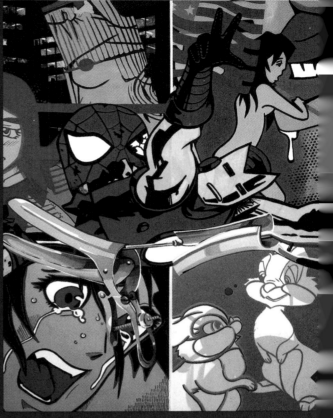

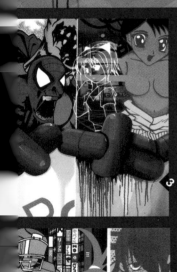

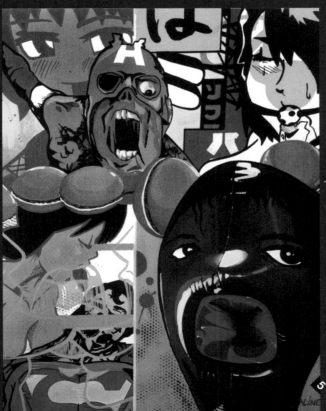

ARTIST__ **TALING**

TITLE_ 1-Y CROIS-TU ENCORE? 2-SPÉCULATION INTENSIVE 3-VGHB 4-IL EST TEMPS D'ALLER AUX FRAISES 5-MORT SUBITE

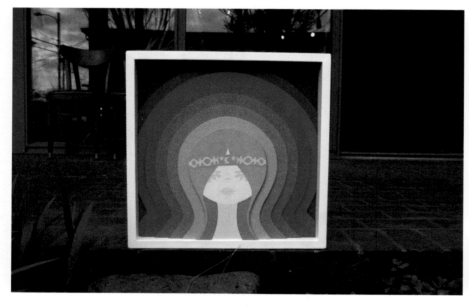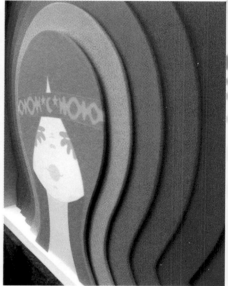

ARTIST__**ARBITO** TITLE__**NOTION MOTION** TYPE OF WORK__**COLLAGE**

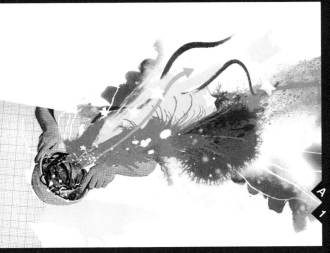

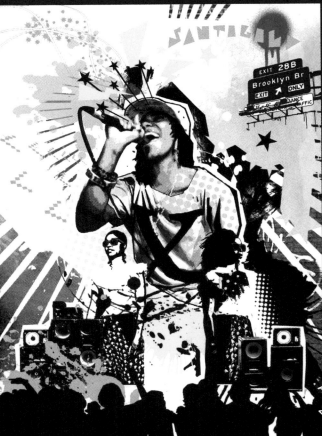

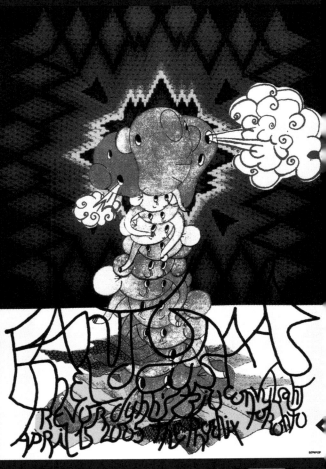

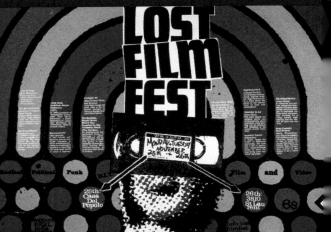

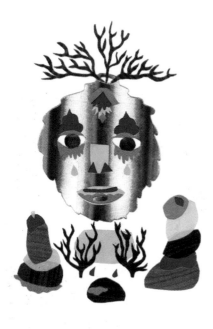

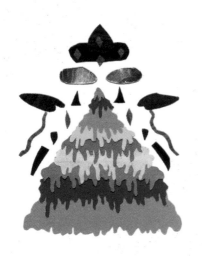

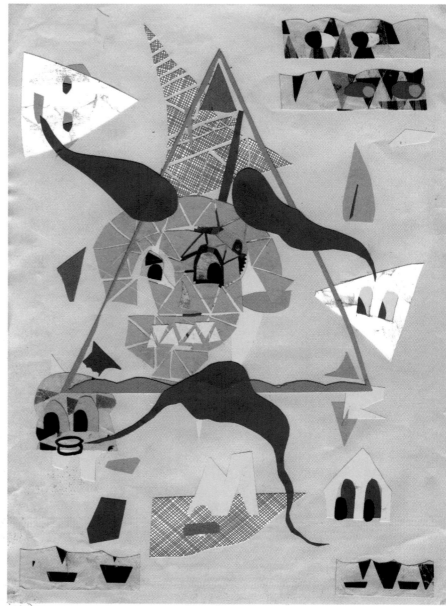

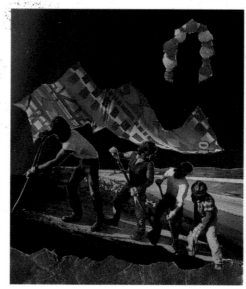

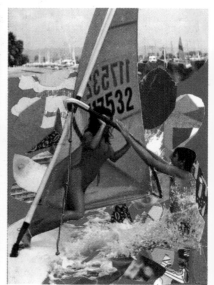

ARTIST__**THOMAS HUDSON** TYPE OF WORK__**COLLAGE**

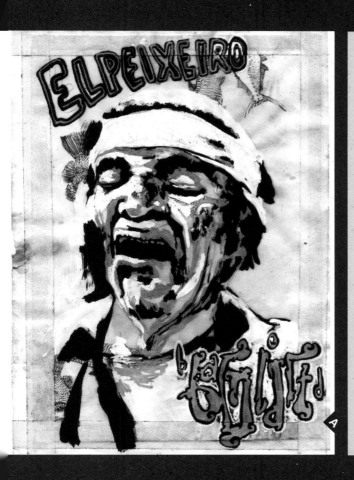

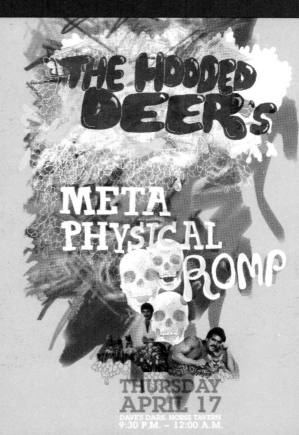

THE HOODED DEER'S

META PHYSICAL ROMP

THURSDAY
APRIL 17
DAVE'S DARK HORSE TAVERN
9:30 P.M. – 12:00 A.M.

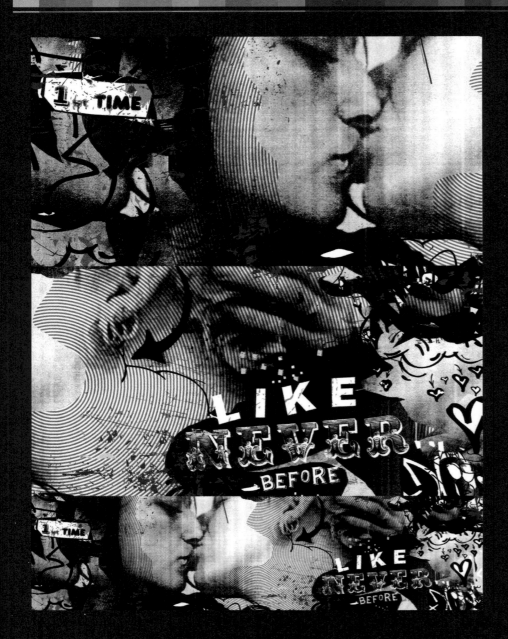

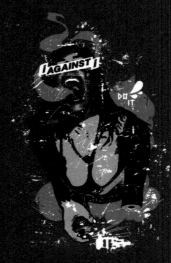

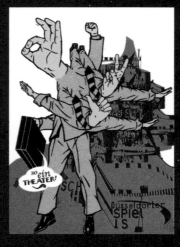

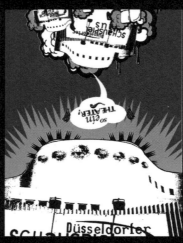

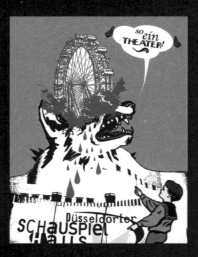

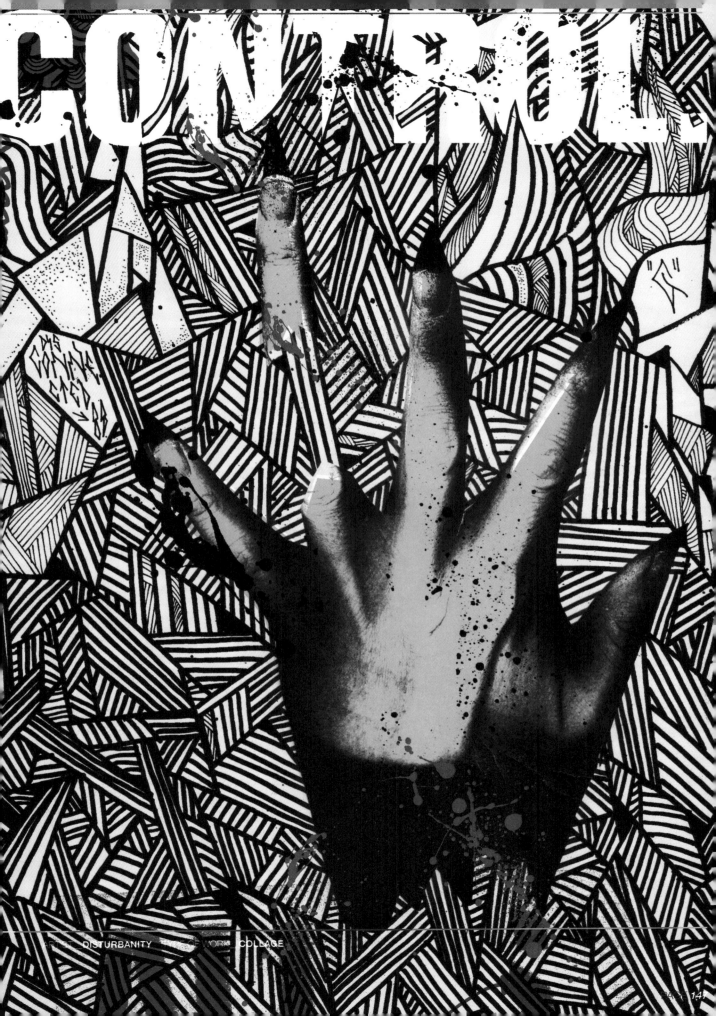

CONTROL

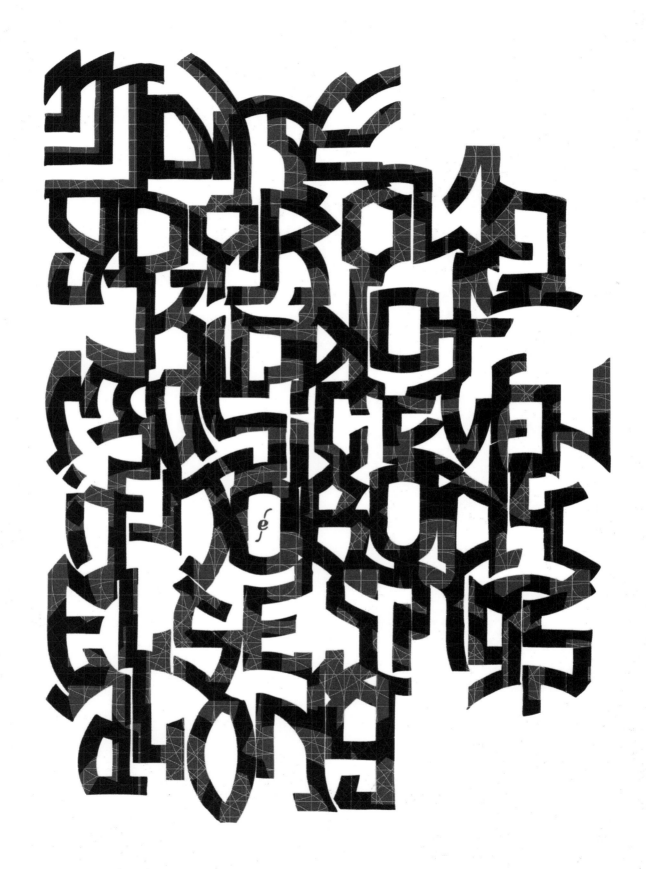

ARTIST__**ENKELING** TITLE__**1-MAKE YOUR OWN KIND OF MUSIC** TYPE OF WORK__**PRINT**

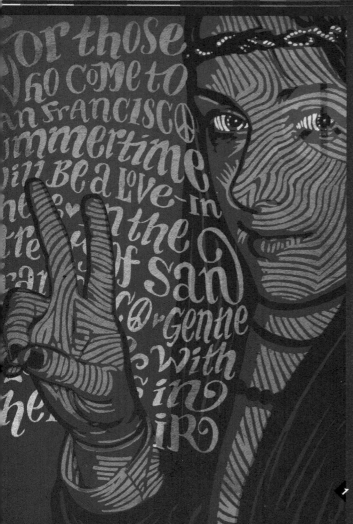

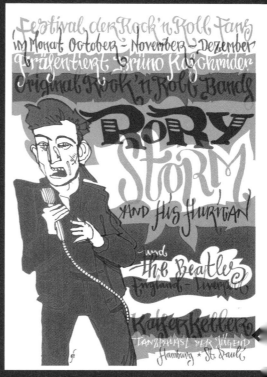

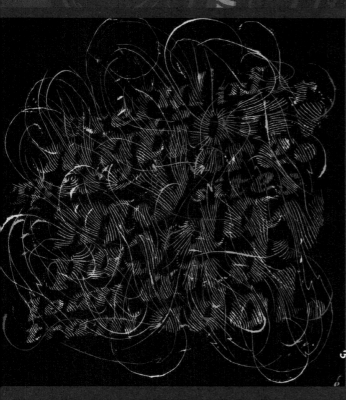

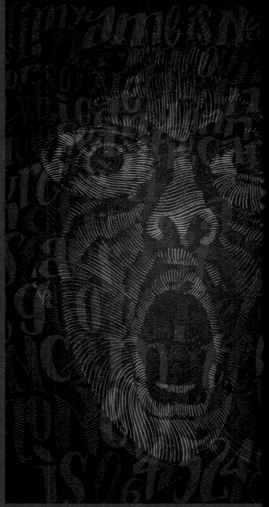

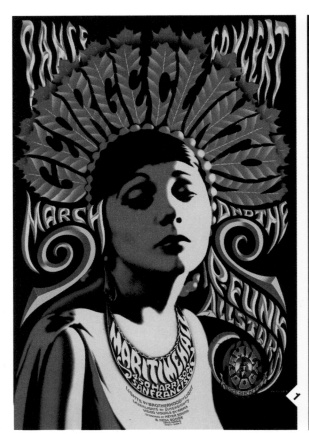

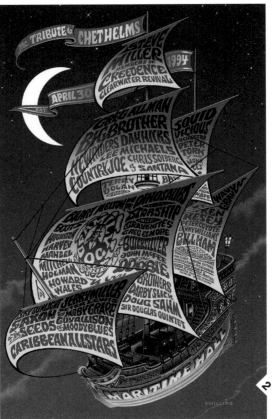

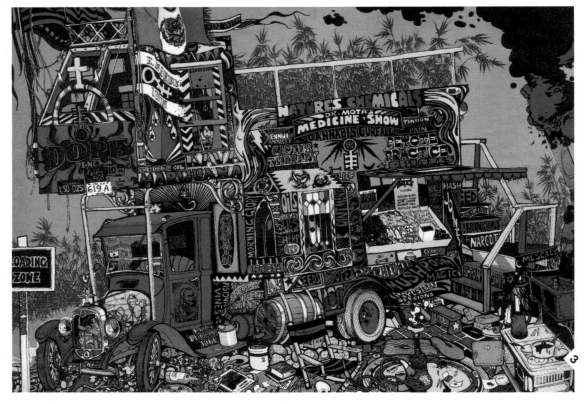

ARTIST__**JIM PHILLIPS**
TITLE__**1-GEORGE CLINTON AND THE P FUNK ALLSTARS . 2-"THE SHIP" TRIBUTE TO CHET HELMS . 3-DR. MOTA'S MEDICINE SHOW**
TYPE OF WORK__**PSYCHEDELIC POSTERS**

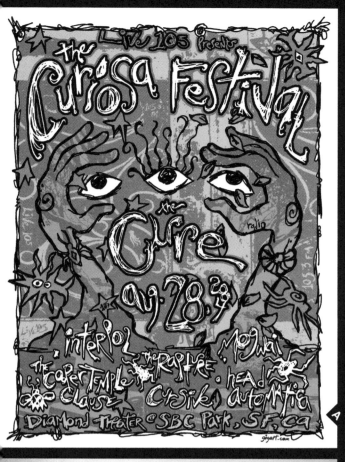

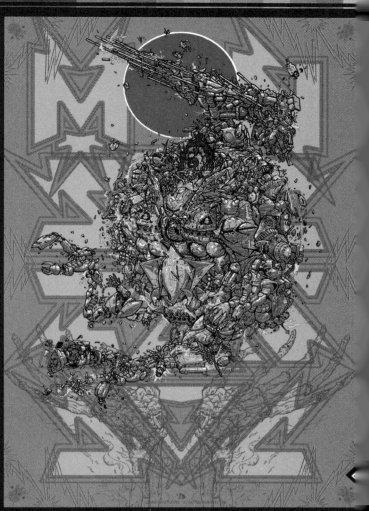

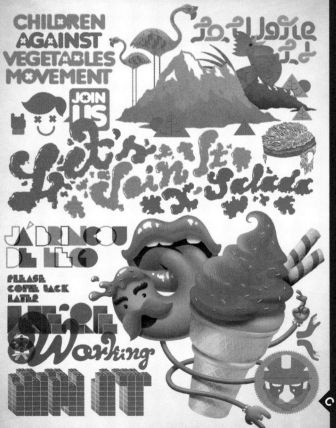

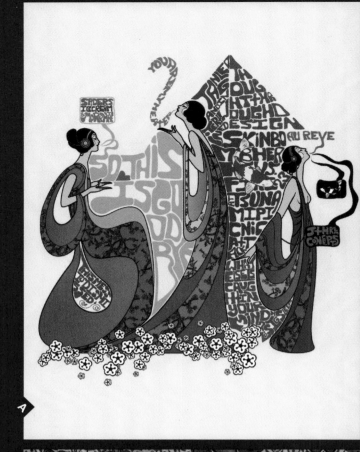

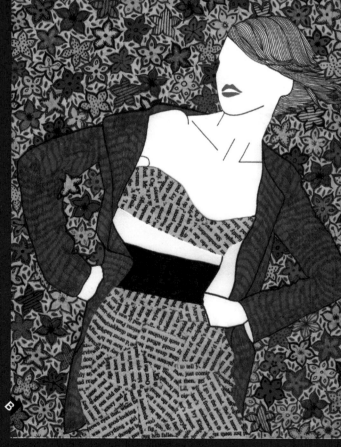

A ... ARTIST__**JTHREECONCEPTS** TYPE OF WORK__**PRINT**
B ... ARTIST__**NIKKI FARQUHARSON** TYPE OF WORK__**PRINT**

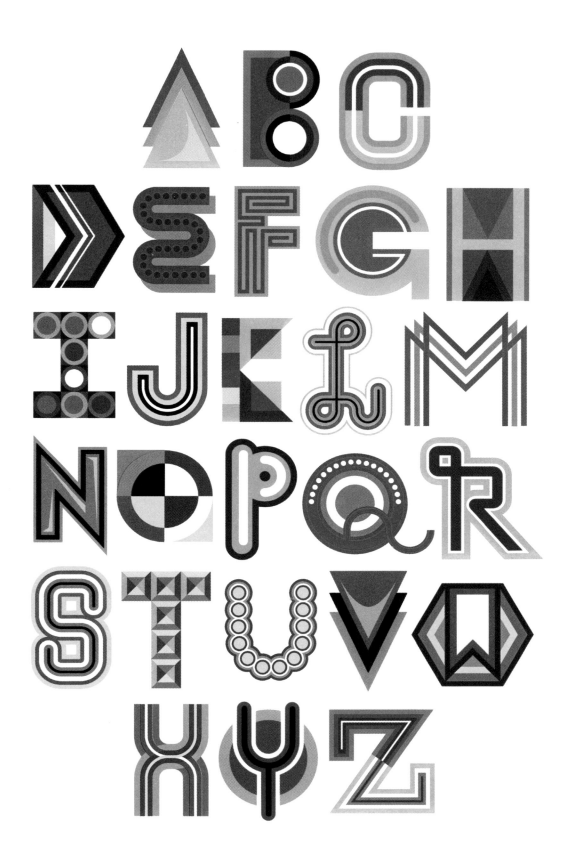

ARTIST__**MWMGRAPHICS** TYPE OF WORK__**TYPOGRAPHY**

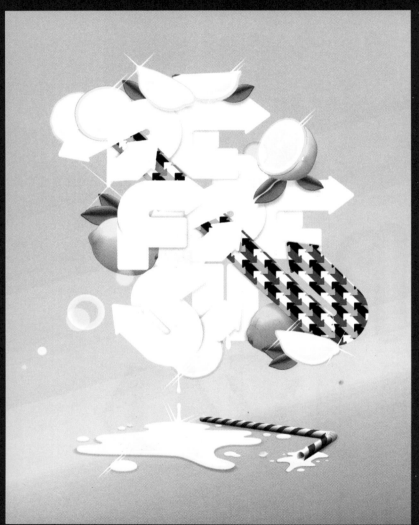

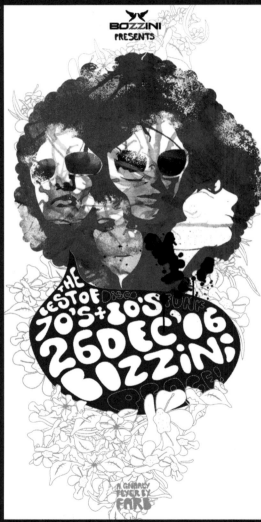

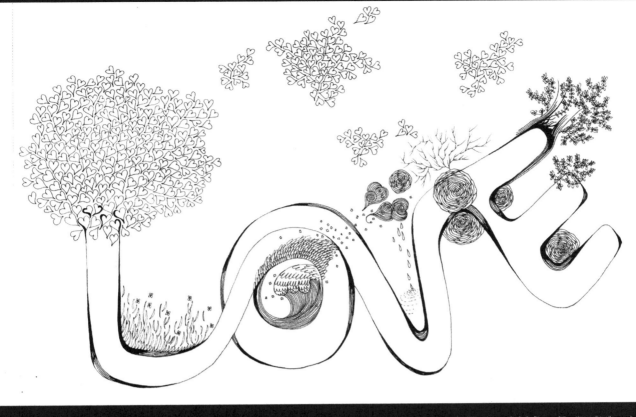

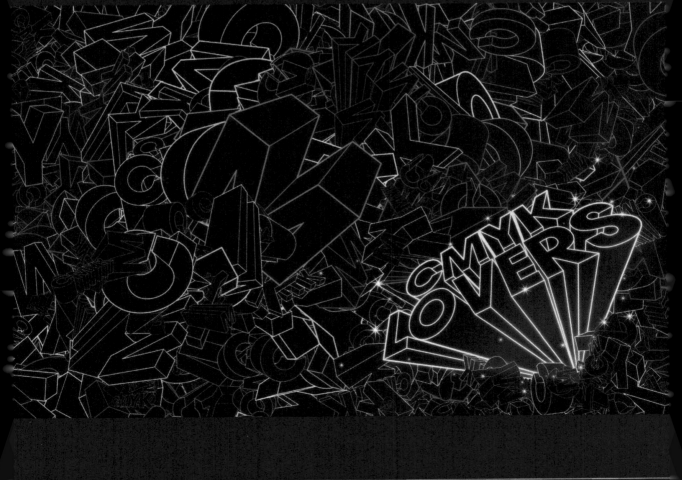

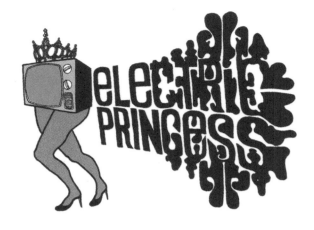

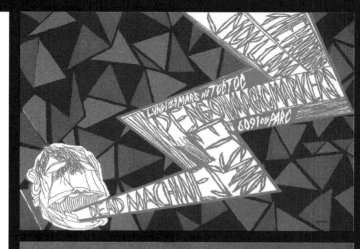

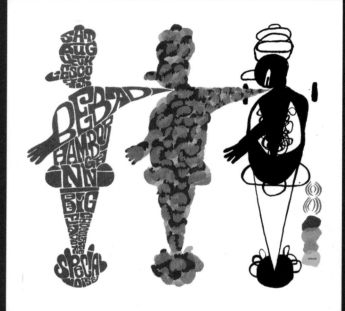

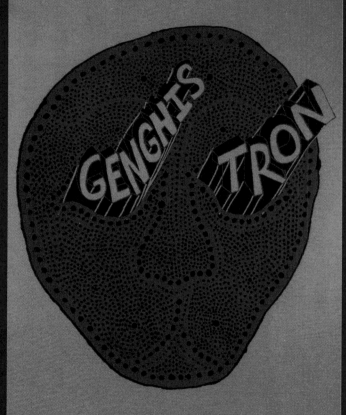

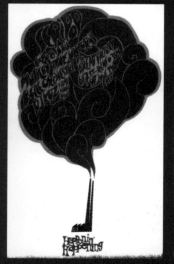

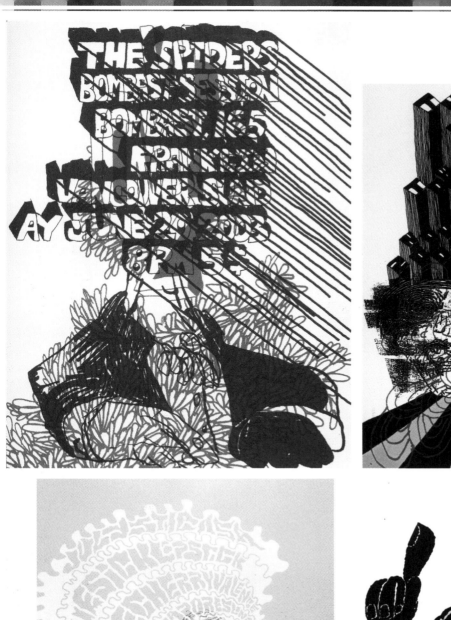

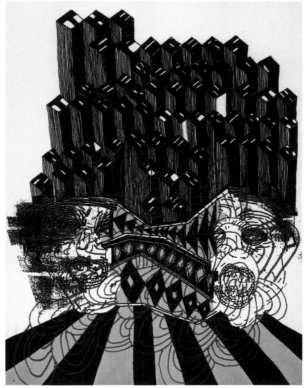

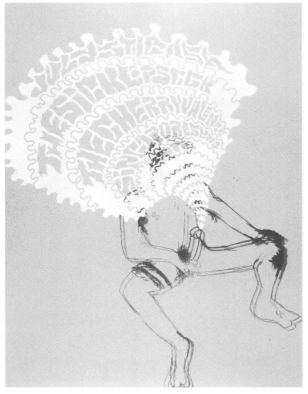

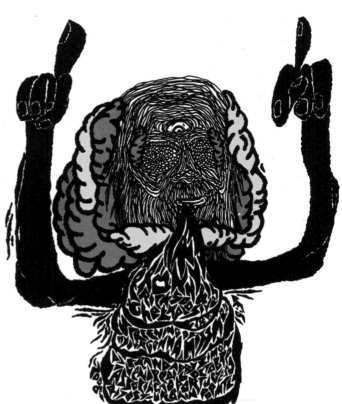

ARTIST__**SERIPOP** TYPE OF WORK__**PRINT**

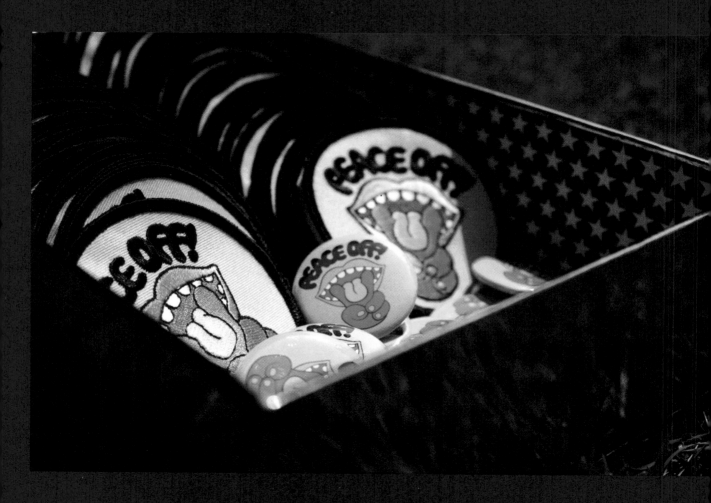

ARTIST__**ARBITO** TYPE OF WORK__**PRODUCT**

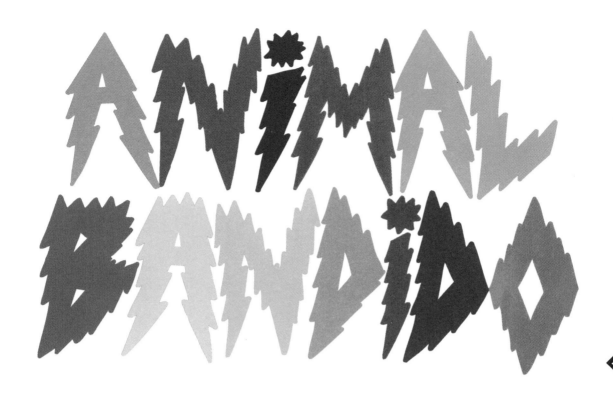

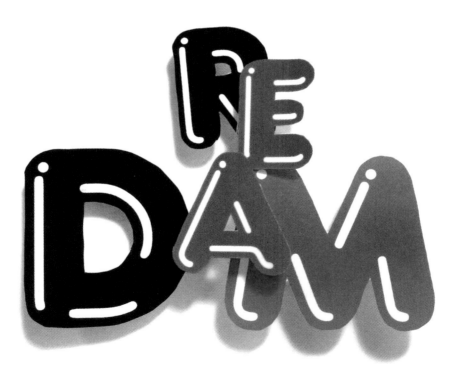

A ... ARTIST__**ANIMAL BANDIDO** TYPE OF WORK__**TYPOGRAPHY**
B ... ARTIST__**ELI CARRICO** TITLE__**DREAM** TYPE OF WORK__**TYPOGRAPHY**

PAGE *159*

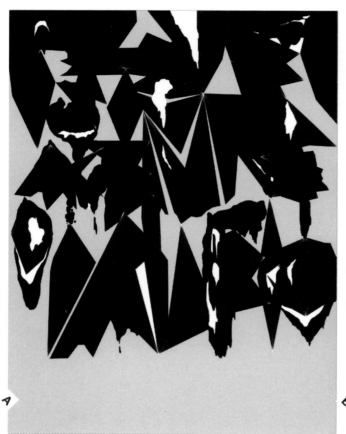

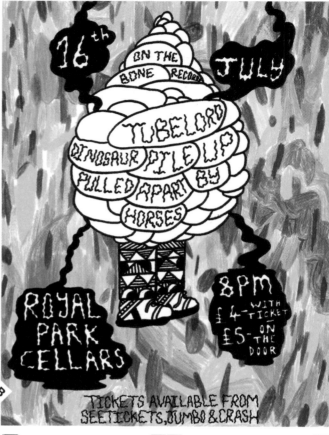

A ... ARTIST__**DIOGO POTES** TYPE OF WORK__**PRINT**
B ... ARTIST__**THOMAS HUDSON** TYPE OF WORK__**PRINT**
C ... ARTIST__**BEN MURPHY** TYPE OF WORK__**PRINT**

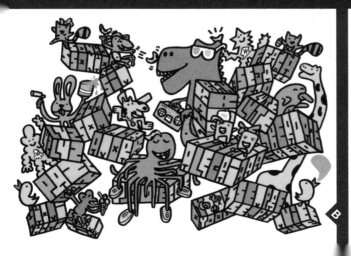

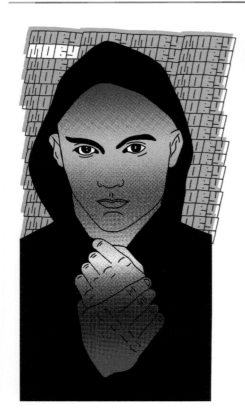

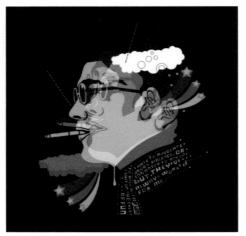

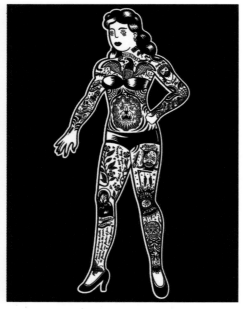

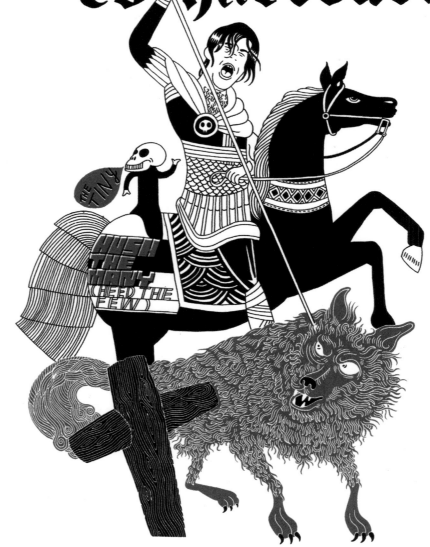

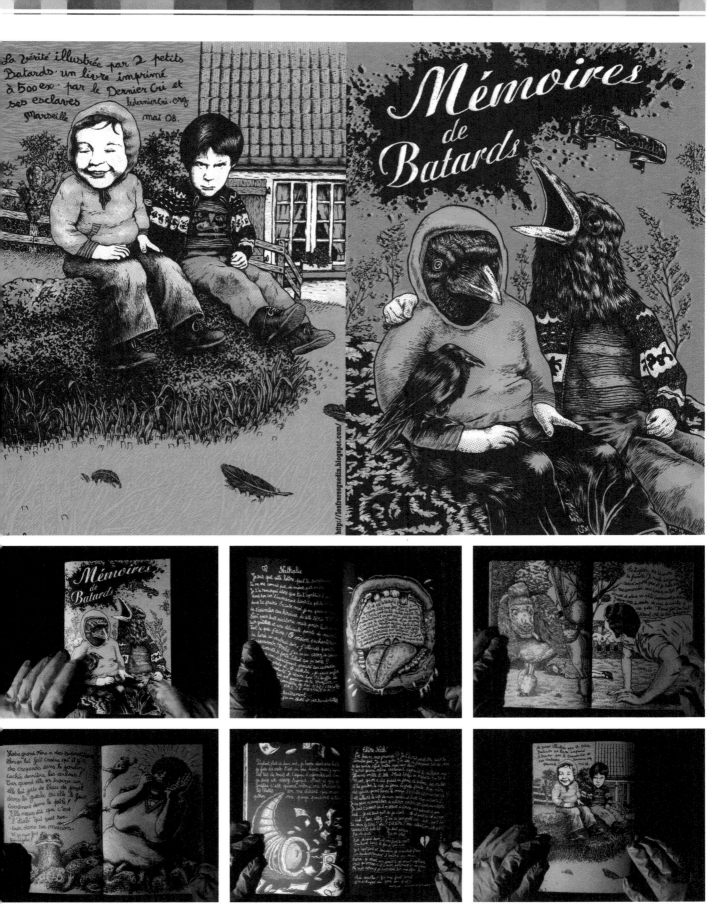

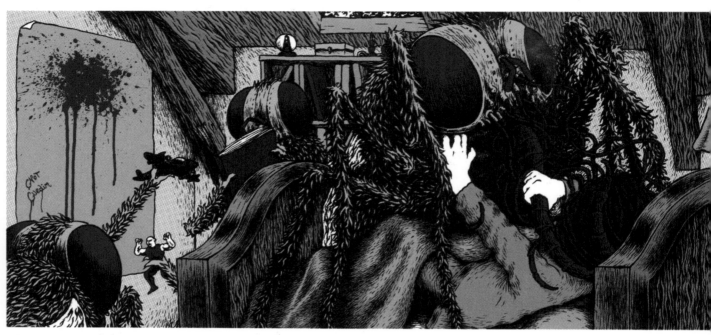

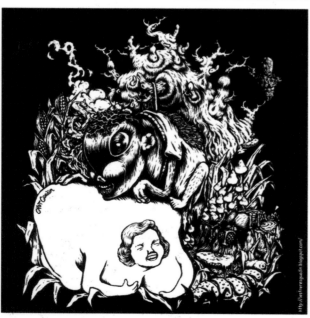

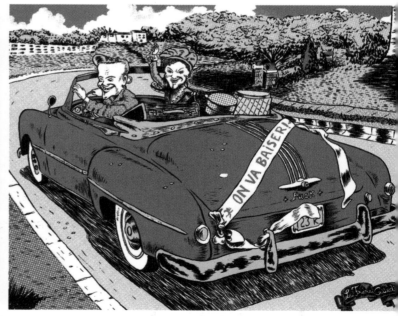

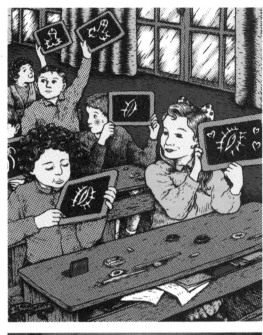

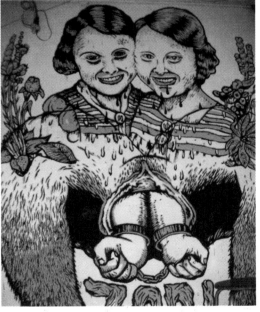

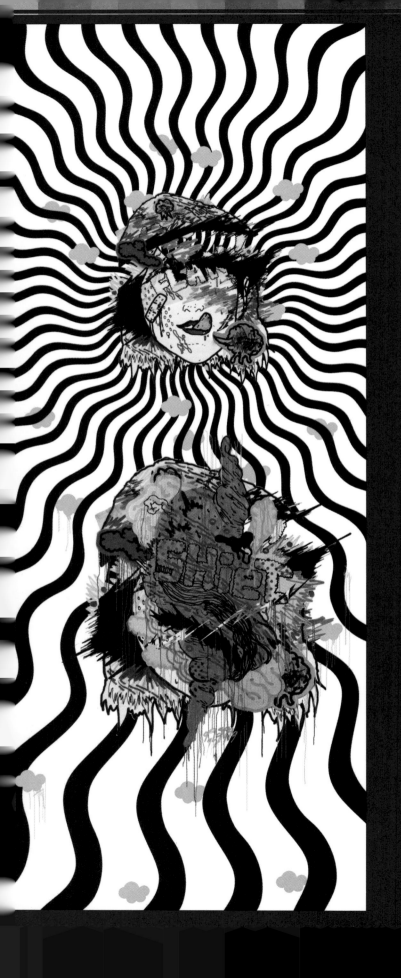
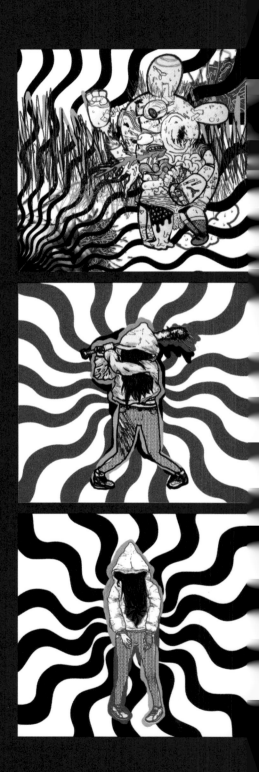

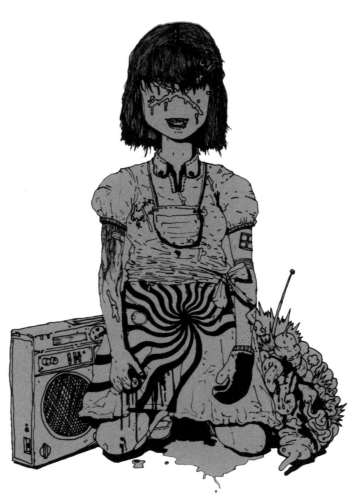

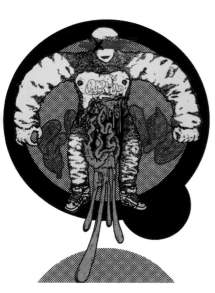

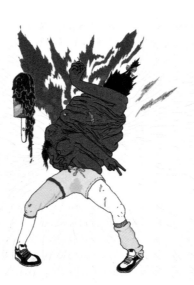

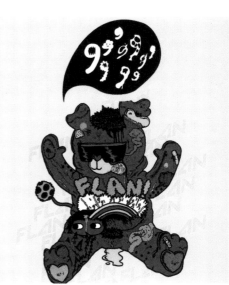

ARTIST__**RANO** TYPE OF WORK__**PRINT**

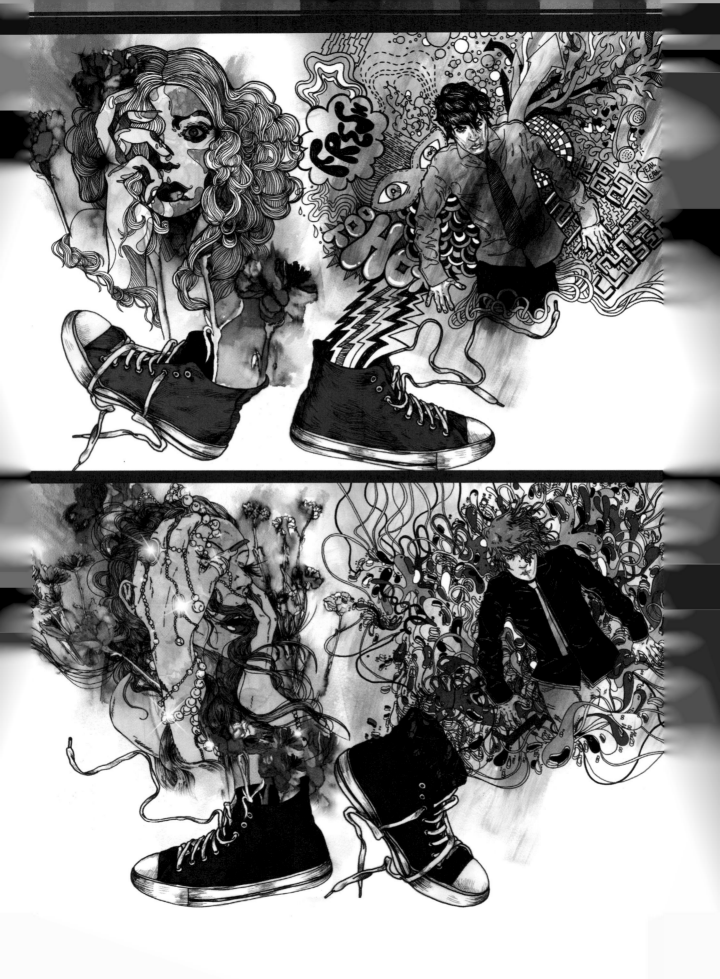

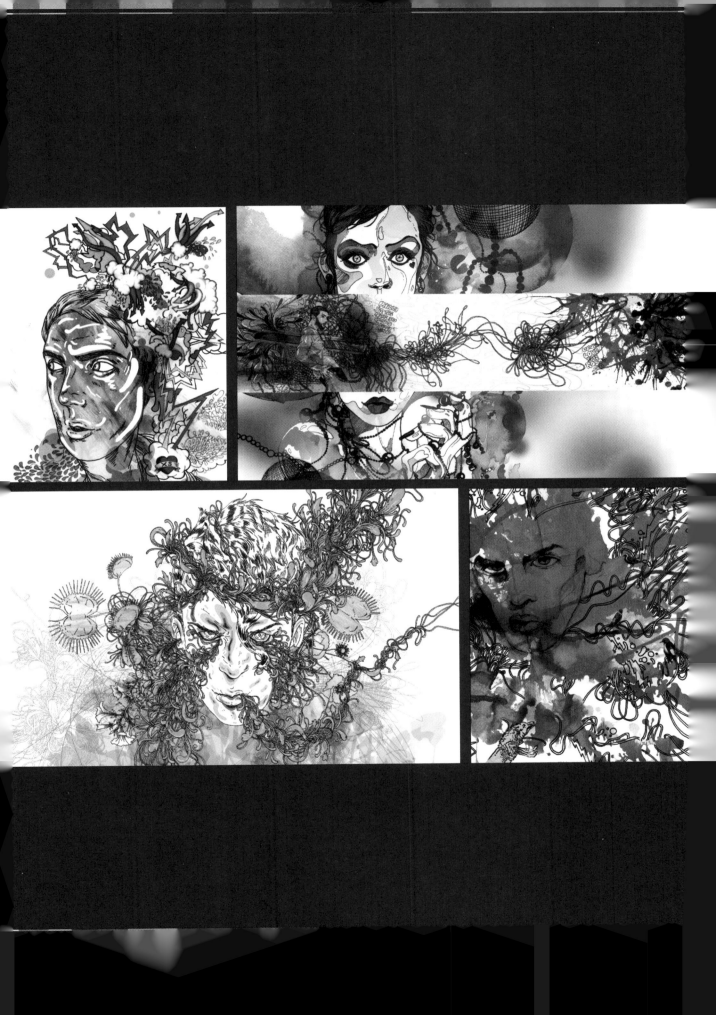

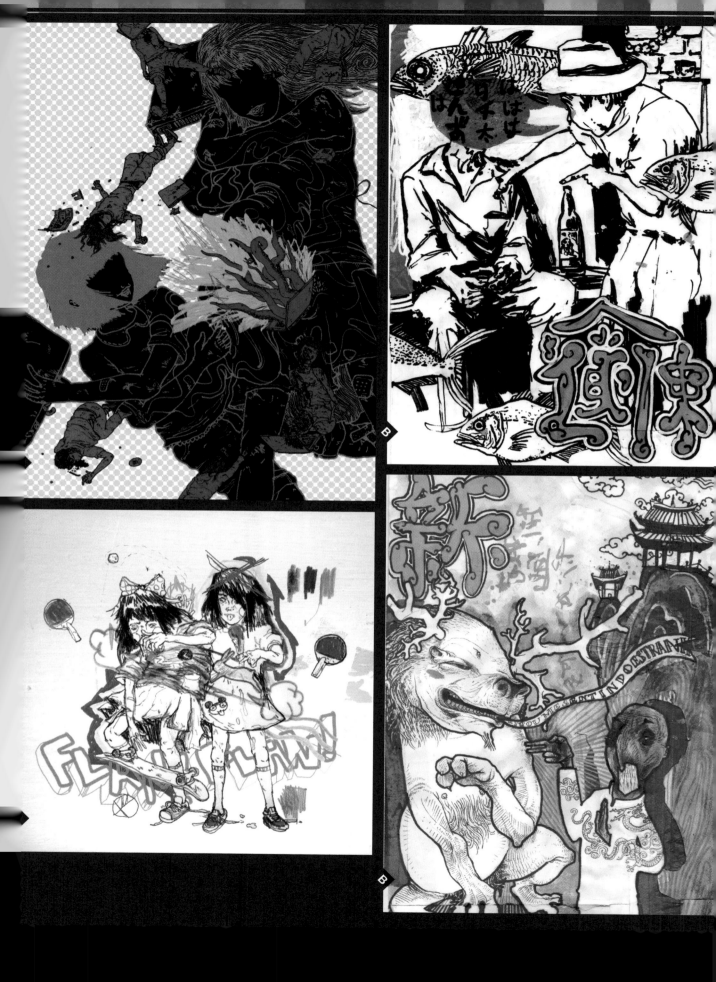

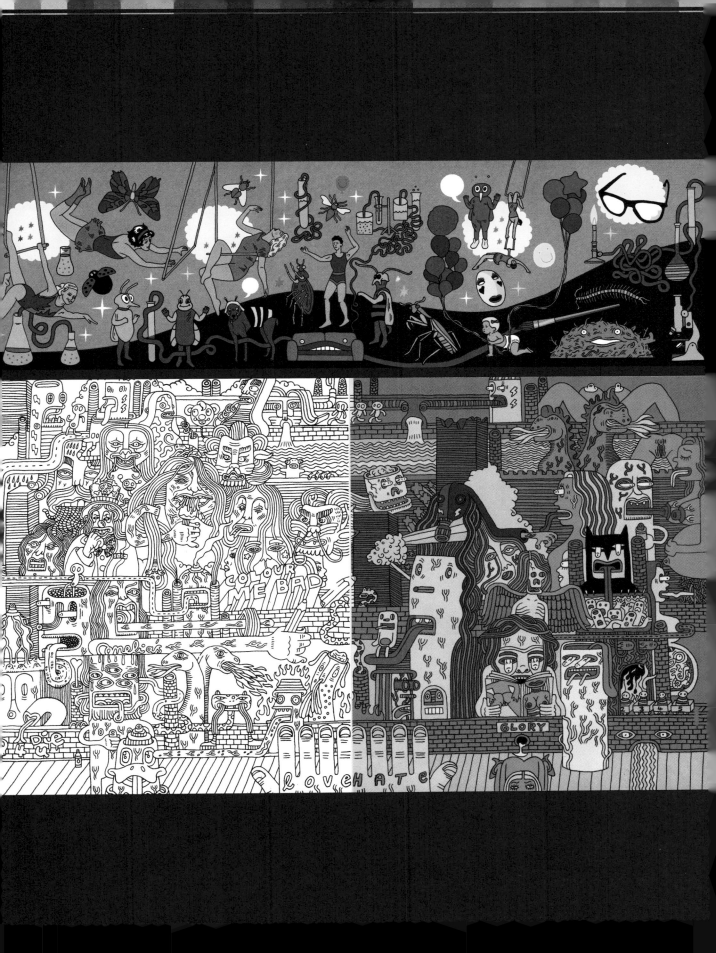

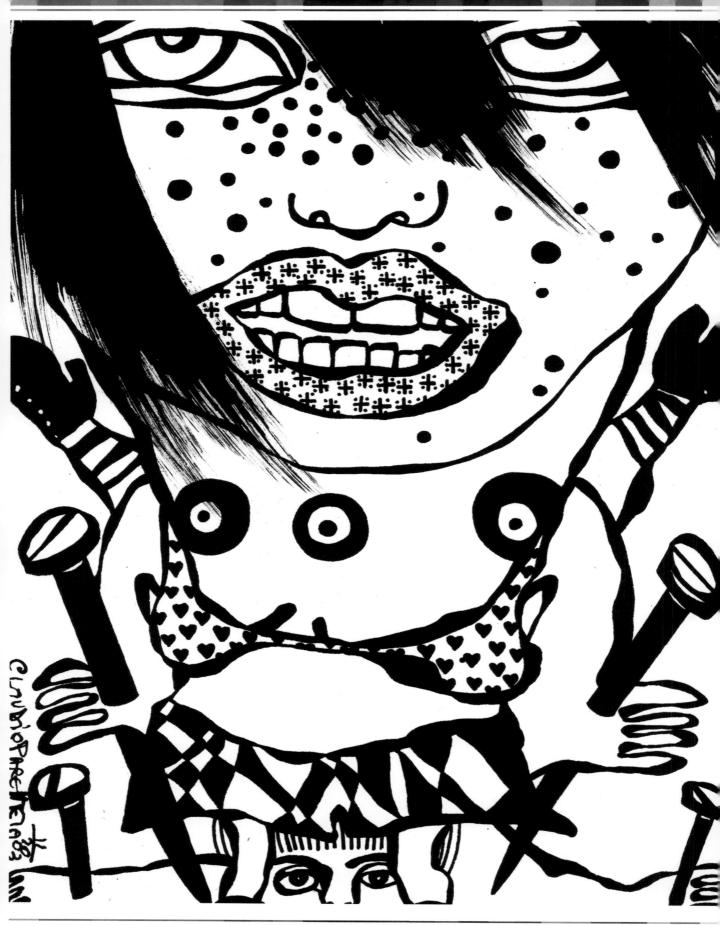

ARTIST__**CLAUDIO PARENTELA** TITLE__**UNTITLED** TYPE OF WORK__**PRINT**

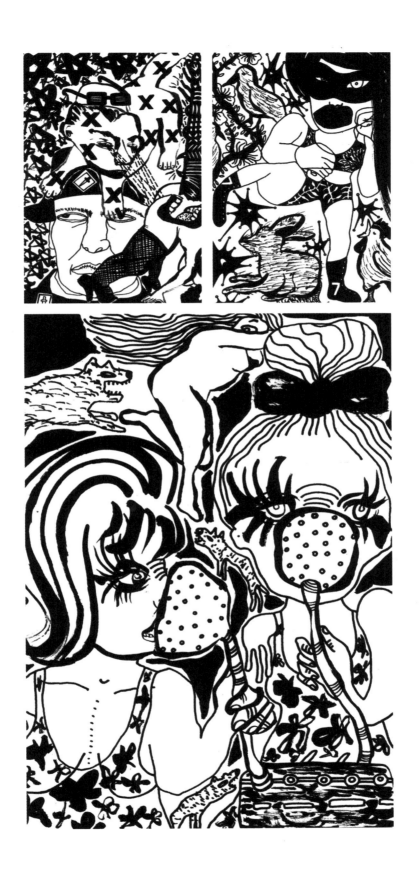

ARTIST__**CLAUDIO PARENTELA** TITLE__**UNTITLED** TYPE OF WORK__**PRINT**

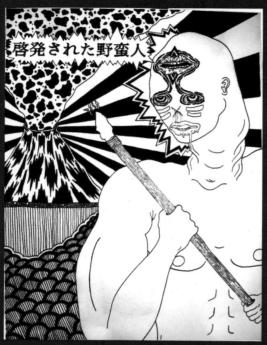

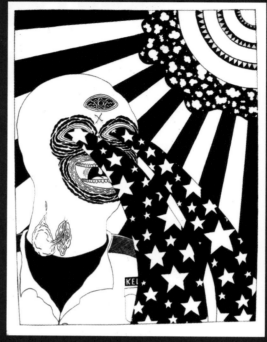

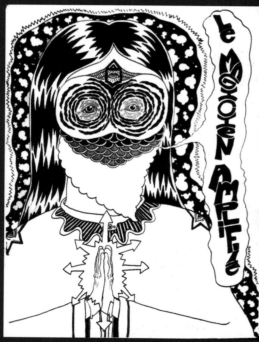

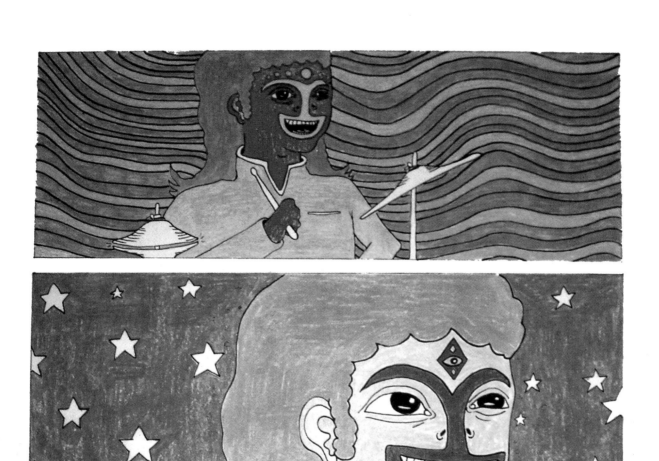

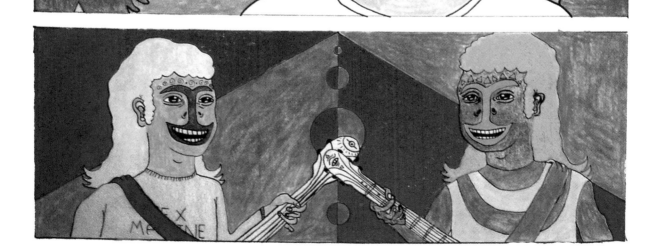

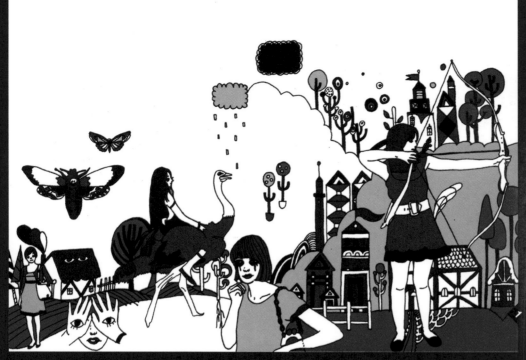

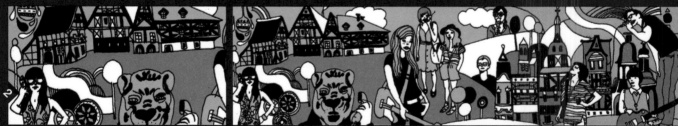

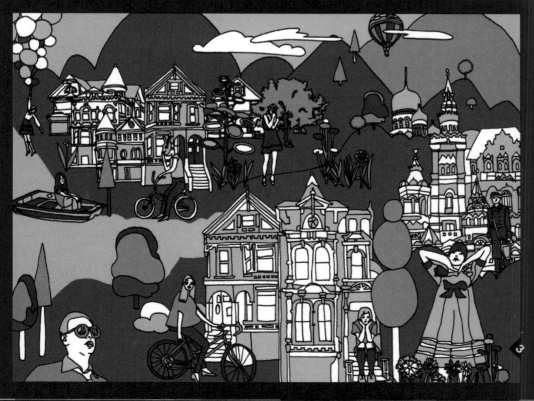

ARTIST__**KEREN RICHTER**
TITLE__**1-ARTEMIS . 2-MUSICALLY INCLINED . 3-DAYGLO NATION**
TYPE OF WORK__**ICON & CHARACTER**

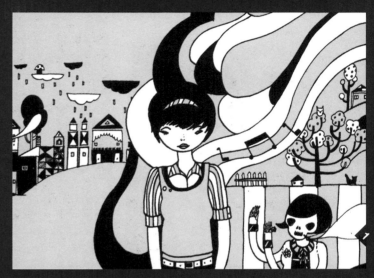

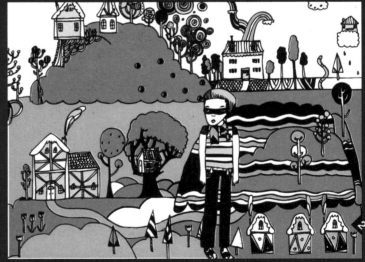

ARTIST__**KEREN RICHTER**
TITLE__**1-PSYCH OUT . 2-BRAINFREEZE BREAKS**
TYPE OF WORK__**ICON & CHARACTER**

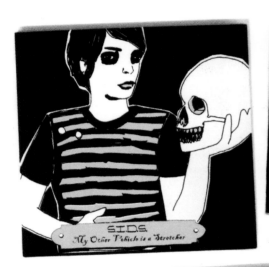

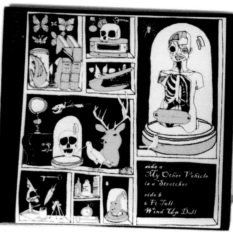

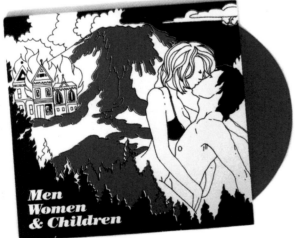

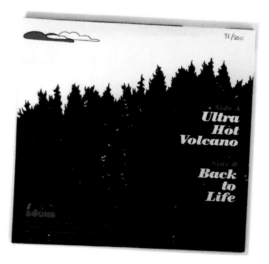

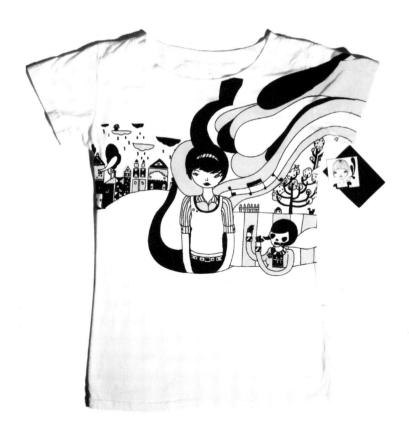

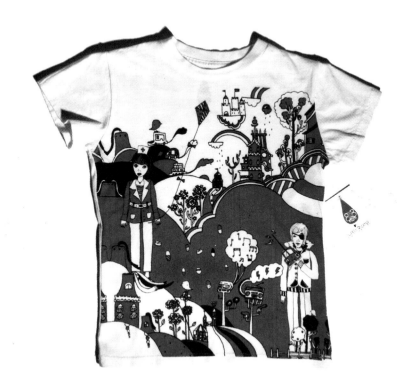

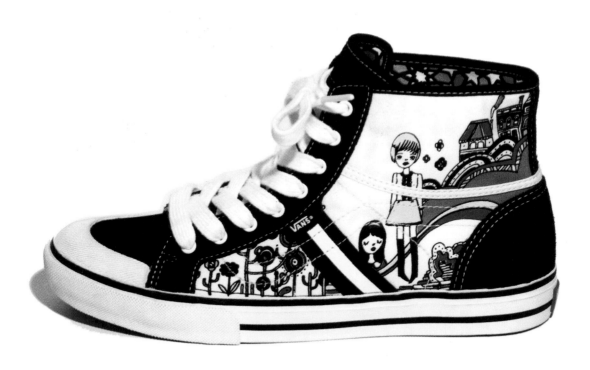

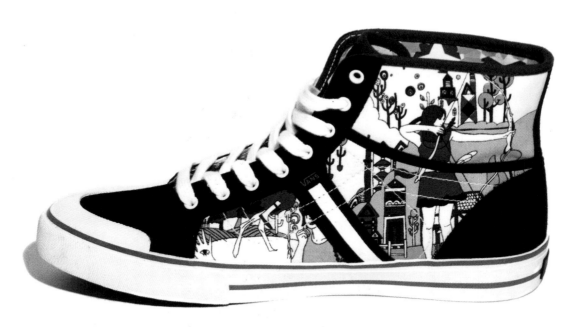

ARTIST__**KEREN RICHTER** TYPE OF WORK__**PRODUCT**

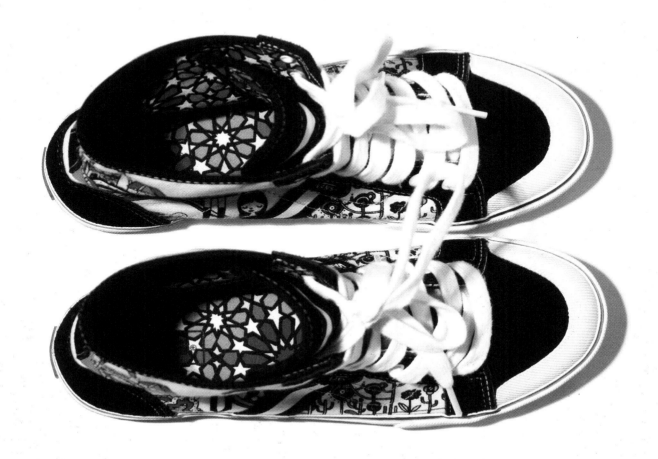

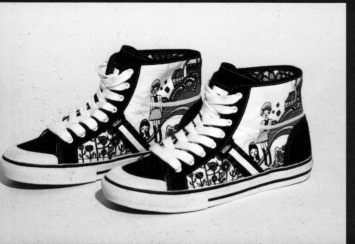

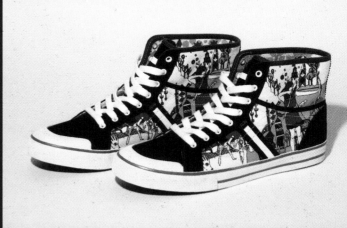

ARTIST__**KEREN RICHTER** TYPE OF WORK__**PRODUCT**

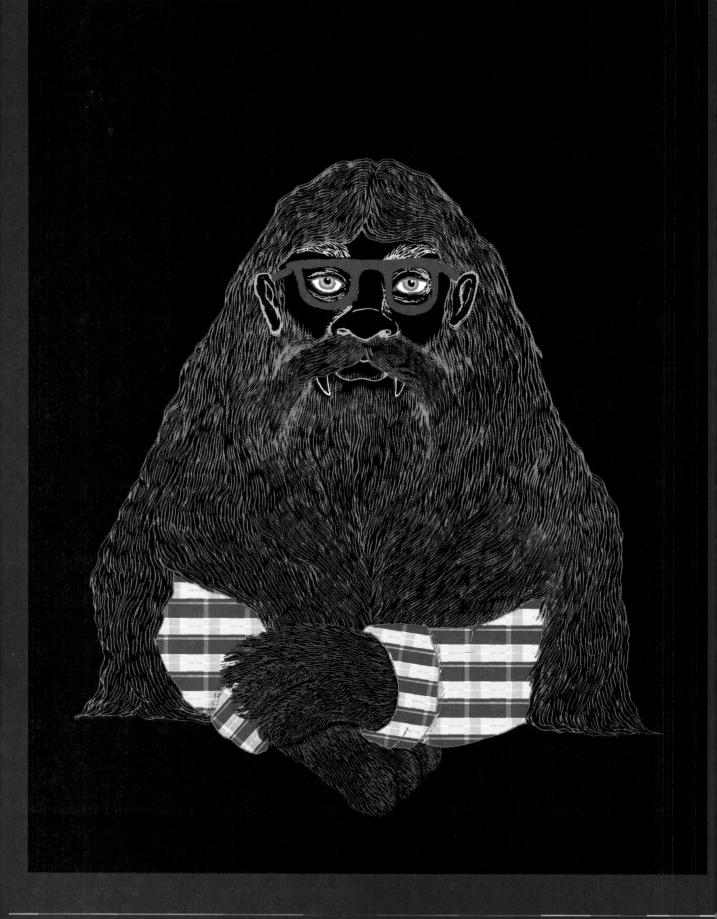

ARTIST__ **ALVAREJO • ALVARO ARTEAGA SABAINI** TITLE__**YOUR FATHER WAS A MONSTER** TYPE OF WORK__**PRINT**

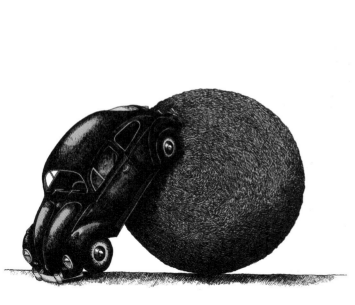

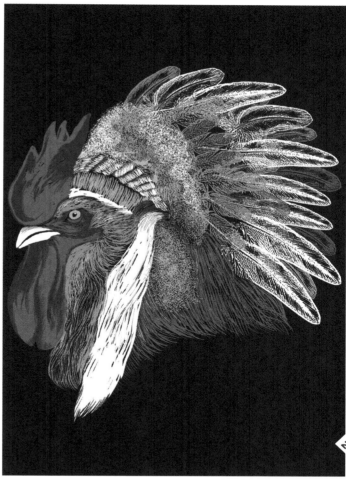

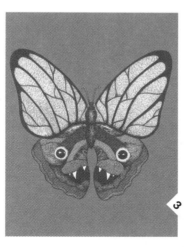

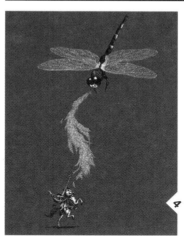

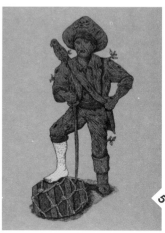

ARTIST__**ALVAREJO • ALVARO ARTEAGA SABAINI**
TITLE__**1-VOLKSDUNG BEETLE . 2-THE COCK CHIEF . 3-SHIVER ME LEG . 4-DIE, OH DRAGONFLY . 5-BATERFLY**
TYPE OF WORK__**PRINT**

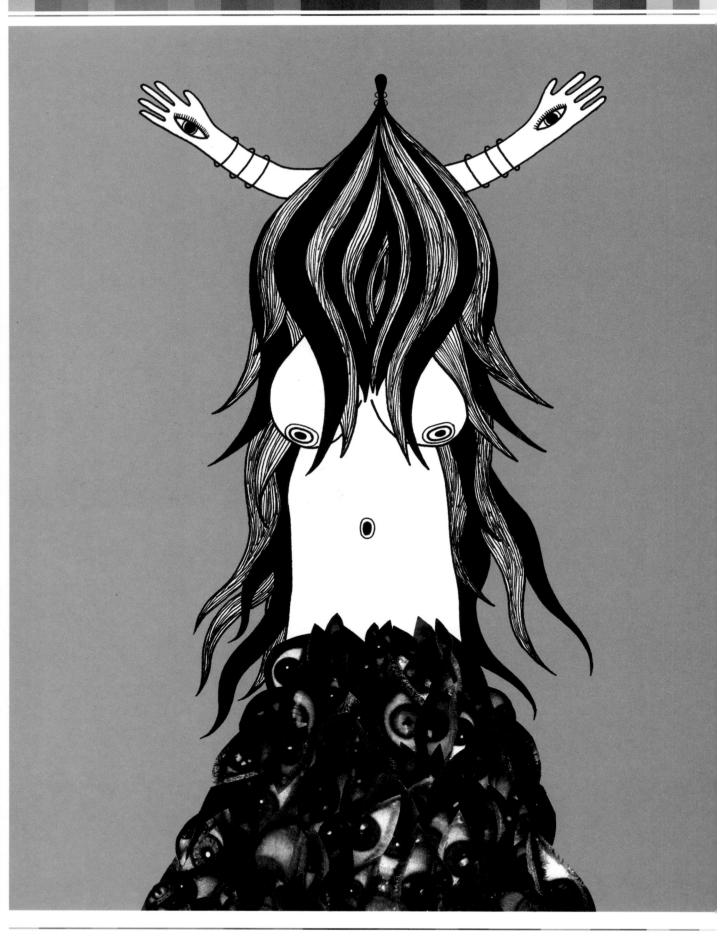

ARTIST__**EMANUELE KABU** TITLE__**"MOTHER"** TYPE OF WORK__**ICON & CHARACTER**

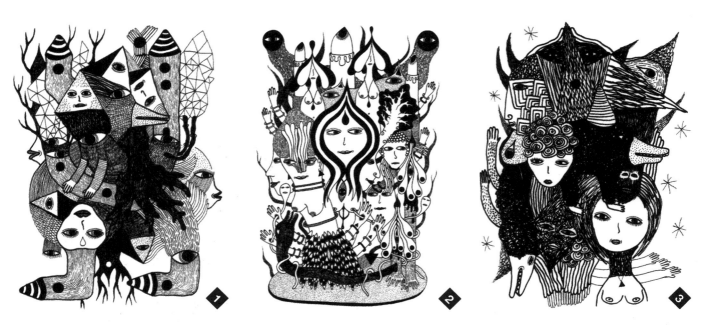

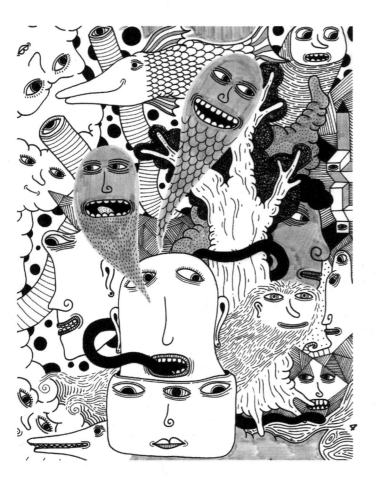

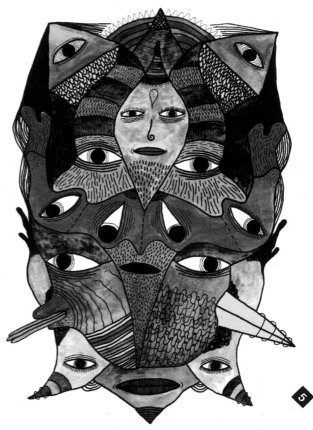

ARTIST__**EMANUELE KABU**
TITLE__1-"DO YOU WANT TO COME HERE?" . 2-"WOMEN OF THE WORLD TAKE OVER 'CAUSE IF YOU DON'T THE WORLD WILL
 COME TO AN HELL" . 3-"UNTITLED" . 4-"NOISE144" . 5-"UNTITLED"
TYPE OF WORK__**ICON & CHARACTER**

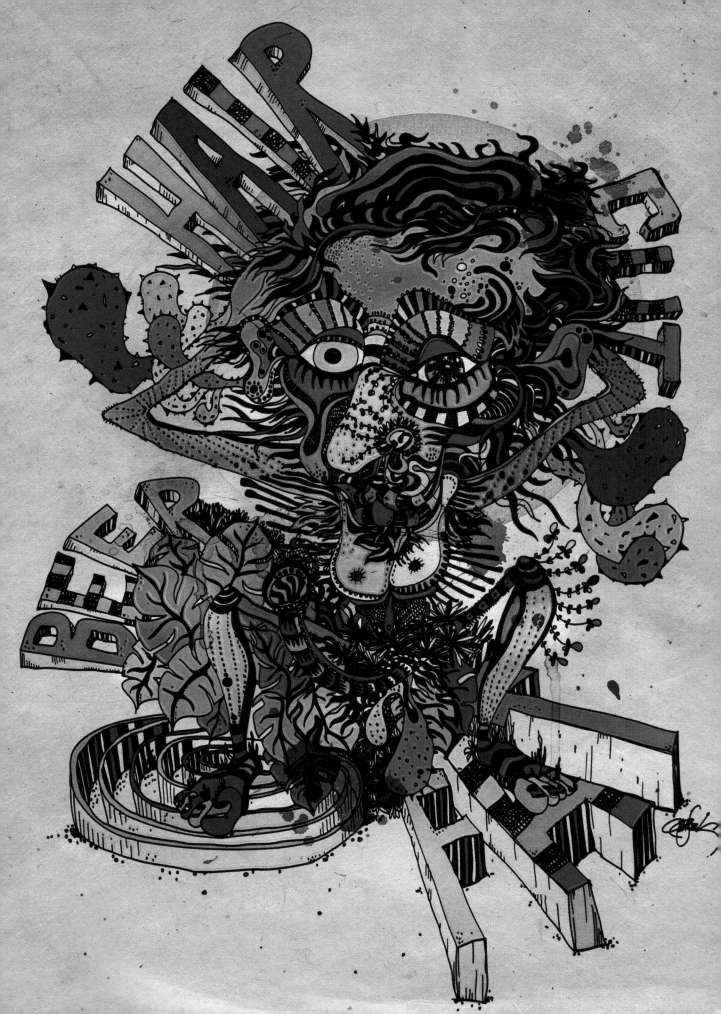

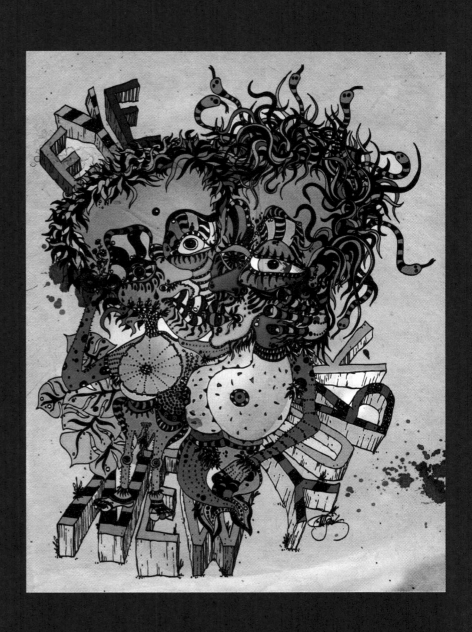

ARTIST__**INGRAPHICSWETRUST • SEBASTIAN ONUFSZAK** TYPE OF WORK__**ILLUSTRATION**

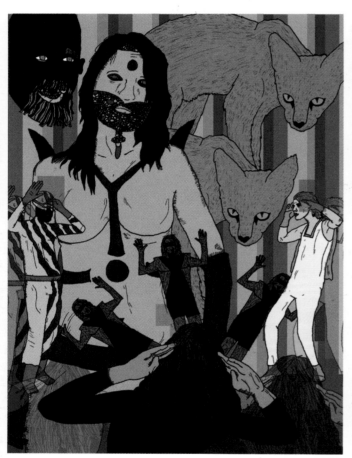

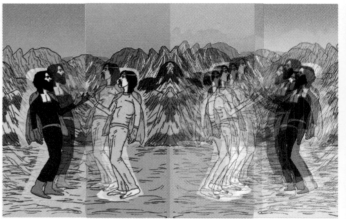

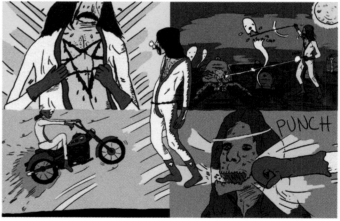

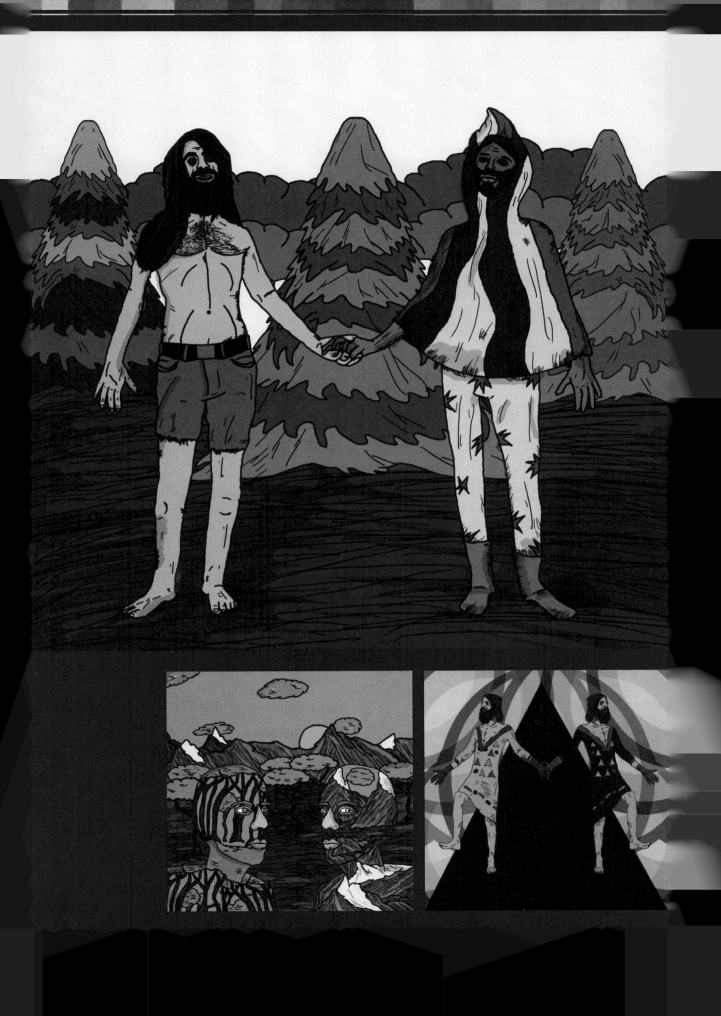

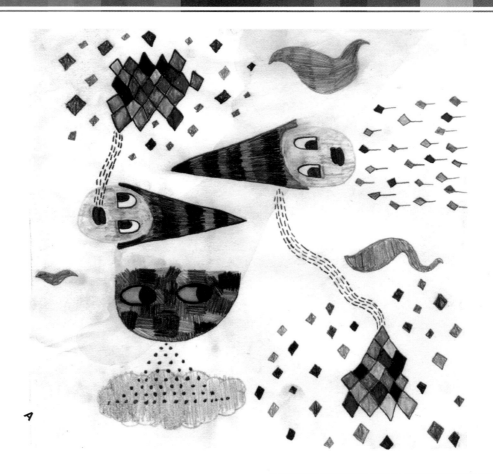

A

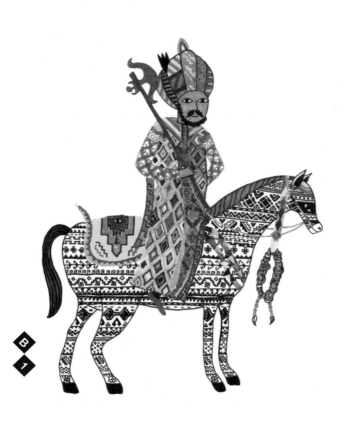

B
1

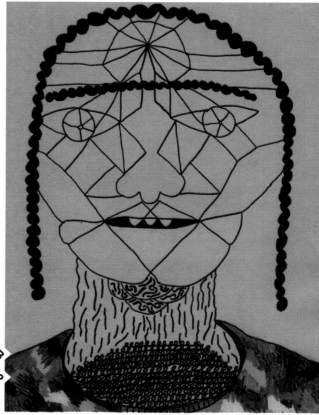

B
2

A ... ARTIST__**THOMAS HUDSON** TYPE OF WORK__**ILLUSTRATION**
B ... ARTIST__**YO!FEST** TITLE__**ILLUSTRATION** TYPE OF WORK__**ILLUSTRATION**

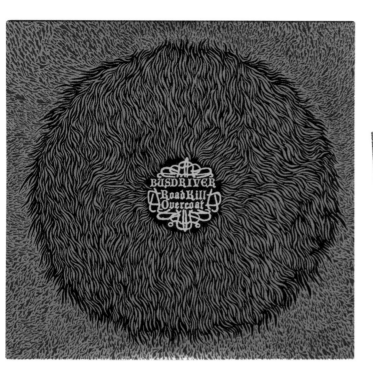

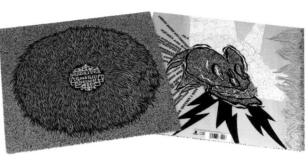

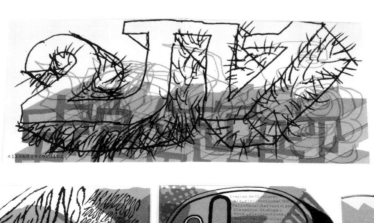

 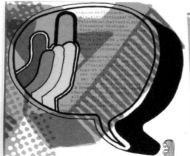

ARTIST__**SERIPOP**
TITLE__**1-ROADKILL OVERCOAT . 2-PAR NOUSSSS TOUSS LES TROUS DE VOS CRÂNES**
TYPE OF WORK__**CD COVER**

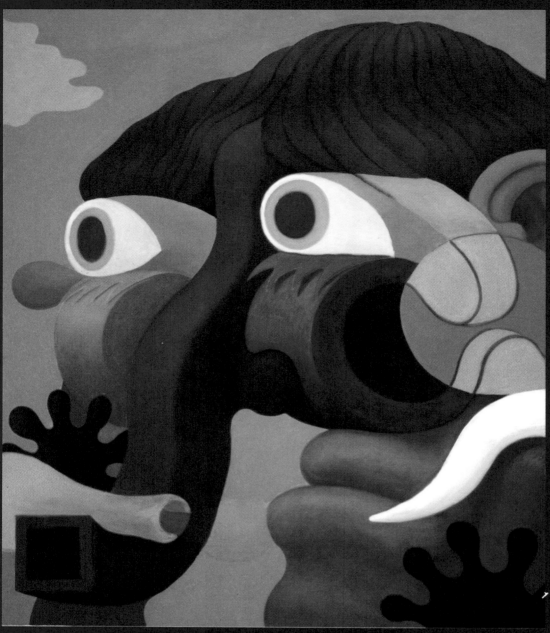

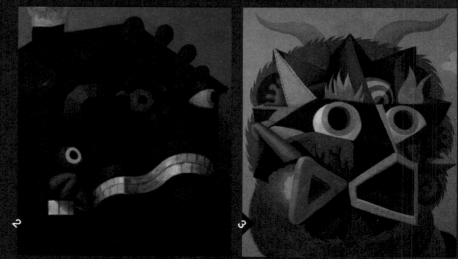

ARTIST__**PATRICK SMITH**
TITLE__**1-ELEPHANT BOY . 2-CABIN . 3-CATERPILLAR**
TYPE OF WORK__**PAINTING**

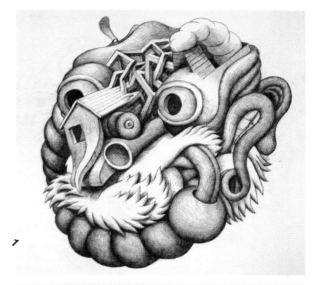

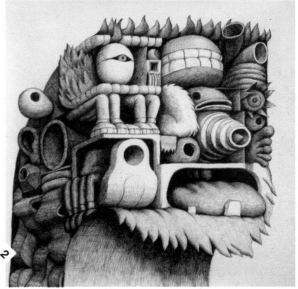

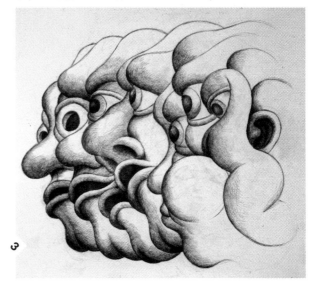

ARTIST__**PATRICK SMITH**
TITLE__**1-BUG . 2-CITADEL . 3-CASCADE**
TYPE OF WORK__**PAINTING**

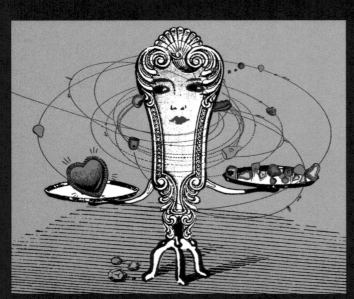
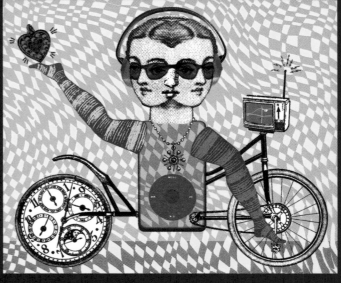
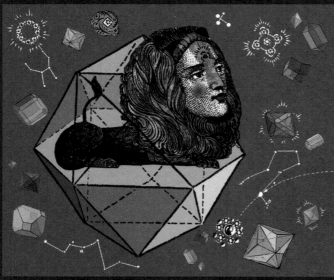
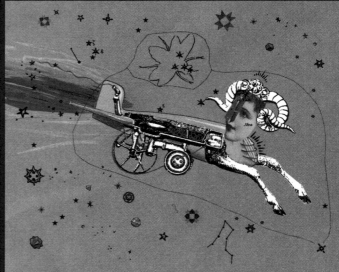

ARTIST__**LYNN HATZIUS**
TITLE__**1-AERIES . GEMINI . LEO . LIBRA FROM THE HOROSCOPE SERIES**
TYPE OF WORK__**PAINTING**

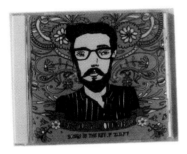

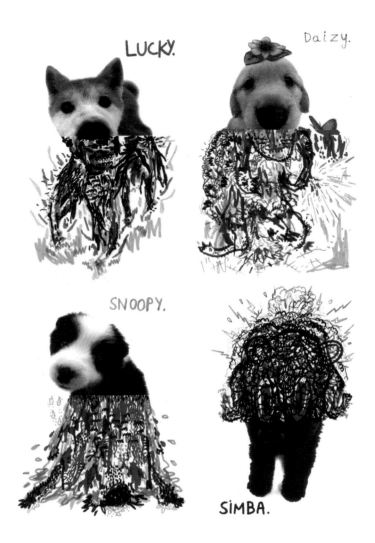

LUCKY.

Daizy.

SNOOPY.

SIMBA.

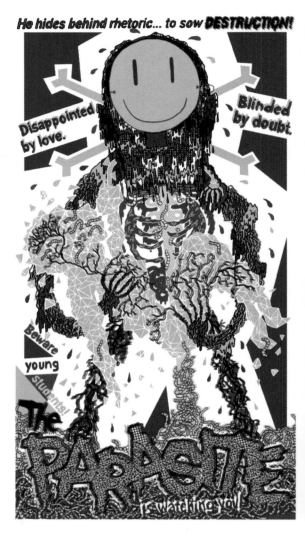

He hides behind rhetoric... to sow DESTRUCTION!

Disappointed by love.

Blinded by doubt.

Beware young students!

The PARASITE is watching you!

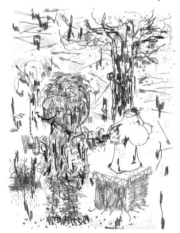

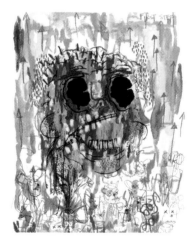

FIRST STEP

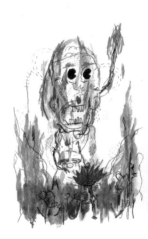

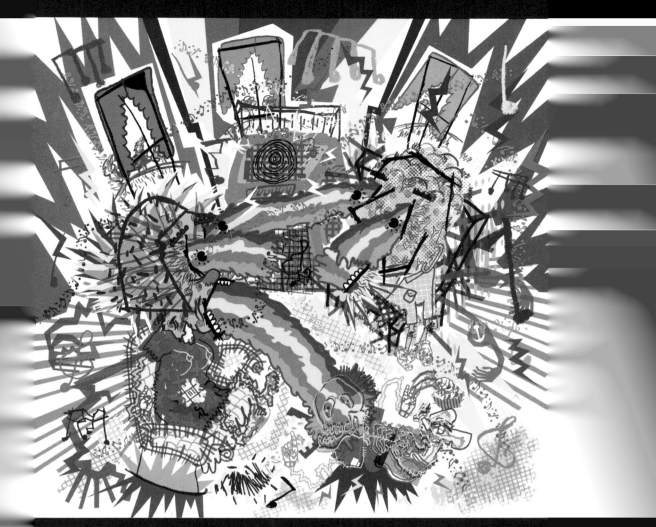

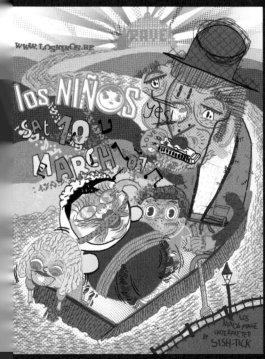

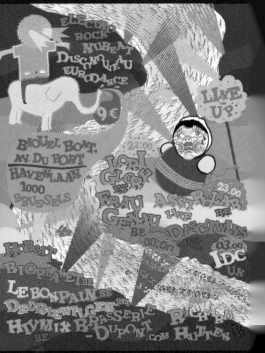

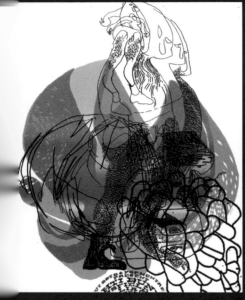

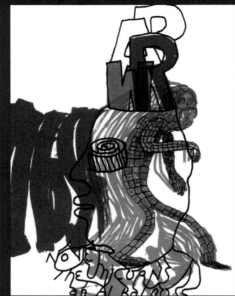

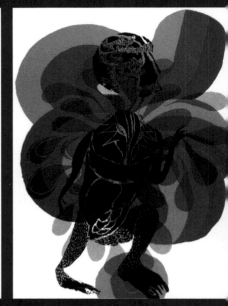

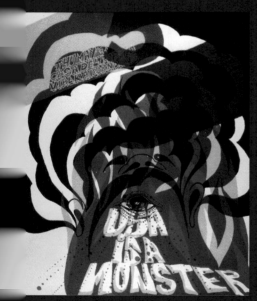

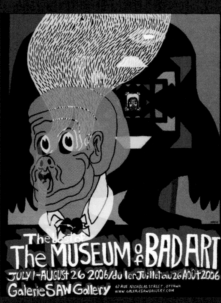

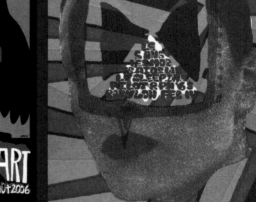

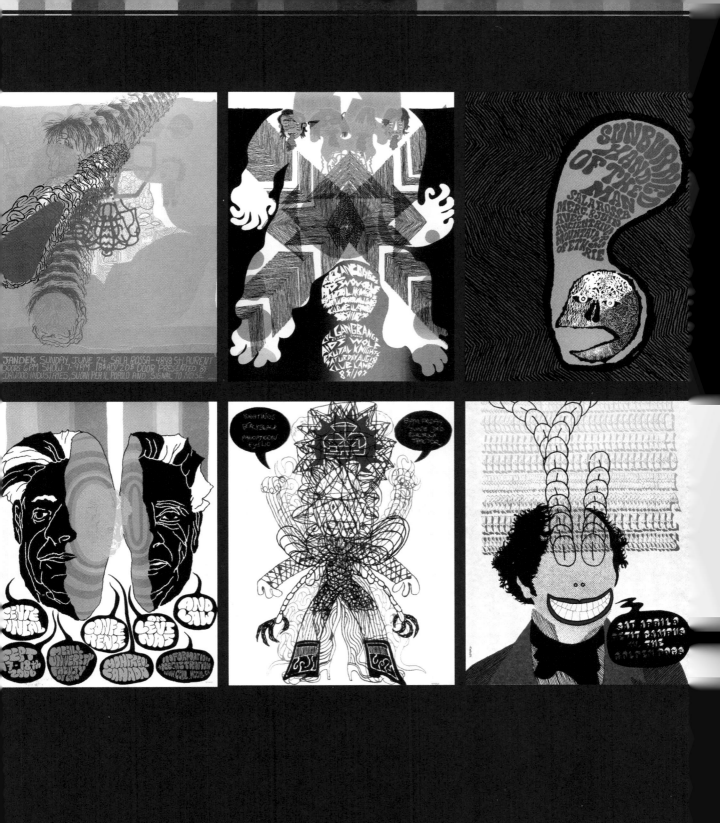

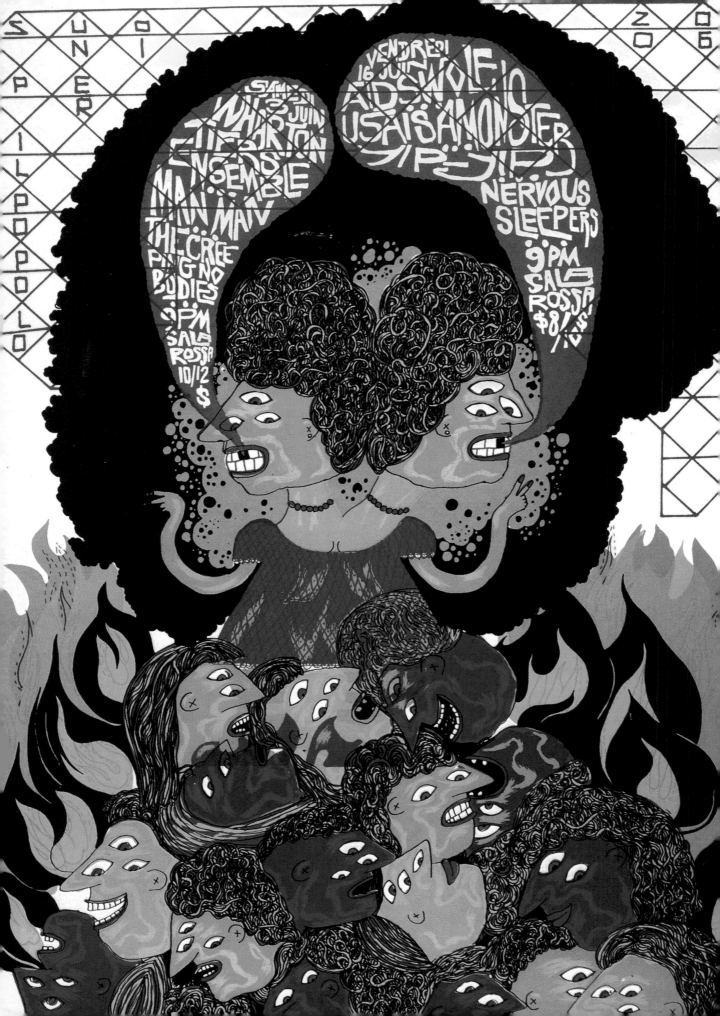

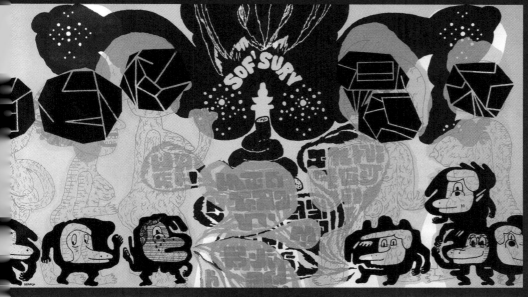

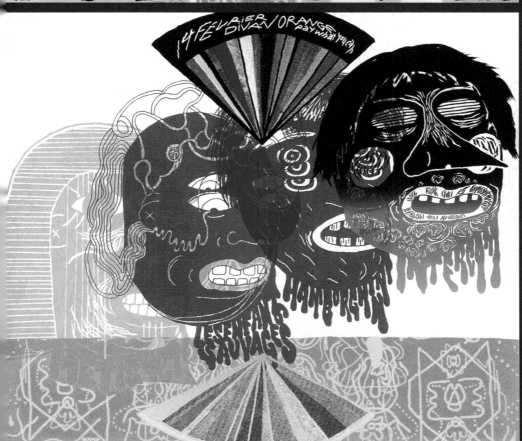

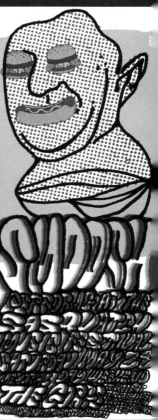

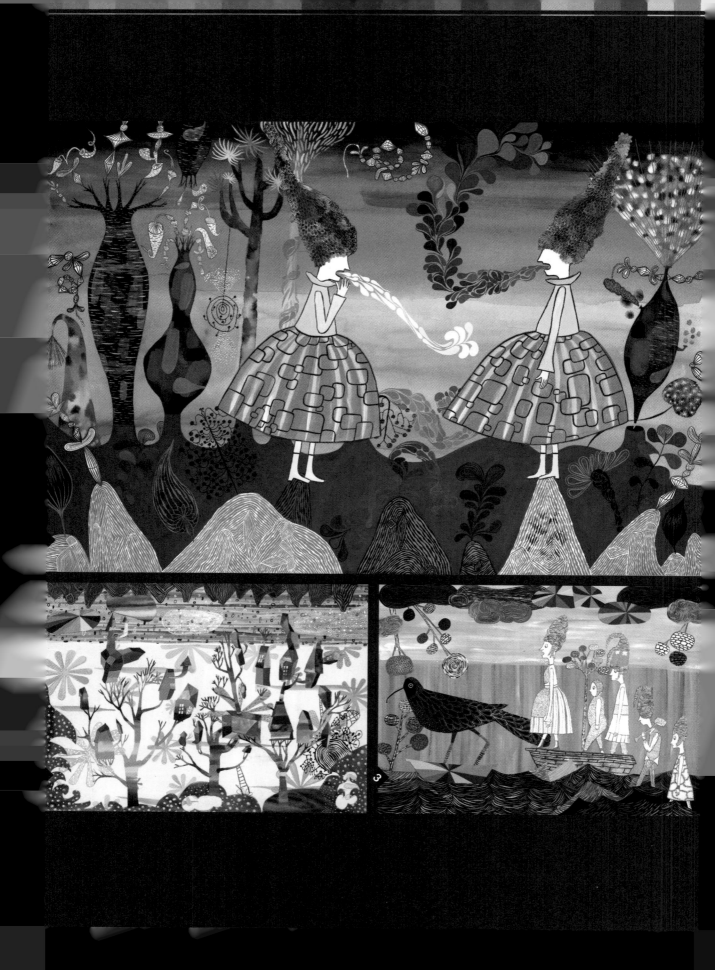

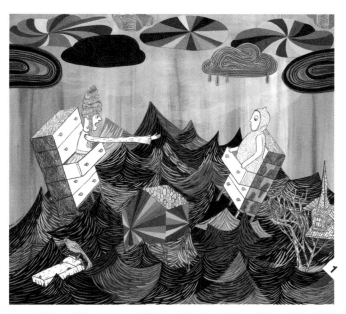

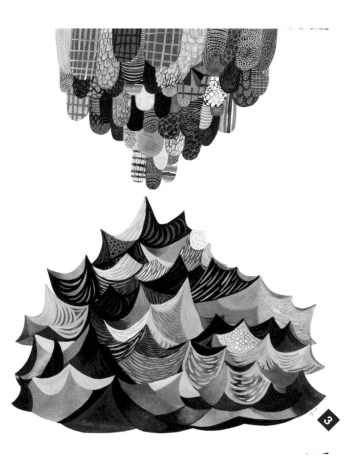

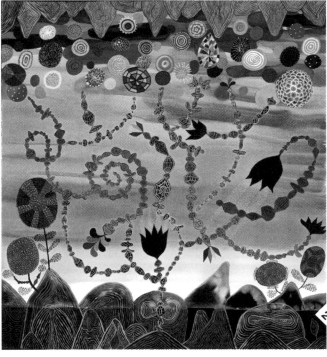

ARTIST__**SARAJO FRIEDEN**
TITLE__**1-"AWAY WE GO" . 2-"JEWELLED BUSH" . 3-"SEA CLOUD"**
TYPE OF WORK__**ILLUSTRATION**

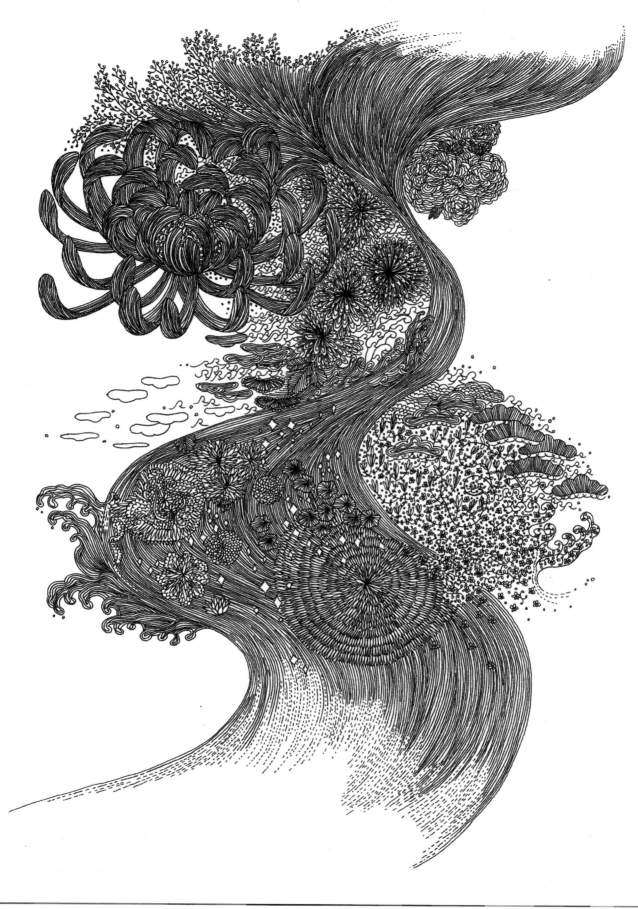

ARTIST__**KEIKO ITAKURA** TYPE OF WORK__**ILLUSTRATION**

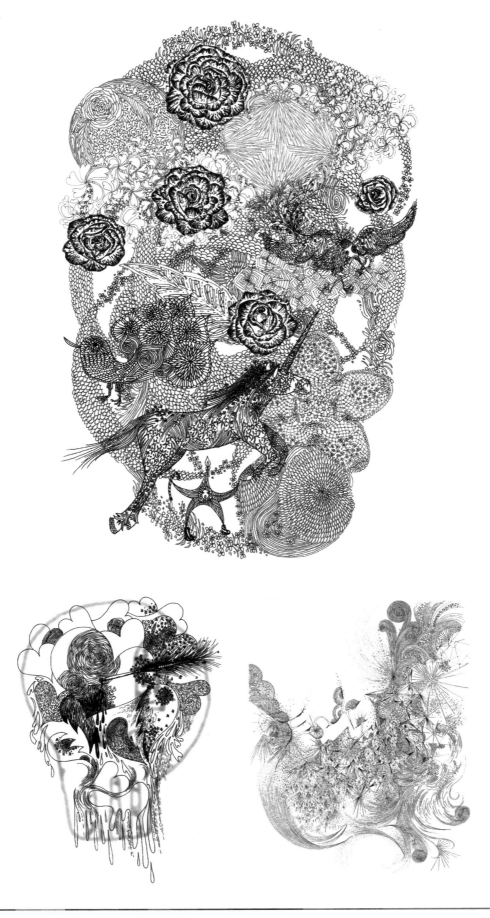

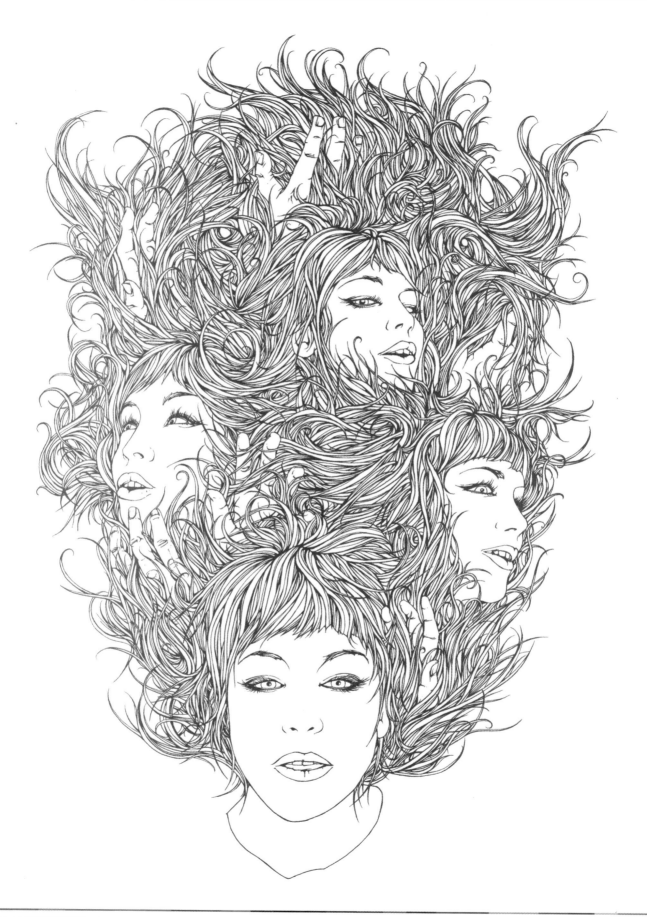

ARTIST__**DAN MUMFORD** TYPE OF WORK__**ILLUSTRATION**

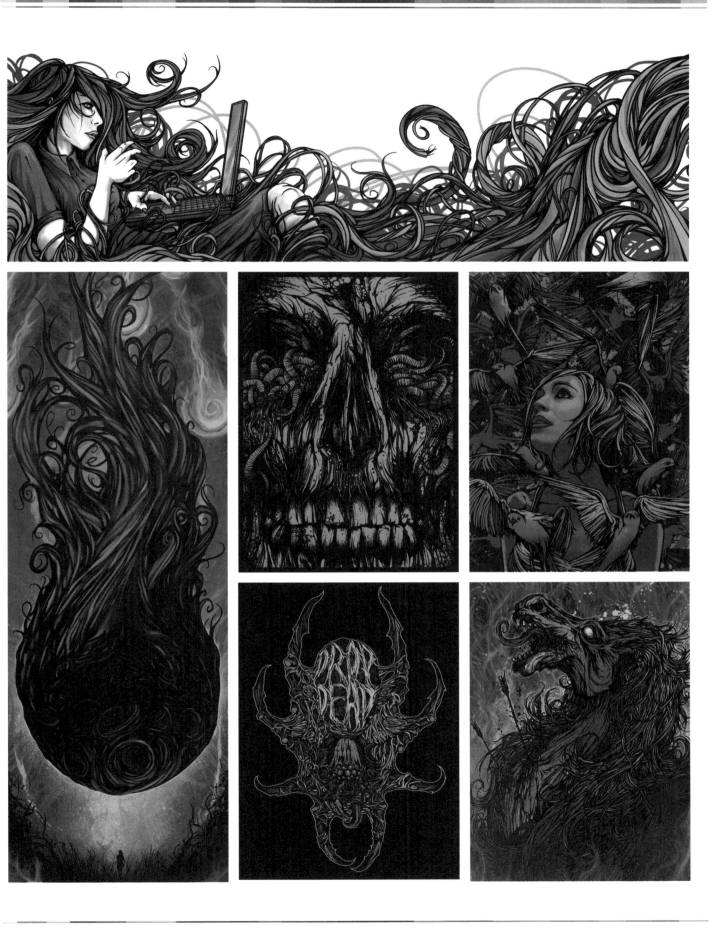

ARTIST__**DAN MUMFORD** TYPE OF WORK__**ILLUSTRATION**

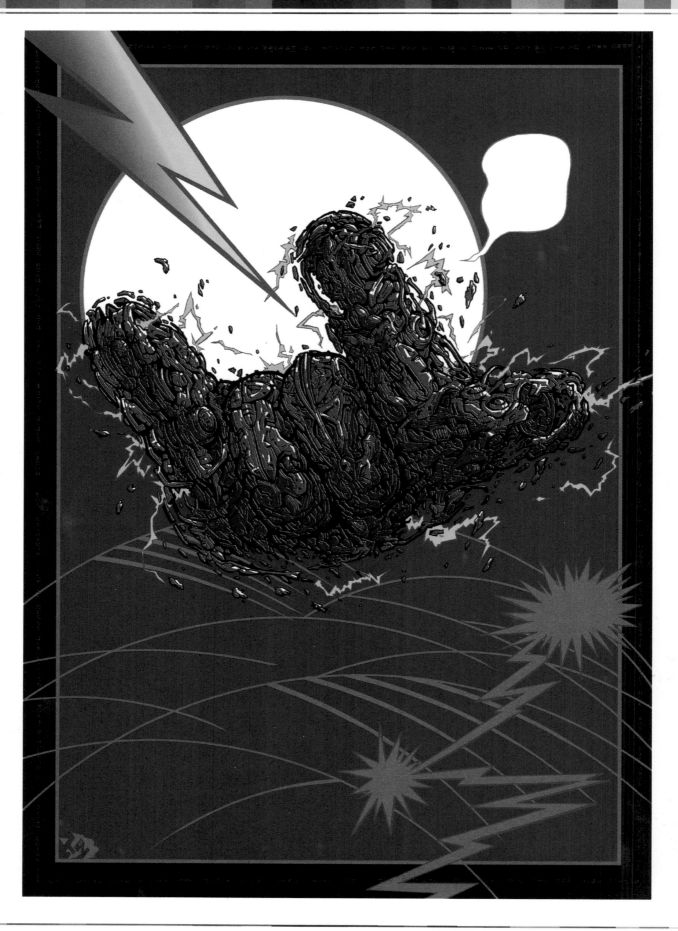

ARTIST__**IMAITOONZ** TITLE__**"SUGIURA HAND"** TYPE OF WORK__**ILLUSTRATION**

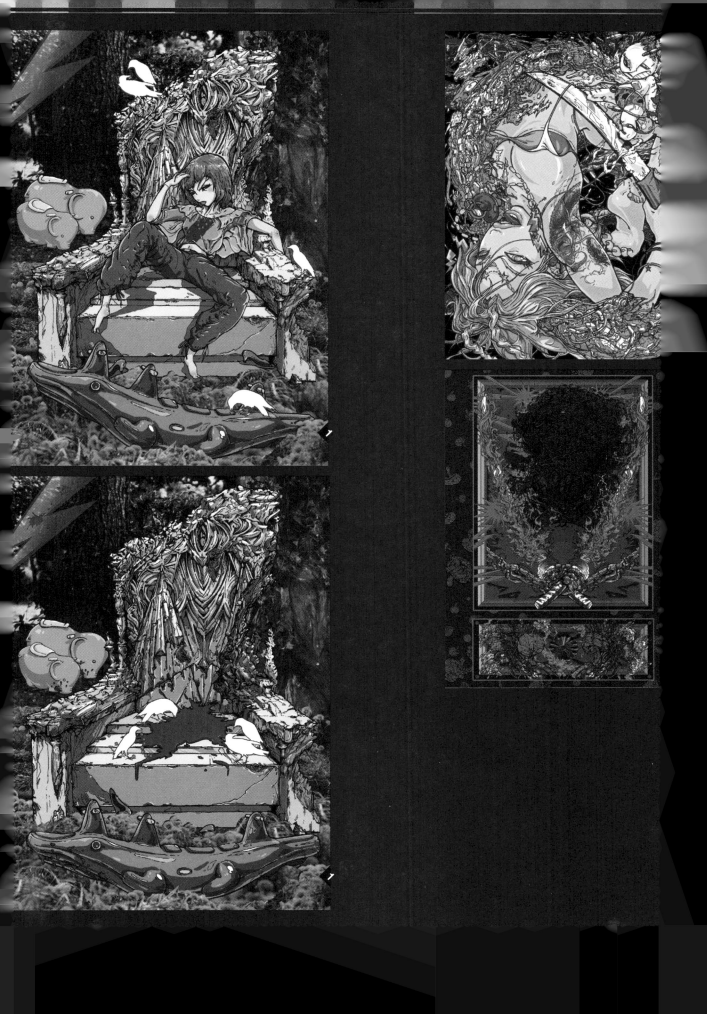

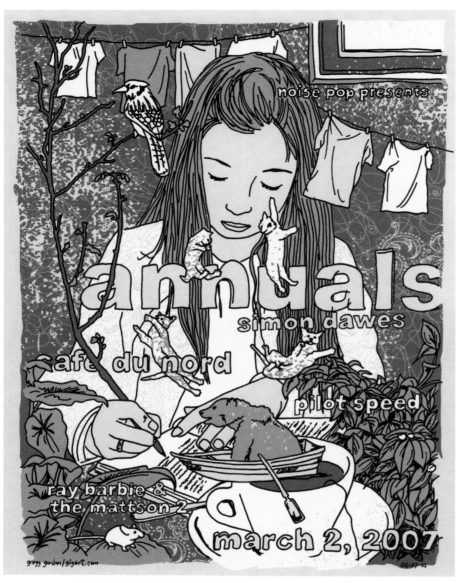

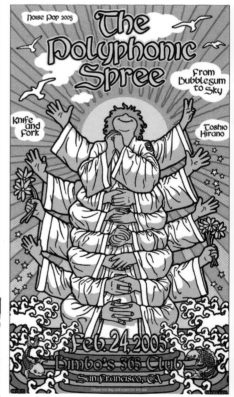

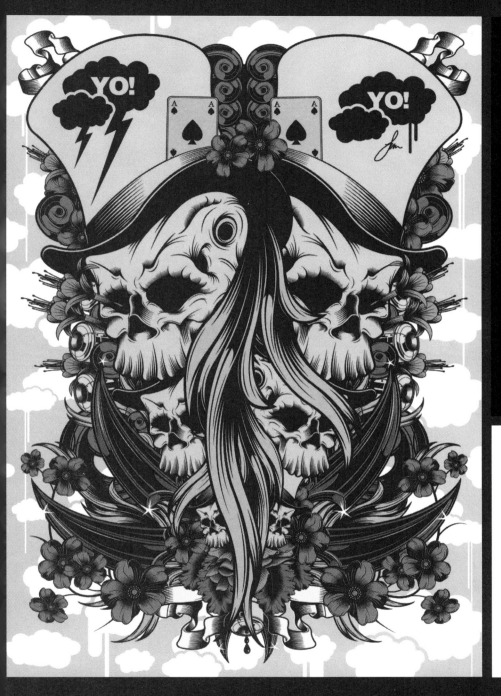

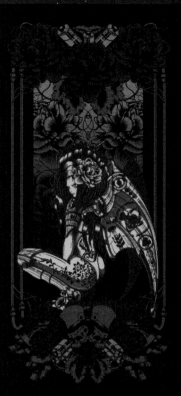

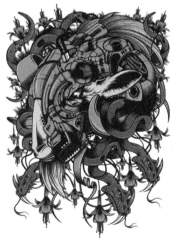

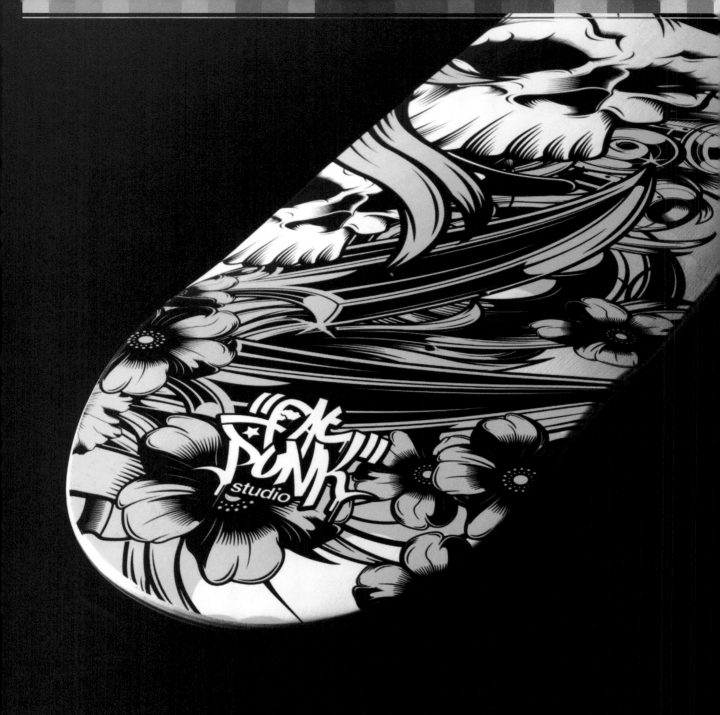

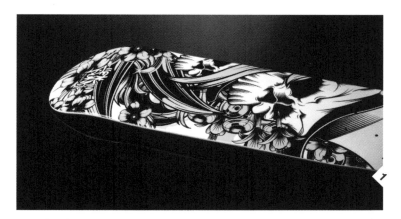

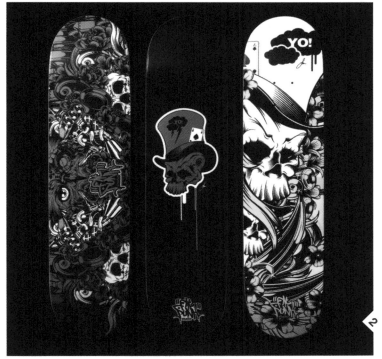

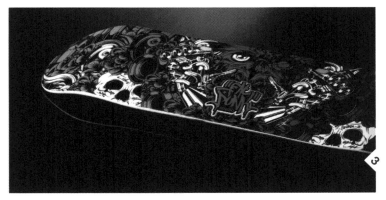

ARTIST__**FAT PUNK STUDIO**
TITLE__**1-EDEN DECK . 2-Deck names from left to right "PISTON" "HATTER" "EDEN" . 3-Piston Deck**
TYPE OF WORK__**PRODUCT**

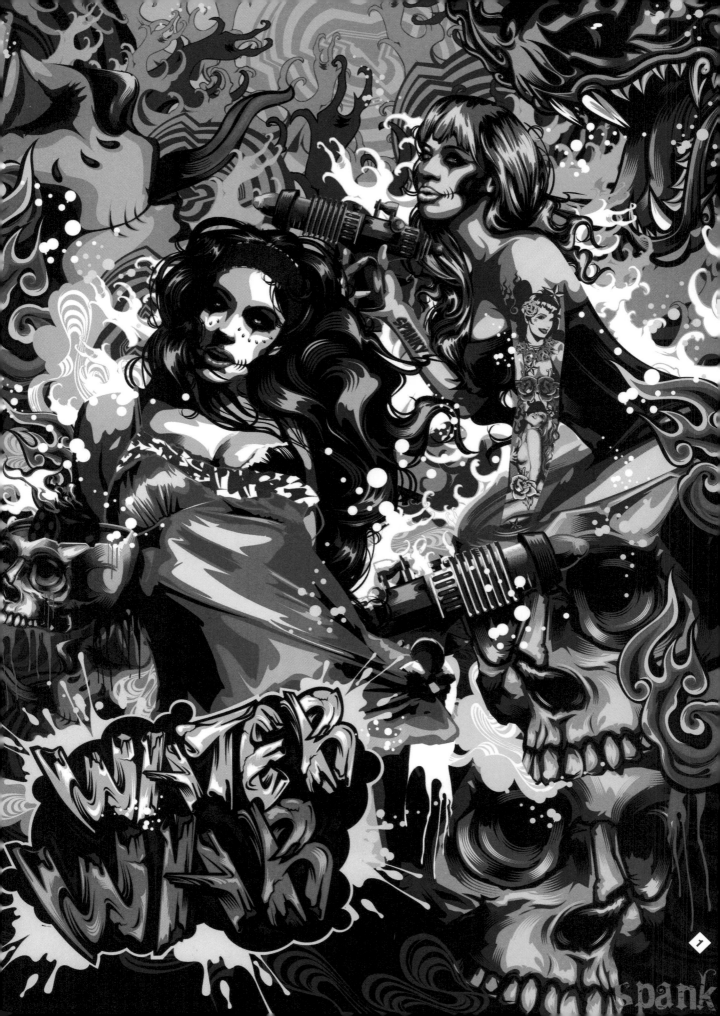

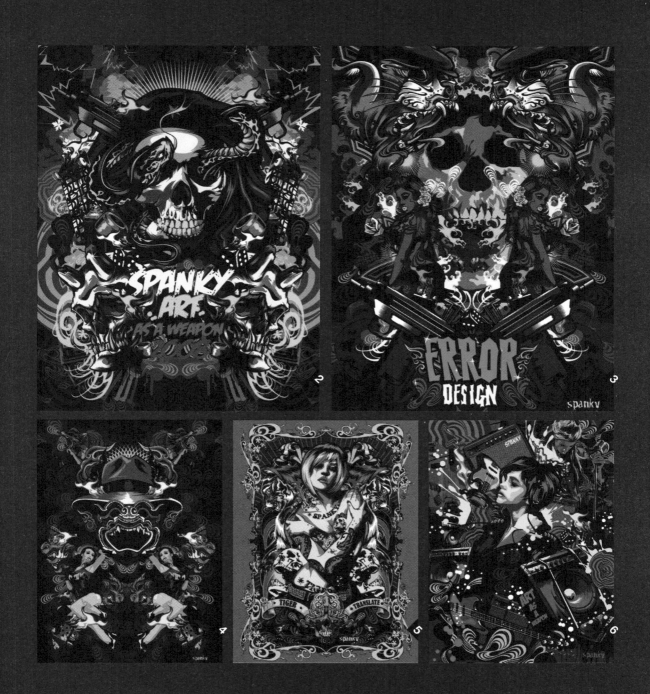

ARTIST__**SPANKY**
TITLE__1-CG PLUS COVER THAI NEW YEAR . 2-CEH SKULL . 3-ERROR DESIGN .
4-SOUL OF THAILAND . 5-PASSION OF ROCK . 6-ROCKSTAR
TYPE OF WORK__**PRINT**

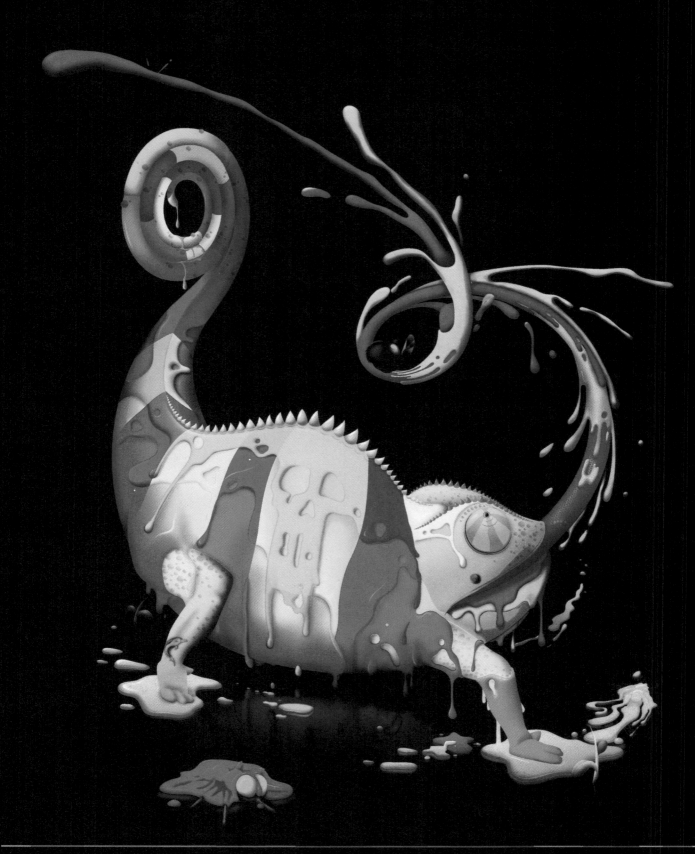

ARTIST__**FARB** TITLE__**KAMELEON** TYPE OF WORK__**PRINT**

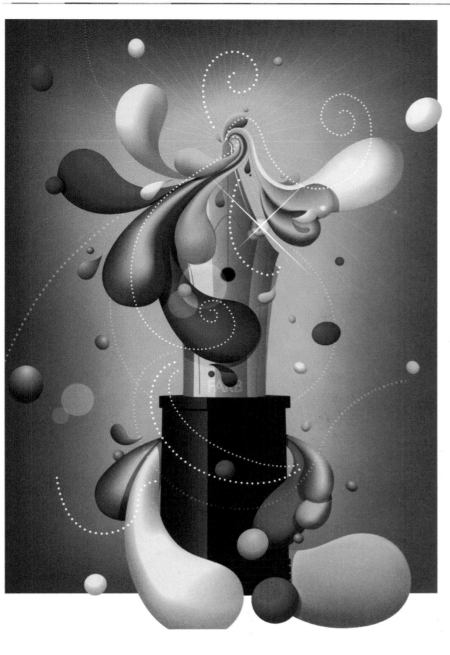

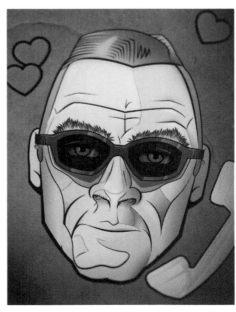

ARTIST__**FARB**
TITLE__**1-CREATIVITY BLENDS . 2-LEKTROLUV**
TYPE OF WORK__**PRINT**

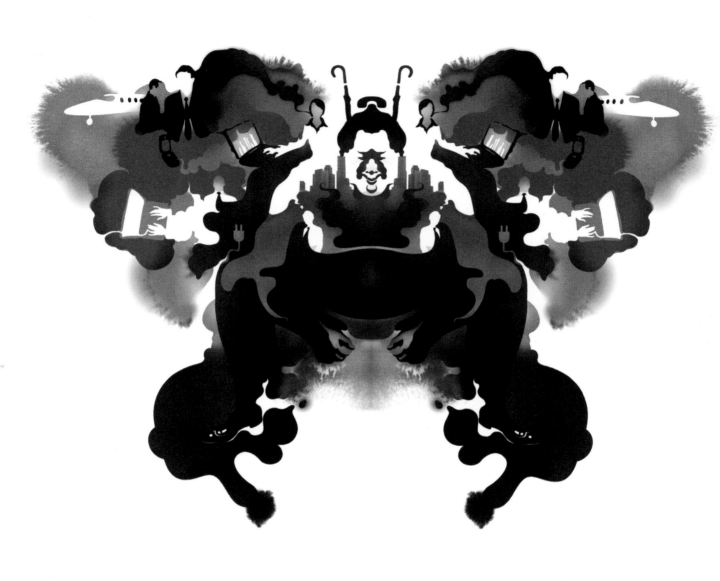

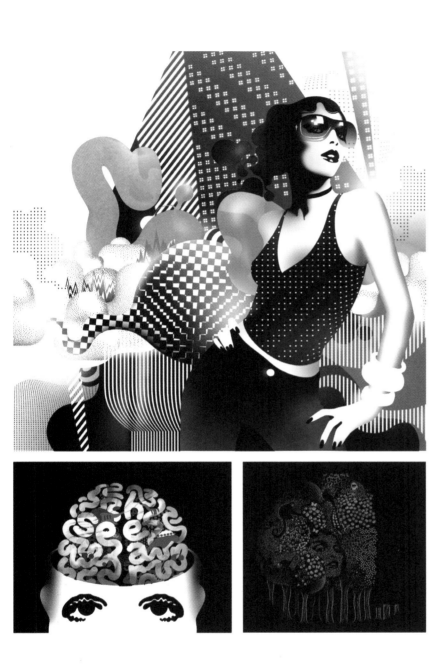

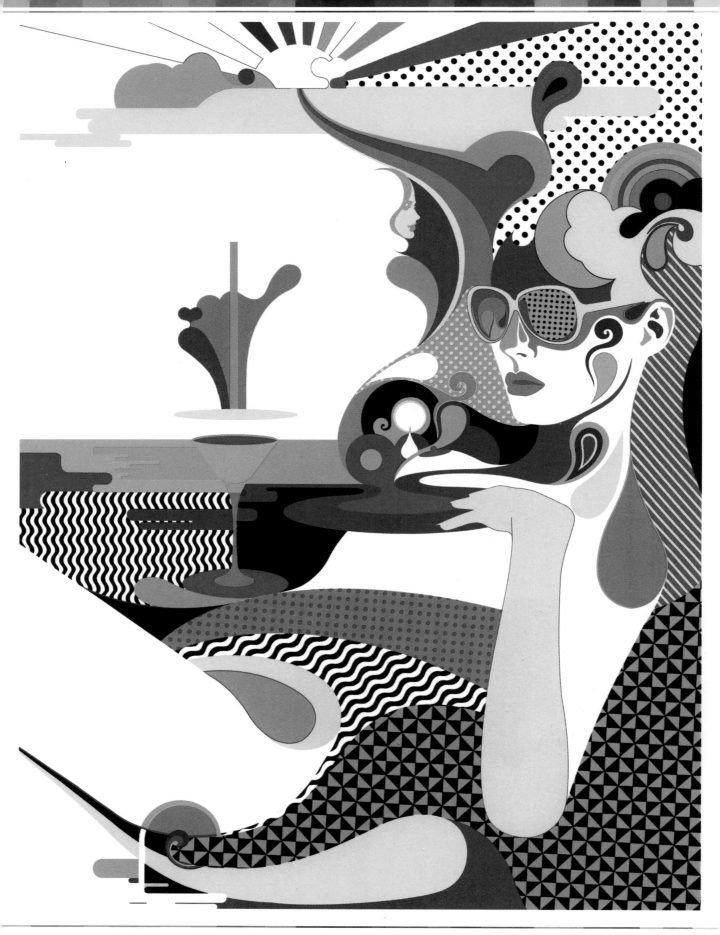

ARTIST__**STEVEN WILSON** TYPE OF WORK__**PATTERN**

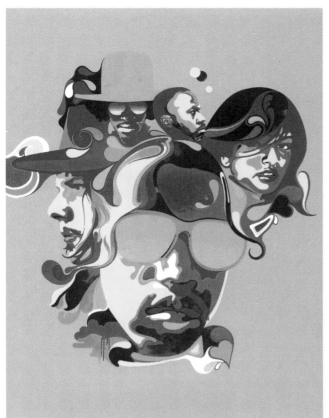

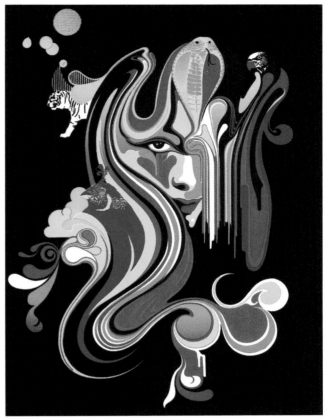

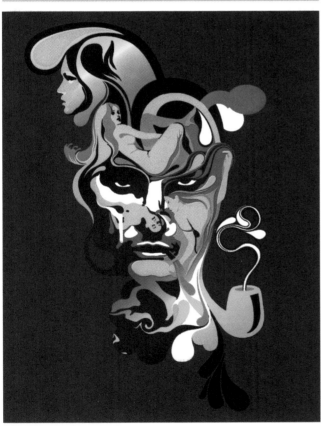

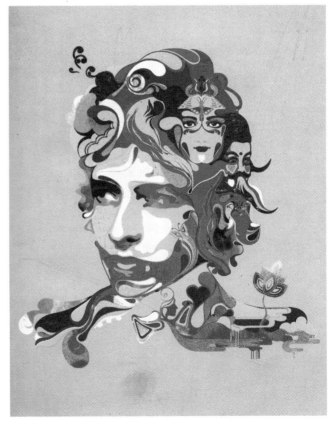

ARTIST__**STEVEN WILSON** TYPE OF WORK__**ILLUSTRATION**

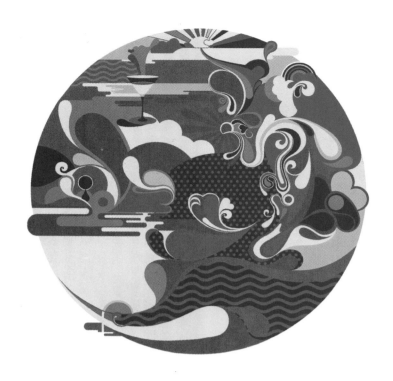

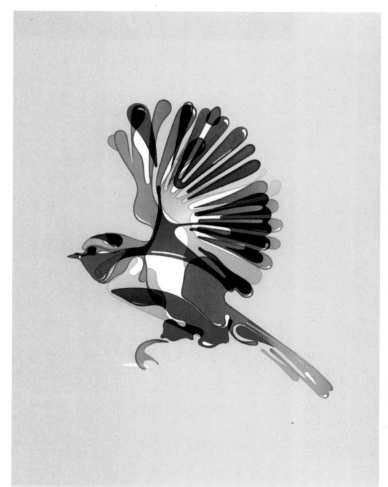

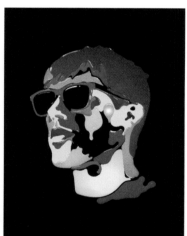

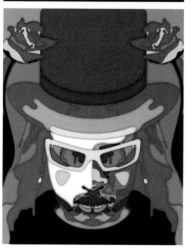

ARTIST__**STEVEN WILSON** TYPE OF WORK__**ICON & CHARACTER**

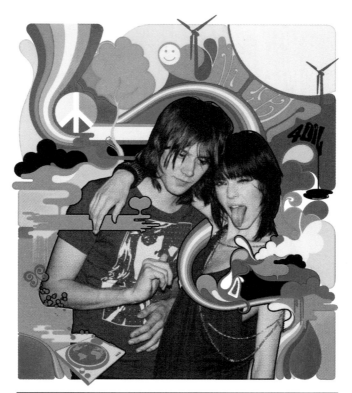

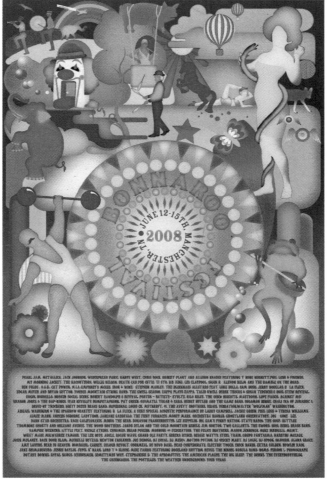

ARTIST__**STEVEN WILSON** TYPE OF WORK__**ICON & CHARACTER**

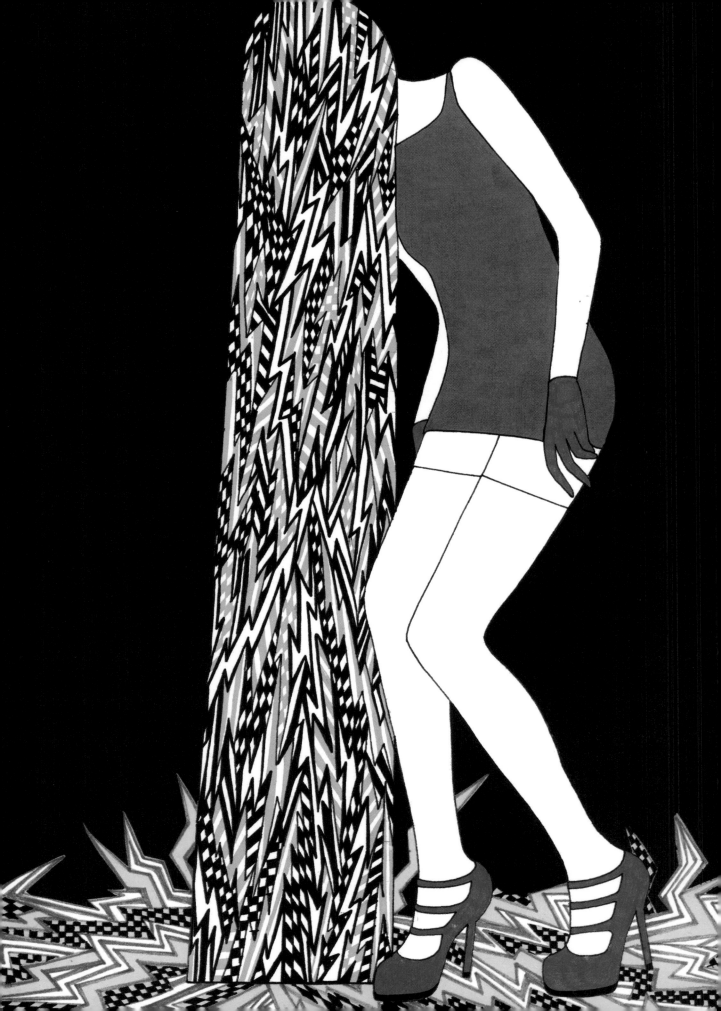

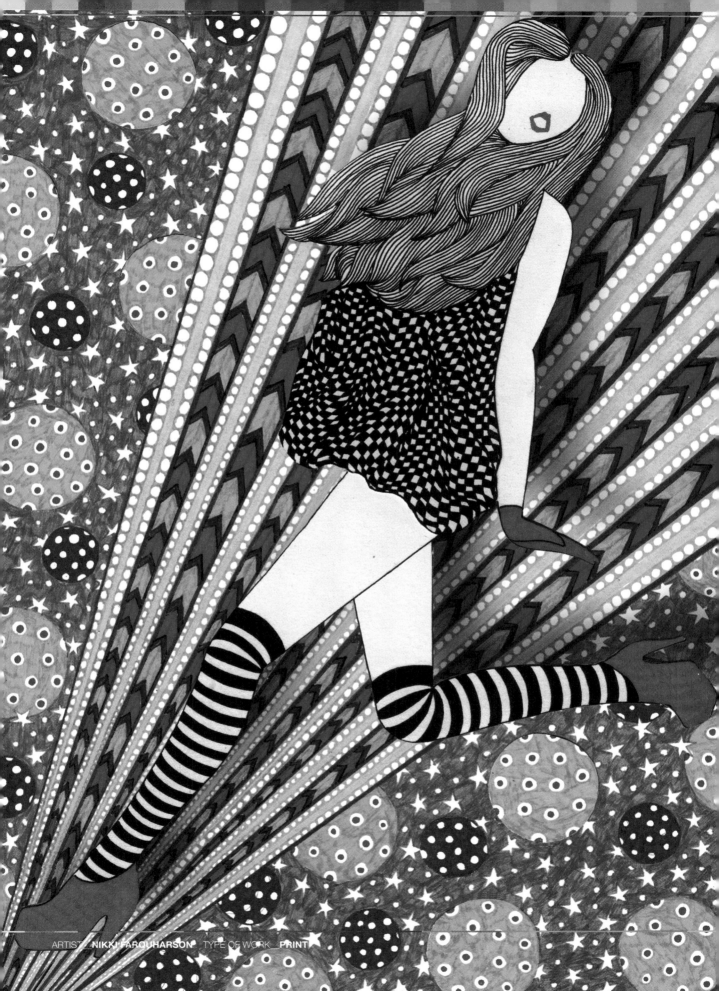

ARTIST: NIKKI FARQUHARSON TYPE OF WORK PRINT

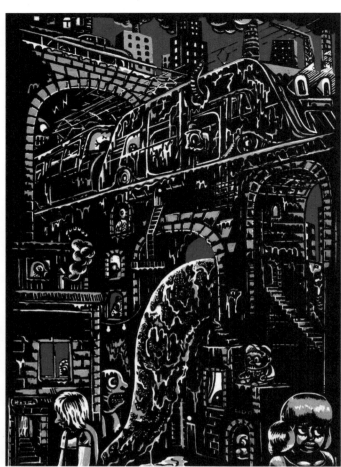

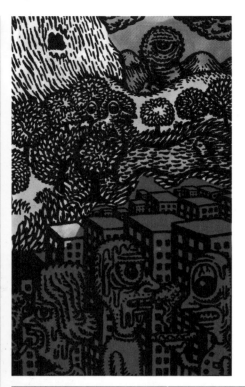

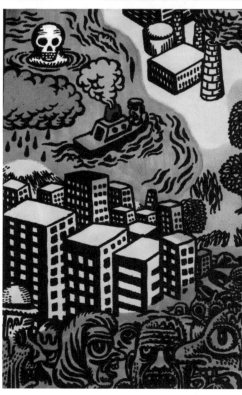

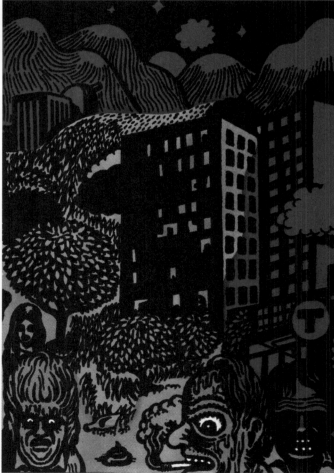

ARTIST__**MARCUS NYBLOM** TYPE OF WORK__**PRINT**

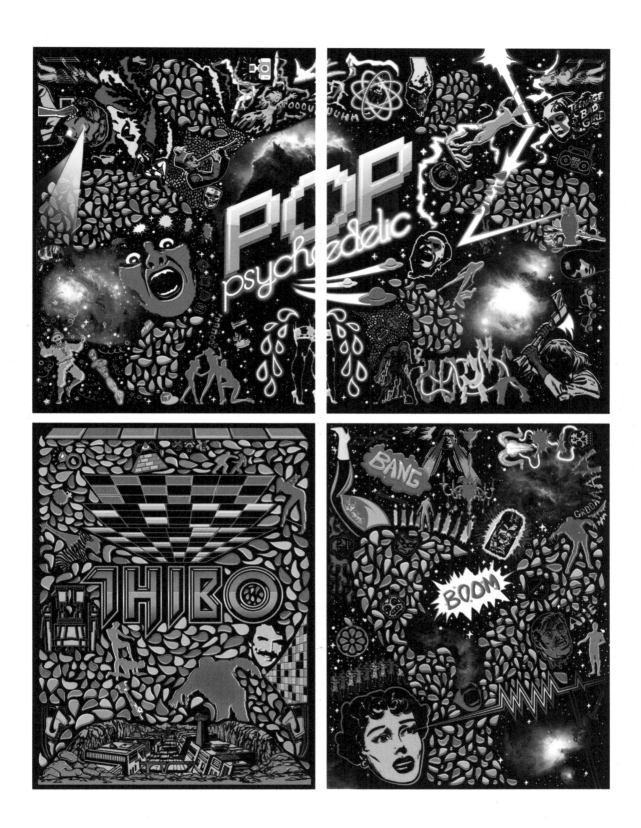

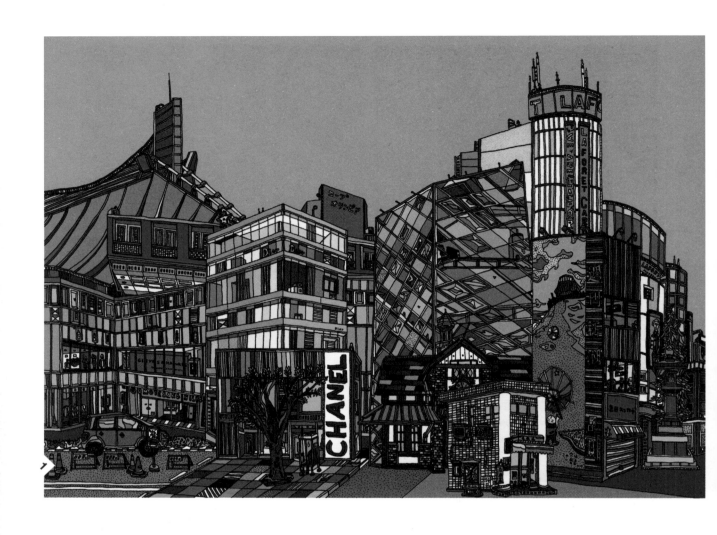

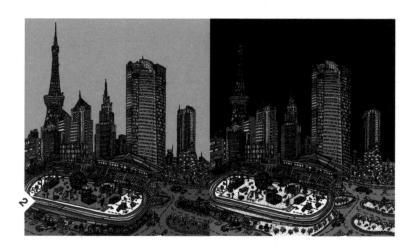

ARTIST__**RYU ITADANI**
TITLE__**1-OMOTESANDO . 2-J-WAVE & J-WAVE NIGHT**
TYPE OF WORK__**ILLUSTRATION**

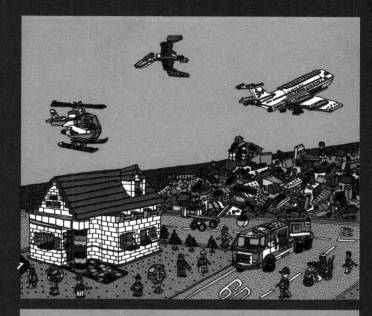

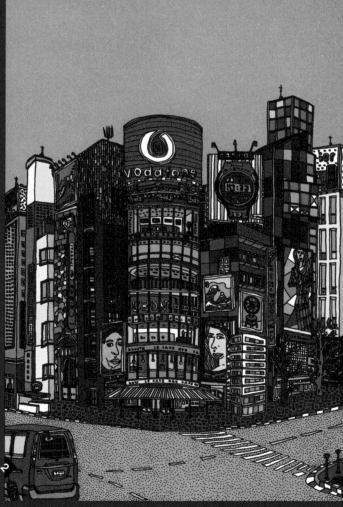

ARTIST__**RYU ITADANI**
TITLE__**1-LEGO_CITY . 2-GINZA**
TYPE OF WORK__**ILLUSTRATION**

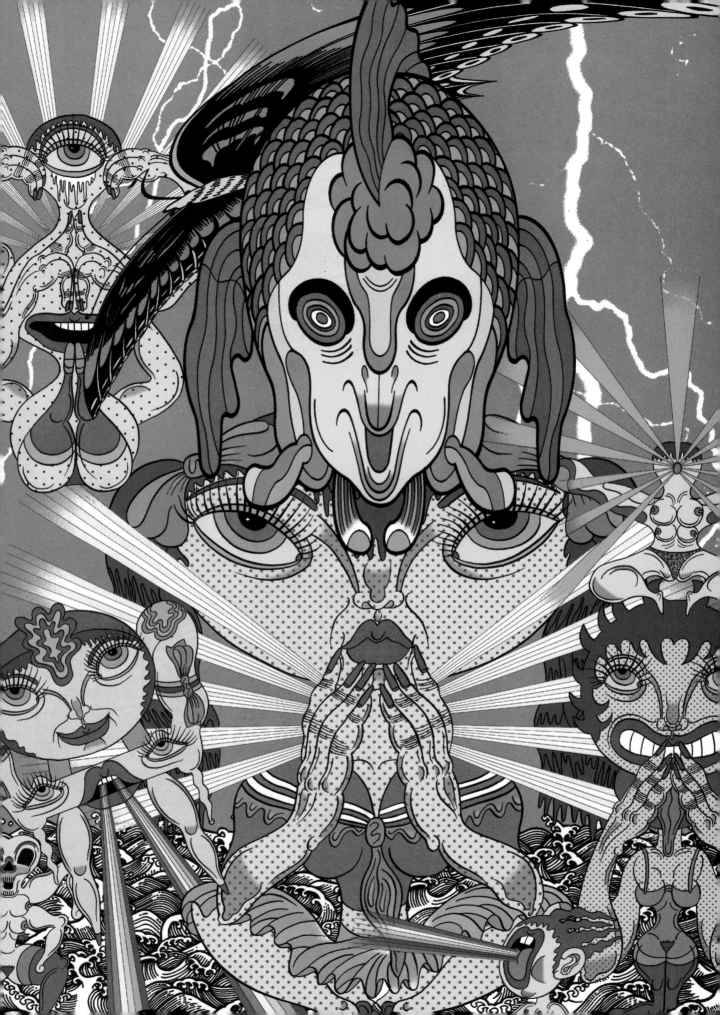

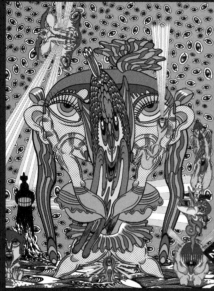

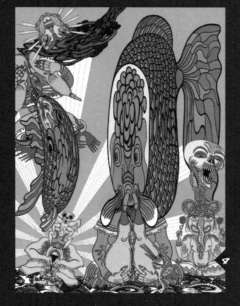

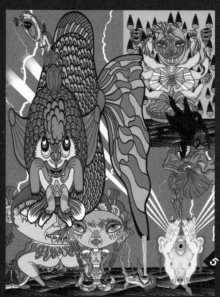

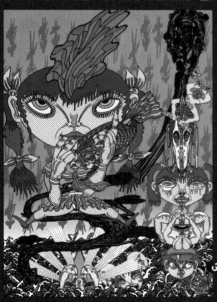

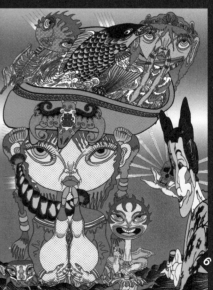

ARTIST__ **KEIICHI TANAAMI**
TITLE__ **1-THE BLUE LIGHTENING . 2-CELEBRATION OF A THOUSAND EYES . 3-FALLING SHADOW . 4-THE TEMPTATION OF THE WAVES .**
5-THE OMINOUS BLACK CROW . 6-THE STORM IN A CONTAINER

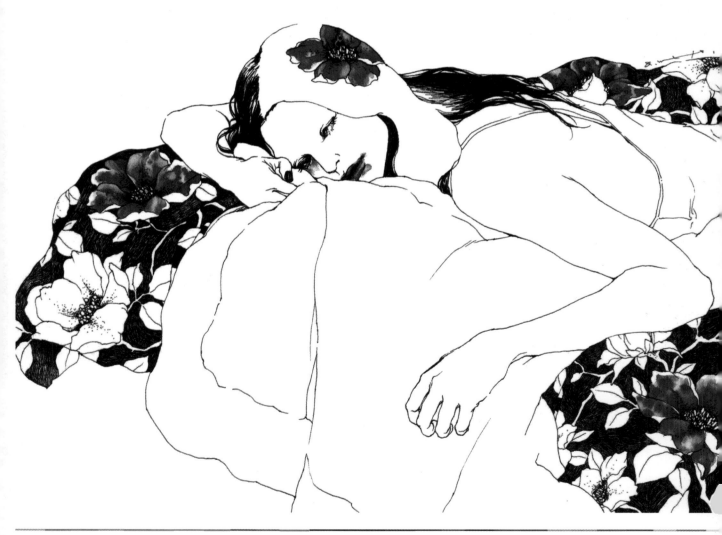

ARTIST__**AKI MIYAJIMA** TITLE__**SIDE** TYPE OF WORK__**PRINT**

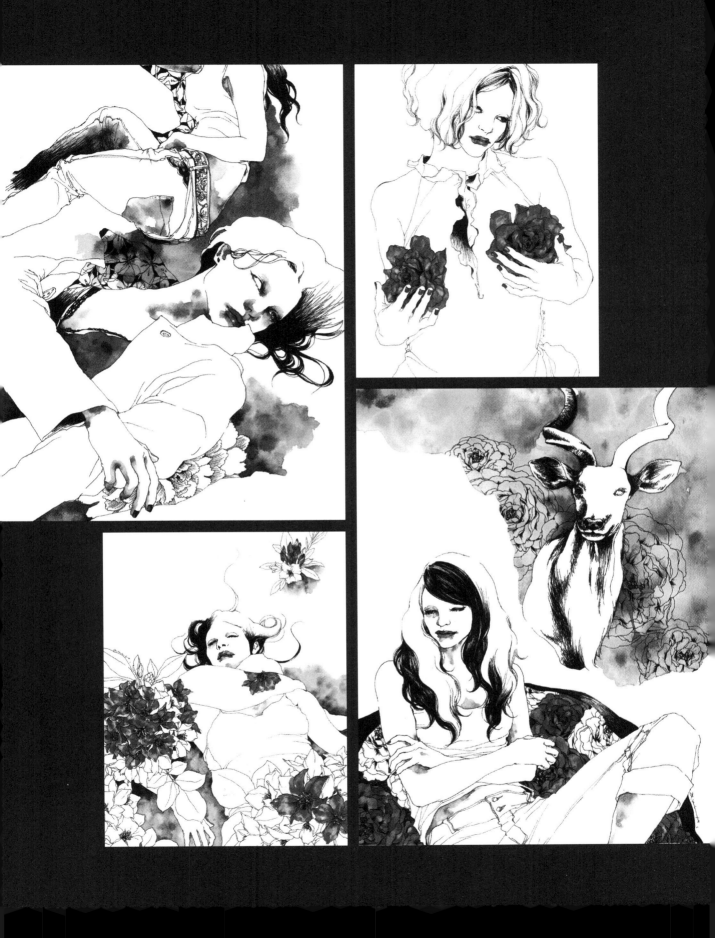

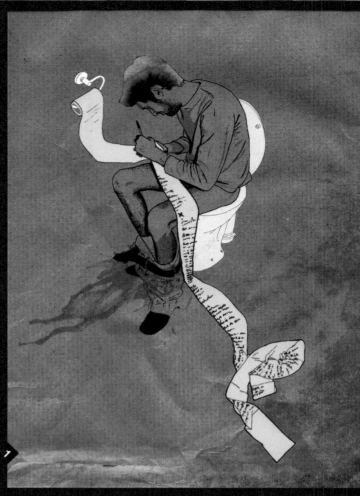

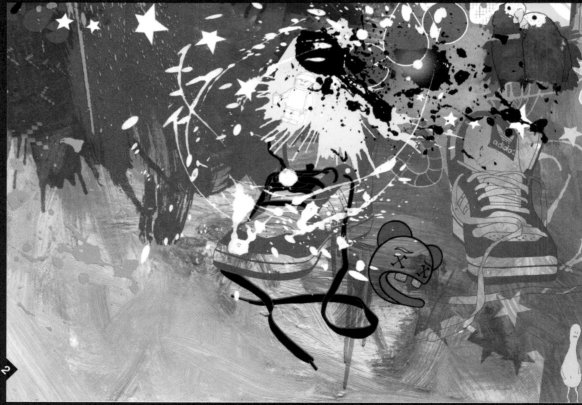

ARTIST__**GREGORY GILBERT-LODGE**
TITLE__**1-OBSESSION, SELF PROMOTION . 2-SNEAKERS, SELF PROMOTION**
TYPE OF WORK__**PRINT**

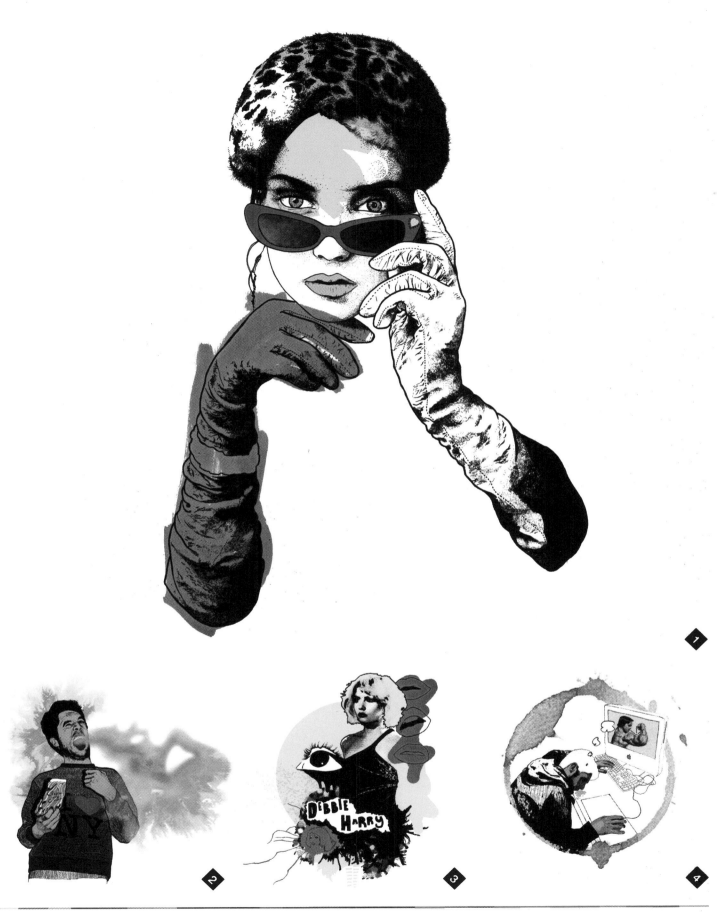

ARTIST__**GREGORY GILBERT-LODGE**
TITLE__**1-DIOR DARLING, VICTIONARY PUBLISHING . 2-YUCK CHEESE &ONION FLAVOUR, THE GUARDIAN .**
 3-DEBBY HARRY, VICTIONARY PUBLISHING . 4-HOW TO REST, SELF PROMOTION
TYPE OF WORK__**PRINT**

Mal konfus, mal Konfuzius

Takashi Murakami als eine Art Warhol zu bezeichnen, wäre zu wenig der Ehre. Denn dieser Japaner designt Taschen, erschafft Comicfiguren, ist Maler, Bildhauer, Gesellschaftstheoretiker. Und mit alldem macht er die Kunst auch *fit for funny*. Von Arthur Lubow (Text) und Gregory Gilbert-Lodge (Illustration)

Neulich besuche ich im Mori Arts Center, das auf einem Wolkenkratzer im schicken Tokioter Neubaugebiet Roppongi Hills thront, eine Museumsausstellung. Sie hiess «Universal Symbol of the Brand» und zeigte laut Katalog «die faszinierende Entwicklung der Geschichte und der Bestrebungen von Louis Vuitton, jener Marke, die nicht nur in Japan unglaublich populär ist, sondern in aller Welt geliebt wird». An einer Reihe von Galerien vorbei, in denen Reise- und Handtaschen ausgestellt waren, fiel mein Blick auf ein grosses Werbefoto der Schauspielerin Uma Thurman und auf kleinere Bilder von Frauen auf dem Laufsteg, die alle Louis-Vuitton-Modeartikel trugen. Was mich in die Ausstellung gelockt hatte, waren zwei Taschen mit der Variation des Louis-Vuitton-Musters, die der zeitgenössische japanische Künstler Takashi Murakami 2003 für die Firma entwickelt hatte. Die bunte Murakami-Linie ist phänomenal erfolgreich: Man spricht von Einnahmen im Bereich von 300 Millionen Dollar. Murakamis Handtaschen wurden zusammen mit zwei Wandschirmen ausgestellt, die mit den gleichen Mustern wie auf den Taschen bemalt waren.

Die Handtaschen in der Ausstellung waren nicht etwa Murakamis einziger Beitrag zum Roppongi-Hills-Komplex aus Glas-und-Stahl-Türmen. Niedliche cartoonartige Figuren – brave Brontosaurier, schlappohrige Kaninchen und lächelnde Ausserirdische –, die er als Markenzeichen für das Zentrum geschaffen hatte, grinsten von Wimpeln und von nach Roppongi Hills fahrenden Expressbussen zu mir herab. In einem grossen Vuitton-Geschäft im selben Viertel werden schon bald neue Handtaschen mit einem von Murakami entworfenen Kirschen-Design präsentiert, zusammen mit zwei Skulpturen des Künstlers, die rote, lächelnde Kirschen darstellen. Letztes Jahr hatte Murakami in einem anderen Tokioter Vuitton-Geschäft eine grosse Fiberglas-Skulptur und einen in vier Felder aufgeteilten Wandschirm gezeigt, der mit seinem LV-Monogramm-Design bemalt war.

Da stellte also ein Kunstmuseum in Tokio Reisetaschen aus, ein Reisetaschengeschäft stellte Kunst aus, ein Künstler entwickelte eine Branding-Kampagne – und niemand fand etwas dabei. Um zu begreifen, warum Murakamis Kunst so aktuell wirkt, ist dieser Einebnen der Statusunterschiede zwischen Kunst, Werbung und Waren in Roppongi Hills ein guter Ausgangspunkt. Der Tokioter Kunstkritiker Noi Sawaragi, ein wichtiger früher Förderer Murakamis und ungefähr gleich alt wie dieser, sagte mir, ich brächte einen

Unterscheidungen ins Spiel, die kein Japaner machen würde. «Dieses Hin und Her kommt uns nicht unnatürlich vor», erklärte er. «Das Museen in Warenhäusern ausstellen, hat bei uns Tradition. Dem Seibu-Museum, das es früher mal im zwölften Stock des Warenhauses Seibu gab, verdanke ich meine Kenntnisse der Gegenwartskunst. Marcel Duchamp, Malewitsch und Man Ray bekam ich erstmals in diesem Museum richtig zu sehen. Ich glaube, das trifft auf alle Angehörigen meiner Generation zu. In den unteren Stockwerken findest du Kleider, Koffer und Schuhe, aber im zwölften Stock findest du Kunst.»

Denker des Superflachen

Im Lauf seiner Karriere hat sich Murakami immer mühelos zwischen seinen verschiedenen Rollen als Künstler, Kurator, Theoretiker, Produktdesigner, Geschäftsmann und Berühmtheit hin und her zu bewegen vermocht. Seit 2003 bei einer Auktion ein Sammler aus Chicago für Murakamis Fiberglas-Skulptur einer langbeinigen Kellnerin 567 500 Dollar bezahlt hat, hält der mittlerweile 43-Jährige den Rekord für das am höchsten bezahlte Werk eines zeitgenössischen japanischen Künstlers. Mit seinen 2001 im Grand Central Terminal und 2003 im Rockefeller Center ausgestellten monumentalen Skulpturen und Siebdruck-Ballons von Cartoon-Figuren ist er auch in New York zum Begriff geworden.

Mehr als allen anderen verdankt das moderne Japan ihm seinen Platz in der Welt der Gegenwartskunst. «Er ist ein Phänomen, da besteht kein Zweifel», sagt Lisa Phillips, Direktorin des New Museum of Contemporary Art in New York: «Meiner Ansicht nach verkörpert seine Kunst Interessen, die weit über Japan hinausreichen. In ihr verbinden sich Fantasy, Apokalypse und Unschuld. Diese Kombination disparater Elemente macht ihn so zeitgemäss. Aber mindestens so sehr wie für sein Werk gilt dies dafür, wie er arbeitet: im öffentlichen Raum mit öffentlichen Skulpturen, riesigen Editionen von Objekten, Merchandising und in Zusammenarbeit mit anderen. Das ist ein sehr ambitiöses und breit angelegtes Projekt.»

Am bekanntesten ist Murakami als Künstler, doch vielleicht noch interessanter ist er als Denker. Vor fünf Jahren entwickelte er eine Theorie mit der cleveren Überschrift «superflat» (Superflach). Darin stellt er einen Zusammenhang her zwischen den flachen Bildebenen der traditionellen japanischen Malerei und der in Japan nicht vorhandenen Unterscheidung zwischen E-

und U-Kultur. Er stellt traditionelle Künstler der Edo-Periode (1603–1868) neben Schöpfer zeitgenössischer Animationsfilme und begründet das damit, dass sie sich in der Flachheit ihrer Werke stilistisch sehr ähnlich seien. Nach seiner selbstsischen Analyse der japanischen Populärkultur hat er sich der Frage zugewandt, welche Funktion das Superflache in der zeitgenössischen japanischen Kultur haben könnte. Als Kurator der Ausstellung «Little Boy: The Arts of Japan's Exploding Subculture», die neulich in der Japan Society in New York eröffnet wurde, beschäftigt er sich mit der sogenannten Otaku-Bewegung. Damit sind japanische Fans gemeint, die sich obsessiv mit popkulturellen Phänomenen wie «Anime» (Animationsfilm), «Mangas (Comic) oder sexuell suggestiven Modellfiguren beschäftigen.

Murakami kommt zu einem provokanten Schluss: Die angesehenen japanischen Künstler, sagt er, haben die Schrecken des Zweiten Weltkriegs und die Demütigungen der Besetzung während der Nachkriegszeit im Wesentlichen ignoriert; sie überliessen diese Themen den Otaku, welche diese harten Realitäten ins Reich kindlicher Zeichentrickfantasien überführten. Dort wurden qualvolle Wahrheiten aus ihrem historischen Kontext gelöst – eine Verflachung, die Künstler wie Betrachter angenehmerweise davon befreite, sich mit den Widersprüchen auseinander setzen zu müssen, dass Japan während des Kriegs sowohl Aggressor als auch Opfergewesen und in der Nachkriegszeit zum wirtschaftlichen Konkurrenten und politischen Untergebenen der USA geworden war.

Flach, bunt und wurzellos sind die Bilder dieser populären Subkultur – die grossäugige, ausdruckslose Katze Hello Kitty, das mutierte Monstrum Godzilla, der riesenhafte Ausserirdische Ultraman, der katzenförmige Beschützerroboter Doraemon –, wie Icons auf einem Computerschirm stehen sie in beliebiger Reihenfolge nebeneinander. Die schwerelosen Bilder sind mittlerweile weit über Japan hinaus bekannt, Animes und Mangas gelten weltweit als cool.

Copy-Paste-Mentalität

Historisch betrachtet ist Japan wirklich eigenartig: Noch vor anderthalb Jahrhunderten war es eine vom Rest der Welt weitgehend abgeschnittene Gesellschaft. Dann stürzte es sich auf alles, was ihm gefiel (vor allem Europäisches), verschlang, absorbierte und adaptierte es im Nu. Diese Fressorgie endete mit der Katastrophe des Zweiten Weltkriegs, worauf Japan wieder einen

Leider teuer: Künstler und Denker Murakami.

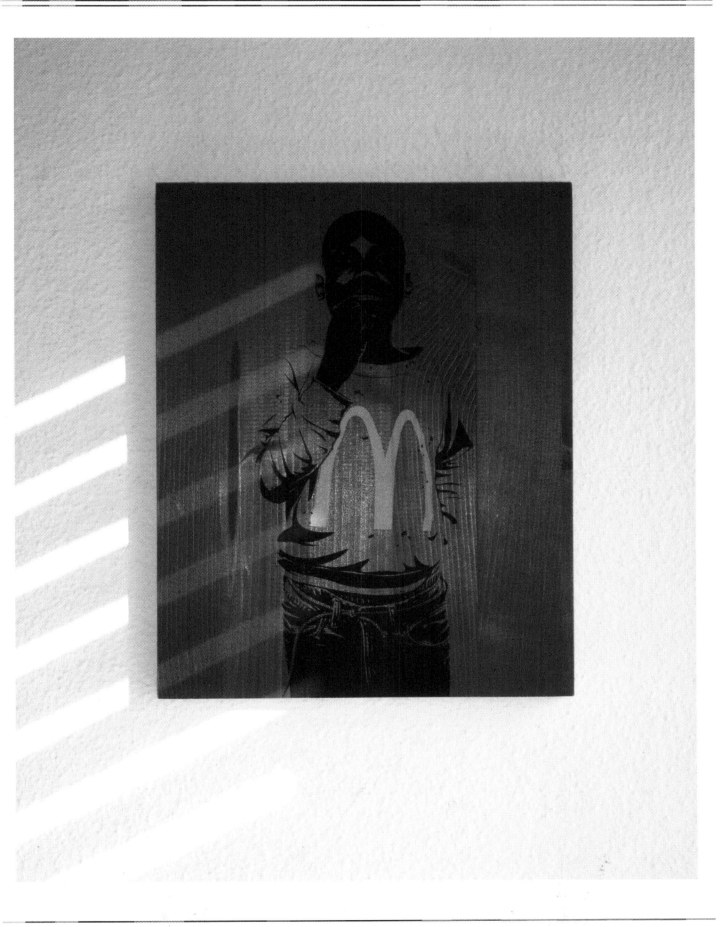

ARTIST__**GREGORY GILBERT-LODGE**
TITLE__**HOMELESS, SILKSCREEN PRINT ON WOOD**
TYPE OF WORK__**PRINT**

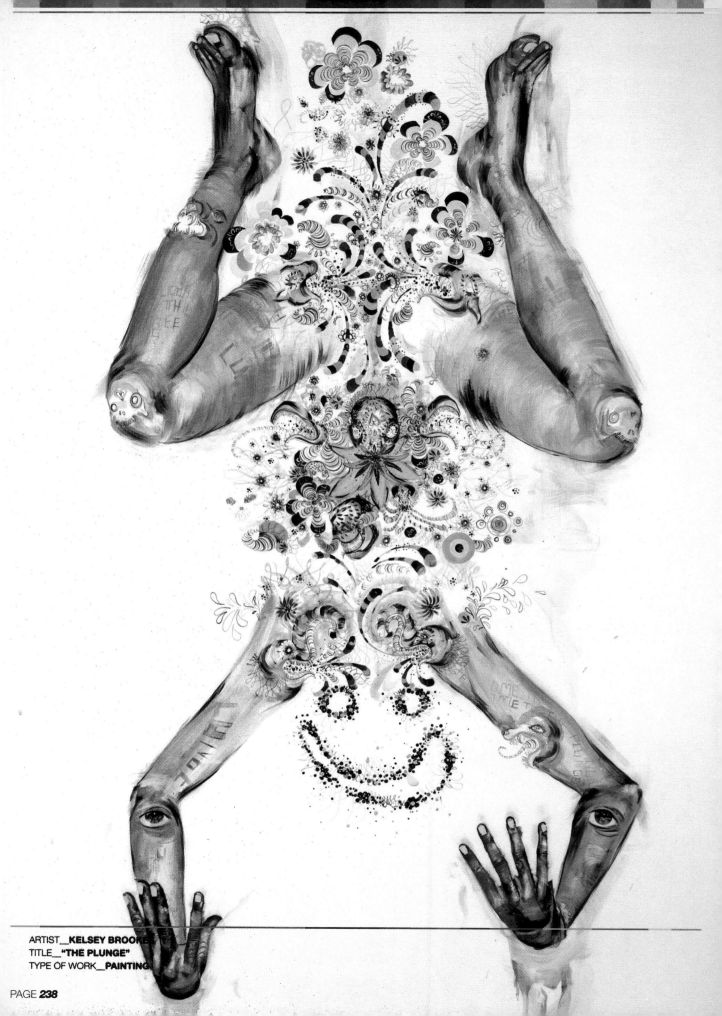

ARTIST__**KELSEY BROOKES**
TITLE__**"THE PLUNGE"**
TYPE OF WORK__**PAINTING**

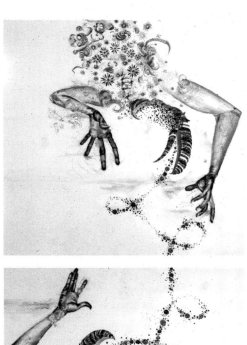

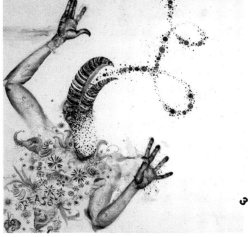

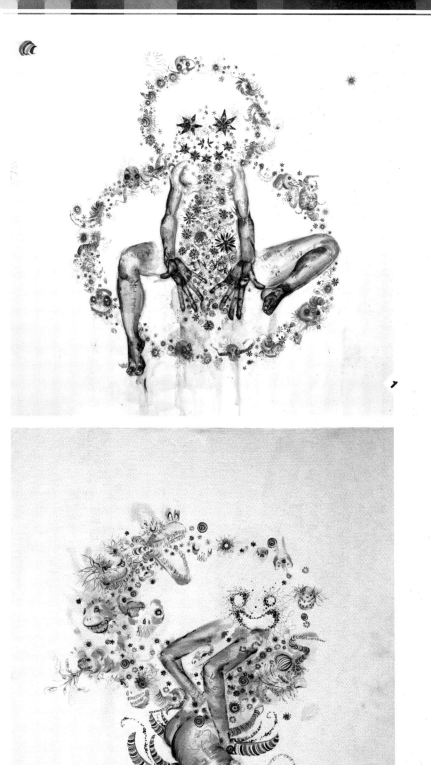

ARTIST__**KELSEY BROOKES**
TITLE__1-**"THE UNIVERSE IS IN YOU"** . 2-**"WELCOME TO THE PLUNGE"** . 3-**"WILL IS SUBORDINATE TO REASON"**
TYPE OF WORK__**PAINTING**

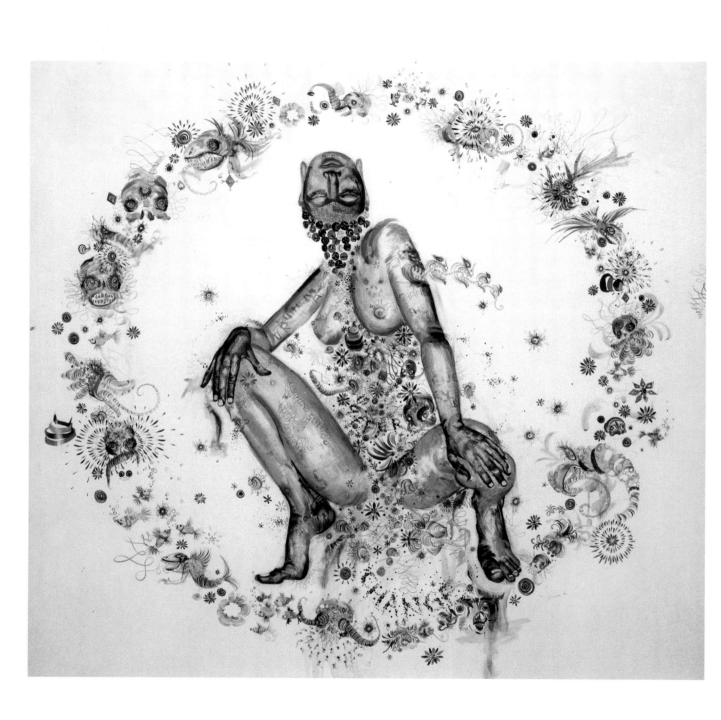

ARTIST__**KELSEY BROOKES**
TITLE__**"EVERYTHING SUFFERS, EVERYTHING CHANGES, THERE IS NO SOUL"**
TYPE OF WORK__**PAINTING**

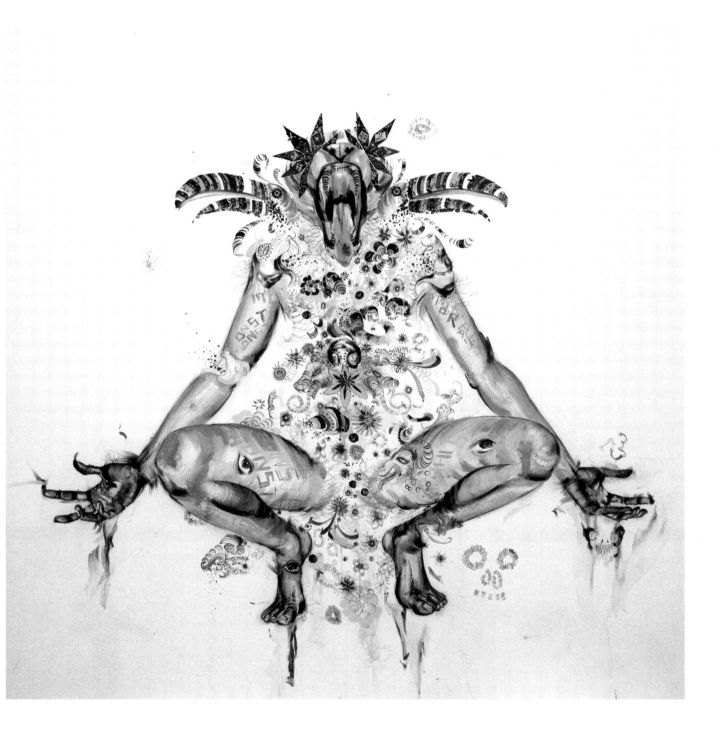

ARTIST__**KELSEY BROOKES**
TITLE__**"MONSTER MORALS"**
TYPE OF WORK__**PAINTING**

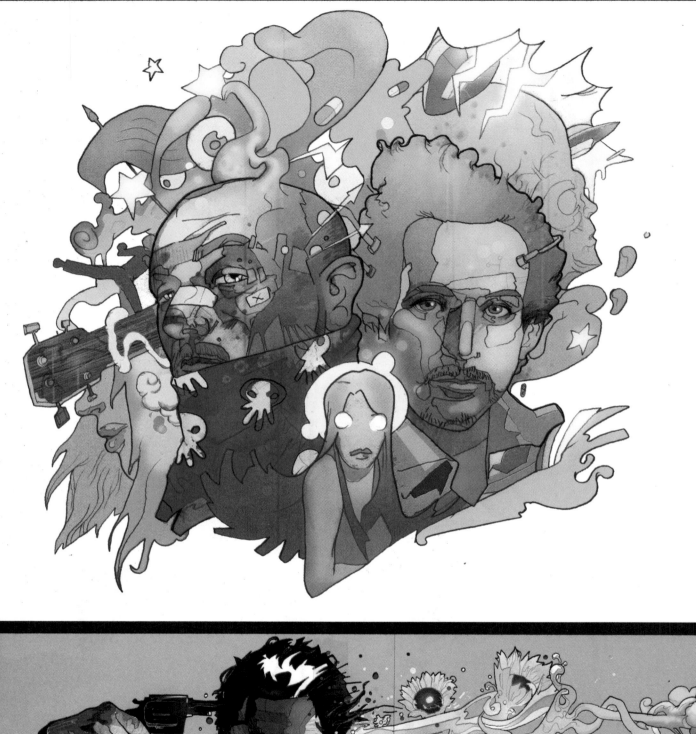
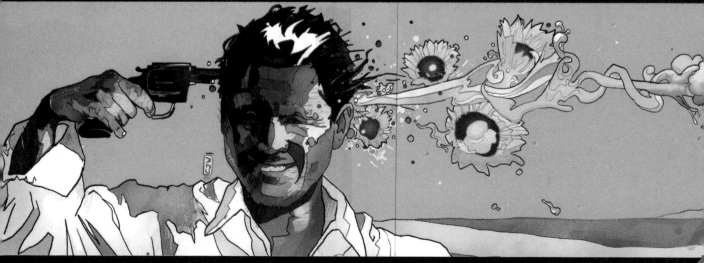

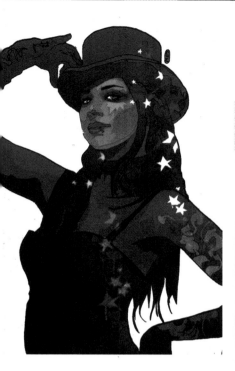

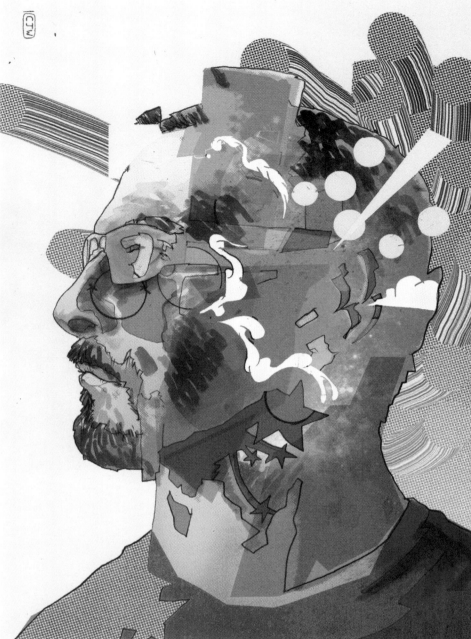

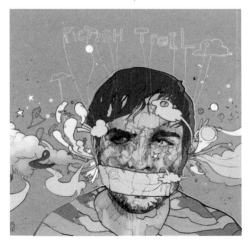

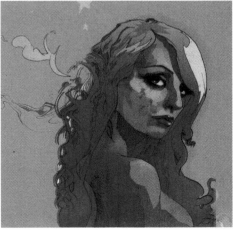

ARTIST__**CHRISTIAN WARD** TYPE OF WORK__**PRINT**

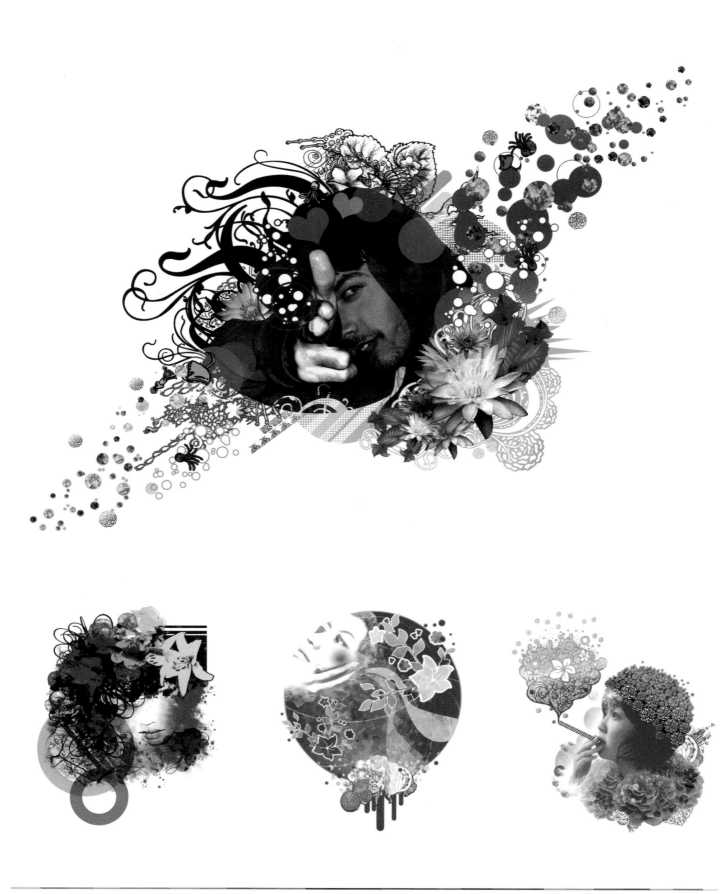

ARTIST__**YUKISTER** TYPE OF WORK__**COLLAGE**

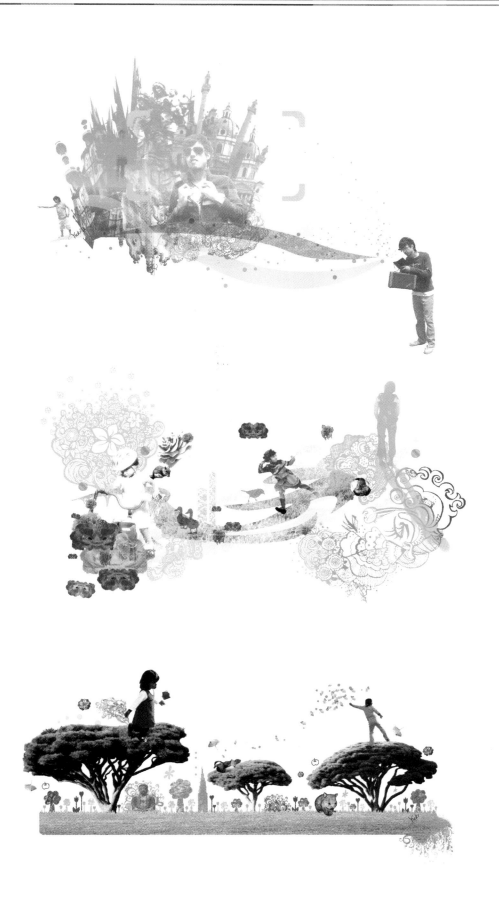

ARTIST__**YUKISTER** TYPE OF WORK__**COLLAGE**

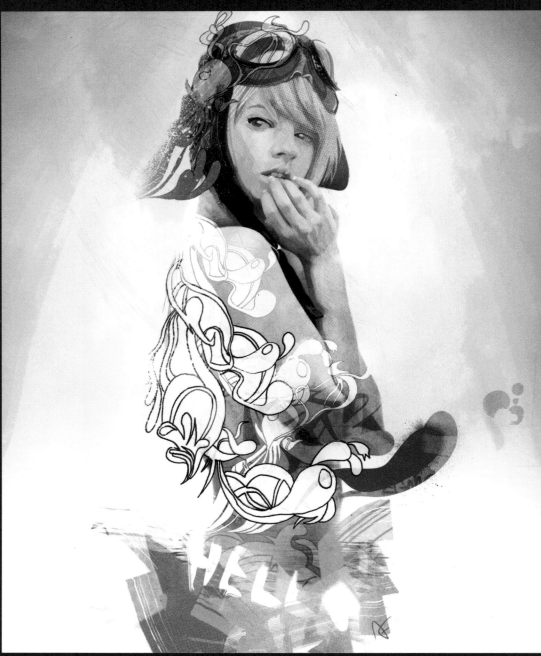

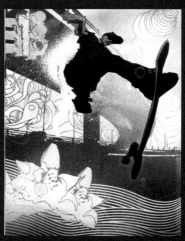

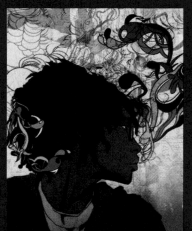

ARTIST__**FLORENT AUGUY**
PHOTOGRAHER__**AUGUY GIRL PHOTOGRAPH @ LEV DOLGACHOV**
TYPE OF WORK__**PRINT**

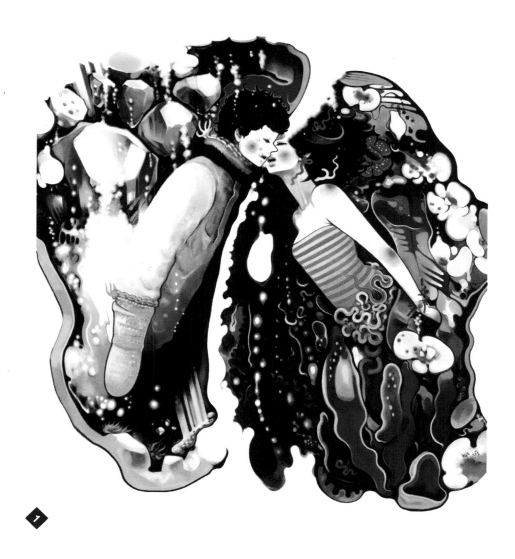

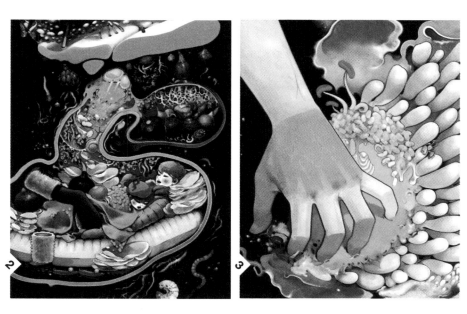

ARTIST__**MINCHI**
TITLE__**1-ALASKAN ORCHID . 2-TOUMIN . 3-HIDE AND SEEK**
TYPE OF WORK__**PRINT**

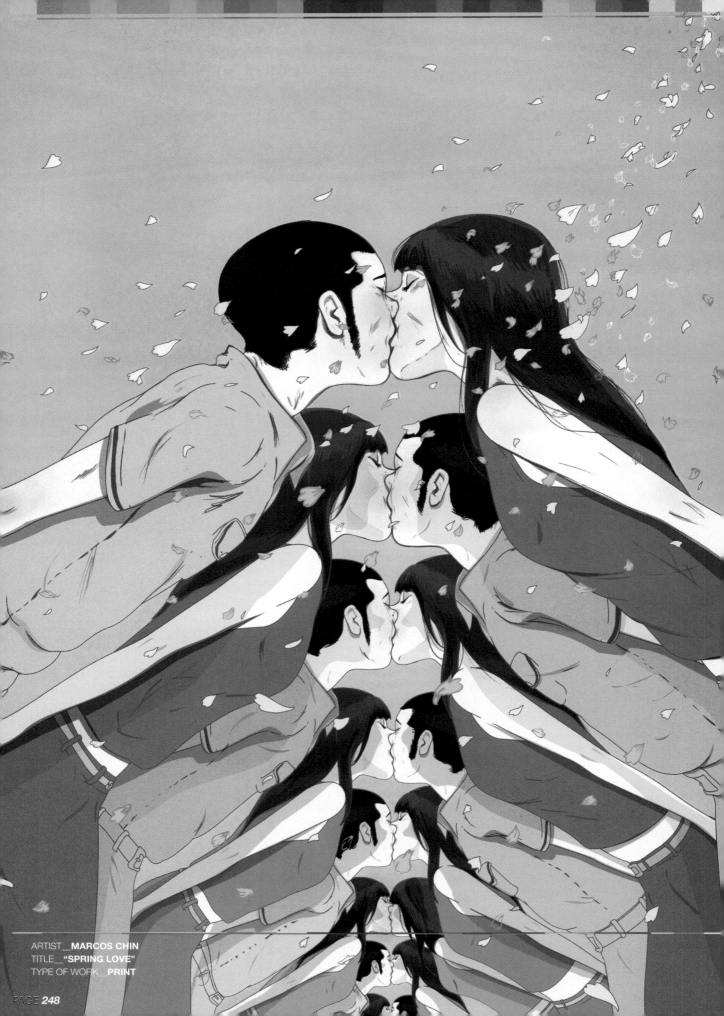

ARTIST__**MARCOS CHIN**
TITLE__**"SPRING LOVE"**
TYPE OF WORK__**PRINT**

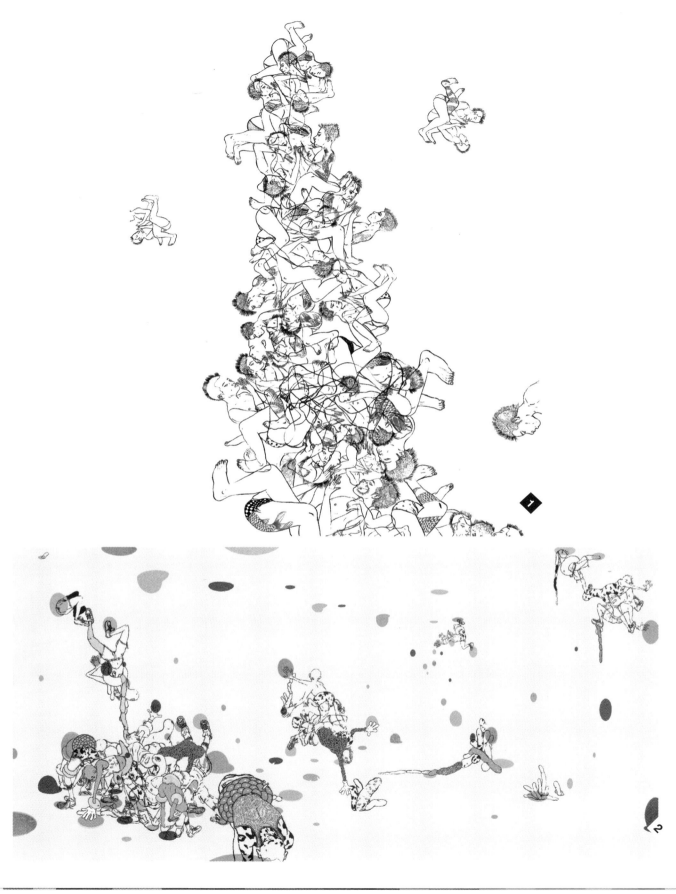

ARTIST__**MARCOS CHIN**
TITLE__**1-"PATTY CAKE" . 2-"HIP TWIST"**
TYPE OF WORK__**PRINT**

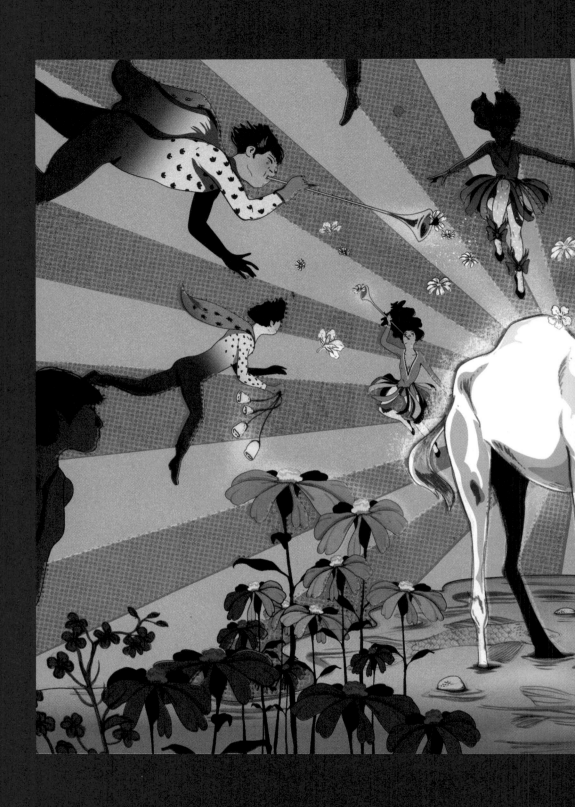

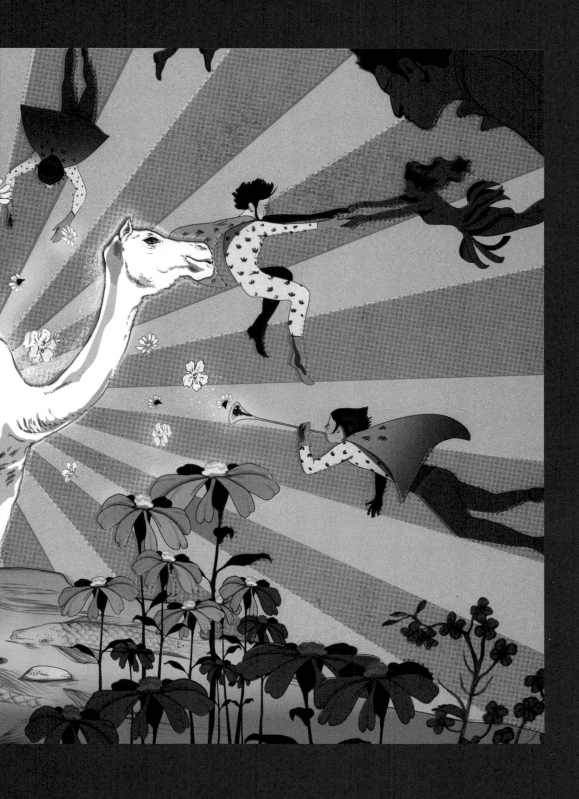

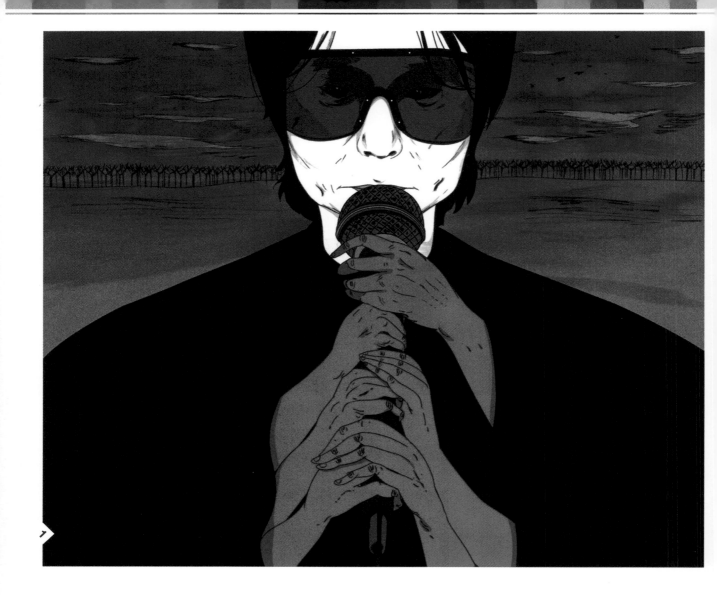

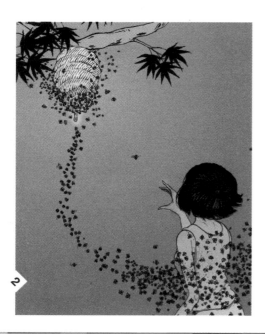

ARTIST__**MARCOS CHIN**
TITLE__1-**"YOKO ONO, YES, I'M A WITCH"** . 2-**"MY PAIN, MY BRAIN"**
TYPE OF WORK__**PRINT**

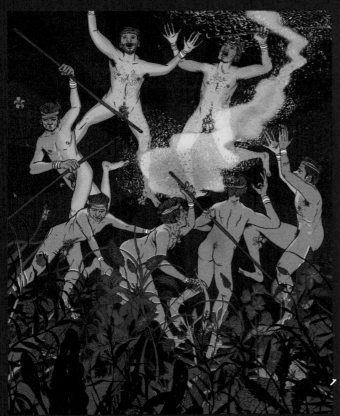

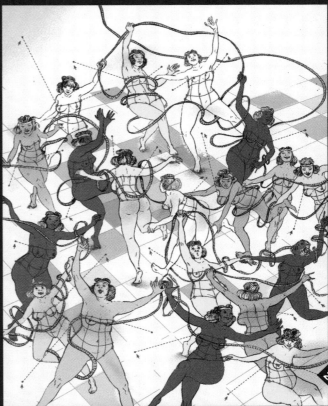

ARTIST__**MARCOS CHIN**
TITLE__**1-"UNTITLED" . 2-"HI-TECH BODY IMAGE"**
TYPE OF WORK__**PRINT**

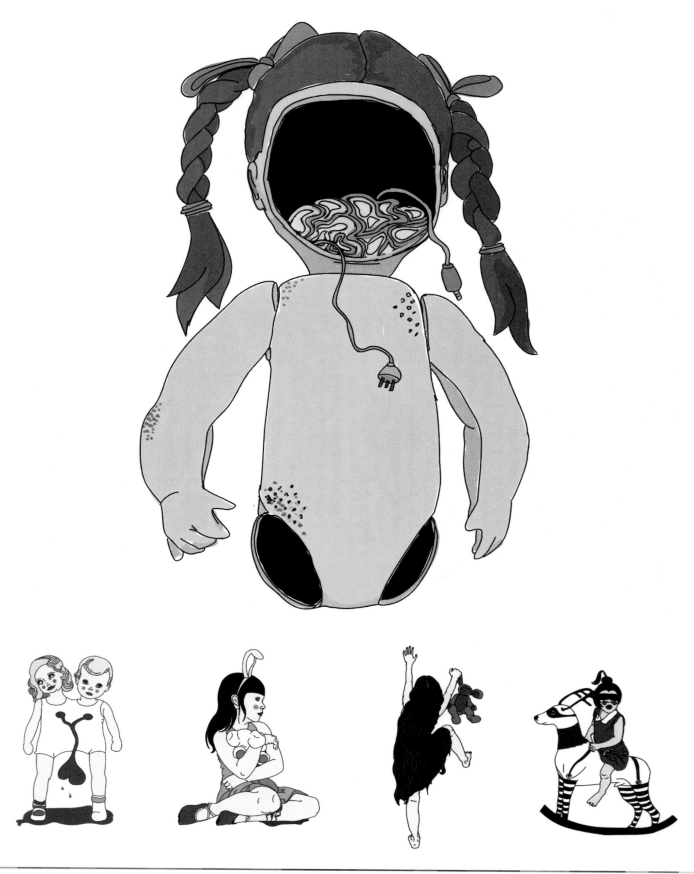

ARTIST__**SUICIDEHAPPY**　TYPE OF WORK__**PRINT**

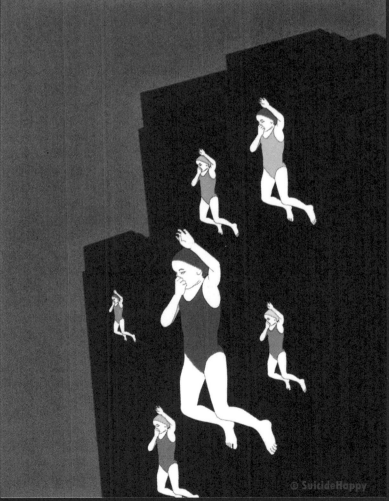

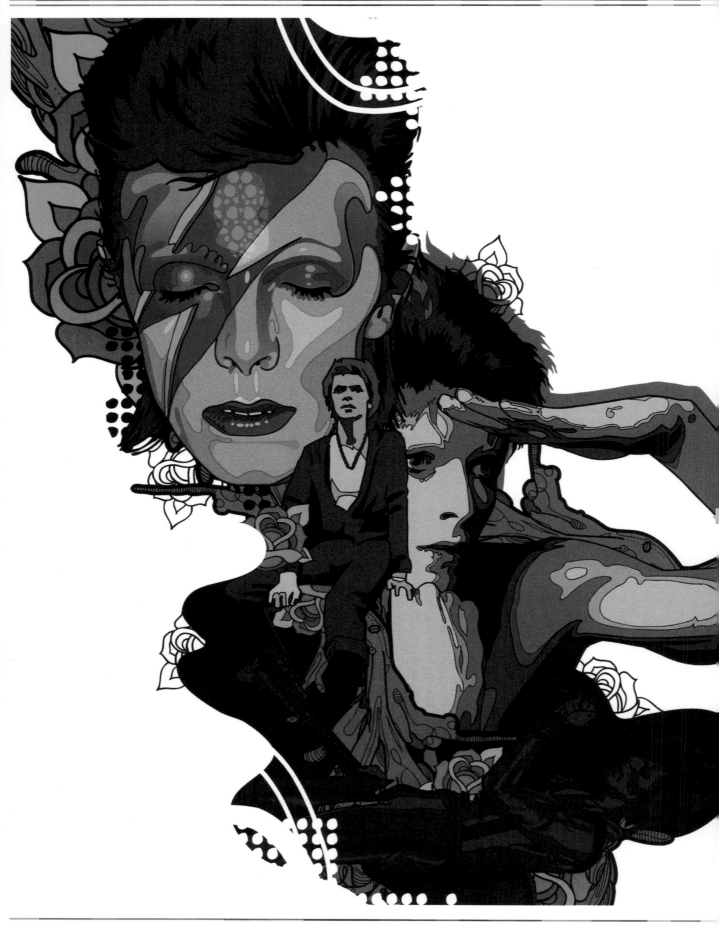

ARTIST__**EELCO VAN DEN BERG** TYPE OF WORK__**PRINT**

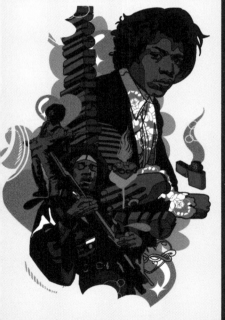

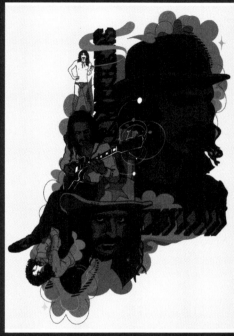

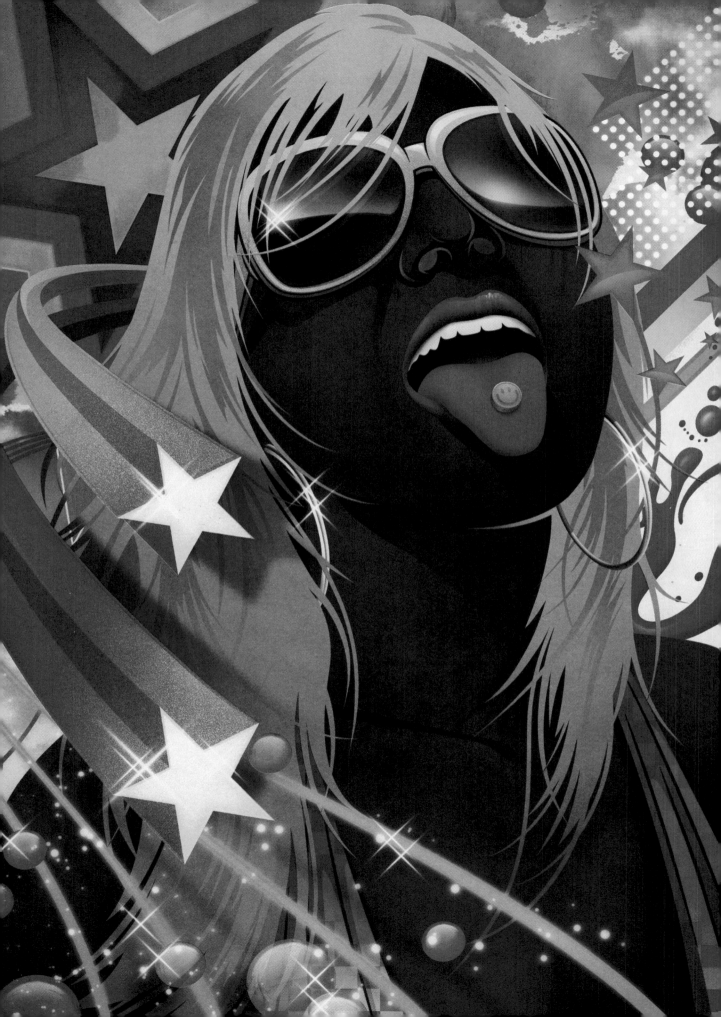

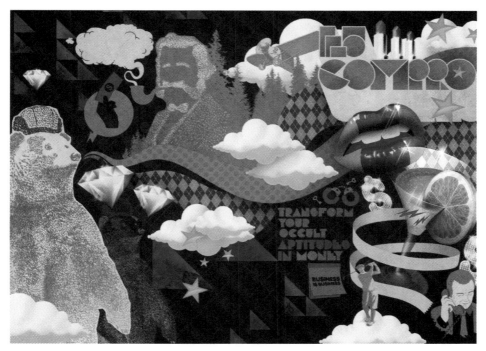

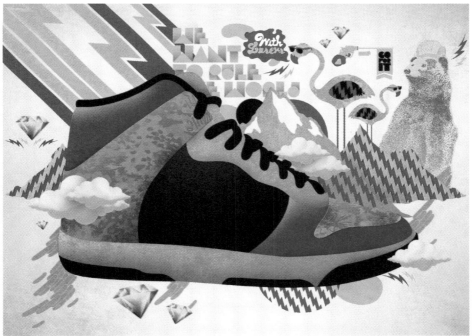

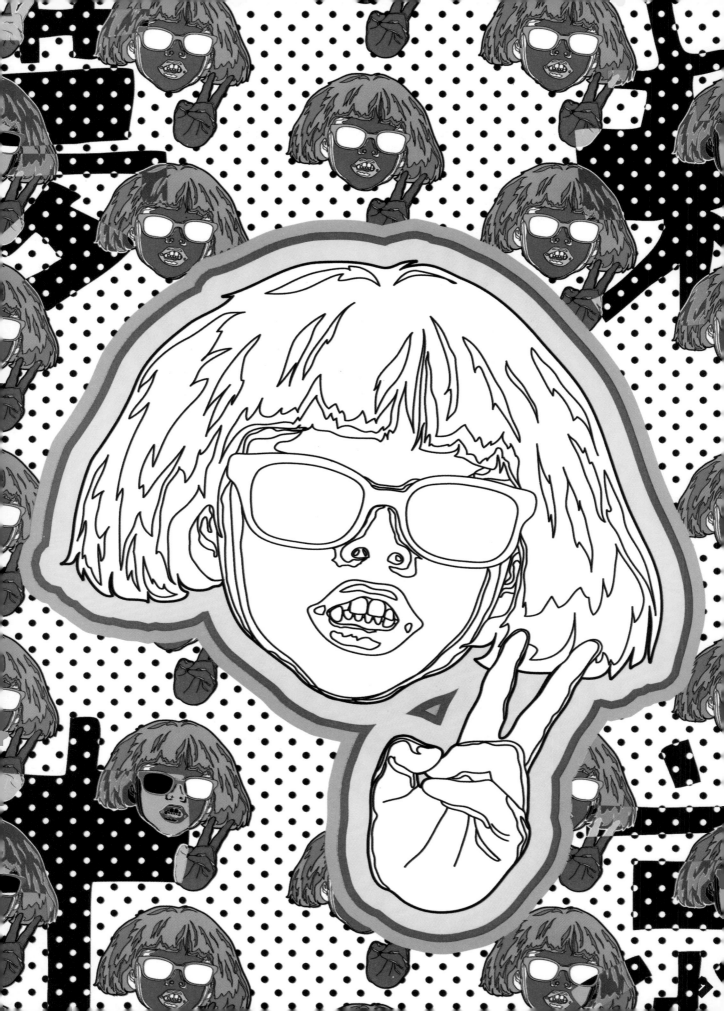

ARTIST__**MIKO** TYPE OF WORK__**INSTALLATION**

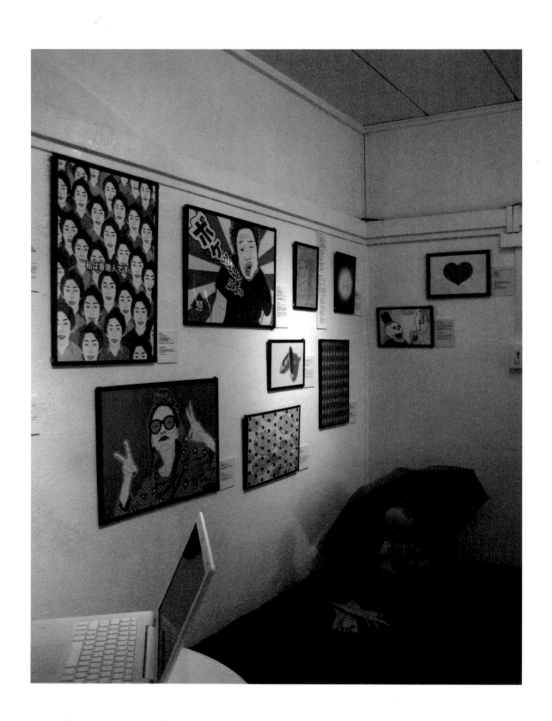

ARTIST__**MIKO** TYPE OF WORK__**PRINT & INSTALLATION**

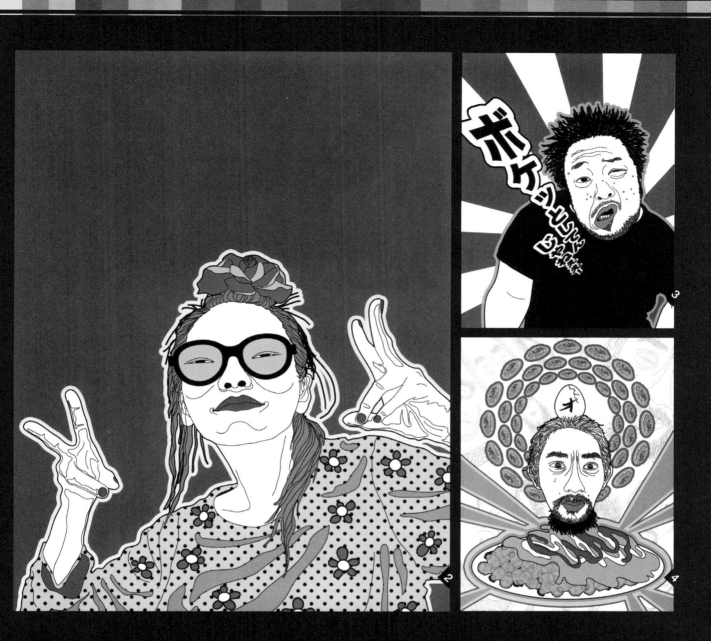

ARTIST__**MIKO**
TITLE__**1-MIKO** 東京夢中 . **2-Room-mate** . **3-Manager Nakamori** . **4-まーちゃんのオムライス**
TYPE OF WORK__**PRINT**

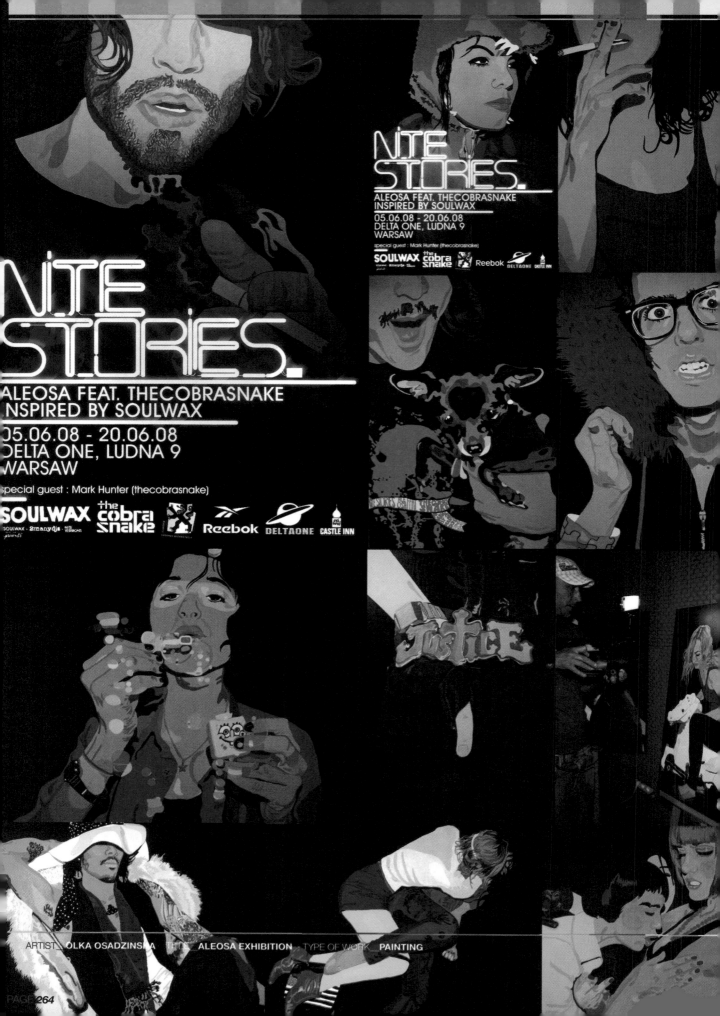

ARTIST__**OLKA OSADZINSKA** TITLE__**ALEOSA BAG** TYPE OF WORK__**PAINTING**

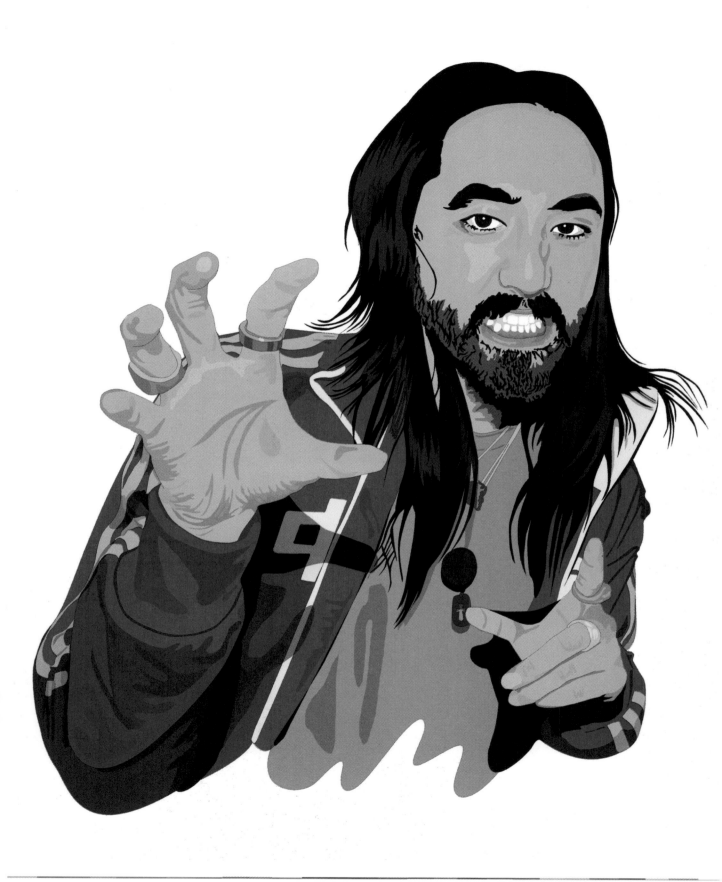

ARTIST__**OLKA OSADZIŃSKA** TITLE__**STEVE AOKI** TYPE OF WORK__**ILLUSTRATION**

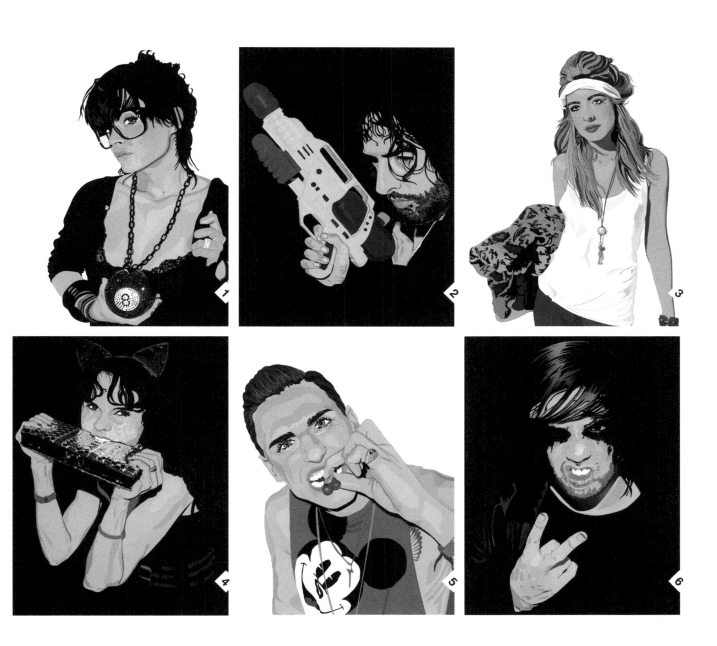

ARTIST__**OLKA OSADZIŃSKA**
TYPE OF WORK__**ILLUSTRATION**

TITLE__**1-New York (Reebok World Tour), feat. Thefacehunter . 2-Black Series***
3-London (Reebok World Tour), feat. Thefacehunter . 4-Black Series*
5-Drop The Lime, Drop The Cherries . 6-Black Series*

* Black Series, Club 55 Warsaw, feat. Thecobrasnake

ARTIST__**BOB LONDON** TYPE OF WORK__**ILLUSTRATION**

ARTIST__**DEESK • XAVIER BRUNET** TYPE OF WORK__**PRINT**

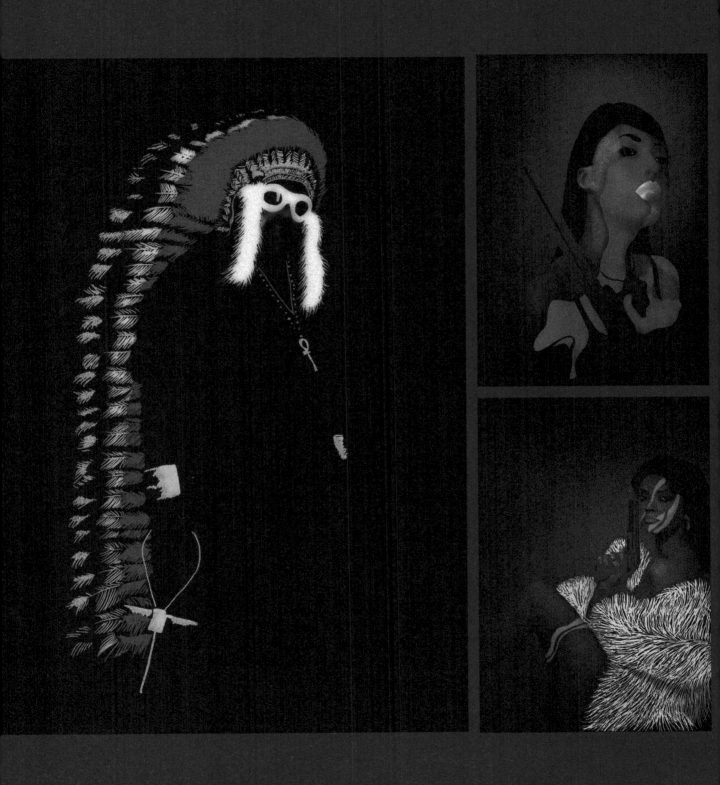

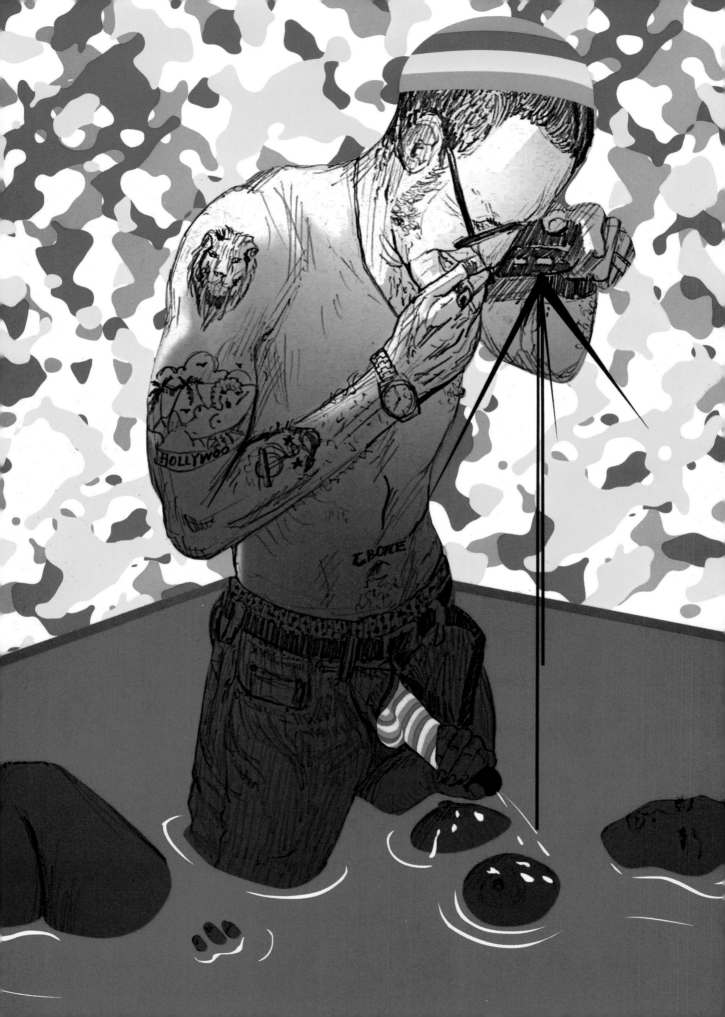

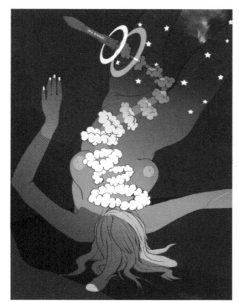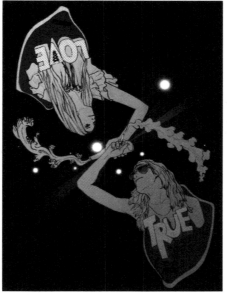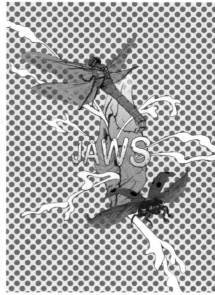

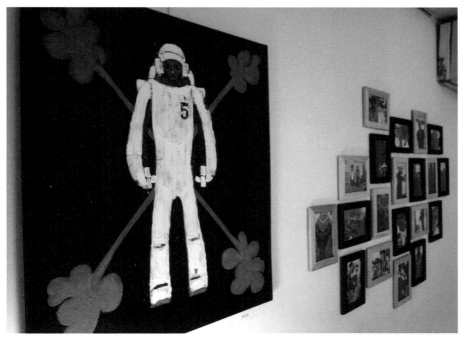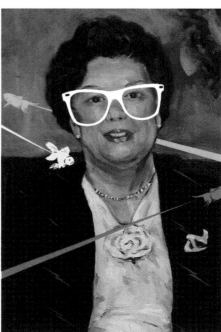

ARTIST__**COWPER WANG** TYPE OF WORK__**ILLUSTRATION & INSTALLATION**

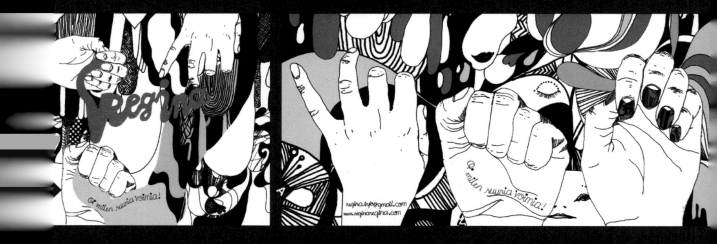

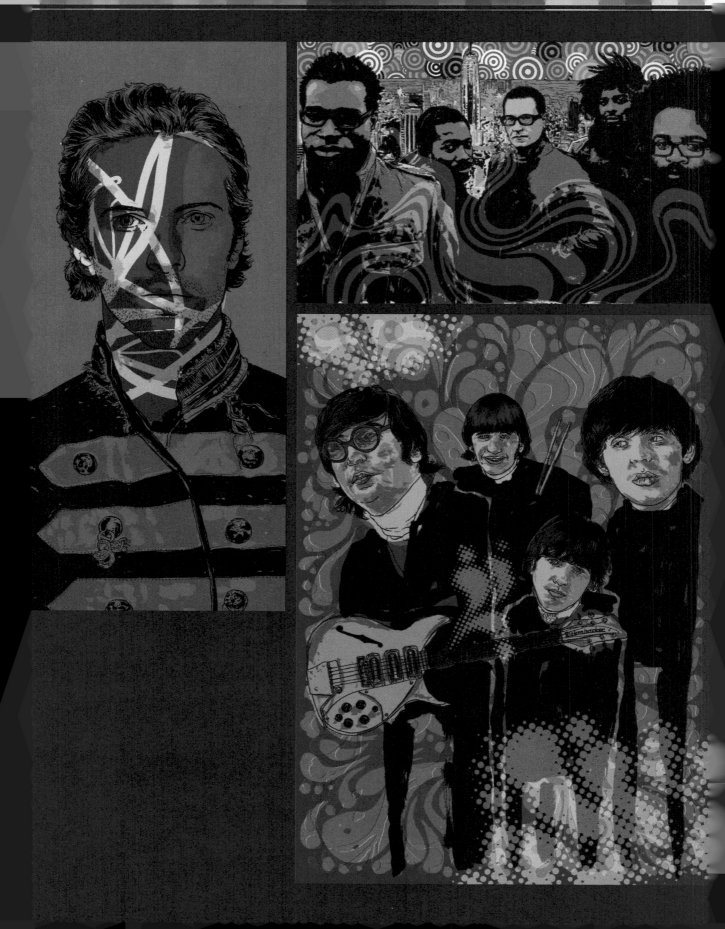

ARTIST__**JAN FEINDT** TYPE OF WORK__**ILLUSTRATION**

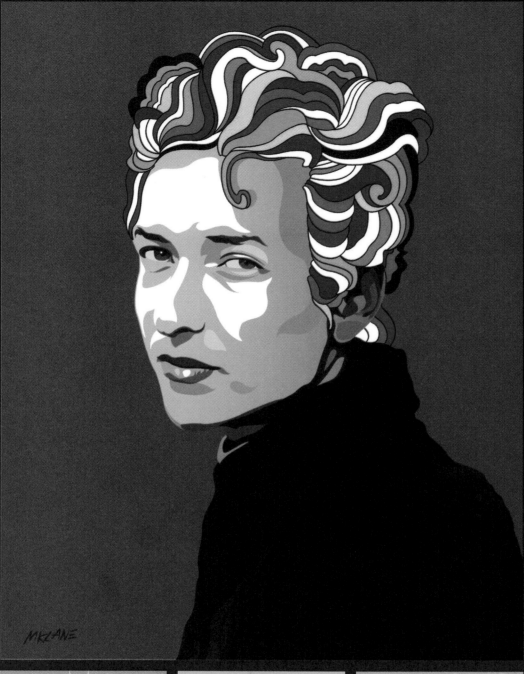

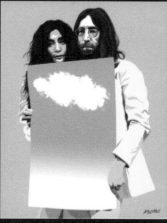

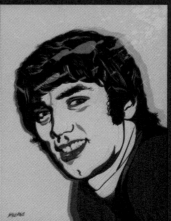

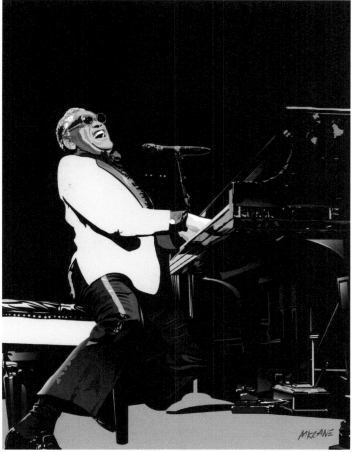

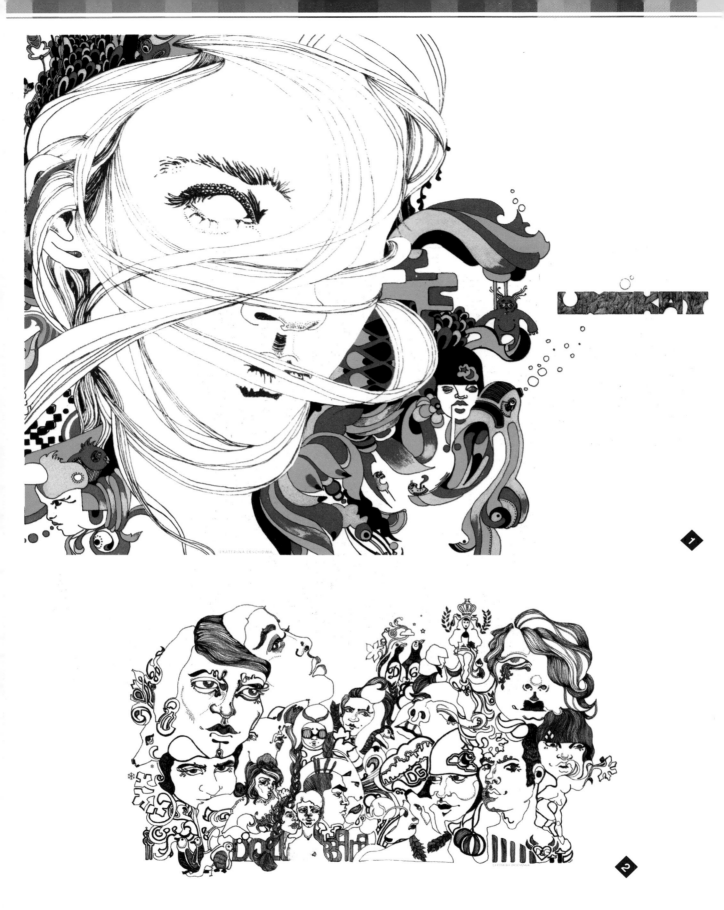

ARTIST__**EKATERINA ERSCHOWA**
TITLE__**1-"UNIKAT" . 2-"SUMMERFALLWINTER"**
TYPE OF WORK__**PRINT**

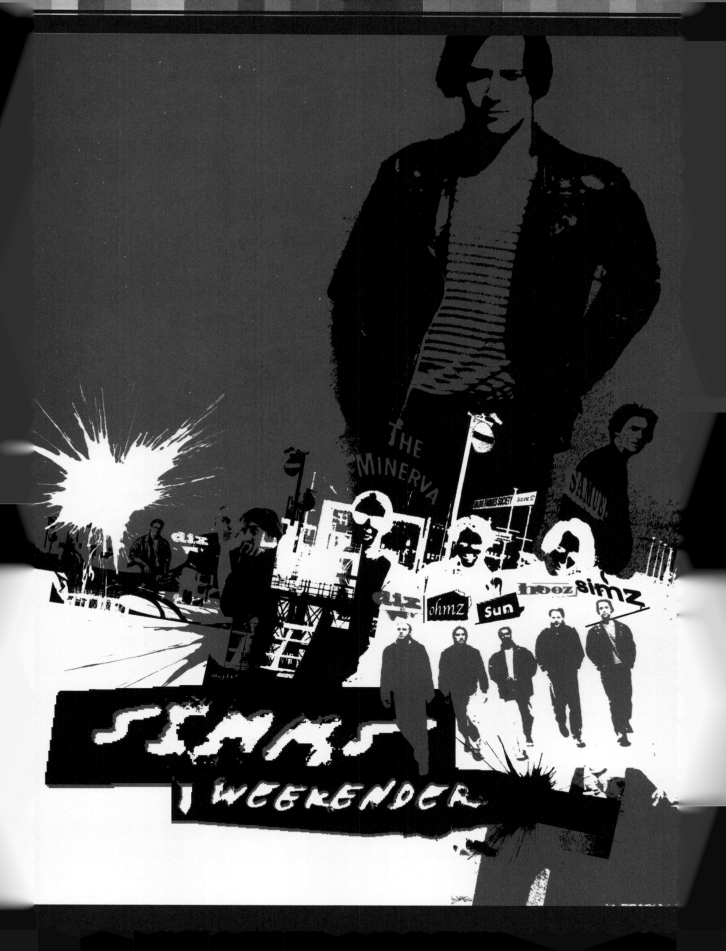

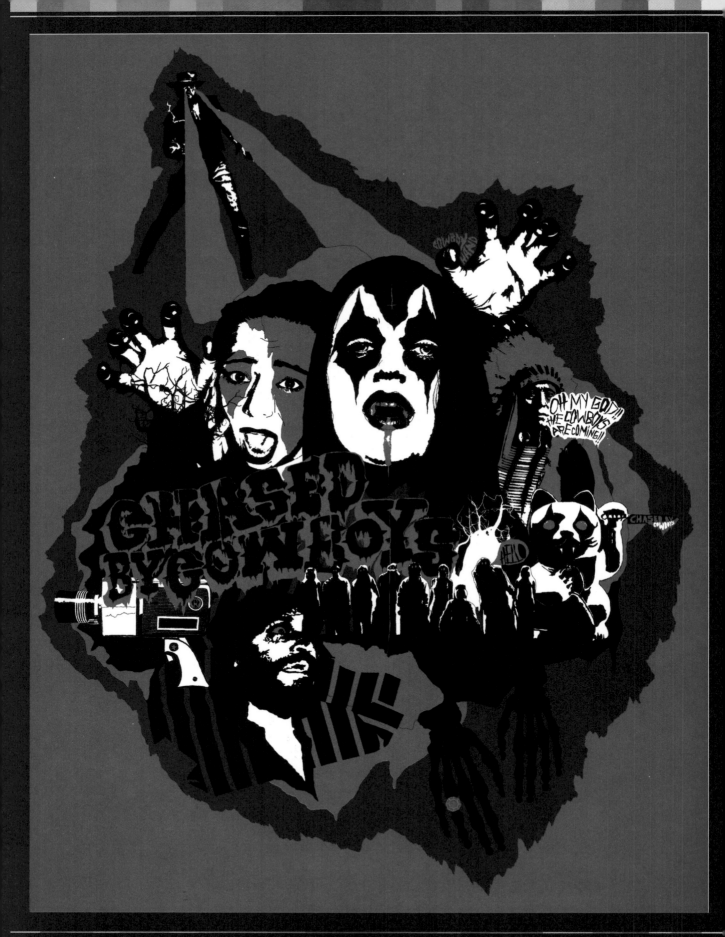

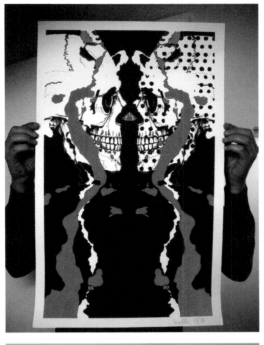
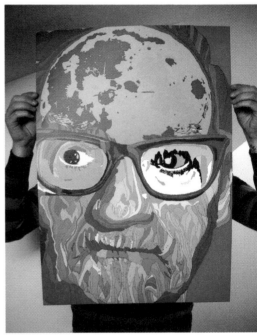
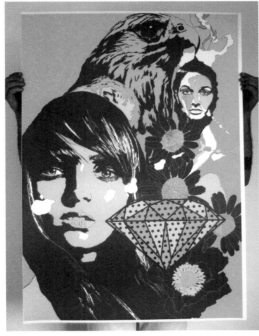
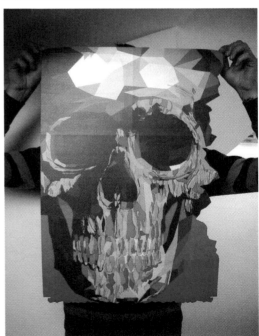

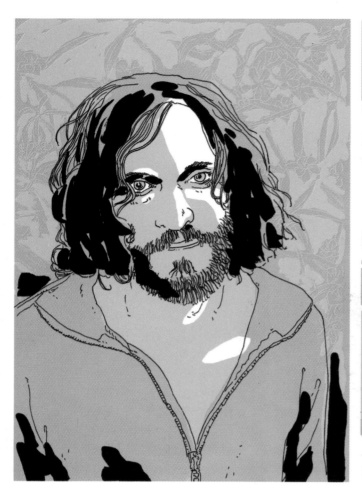

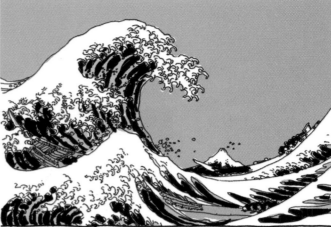

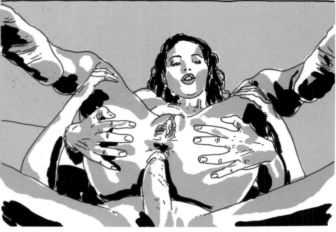

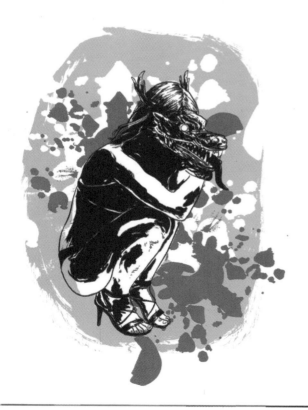

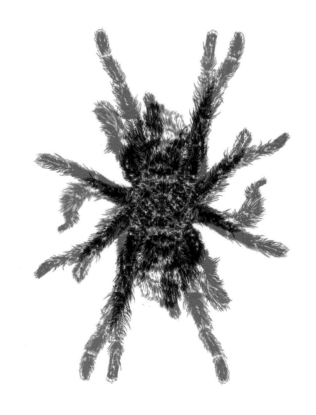

ARTIST__**JAN FEINDT** TYPE OF WORK__**ILLUSTRATION**

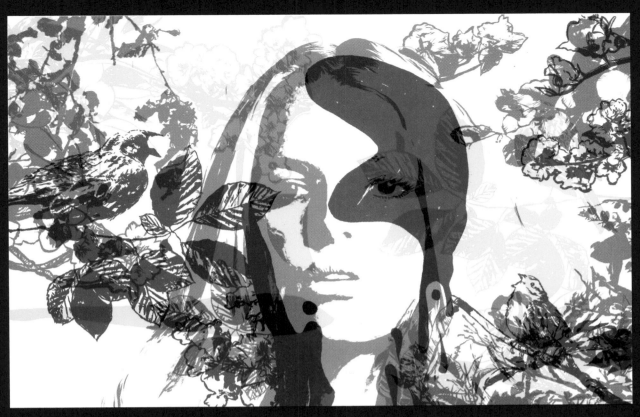

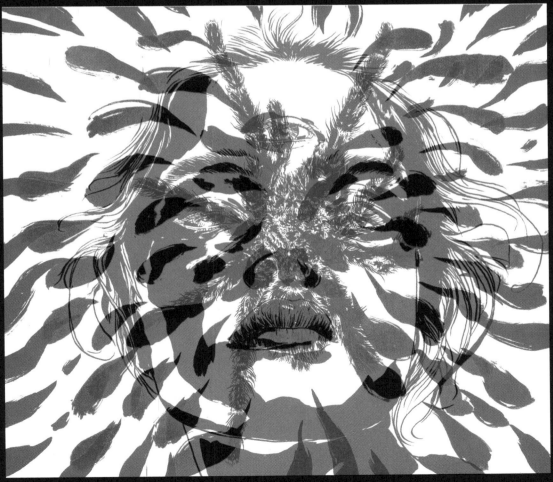

ARTIST__**JAN FEINDT** TYPE OF WORK__**ILLUSTRATION**

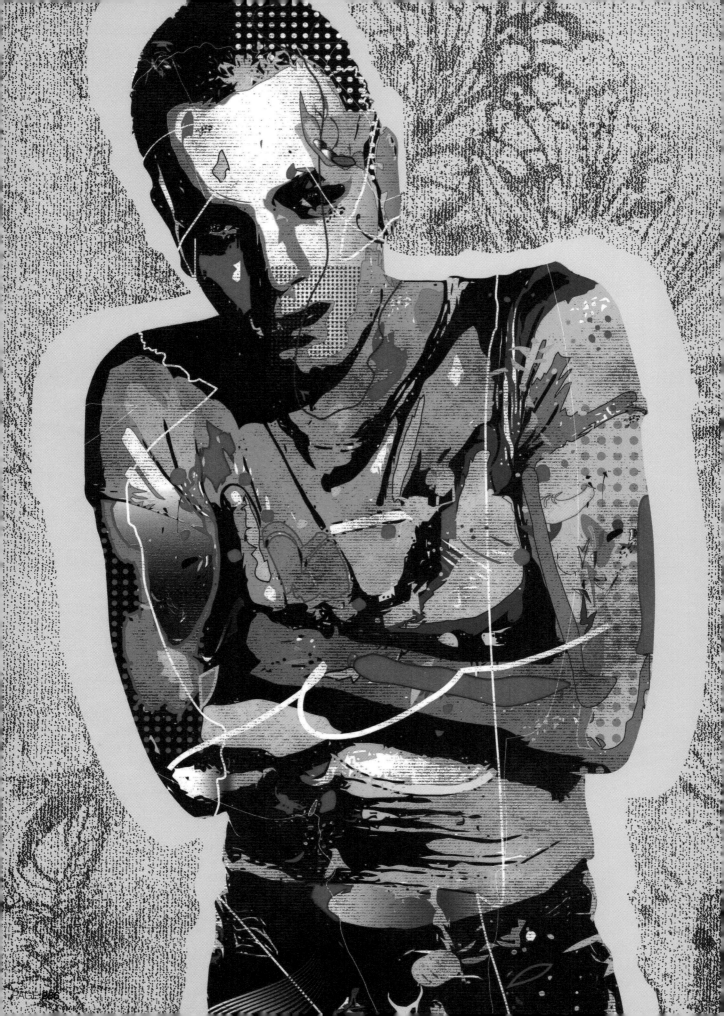

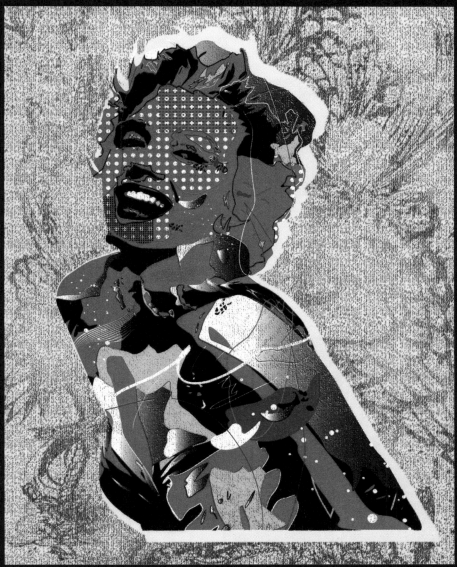

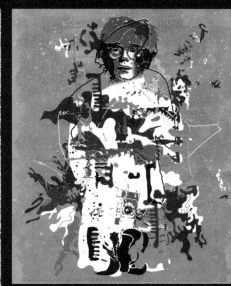

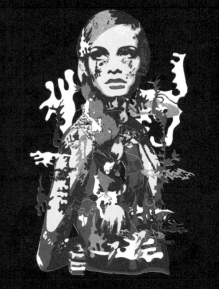

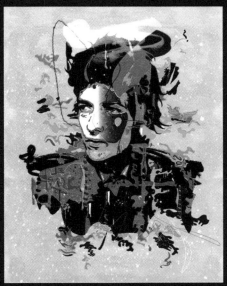

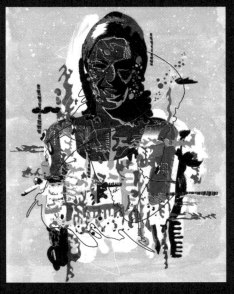

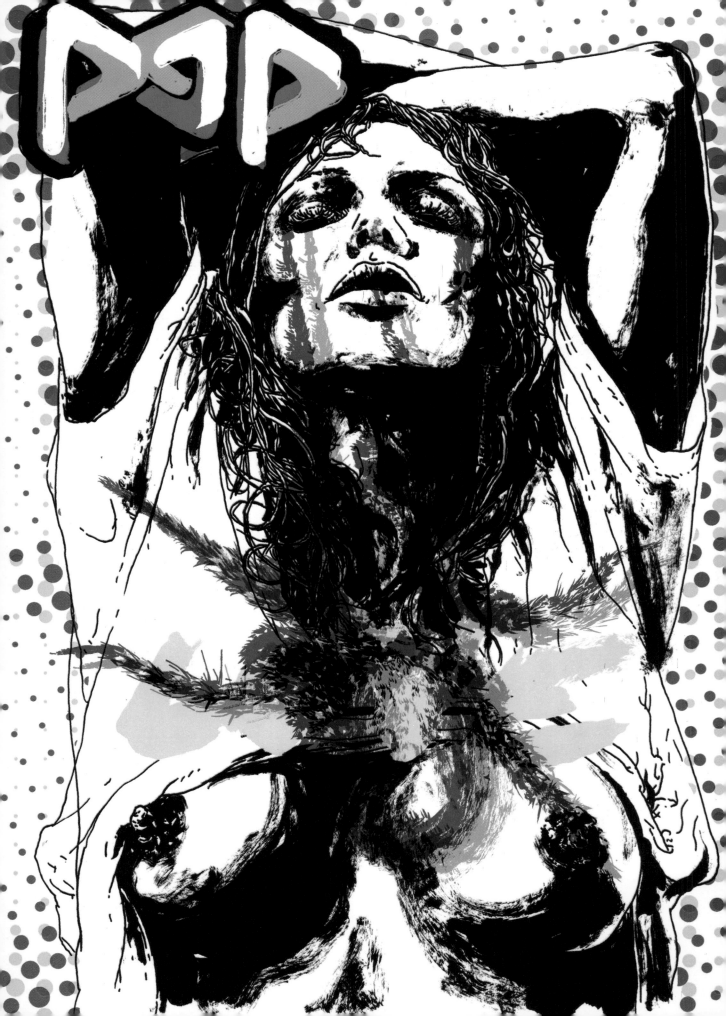

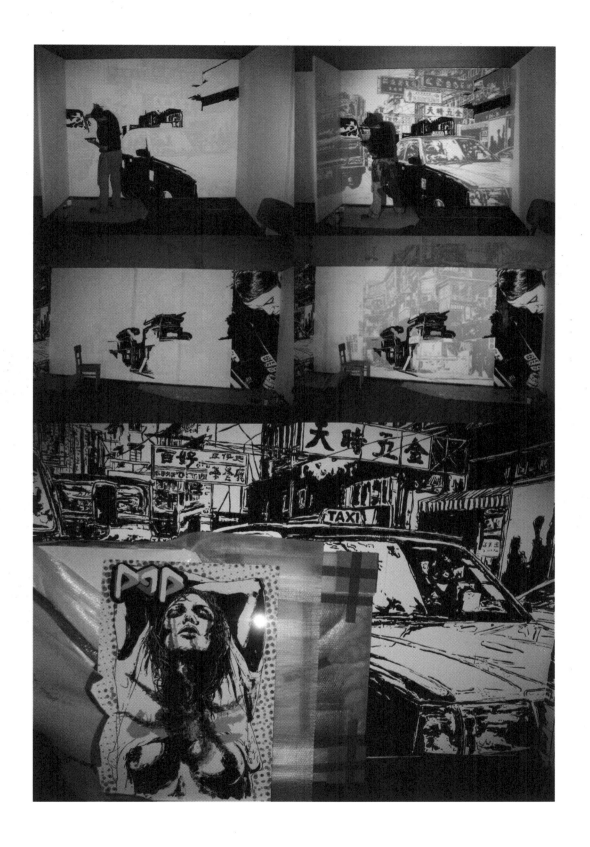

ARTIST__**JAN FEINDT** TYPE OF WORK__**INSTALLATION**

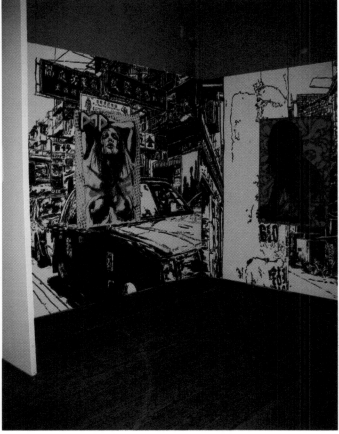

ARTIST__**JAN FEINDT** TYPE OF WORK__**INSTALLATION**

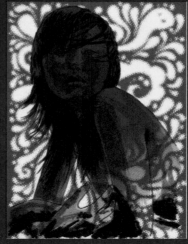
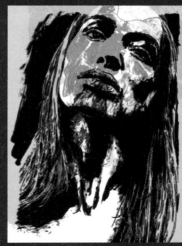
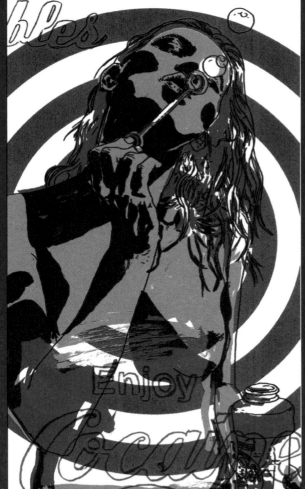
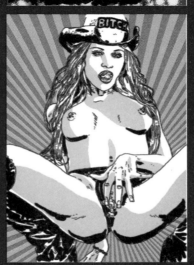
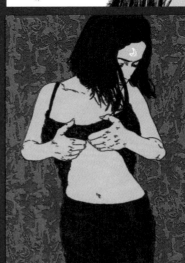

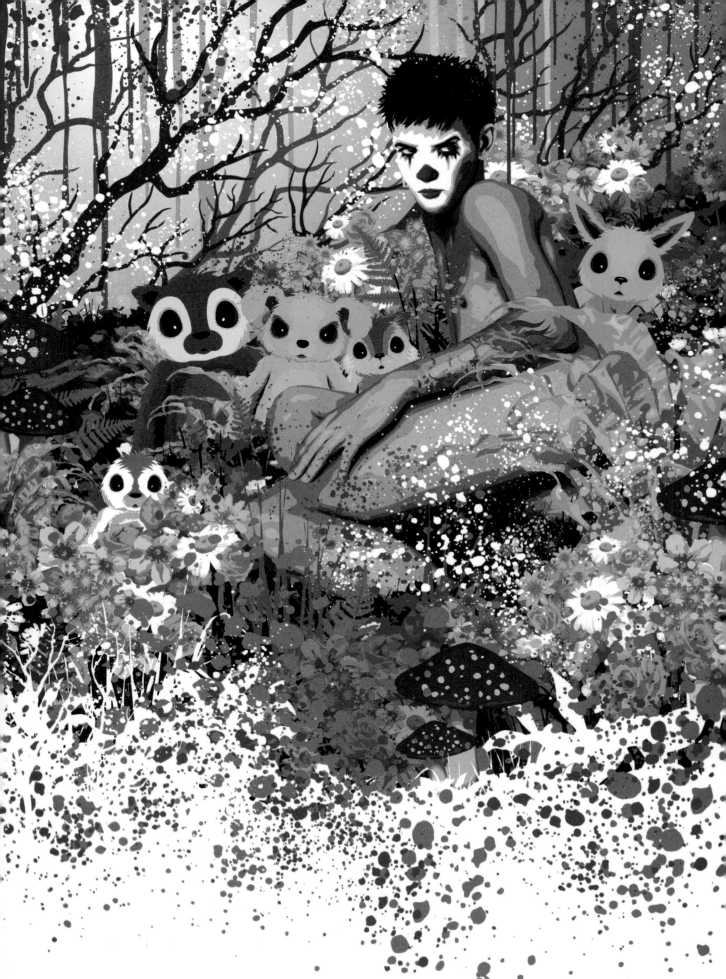

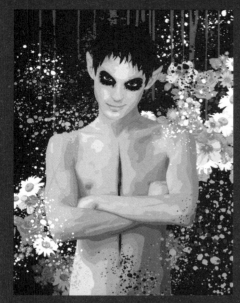
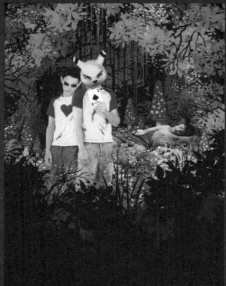
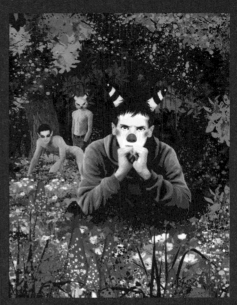
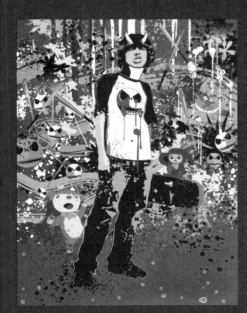
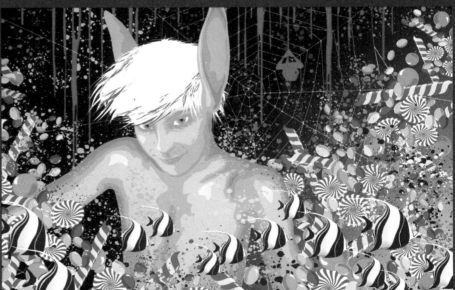

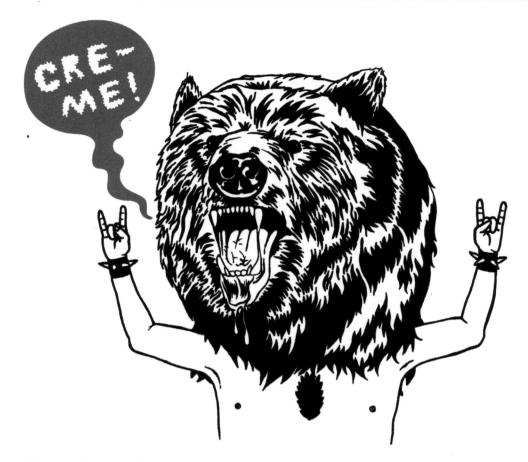

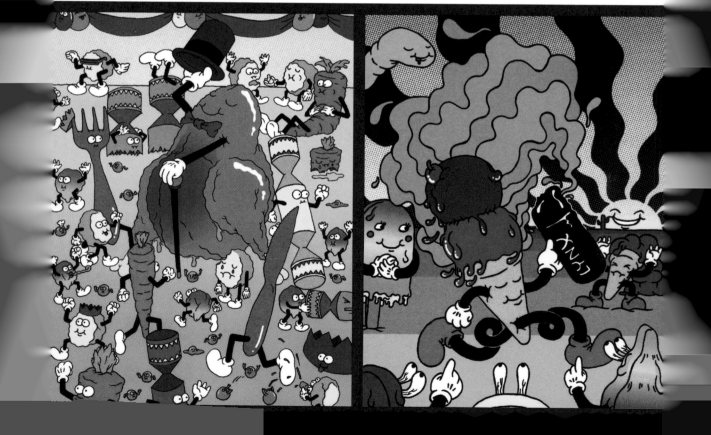

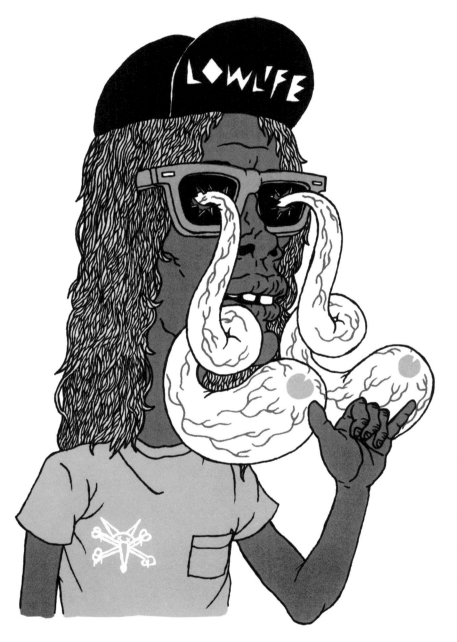

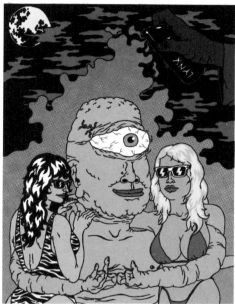

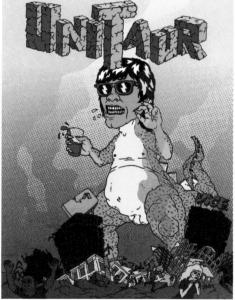

ARTIST__**JIROBEVIS** TYPE OF WORK__**PRINT**

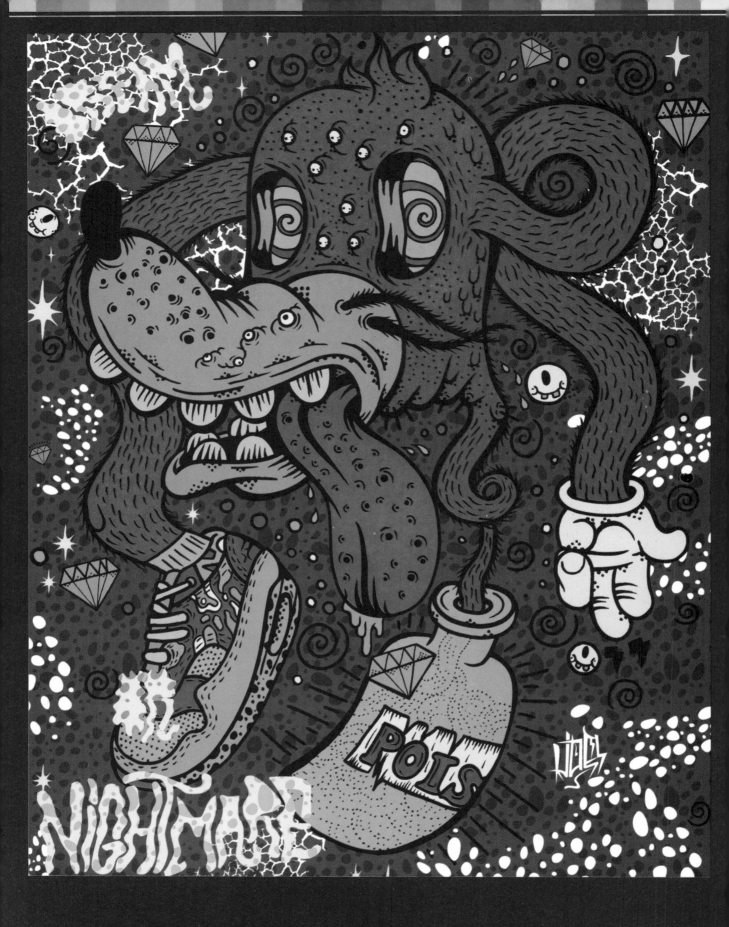

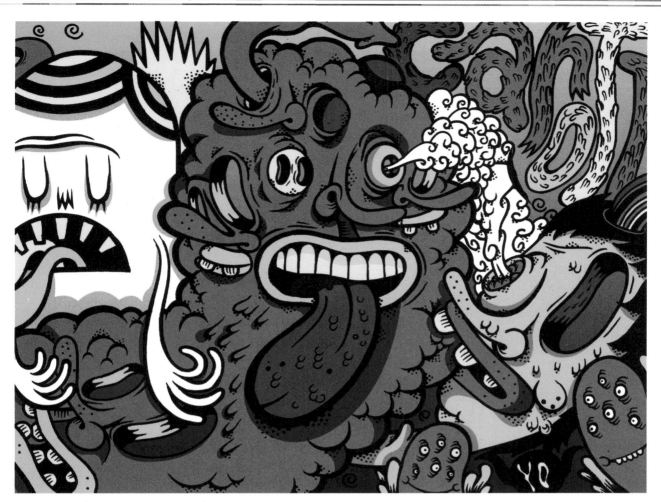

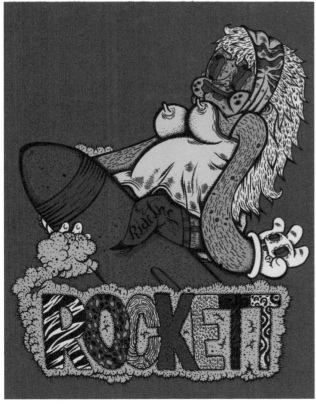

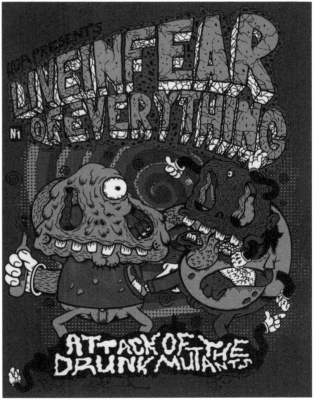

ARTIST__**KOADZN** TYPE OF WORK__**PRINT**

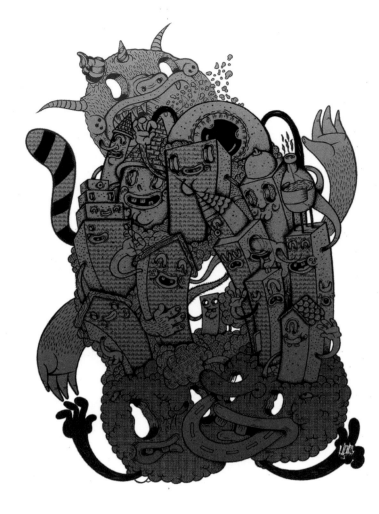

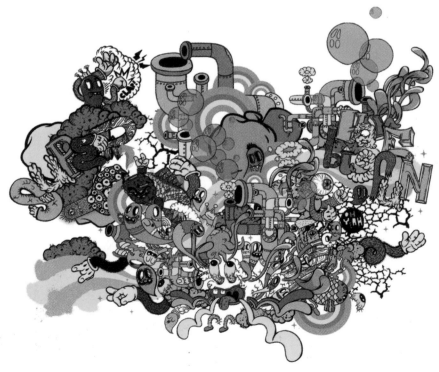

ARTIST__**KOADZN** TYPE OF WORK__**PRINT**

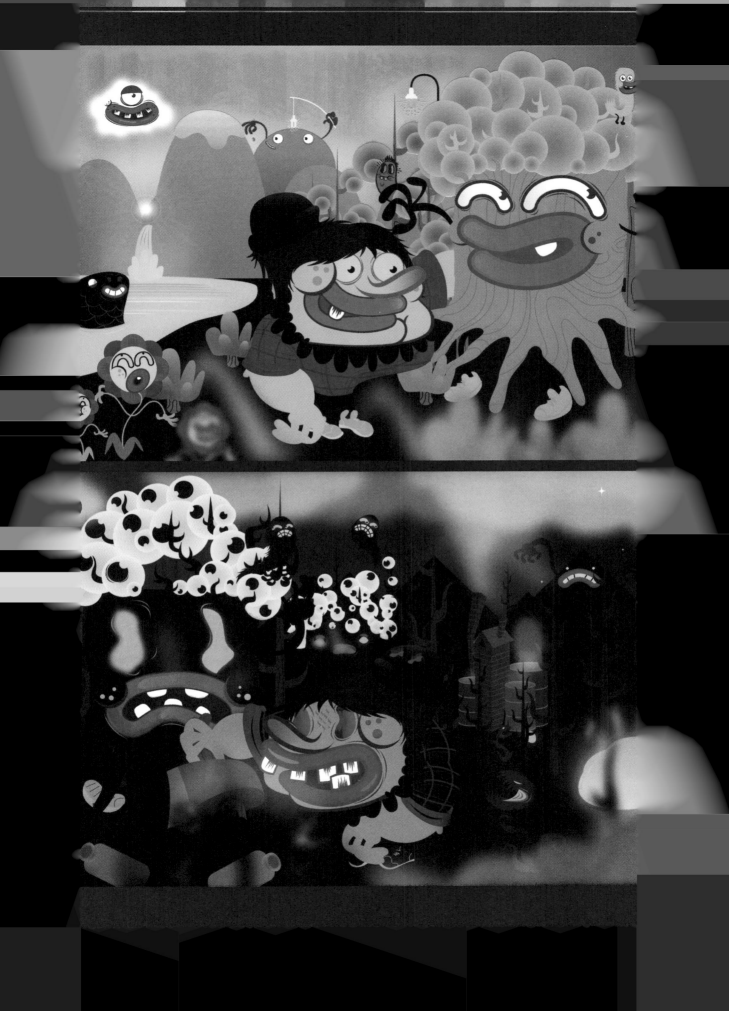

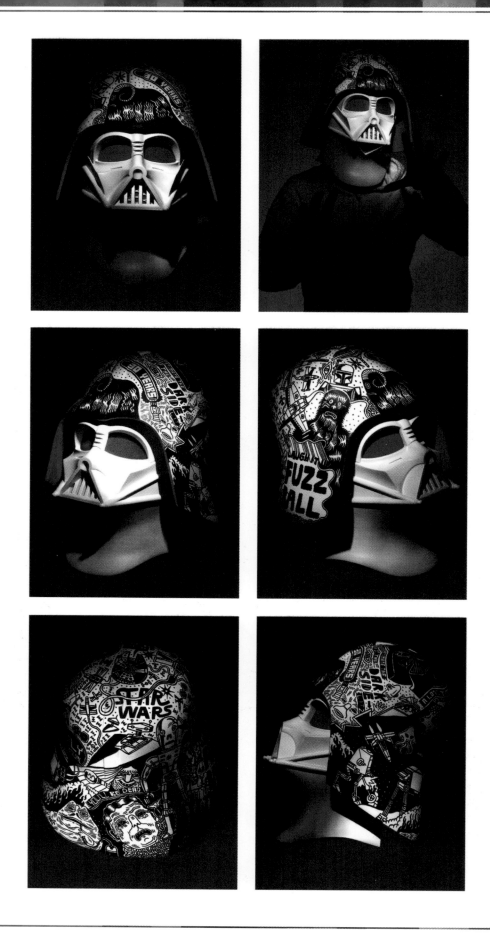

ARTIST__**SERGE SEIDLITZ** TYPE OF WORK__**ICON & CHARACTER**

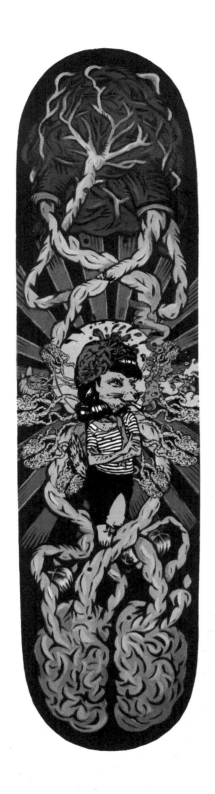
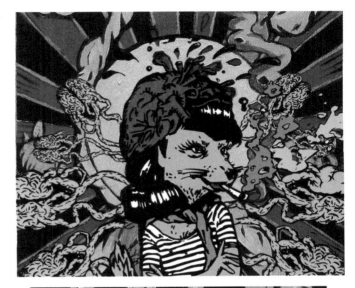

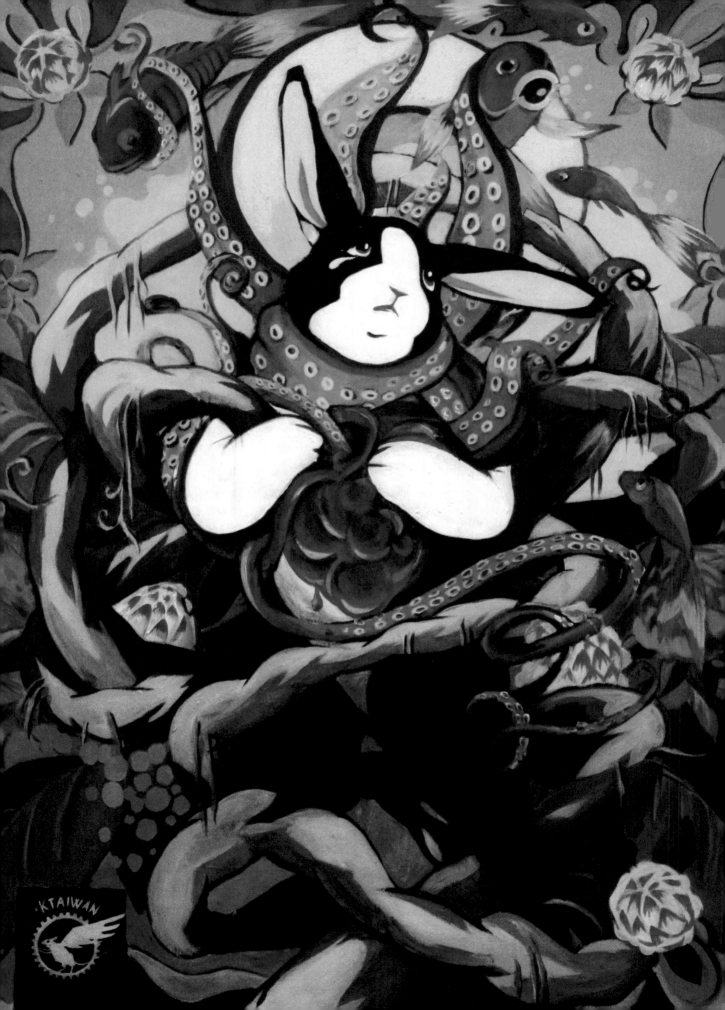

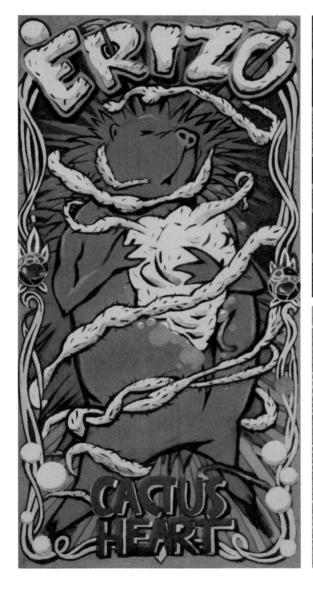

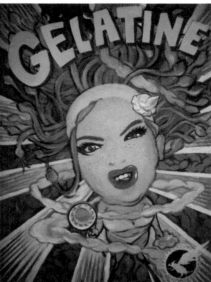

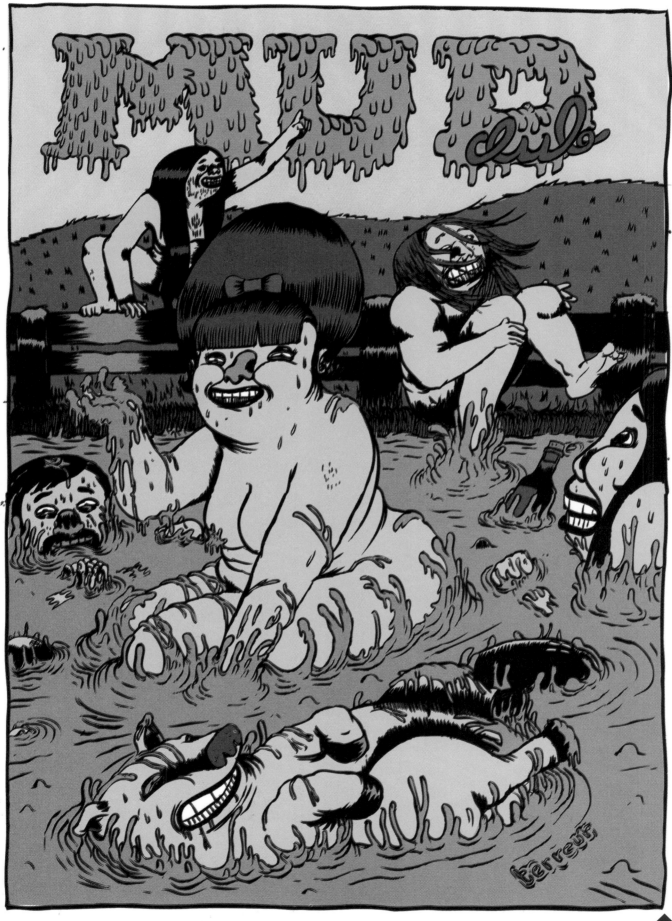

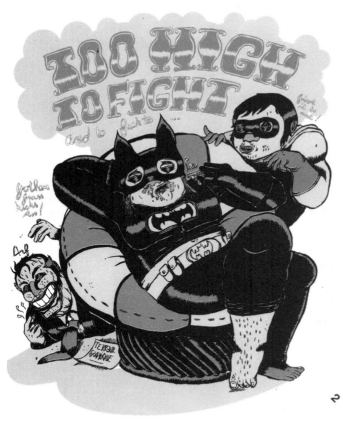

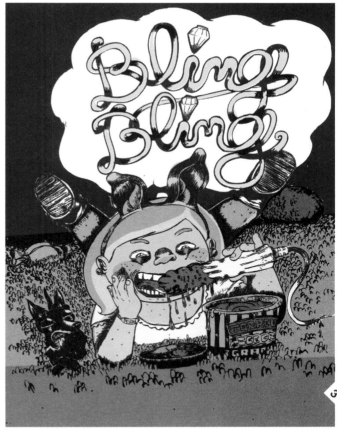

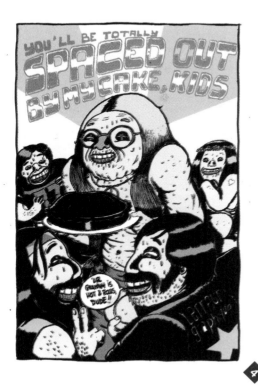

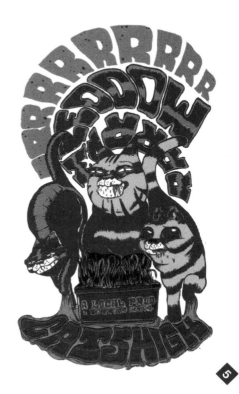

ARTIST__**TERREUR GRAPHIQUE**
TITLE__**1-"MUD CLUB"** . **2-"GOTHAM CITY GRASS KICKS ASS"** . **3-"BLING BLING"** . **4-"SPACED OUT"** . **5-"CATS HIGH"**
TYPE OF WORK__**PRINT**

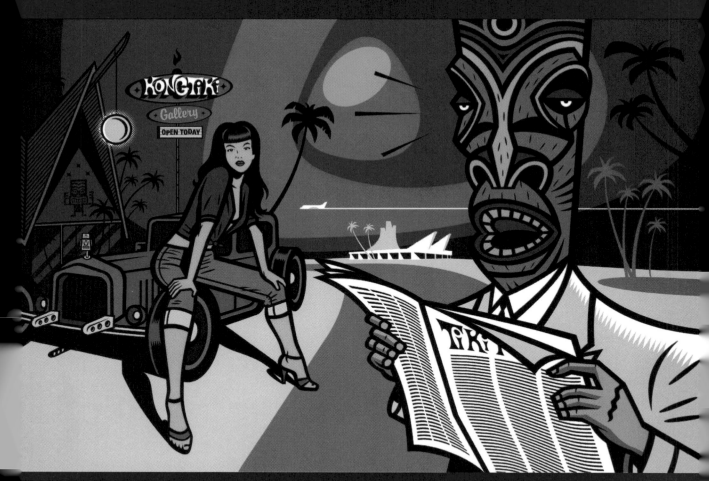

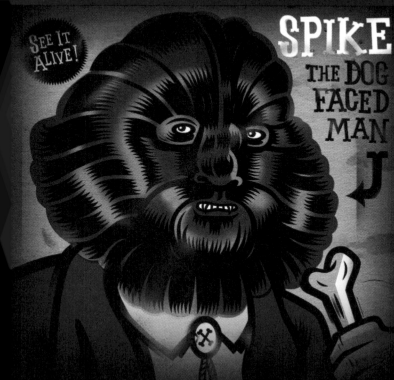

See It Alive!

SPIKE THE DOG FACED MAN

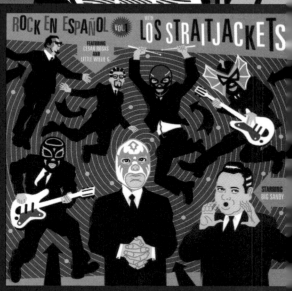

ROCK EN ESPAÑOL VOL 1 WITH LOS STRAITJACKETS

FEATURING CESAR ROSAS AND LITTLE WILLIE G

STARRING BIG SANDY

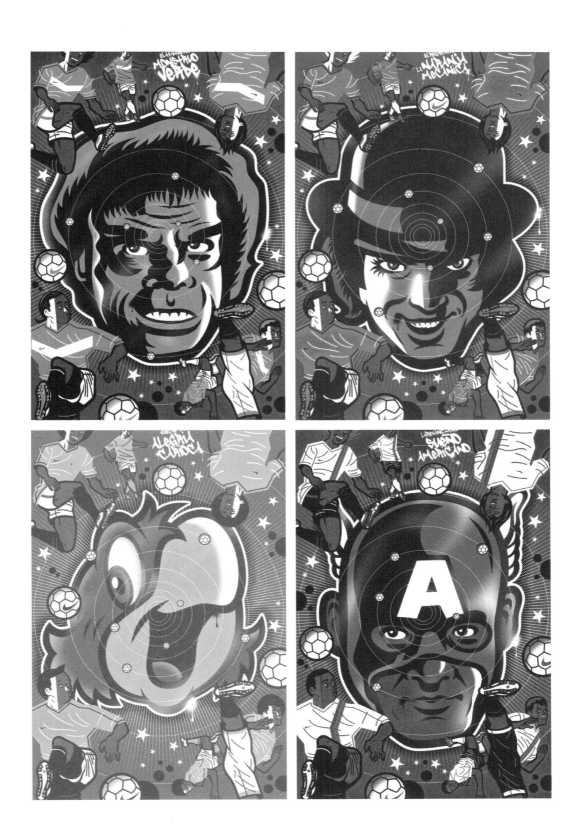

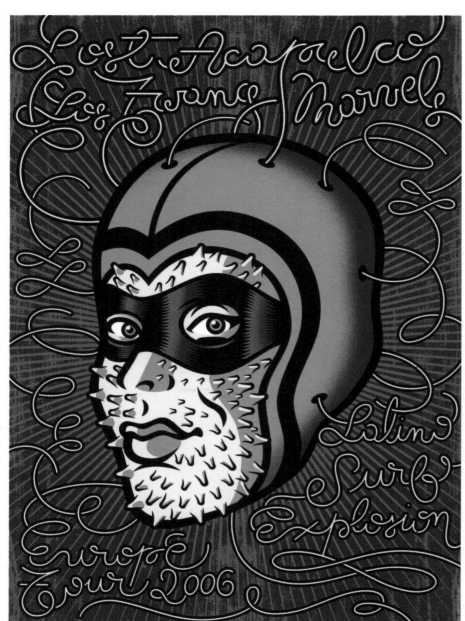

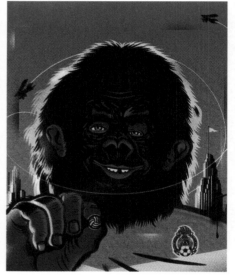

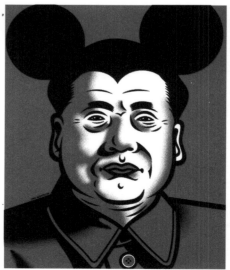

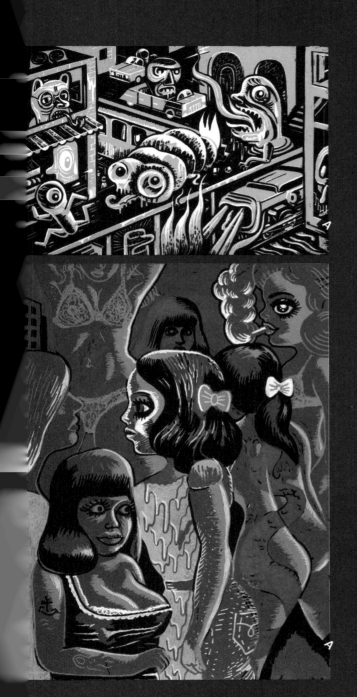
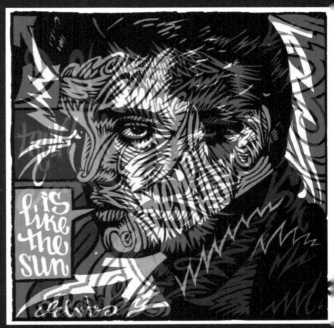

is
like
the
sun

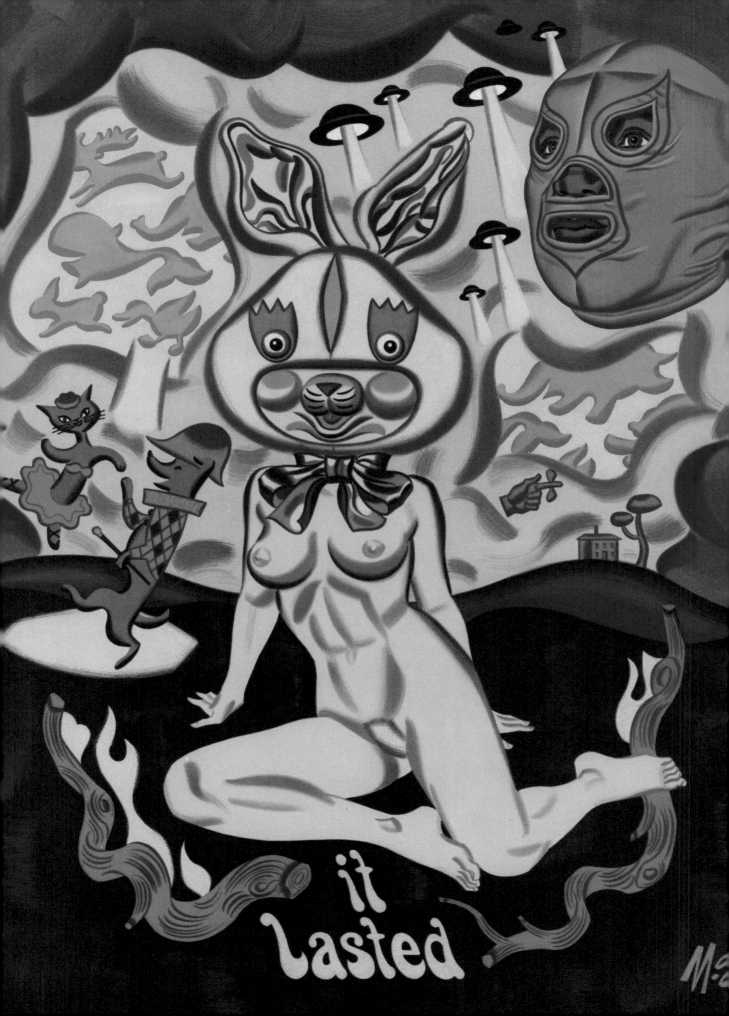

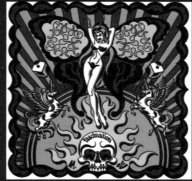
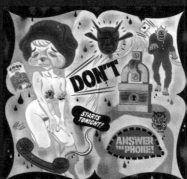
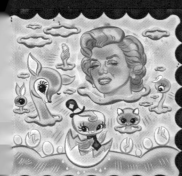
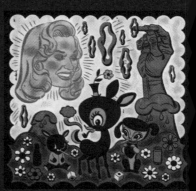
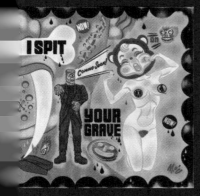
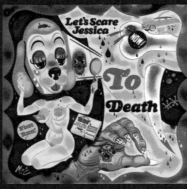
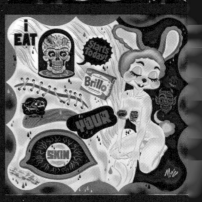

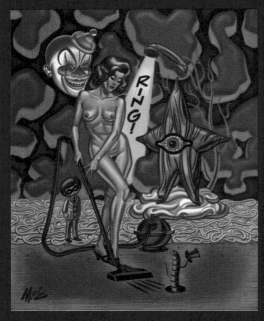

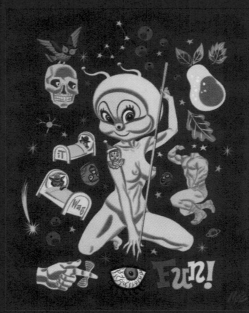

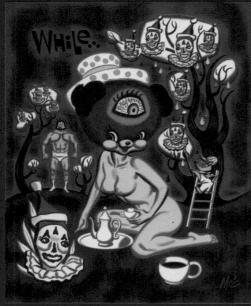

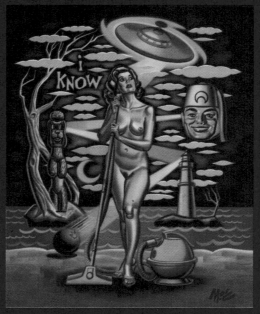

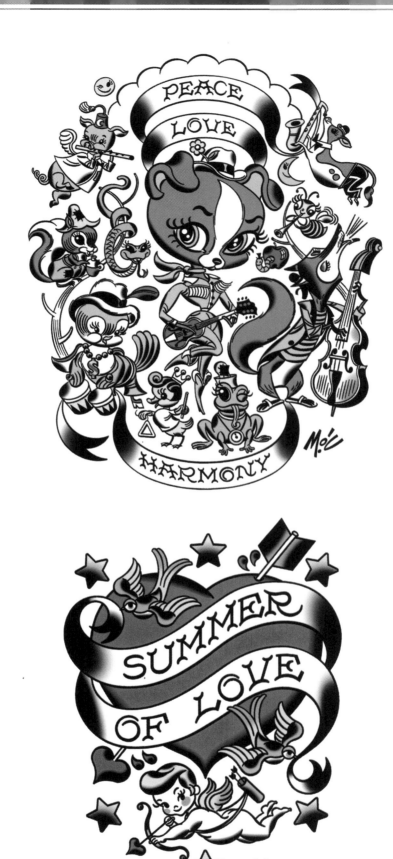

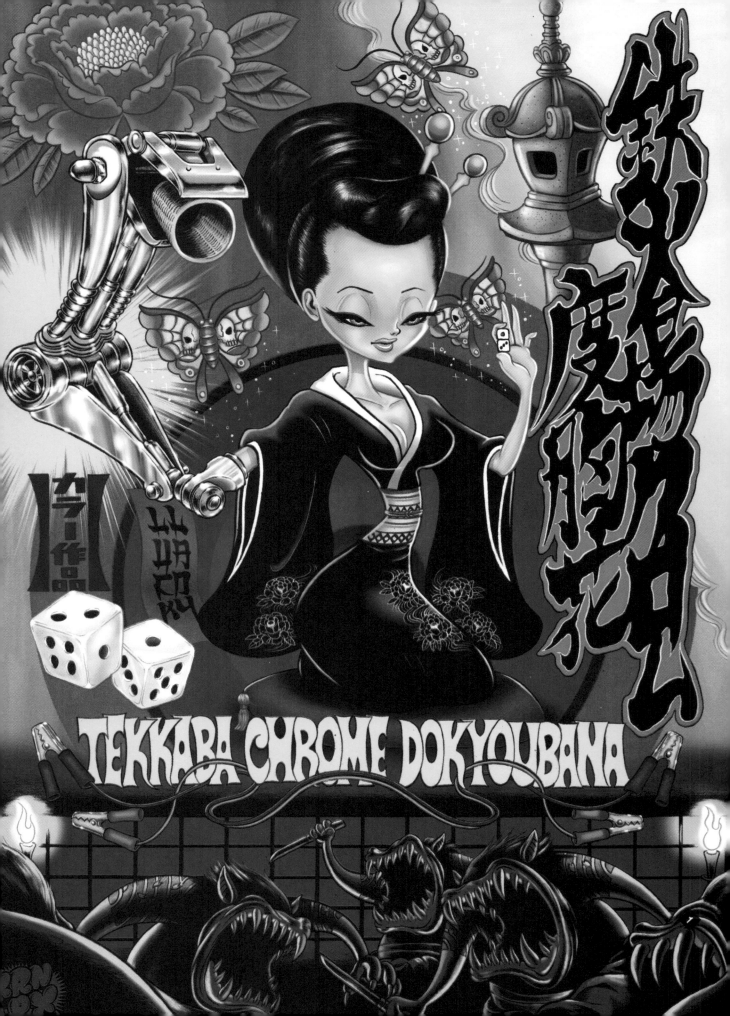

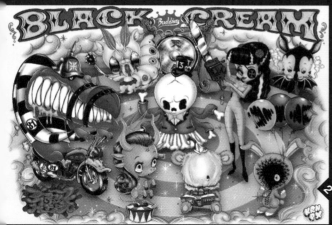

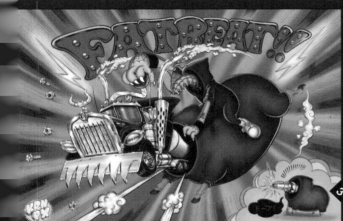

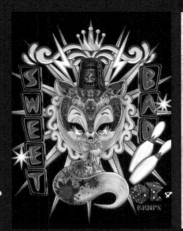

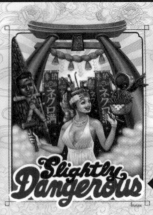

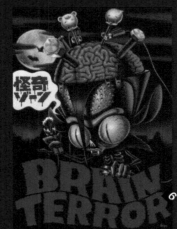

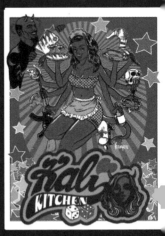

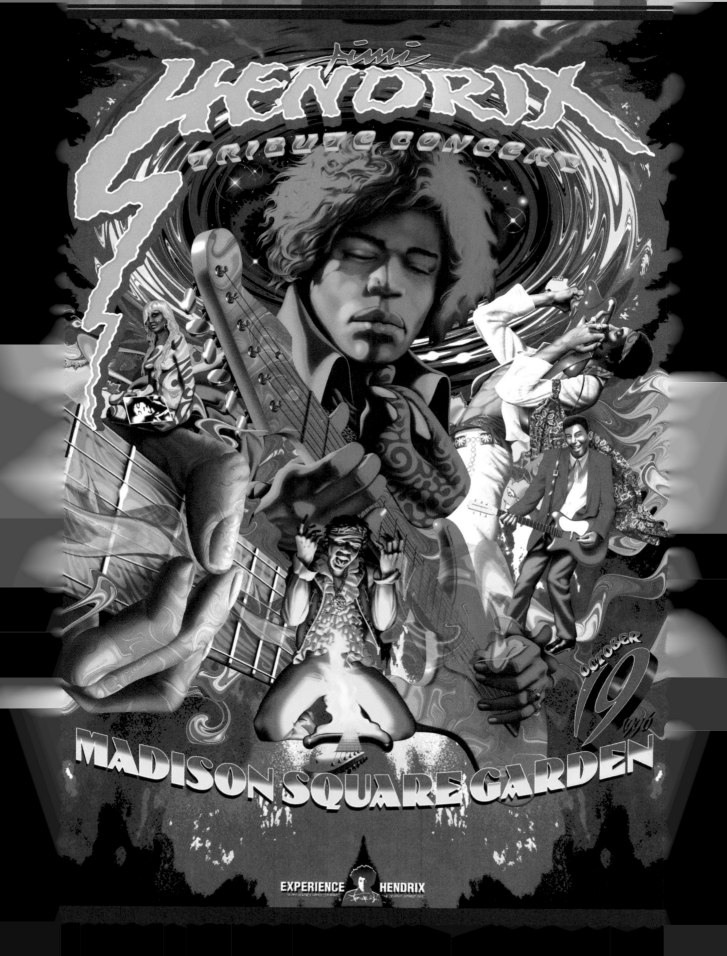

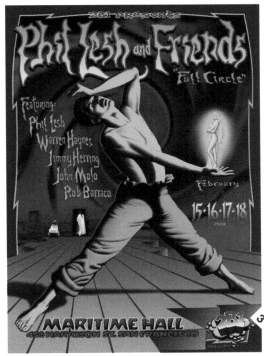

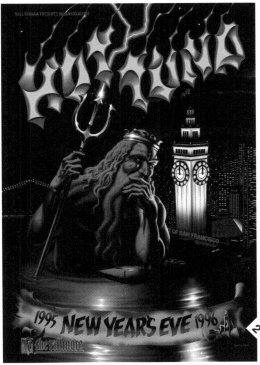

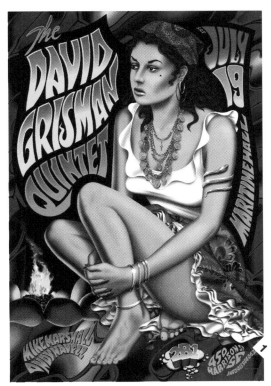

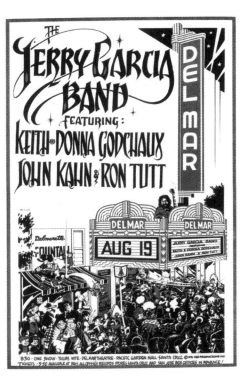

ARTIST__**JIM PHILLIPS**
TITLE__**1-DAVID GRISMAN QUINTET . 2-HOT TUNA AT THE FILLMORE . 3-PHIL LESH AND FRIENDS . 4-JERRY GARCIA AT THE DEL MAR**
TYPE OF WORK__**ILLUSTRATION**

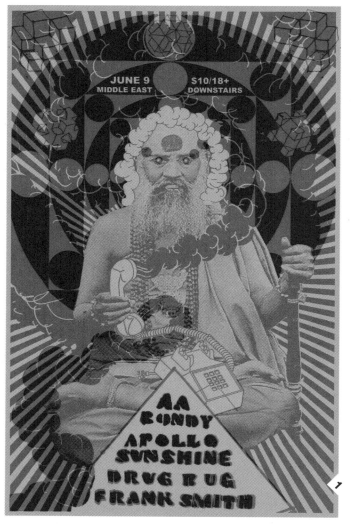

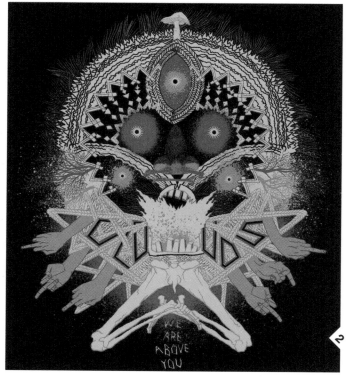

ARTIST__**CODY HOYT**
TITLE__**1**-**"APOLLO SUNSHINE SHOW POSTER"** . **2**-**"CLOUDS T-SHIRT VER. 1"**
TYPE OF WORK__**ILLUSTRATION**

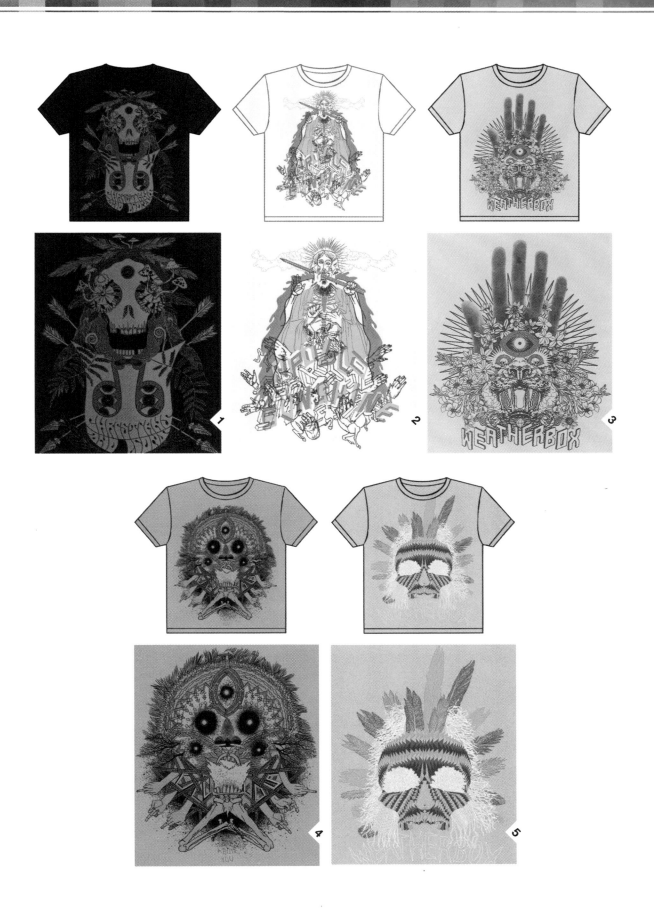

ARTIST__**CODY HOYT**
TITLE__**1-"CHRISTIANS AND LIONS T-SHIRT" . 2-"APOLLO SUNSHINE T-SHIRT" . 3-"WEATHERBOX T-SHIRT 1" .**
 4-"CLOUDS T-SHIRT VER. 2" . 5-"WEATHERBOX T-SHIRT 2"
TYPE OF WORK__**ILLUSTRATION**

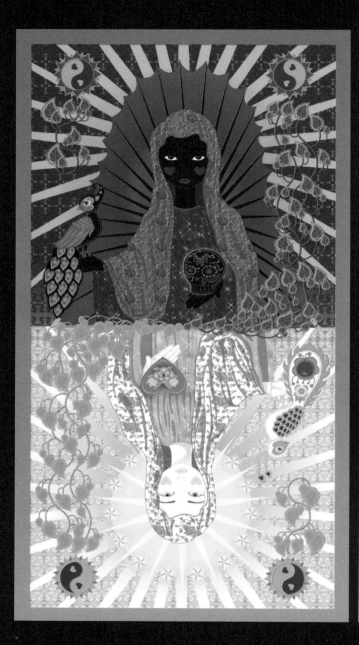

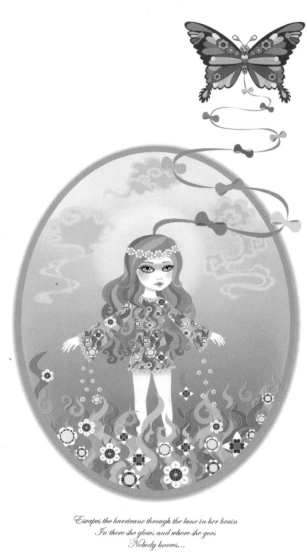

Escapes the hurricane through the lane in her brain
In there she glows and where she goes
Nobody knows...

ARTIST__**MARIA ROZALIA FINNA** TYPE OF WORK__**PRINT**

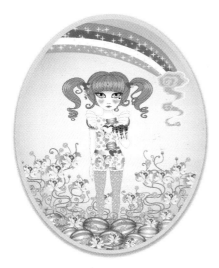

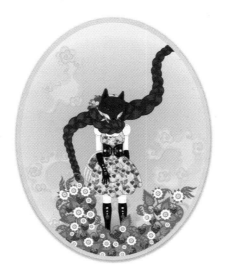

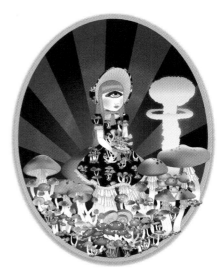

Inspired with fantasia
I want to see falling
Where you eat in my heart
Like a waxing melon

Ever since I was a small girl with rosy red cheeks,
In the letters into...
My beautiful heart
I've always wanted you too.

Strange things grow in dark places

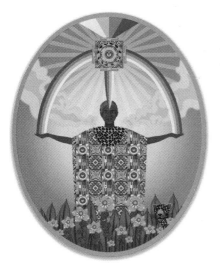

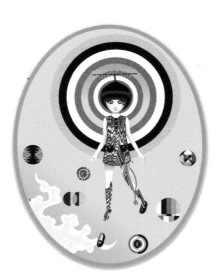

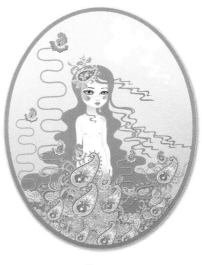

Nelssie's Mandala

Searches for the frequency to know what it's about.
Swimming through black and white in
From in, now in, deep red

Praise be all hazy,
Glaze we in paisley
That play free like crazies

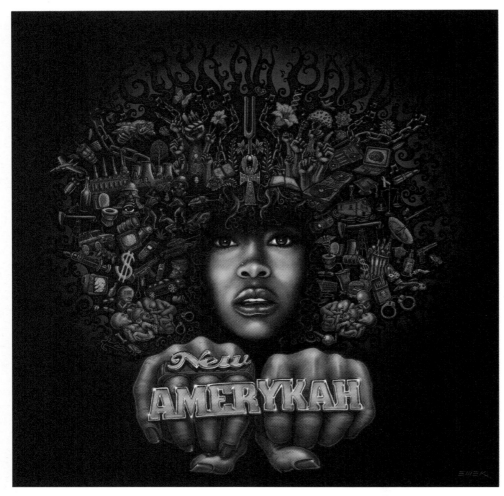

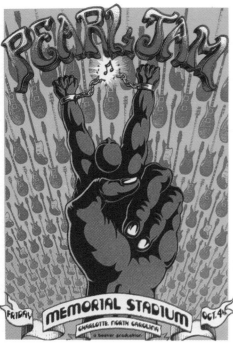

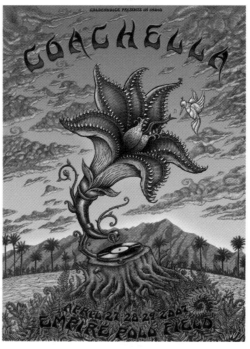

ARTIST__**EMEK** TYPE OF WORK__**ILLUSTRATION**

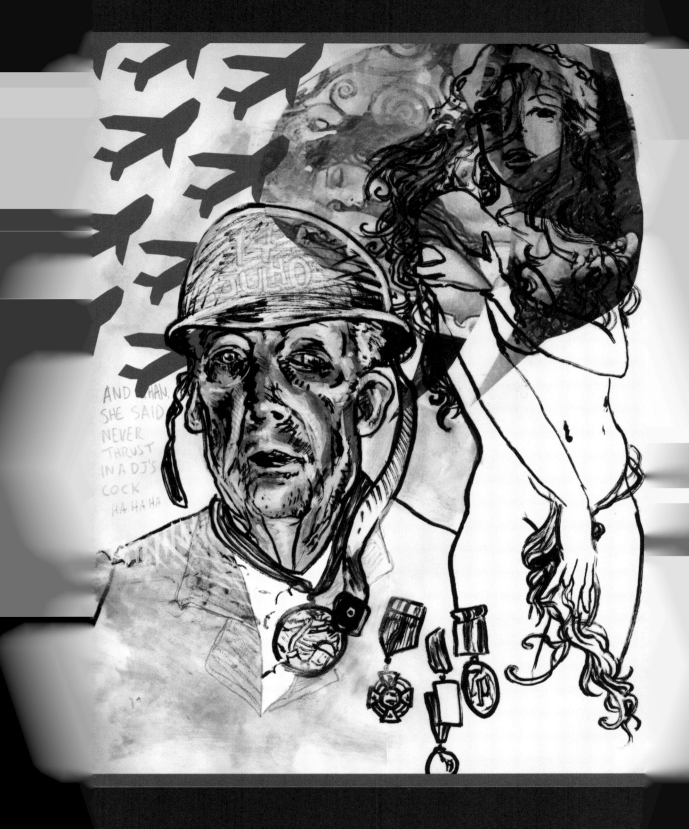

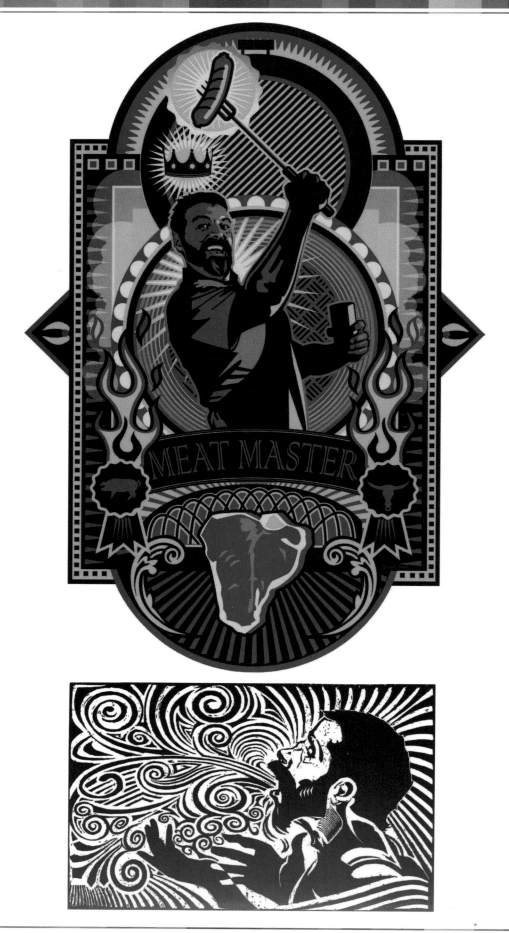

ARTIST__**JOSEPH TAYLOR** TYPE OF WORK__**ILLUSTRATION**

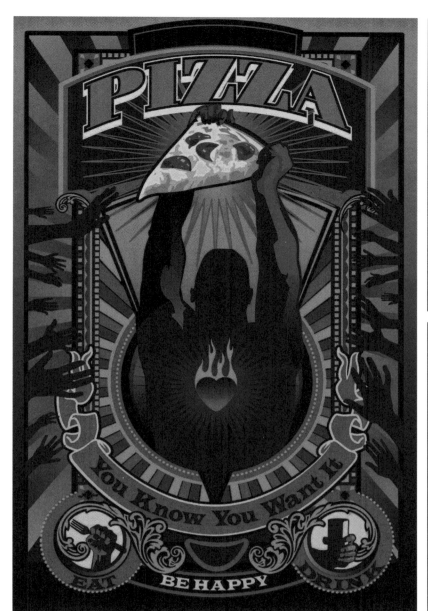

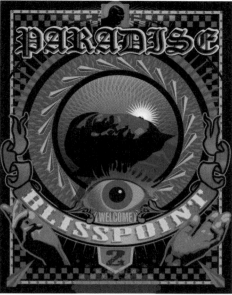

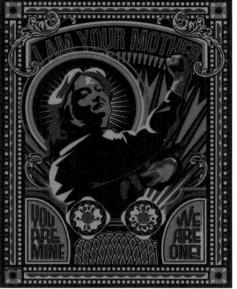

ARTIST__**JOSEPH TAYLOR** TYPE OF WORK__**ILLUSTRATION**

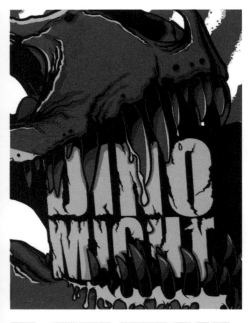

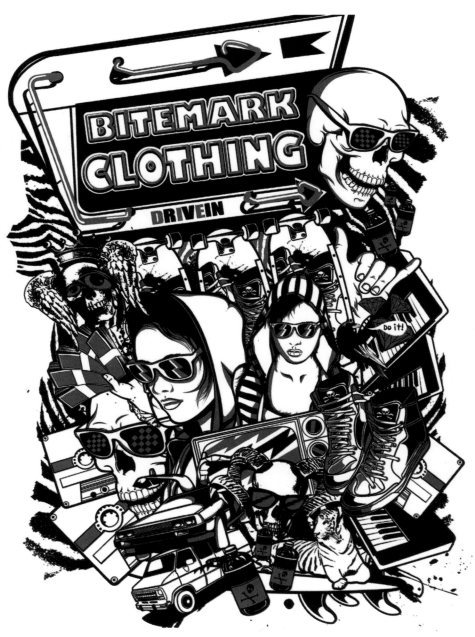

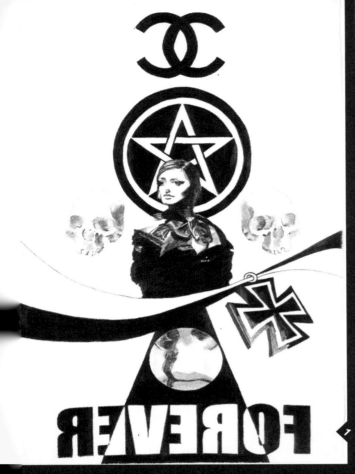

INDEX

INDEX

ZEh Palito
Zosen

www.animalbandido.com •
www.totulines.com
www.flickr.com/zehpalito
www.totulines.com

totulines@gmail.com
ouwnn@yahoo.com.br

Yukister • Yuki Nakano

www.yukister.com
www.billyartnyc.com

hi@yukister.com
Billyartnyc@yahoo.com